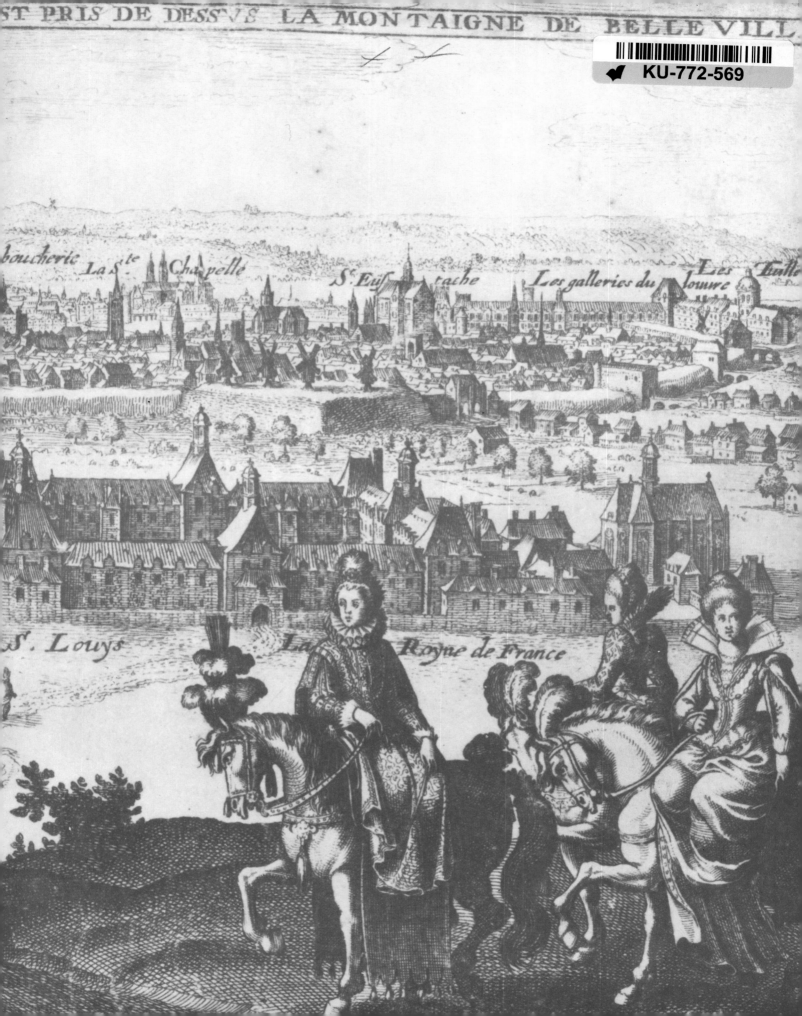

ST PRIS DE DESSVS LA MONTAIGNE DE BELLEVILL.

boucherie La S^te Chapelle St Eustache Les galleries du louure Les Tuille

S. Louys La Royne de France

KU-772-569

PARIS

PARIS

by

Jean de la Monneraye

Honorary Chief Librarian
of the Bibliothèque Historique
de la Ville de Paris

and

Roger-Armand Weigert

Librarian at the
Bibliothèque Nationale

English translation by
Vivian Rowe

GEORGE G. HARRAP & CO. LTD
London Toronto Wellington Sydney

First published in France 1968
© Horizons de France 1968

First published in Great Britain 1971
by GEORGE G. HARRAP & CO. LTD
182-184 High Holborn, London, WCIV 7AX

English translation © George G. Harrap & Co. Ltd 1971
All rights reserved. No part of this
publication may be reproduced in any
form or by any means without the prior
permission of George G. Harrap & Co. Ltd

ISBN 0 245 59948 7

Printed in Switzerland

CONTENTS

PARIS IN HISTORY
by Jean de la Monneraye

ART IN PARIS
by Roger-Armand Weigert

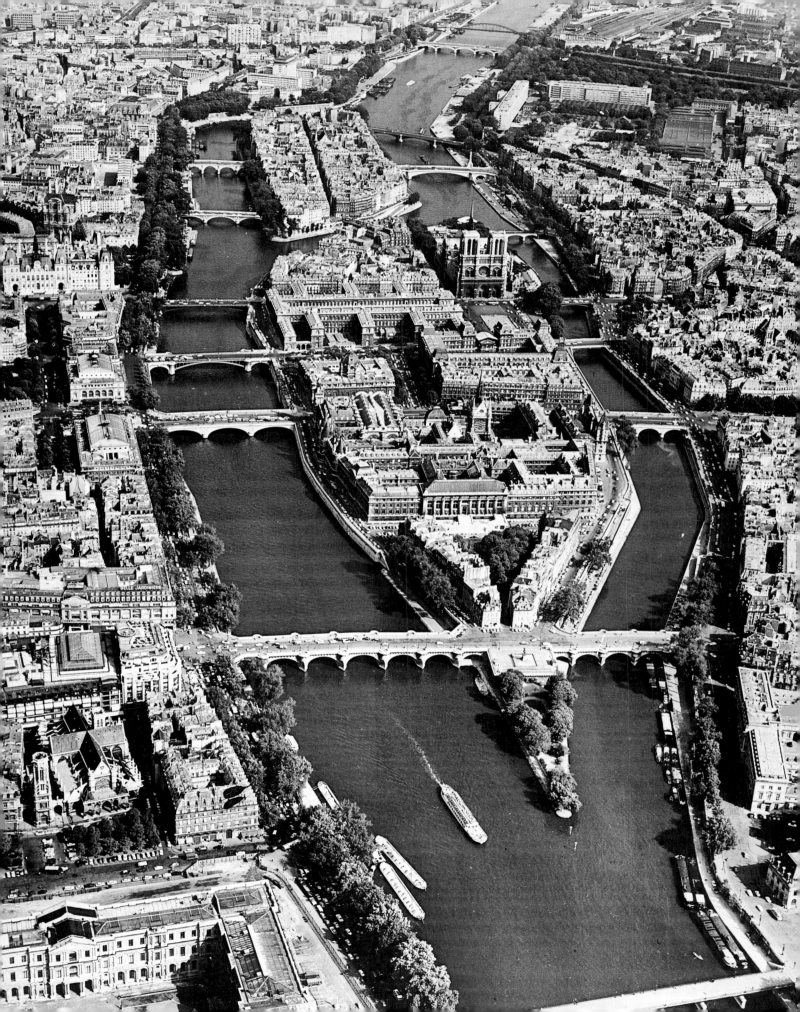

PARIS IN HISTORY

It would be presumptuous to suggest that these swiftly moving pages constitute a history of Paris; they do not even pretend to be an abbreviated version of a full history. They are only intended to portray the ebb and flow of life in a city whose own destiny has, for a thousand years, been inseparable from the destiny of all France. The life of Paris has always mirrored human existence with its alternation of contrasting periods, its times of strength and its times of weakness. It has known moments of desperate search for means of prolonging for a little while more a state of precarious stability.

It has known others when it has given itself over to new ideas, or in the course of troubled growth has suffered the effects of the great tensions created by differing political and moral issues. At other times its life has moved along with the calm of a quiet stream. It was often at these times that life in the city reached its culminating point. It was a creative city in different ways at different times, ranging from a new philosophy to those little trinkets known as *articles de Paris*, from a new school of painting to a novel design for a new model of car. And in all its history this city, the loveliest in the world, has never failed to fascinate mankind.

THE BEGINNINGS OF
A NEW CAPITAL:
FROM LUTETIA TO PARIS

The slow passage of a thousand years preceded the active centuries of growth and greatness for Paris. At first Paris was not even Paris by name, which it became only after a slow rise whose beginnings are veiled by the mists of pre-history.

The future capital owed a greater debt to primary elements of a natural and geographical order than to man himself: the island and the river predetermined its position in history as a place of transit and of great defensive strength. The earliest traces of human habitation in these parts suggest that a desire for security determined its choice. It is on the southern and most easily defended promontory of the Villejuif heights that pottery and arms of the La Tène period (fifth century B.C.) have been found. It was many centuries before the region became more fully organized. The Celts came swarming into Gaul from Central Europe and must quite soon have been attracted by the situation of the future Paris, for it has been proved that long before the first Roman legions came, the Celtic *Parisii* lived in a flourishing town on the banks of the Seine. They had made the Ile de la Cité their headquarters. They chose the islet, which is only a little way downstream from the confluence of the Seine and the Marne and in the very centre of the Paris basin, as early as 250 B.C. The actual size of this settlement, known to us as Lutèce or Lutetia, and the extent of its activities remain largely conjectural. It was doubtless of a certain commercial importance and must have handled the trade in the timber of the great forests which surrounded it. There were boatmen there, foreshadowing the Gallo-Roman *Nautes* (corporation of boatmen of

the Seine) and the medieval Parisian *Hanse*, the famous *Marchandise de l'Eau* whose principal office-holder became automatically the Provost of Paris Merchants. These times are recalled by the very fine coins struck by the mint of the *Parisii*. Julius Caesar, in his *Commentaries on the Gallic War*, made clear the defensive value of Lutetia when he described the disaster which befell the township in 52 B.C. In order to bar the river crossing to Caesar's lieutenant Labienus, the *Parisii* destroyed the bridges and burned the town. Although, as we know, this despairing act did nothing to arrest the general progress of the Roman conquest, history confirms that Roman rule gave the principal town of the conquered *Parisii* three centuries of all but perfect peace. The new military power made the island its headquarters. With the island rebuilt, the capital spread along the river's left bank, where, on the slopes of *Mons Lucoticius*, a new town took shape, following the pattern of Roman towns elsewhere. It became the supply base and transit camp for the Imperial armies, which helped to develop its commerce, almost entirely water-borne. Soon Roman and Gallic inhabitants fused in a single race. In all, those who lived in this city numbered probably from seven to eight thousand.

Before long almost nothing of this prosperity remained. Doubtless prior to A.D. 280 Lutetia, left without any fortifications and but ill-defended by Roman arms, was overrun by invading bands from across the Rhine. The island seems to have escaped devastation by fire but the Left Bank settlement was utterly destroyed and ceased for several centuries to have any urban significance: when it did

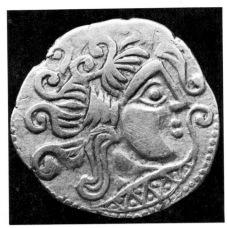

Coin minted by the Parisii. From the Medals Cabinet of the Bibliothèque Nationale.

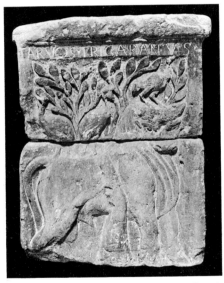

Monument erected by the Nautes: a bull god and three cranes. In the Musée de Cluny.

The prow of a ship. This stone carving was discovered in 1868 near the Sainte-Chapelle and evokes the age-old activities of the river port. In the Musée Carnavalet.

come back to life it was in a totally different form.

Only a few years had passed after this catastrophe before the name of Lutetia had ceased to be in common use. Instead the town gradually came to be called Paris. The name of the tribe which first founded Lutetia was thus perpetuated. All through the fourth and fifth centuries A.D. the Roman Empire struggled against the irresistible onset of decadence. Everywhere the barbarians were clawing down its defences. Paris, though, was far from being abandoned. Generals, and even emperors, lived in it. It was to the cheers of the Parisians that Julian was raised to Imperial dignity by his soldiers in the year 361. Valentinian came to live in Paris in 365, and for long Roman generals controlled the operations of their lieutenants in the field from the Palace of Paris. By the end of the fifth century the Germani had finished carving up the Empire. It was the Franks who took possession of the Paris basin. Clovis was their chief at that time, and to him must go the credit for having taken the first step towards making Paris a place of political importance. It was when he returned in 508 from a victorious campaign against the Visigoths of Aquitania that he decided to make Paris "the seat of Government of his Kingdom". As far as it lay within his then limited powers, this was to make it a capital city. Certainly the choice was dictated by administrative considerations, and possibly even more by military ones. This choice of a town so inadequate could at that time be no more than a promise of influence and glory to come at some later date. Nevertheless the promise engendered some quite resounding echoes. The nation had for long been trying to develop a personality of its own. This action appears to have given it one, for little by little thereafter Paris became the heart of the nation. Such was the outcome of the Merovingian king's decision.

Parallel to the growth of political power was that of the spiritual power of Christianity. Paris accepted Christianity in the middle of the third century, with Saint Denis (Dionysius) as its first bishop. How rapid thereafter was the rise of Christianity was disclosed in the nineteenth century when a vast Gallo-Roman and partly Christian necropolis was unearthed on the site of the former suburb of Saint-Marcel. A Council was held in Paris as early as the first half of the fourth century and many similar assemblies, some of great importance, followed the Merovingian period. The civilizing, and perhaps political, influence of the heads of the Church in Paris over a fragile and highly unstable society is made manifest in the lives of a Parisian saint (Sainte Geneviève) in the fourth century and bishops such as Saint Marcel in the fifth century, Goslin in the ninth century, and others who came later.

The Seine and the Cité in mid-fifteenth century. "The Descent of the Holy Ghost" by Jean Fouquet in the Book of Hours of Etienne Chevalier, in the R. Lehman Collection, New York.

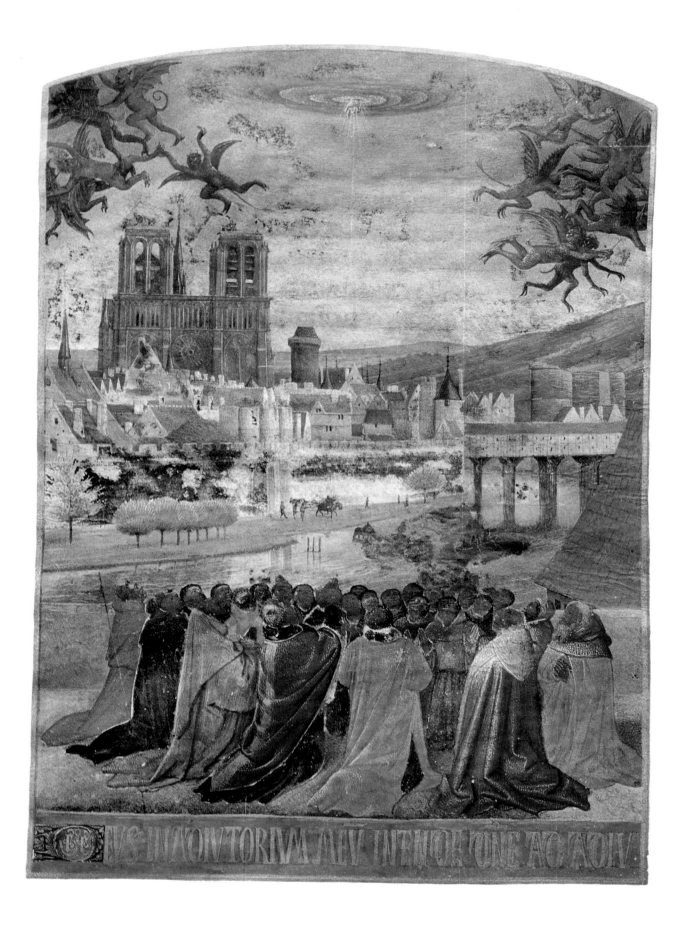

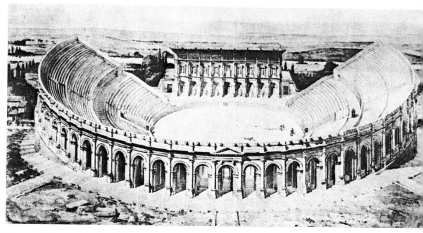

The Arena. This important monument could date from the first century and would therefore be the oldest in Lutetia. Reconstruction by Formigé. From "Paris antique" by P. M. Duval (Hermann).

Written evidence, such as the Lives of the Saints, is not the only proof of this. The Merovingian cathedral of Saint-Etienne was the largest church yet built in the land which was about to become France. Its very dimensions point to the progress made by the town and to its increasing resources and man-power. What were the daily cares and the daily activities of the people of Paris during the half-millennium which opened with the fall of the Empire and closed with the rise of the first Capetian kings? It is not possible to give a complete answer in the absence of well-informed and accurate chroniclers and without the lasting testimony of stone buildings. Circumstantial and lively evidence is best obtained from the records which tell of invasions by Norsemen. All through the ninth century these depredators were the nightmare of the Parisians, who barred their way to the wealth of Burgundy. In doing so, Paris earned the respect of all her smaller neighbours whom she protected throughout this ceaseless struggle. There were also other advantages she derived from it. For example, it led to the most fruitful of political unions with her direct rulers, the Robertian and Capetian Counts of Paris who were the efficient representatives of distant and ever more useless monarchs. When the Carlovingian dynasty fell in the tenth century the Counts took the Crown for themselves.

Paris at that time was still very clearly in her infancy. Her normal growth had been slowed down by the violence of the times and Aix-la-Chapelle, the ephemeral seat of Carlovingian power, had usurped her position as capital of the weakly kingdom. The principal obstacle she had to overcome was, however, a feudal society utterly opposed to urban civilization. Nevertheless signs pointing to a better future became more frequent from the tenth century onwards. Paris was no longer confined to the Cité and appeared to be growing in all directions at once. Clovis had already built a basilica dedicated to Saint Peter and Saint Paul on the very top of the old Mont de Lutèce. This sanctuary was built to shelter the tomb of the city's first saint, Sainte Geneviève; it was destined also to enclose the tomb of its founder. Thanks to the munificence of the successors to Clovis, abbeys sprang up everywhere in the city and its immediate surroundings to become the foundation stones of the future development of Paris. Saint-Germain-des-Prés came in 543, Sainte-Geneviève at the end of the seventh century, Saint-Martin-des-Champs in 1060, and there were others of lesser importance. These creative centres gave rise to widespread activity, and little urban agglomerations arose around them. There are other very clear signs of urban expansion. The names of new parishes on the Left Bank are to be noted, and significantly more on the Right Bank, now established as the home of commerce. Houses began to line wide roads leading to those monasteries which were close to the city as well as to others relatively far away but with which the city had commercial or religious ties. Defended to the south by a fortress guarding the approach to the Petit-Pont and to the north by another (known as the Grand-Châtelet) near the Grand-Pont, the Cité remained, though more than ever encumbered by street-traders representing every kind of retail trade, the heart of Paris. The palace from which so many previous occupiers had sent forth their orders had been rebuilt and by the end of the period was being lived in by the Capetian kings. The domain of a rival power, the Bishop and his Chapter, lay eastwards. In this quieter part of the island, schools had been installed in the cloisters of Notre-Dame. By the end of the eleventh century the cloisters buzzed with the talk of scholars who had descended upon them, often from great distances. In these schools lay the promise of the future intellectual development of the capital.

Saint Denis, with Catulla his convert who buried him and his two companion martyrs. Miniature from a thirteenth-century "Life of Saint Denis" in the Bibliothèque Nationale.

9

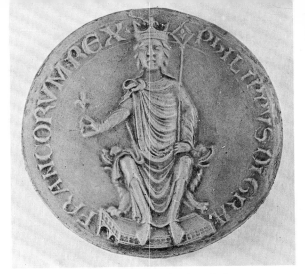

Seal of Philip Augustus, 1180.
This king's labours on behalf of Paris lasted
through all the forty-three years of his reign.

THE PARIS
OF NOTRE-DAME

During this period, one of the most fruitful in the history of the French nation, Paris acquired a position of decisive power, taking an incontestable lead over all other towns in the kingdom. A specifically Parisian way of thought soon developed in its atmosphere of freedom. The liveliness and the clarity of this way of thought gave it an influence which was exercised well beyond the limits of Capetian France. This was the point in time at which medieval civilization entered into its high period and, as the feudal system began its decline, the idea of a nationhood under a monarchy grew ever stronger. So far nothing had happened to shake the city's religious faith, which was still firmly held by all. From 1163 onwards for a full century the slow building of the new cathedral symbolized the growth of the town itself. As a work of art this masterpiece in stone, this *opus francigenum*, was essentially Parisian and for long dominated Western architecture.

The times were particularly favourable. The kingdom and the nations surrounding it were in full development. Towns proud of their wealth, from Bruges to Florence, sought to establish closer connections with it. In war, as in peace, the activities of the Capetians were generally successful. The city watched the consolidation of its defences, the growth of an increasingly efficient administration, the development of new opportunities for wage-earners, and the expansion of wealth. The city's rapid growth during that time was not just a matter of chance, but the outward manifestation of inner strength, as the light of history now discloses. A new phenomenon, extraordinary if only for its intensity, became apparent at the opening of the twelfth century: Paris opened wide its gates to learning with such enthusiasm that it affected the city materially and became a continuing influence upon its spirit. The young scholars who once were taught in the cloisters of Notre-Dame now crossed the Petit-Pont with their teachers and settled on the long-deserted slopes of the Montagne Sainte-Geneviève. Here the abbey of Saint-Victor, which was founded by Louis VI in 1108, became one of the greatest centres of medieval science. Italian, German, English, Flemish, Swedish, Polish, and Danish students, and the students of other nations still, flocked there to sit at the feet of great teachers: Abelard, Guillaume de Champeaux, Pierre Lombard. All this learning came within the control of the Church, which found new strength in it.

At the other end of the town, beyond the Grand-Pont, the pursuit of commerce continued to increase. In 1118, in order to reduce the crowds who were choking the busy streets of the Cité, Louis VI arranged for a big new market (the Marché des Champeaux) to be opened at the very edge of the town, practically in the country. At about the same time (in 1121) he favoured the boatmen by granting their corporation a monopoly of river traffic from Corbeil to Mantes. Another important trade gathering, the Lendit Fair, was instituted in 1117 on the plain of Saint-Denis. It soon acquired international fame and was reopened there every June thereafter.

By the time that Philip Augustus came to the throne in 1180 it would seem that the commercial, political, religious, and intellectual foundations of a city of the period were already firmly laid in Paris. This monarch's long, and effective, reign was one of the five or six most important periods in the evolution of the city. Paris was now recognized as essential to the very existence of the kingdom and as the pillar on which the dynasty depended for support. His first care, then, was to consolidate its defences. A strong, continuous, fortified *enceinte* was built round an area of about 470 acres. Much of it was still field or vineyard, but by royal desire colonizing of this newly added rural zone was accelerated. Immediately north of the river the *enceinte* was strengthened by a tower stronger than any of the others. This was the Tour du Louvre, in which the King's treasure was kept, and was the origin of the city's most famous palace. And for 200 years the *enceinte*, with its twelve gates, was

Seal of Maurice de Sully, 1170. As Bishop of Paris
he was concerned from the beginning with the rebuilding
of Notre-Dame. From the Archives Nationales.

never attacked. This was only one of many improvements which Philip Augustus made in Paris. The main streets were paved. Water supplies were piped. Public fountains were installed. The Champeaux market was housed in new buildings (Les Halles) to increase its efficiency.

All this was no more than the purely material aspect of the changes: the union of King with City brought many other advantages. Philip Augustus made a first approach towards co-operation with the citizens when he asked for financial help towards the building of the new fortifications, and thereafter they demonstrated their loyalty and their importance on many occasions. Six of them were appointed by the King to the Regency Council which would rule during his absence on the Crusade. In their keeping he placed both the royal treasure and the royal seal, a remarkable example of his confidence in them. The most important social and political event of the times was, for Paris at least, this rapid rise of the middle classes under Philip Augustus and his successors. Trade had much enriched the capital, and to the burghers' advantageous economic situation were added further benefits in connection with the King's service. State institutions had expanded and in practice were almost exclusively Parisian. The townspeople willingly accepted such posts as were offered to them and became servants of the State, which in fact meant that they were first and foremost servants of their own city. This recognition of the importance of the middle classes was closely linked with great improvements in the administration of the city.

In 1060, Paris had one administrator only, the Provost, who derived his authority directly from the monarch. By the thirteenth century, following a change in the Water Merchants' activities, which previously had been purely commercial, a parallel administration began to form. By the grace and favour of the monarchy the *Hanse* was becoming a municipality. From the end of the reign of Philip Augustus onwards the process of municipal evolution was greatly accelerated: the first mention of the Provost of the Merchants as the head of a municipal organization occurs in 1260. The King's authority over the city was already shared with the nobility, whose power was on the decline, and with the Bishop and other eminent ecclesiastics. The wealthier citizens of Paris now began to take their share of municipal responsibility. Municipal organization changed its shape during the thirteenth century, incorporating the Provost of the Merchants and *Echevins* (City magistrates) and having its own offices. In the first third of the fourteenth century the nation's representatives met in assembly on many occasions to discuss administration and taxation with the King and this resulted in a notable increase in the authority of the burghers of Paris.

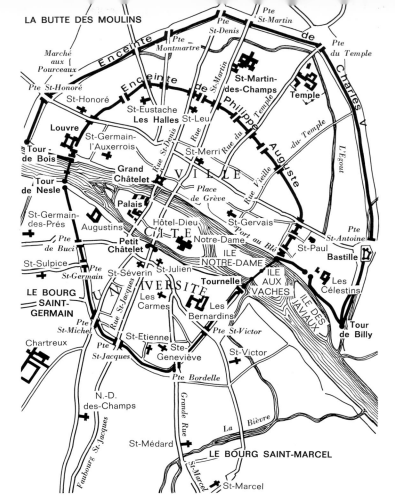

Plan of Paris at the end of the fourteenth century.

Despite this, none of the kings of these times saw fit to grant the city a charter. At first the embryonic city council used to meet at a house not far from the Grand-Châtelet which became known as the *Parloir aux bourgeois* (the Burghers' Parlour). This was soon found to be too small for municipal needs and in the middle of the fourteenth century Etienne Marcel, Provost of the Merchants, bought a bigger house to take its place. This house was on the Place de Grève, then the very centre of *Hanse* affairs. It became famous in history as the House of Pillars, and in the sixteenth century a full-scale Town Hall was added to it.

Materially the town was acquiring greater cohesion, and to this the great wall of Philip Augustus contributed not a little. The wall had forcibly separated the urban parishes from the suburbs beyond it, and they became a strong unifying element within the town. At the same time little feudal urban empires which had always strengthened the tendency towards separation were being forced to conform to the parish pattern. The Cité, however, remained the town's most lively element and continued to be the true heart of Paris. The kings lived in their ever-expanding palace in the Cité until the middle of the fourteenth century and admiration for this venerable old building was increased when, with the building of the Sainte-Chapelle, a noble

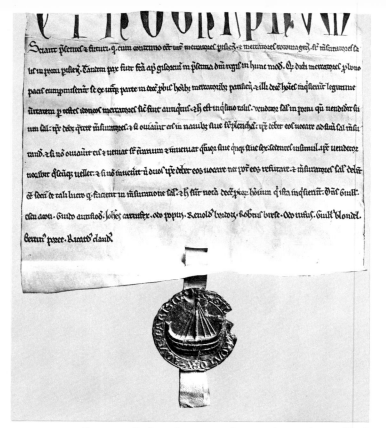

Fragment of a formal agreement between the merchants of Paris and those of Rouen concerning river traffic. The seal of the Water Merchants of the year 1200 is the earliest known. From the Archives Nationales.

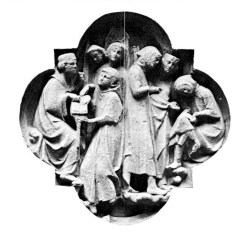

Scene from University life in the thirteenth century. Bas-relief from one of the portals of Notre-Dame de Paris.

branch of mercantile activity which was essential to all the others — the money handlers. Capitalism in Paris was born in the thirteenth century. Money irrigated the fields of commerce. And money became more and more closely linked with a monarchy which was constantly short of it.

This activity sprang from material expansion and it is not in that quarter that the greatest originality of the Paris of Notre-Dame should be sought, but in the one beyond the Petit-Pont, for, far from slowing down, the impetus of learning increased after the end of the previous century. Philip Augustus brought a little more order into the somewhat ill-organized republics of teachers and students and in the year 1200 brought the learned men of Paris together in a University to which he granted great privileges, thus showing the importance he attached to human intelligence. To royal privileges the Pope added ecclesiastical ones. Colleges were founded to harbour the growing crowds of students. The most celebrated of them was founded in 1257 through the generosity of Robert de Sorbon, chaplain of Saint Louis. In 1219

idea of Saint Louis became a sublime reality. Not far to the east, the cathedral had just reached completion and a little flock of smaller churches was gathering around it. Between the Palace and Notre-Dame there was a network of little streets in which artisans exercised their trades. There were booksellers and bookbinders and apothecaries (the Hôtel-Dieu hospital was close by) on the cathedral side, whereas towards the Palace was the quarter of drapers, furriers, goldsmiths, and others who catered for the rich. Beyond the Cité was the Grand-Pont, built up with houses on either side, the centre of the capital being increasingly short of building sites: here were the bankers and money changers. In the town proper, *La Ville*, across the river from the island, shopkeepers existed side by side with those artisan industries in which Paris workers already excelled. There were dyers, weavers, and fullers and the members of the very powerful Guild of Butchers. More to the north-east were the armourers and fashioners of helmets, as well as tanners and workers in a dozen other trades. Thanks to one Etienne Boileau the way in which busy commercial life was organized is well known. Boileau was Provost of Paris in the reign of Louis IX, and wrote *Le Livre des métiers* (The Book of Trades) about the Paris he knew so well. *La Ville* had two other very busy centres, the covered market *(Les Halles)* and the strand *(La Grève)*, where the river boats bringing wood and charcoal to the capital came in to berth. None of this lively commerce could have existed without the help of one particular

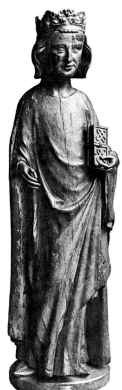

Saint Louis.
His reign was marked by many royal foundations in Paris.
Yew-wood statue in the Musée de Cluny.

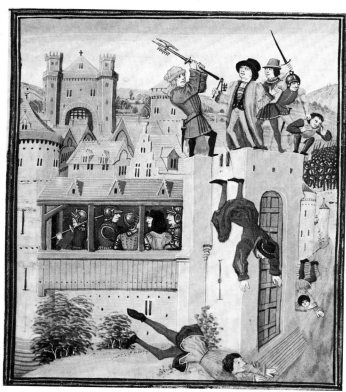

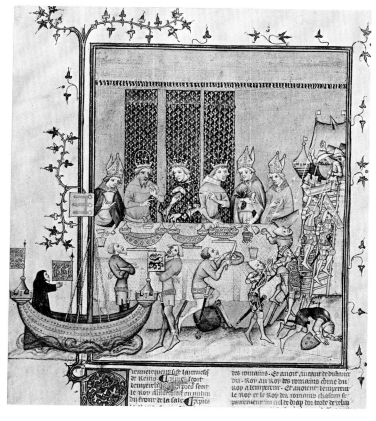

The death of Etienne Marcel on July 31st, 1358.
Miniature from Froissart's " Chronicles ",
in the Bibliothèque Nationale.

enceinte, on the line now marked by the present inner boulevards. An imposing fortress, the Bastille, was built to protect the eastern gate. The King himself moved eastwards to the Hôtel Saint-Paul and later found shelter in the Bastille.

Meanwhile grave events were taking place. The city was terror-struck in 1348 by the onset of a fatal epidemic, the Black Death. A few years later an insurrection threatened to destroy the alliance between King and city. The burghers of Paris, taking advantage of the unhappy events following the captivity of King John the Good, sought under the leadership of Etienne Marcel to enforce their own rule of law and to arrogate to the city of Paris — in effect, to themselves — the wavering power of the Dauphin Charles. The attempt was more than audacious, but it underlines the political heights to which the bourgeoisie had risen that the Dauphin could even momentarily be forced to wear the red and blue hood — the emblem of the insurgents in the colours of the city. Marcel was assassinated on July 31st, 1358, and the insurrection was crushed, but by then the most serious revolutionary situation the city had yet known had lasted for more than five months. Many, many other crises occurred in the course of ensuing centuries. Political power was always exercised in Paris, except during the Versailles interlude, and when it was authority had to keep a close and constant watch on a population bubbling with new ideas and behaving in unpredictable ways. On the other hand, Paris was able to provide authority with the power-

the Masters of Paris University ceded the church of Saint-Jacques, on the top of the hill, to the then new Order of the Friars Preachers. Fifteen years later there were over 120 of the Brothers working in the convent of Saint-Jacques, which was graced by men of the standing of Saint Albert the Great and his disciple, Saint Thomas Aquinas. At the beginning of the fourteenth century there were more than fifty colleges grouped on the Left Bank. This was truly a " Latin country " where all knowledge was transmitted in the language of the Church, pride of place being taken by theology, " the science of sciences ". More than anywhere else in town was the Church present in the University, where Franciscan monks and White and Austin friars joined in with the students. There was hardly any new Order, French or foreign, but wished to have a House in Paris, preferably on the Left Bank, which was well populated by now and was generally known as the University. The name ' Cité ' was kept for the island itself; the Right Bank was more than ever The Town, *La Ville*.

The destiny of the capital was so closely linked with that of the King's realm that it felt all the shocks of French history more deeply than any other town. Paris suffered many such shocks and misfortunes in the closing half of the fourteenth century and the first half of the fifteenth. With the exception of a minor alert in 1338, the beginnings of the Hundred Years War took place far from the capital. The old fortifications of Philip Augustus, swamped by the rising tide of new buildings on the Right Bank, were an inadequate protection, and Etienne Marcel hastily began to strengthen the city's defences. A new rampart was built, under Charles V, far beyond the old twelfth-century

Charles V receiving the Emperor Charles IV in 1378.
Miniature from the " Grandes Chroniques de France ",
in the Bibliothèque Nationale.

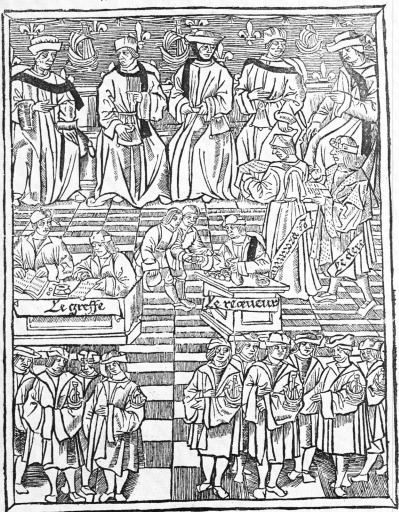

Messeigneurs les preuost des marchans et escheuins
de la ville de Paris

Le greffe

Le crieur

Les quatre sergens de
la marchandise

Les six sergés du parlouer
aux bourgoys

*The municipal authorities of Paris. From top to bottom:
the Provost and his Echevins (Magistrates); the Procurator
and his Clerk; the Clerk of the Court and the Collector; the
Sergeants-at-Arms of the Corporation, and those of the
Burghers' Parlour. Woodcut heading to the Royal Ordinances
of the Provostship of Paris, 1501.*

*" How the Maid and the French came before Paris "
(September 1429). Miniature from the " Vigils of Charles VII "
by Martial d'Auvergne, in the Bibliothèque Nationale.*

ful means needed for ambitious plans — a constant
renewal of financial resources, an inexhaustible
supply of able administrators for all the under-
takings of the State, and artists and artisans com-
petent to embellish the sovereign's palaces and to
bring lustre to his reign.

After this particular shake-up the capital had a
peaceful respite of some twenty years. Charles V
and his Provost, Hugues Aubriot, ensured its
tranquil existence. The city was enabled to renew
its taste for building and recovered a prosperity
which caused much contemporary comment.

> *This is the city, crowned above all others...*
> *There is nothing else can be compared to Paris*

wrote Eustache Deschamps in a celebrated *Ballade
de Paris*.

Charles V, alas, died too soon. A reign which
had been one of the most sombre periods in French
history was followed by a regency of which folly
was the keynote. The uncles of the twelve-year-old
boy king robbed the Treasury and brought back
unpopular taxes to restore their financial position,
and thus provoked the terrifying revolt of the
Maillotins (1382). This was not all that Paris suf-
fered, for then came the King's madness, and the
assassination of the Duke of Orleans in the Rue
Vieille-du-Temple in 1407 and its consequences —
the relentless struggle between Burgundians and
Armagnacs who turn by turn became masters of
the city. Then came the revolt of Caboche and his
pillaging followers and, finally, the arrival of the
English to become the governors of the city of the
fleur-de-lys and to be confirmed in their possession
of it by the treaty of Troyes. Thus, on December
1st, 1420, Henry V of England made his solemn
entry into the capital of Philip Augustus and
Saint Louis to be crowned King of France in
Notre-Dame. Despite all the efforts made to free
Paris, the stringent occupation lasted seventeen
years. In the course of one unsuccessful attempt
Joan of Arc was wounded in an assault on the Porte
Sainte-Honoré (1429). The legitimate King was not
able to return to his own capital until 1437. Could
Charles VII claim to be properly King of France
whilst the English kept him out of a city essential to
the nation and to himself? Certainly no contem-
porary Frenchman thought so.

The return of the King to his capital marked the
end of one period in the city's history: the Paris of
Notre-Dame (that is to say, medieval Paris) was no
more. To this the tribulations of the last fifty years
had greatly contributed, as they put a stop to all
expansion of trade and interfered with all forms of
normal existence. Its most glorious institution, the
University, was suffering from a hardening of the
arteries since its Chancellor, Gerson, the last of the
great intellectuals of his era, died in 1429.

OPENING OF
THE MODERN ERA:
RENAISSANCE AND REFORM

As soon as the English were driven away, external perils dwindled. The only echoes of fighting which reached the ears of Paris were in 1465, caused by the war of the League for the Public Good and the battle that Louis XI waged against it at Montlhéry, and they lasted only for a short period. The legitimate King had once again taken his place in the midst of his reconciled Parisians. The wounds of the city were all but healed. It stood ready to take advantage of all the changes which the spirit of the Renaissance was bringing about in a Europe soon to be enriched by the gold of the Americas.

The stage which the city had reached could be described as a questioning of the values of medieval culture in the light of a new way of thought. The change was not only in the taste for the arts, but in the mode of life as well. There was also a growth in population which continued well into the sixteenth century. It does not seem at all excessive to attribute to the Paris of the beginning of the century a population figure of 300,000. As might be expected, it was at one and the same time the cause and the effect of a remarkable economic progress.

However, the critical phenomenon of the entry of Paris into the modern era is the scrutiny of conscience which led to an almost unbroken series of crises during the entire sixteenth century. The prelude was an invention reaching France from the banks of the Rhine — the printing machine. Paris gave it a warm-hearted welcome, and in doing so speeded up the intellectual process of discarding old ideas. The first Parisian book came off the press in 1470; hundreds of printer-booksellers opened up on the Left Bank, where parchment-makers and manuscript-copyists were already installed. Amongst them were men of erudition like the Estiennes, who made Greek and Roman sources available. The old scholastic disputes at the Sorbonne ceased to interest the men of the new century who aspired to the liberation of all knowledge. Another factor in this renewal of the art of thinking was a political one: the kings, from Charles VIII to Francis I, were leading French chivalry to war across the Alps, and all returned home marvelling at what they had seen in Italy, which had then reached the highest peaks of Renaissance art. The French first experimented with these new ideas in Paris, and the capital soon adopted the Italian School. At first the arts were dominated by artists from across the Alps, until a national genius awoke and the French assimilated and transformed what Italy had to teach.

Francis I, who was a king greatly in sympathy with his times and who, as du Bellay said, had

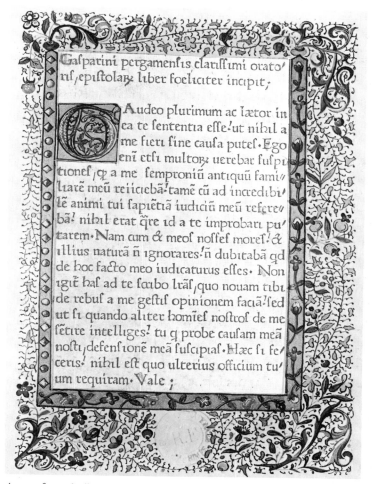

A page from the " Letters of Gasperin de Bergame " from the workshops of the Sorbonne, first book to be printed in France (1470). The illumination was carried out after the printing. From the Bibliothèque Nationale.

" demolished that ugly monster, ignorance ", introduced an innovation which goes far towards explaining the profound changes in mental outlook. In 1522 he founded a College of Royal Lecturers, which soon afterwards became the Collège de France. Here, under the protection of the monarch, the scholarly and erudite could present the results of original research without risking restraint or condemnation. The new college made its first appearance as an institution born of the new era. Its first principal was the Hellenist Guillaume Budé, who immediately surrounded himself with kindred spirits. Carried away by an expansion of the mother tongue, literature took giant steps forward. This speech of France was the speech of Paris, which was slowly emerging from its Roman matrix, for the speech of Paris had one great advantage over all others spoken in different parts of France — it had for centuries been the language of the country's kings. A number of authors, some still smacking of the soil, had already begun this expansion in their different ways when France's first poet, François Villon, launched his poignant verse on Paris. The literary ferment became very lively during the

Sermon des repeus fraches de Maitre Francoys villon.

sixteenth century, and whilst Paris could not claim all authors as her own — not even all the best authors — she was beyond dispute the literary centre. The reasons for this were her theatres, to be found everywhere, her Confraternities of the Passion, her Italian companies, her Court poets, and her academies, reflecting an image of antiquity, whose success was lasting. And it was in Paris that first the *Brigade* and then the *Pléiade* were formed by the fanatics of the new French tongue, under the leadership of Ronsard. The second proved to be the most brilliant literary movement of the age.

New impulses, new quests, and new triumphs were, for Paris, the landmarks in a century otherwise troubled and uncertain. The Catholic Church, for long the undisputed mistress of men's souls, faced a major crisis in the West. The convulsions which rocked Paris were all the more deeply felt because the men who guided the nation were the thinkers, the theologians, and even the politicians of the capital. If Paris had become Huguenot, France would almost certainly have turned Protestant with it, but as long as Paris remained Catholic, heresy had no chance of succeeding. The abjuration of Henry IV in 1593 put this fact beyond dispute, coming as it did after so many events in Paris which underlined the same point. There was the " affair of the seditious posters " in 1534, the death by burning of Etienne Dolet in 1546, the massacre of Saint Bartholomew in 1572, the interminable insurrection of the League (1588) with all its disorders, its boisterous processions, the expul-

sion of the King, the defeat of the Municipality on the Day of the Barricades and replacement by a faction (the Council of Sixteen), the calling in of the Spaniards and, finally, blockade and famine. Despite this, it would be wrong to equate these feverish days with those which the capital had known at the end of the Middle Ages. Times were indeed difficult in the sixteenth century, but at least these were not the troubles of decadence.

The rise of the city continued. Politically, the State was growing in strength, and the State was for the most part the mass of Royal Officers and Royal Courts, *Parlement*, the men of the Châtelet, and the men of the Town Hall, who all lived and worked in Paris to the number of some tens of thousands. Although the sovereigns and the Court periodically emigrated to the châteaux on the banks of the Loire for long periods at a time, their absences caused no great inconvenience to Paris. They did not even prevent the kings from continuing their interest in their Parisian palaces, as the new buildings added to the Louvre and the entirely new Tuileries palace bear witness. Furthermore the period was particularly rich in Parisian festivities, during which the monarch and his courtiers by the hundred, or even by the thousand, made the utmost display of luxury. Receptions for the great of the outside world and formal entries of the kings into their city (of which that of Henry II in 1549 was certainly the most extraordinary) made red-letter days in city life. Moreover, in a somewhat Italianate imitation of Roman antiquity, this was the century of ' triumphs '.

Guillaume Budé, one of the great minds typical of his time. Erasmus called this brilliant Hellenist, this man of universal knowledge, " the prodigy of France ". Crayon drawing by J. Clouet at the Condé Museum in Chantilly.

A Parisian pleasure garden in the days of Francis I. Flemish School, sixteenth century. In the Musée Carnavalet.

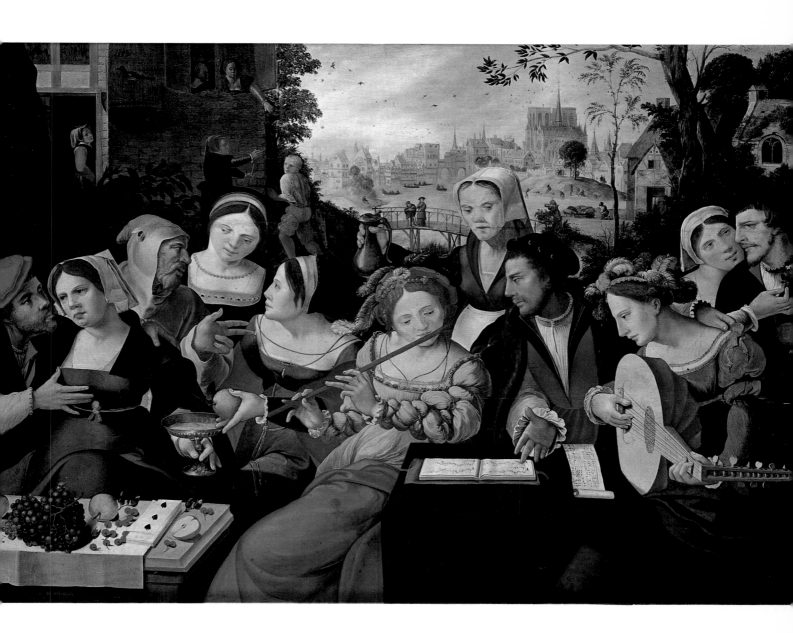

Even though the city was gradually changing in appearance, the feelings and the customs of a majority of the people still belonged to the Middle Ages. The city continued to absorb crowds of immigrants. Many of these newcomers belonged to the provincial nobility and had hopes of enjoying a brighter and freer life than the one they had left behind them. Amongst them were many for whom life in the capital was more than a living adventure. It was also the opportunity to make a quick fortune, most often in the service of the King. There was plenty of money, thanks to the hard-working Parisians, and money began to attain ever greater importance in the life of the city. Bankers and financiers, who were nearly all of Italian origin, played a great part in the city's economy. Parisians were drawn more closely into the financial game when a system of State borrowing was introduced, with the city as broker. Municipal annuities were placed with a broad section of the public in 1522. Their success during the entire century and well beyond it shows how well off a good part of the population was. The wealth of Paris in this period was very diverse in origin, but much of it came from office holders and merchants. Commerce expanded as improvements were made in the road system. Picardy, Flanders, Germany, Italy (via Lyons and the Rhône), and Spain (via the Loire valley) found their ties with the capital strengthened by these improvements. The Lendit Fair had by now lost its international character, but the Saint-Germain fair, begun in 1482, became, after various developments,

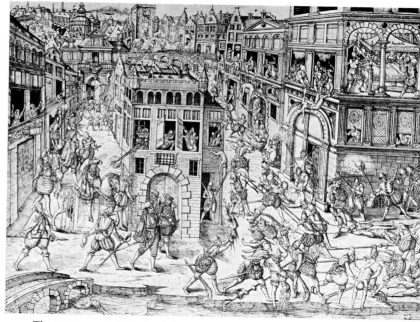

The massacre of Saint Bartholomew, August 24th, 1572. Anonymous engraving, from the Bibliothèque Nationale.

the commercial mirror of trade and life in Paris, lasting until the Revolution. The Seine ports continued to fulfil their function, but there was one new development: in mid-century timber floated down from the Morvan began to compete with the traditional timber brought from the forest of Compiègne down the Oise and up the Seine to the quays of Paris.

Whatever kings might be doing by way of changes, the artisans who made up Parisian industry made hardly any at all. Some expansion in the manufacture of cloth took place in the region of the little river Bièvre which flows into Paris from beyond

The procession of the League, about 1590. The Town Hall, House of Pillars, and Place de Grève are the background to this boisterous scene. French School. From the Musée Carnavalet.

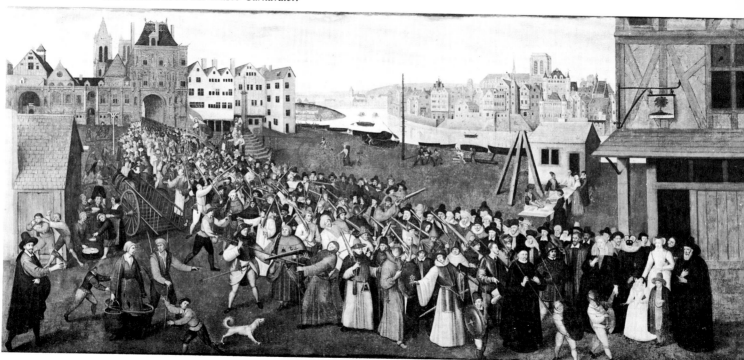

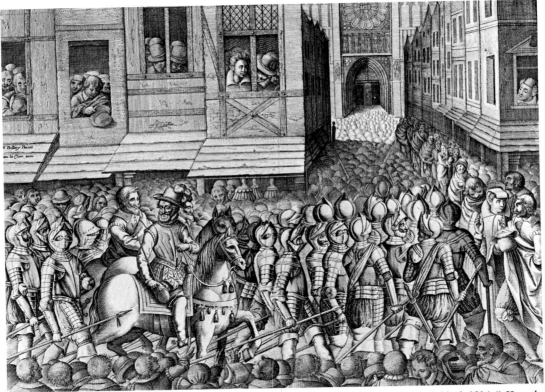

Entry of Henry IV into Paris on March 22nd, 1594. " How the King went to the church of Notre-Dame to render solemn thanks to God for this marvellous subjection of the capital city of his kingdom. " Engraving by Jean Le Clerc. From the Bibliothèque Nationale.

Saint-Cyr, but it met with only passing success and in general terms no change was observable in the city's industrial and mercantile functions. Paris was the nation's goods depot, and as such it just grew and grew.

Much attention was paid to improving the city. New amenities were provided on the river's banks. Quays were constructed on the Right Bank near the Louvre, near the Pont Saint-Michel, on the approaches to the Port des Bernardins and, at the other end of Paris, near the Port de Saint-Paul; others were built on the Ile de la Cité. New measures of doubtful efficacy were taken to improve the cleanliness of the streets. A few more were added to the existing fourteen public fountains through which water was distributed in the streets of Paris. This took place at the turn of the century, a period which introduced many other examples of municipal enterprise. The Fontaine des Innocents was planned on a monumental scale and became one of the artistic glories of Paris. The Pont Notre-Dame having collapsed, it was rebuilt in an up-to-date style, characterized by the symmetry of houses built in a novel combination of brick and stone. Towards the end of the century (1578) work was begun on the Pont-Neuf, which was intended as a link between the fast-growing Saint-Germain quarter and the western royal quarter. It proved to be a remarkable example of Latin genius. Il Boccador (Domenico da Cortona) designed the Hôtel de Ville, which was built in the immediate vicinity of the House of Pillars — a clear indication of the increasingly important part the Municipality was taking in the government of Paris.

Beautifully engraved plans of the city began, from the middle of the century onwards, to make the new developments apparent. The first signs of the decline of the royal quarter in the east of Paris are to be seen towards the end of the reign of Louis XI. This tendency was accelerated by the death of Henry II (1559). By contrast, the Louvre was the subject of much rebuilding, following its adoption by Francis I and his successors. The appeal of this royal dwelling, to which was added the Tuileries palace built for Catherine de Médicis, became the decisive element in the westwards expansion of the city. The suburbs were both pushing out in every direction and closing in on the city limits, so that every time the question of improving the city's defences arose the administration found itself unable to face the destruction of so many houses. In the Faubourg Saint-Jacques and in the Saint-Marcel area, in the Faubourg Saint-Honoré and at Villeneuve-aux-Gravois, houses were being rushed up to accommodate " the multitude of people who flock there ", as the King said in 1543.

Thus did the capital enter into the modern world. The sixteenth century, despite the terrible setback caused by the League, fulfilled its mission. It laid the foundations of an intellectual revival and, profiting by the economic advantages of the times, transformed the art of Paris to conform to the Italian School, though this is not the place to deal with that aspect.

THE CAPITAL AT ITS ZENITH: SEVENTEENTH AND EIGHTEENTH CENTURIES

There are remarkable similarities in the history of Paris during each of these two centuries. First came a new political experience for the country — the absolute monarchy, which had important consequences for the capital, from the reign of Henry IV to that of Louis XVI. Unlike the sixteenth century, this period was not one of moral and intellectual exploration but a privileged era for firm assertion and assured accomplishment with none of the waverings of the transitional epoch just ended. The nation had now acquired unity, and this was reflected in the French thought of the times. A form of discipline, frequently called 'classical', was observed in every field from language to manners. The French language, having reached the height of its perfection, was the keystone of works of clarity and logical reasoning. Paris was, and remained, the very centre of this major revolution. All France and all Europe honoured the capital for its new art of living and for what seemed to be an unparalleled state of civilization. Never before had the aged myth of Paris, old as the city itself, appeared to have been based on such fascinating realities. Also, the whole visual aspect of the city was transformed in an equally satisfactory way. The artistic ideas inherited from the Renaissance were not forgotten, but the conquering Italianism of the past gave way to a style which incorporated all the virtues of learning and good taste so typical of that moment in history.

The acknowledged pre-eminence of the capital paradoxically corresponded to a political decadence. Not until the very end of the monarchy did the Parisians recover the influence they had previously so often exercised on the destiny of France. This decadence, following upon a series of political accidents, came about mainly as the result of general causes. Certainly the evolution of the monarchical system and the conditions under which centralized power was exercised jointly tended to limit the autonomy of the capital. This piece of political history was in two phases. As soon as Henry IV became master of Paris he set out to put an end to the disorders which followed the rebellion, and he found that the exercise of his authority was made much easier by constant residence in the city. First place in the kingdom was no longer disputed with Amboise or Blois. It now belonged to Paris and Paris alone. The King then set about a programme of urbanization and municipal administration of real importance. He worked in close contact with his most intimate friends, with Sully, and with the magistrates. From 1596 to 1609

François Miron, Provost of the Merchants, gave him admirably efficient support. This zealous servant of King and city completed, amongst many other projects, the building of the Hôtel de Ville begun under Francis I. Later, under Louis XIII, all the provosts in turn had big administrative parts to play. The capital was in the full flight of progress. It had all the benefit of peaceful days, hardly at any time overshadowed by quarrels amongst the great and hardly more by the approach of the Spaniards when they threatened Corbie in 1636. Then, alas, there came a new crisis which peace could not weather — the Fronde. It began as no more than a dispute about taxation, but quickly developed revolutionary overtones. On August 27th, 1648, the streets of Paris were barred by 1260 barricades. Fed by the often .sordid ambitions of princes, parliamentarians, burghers, and even priests, public feeling did not die down until 1652. For a long period the people were engaged in this adventure of little true political significance. The city, conquered and disenchanted after years of misery, having taken sides against Mazarin, against Anne of Austria, and against the monarchy, lost what remained of its autonomy. The young Louis XIV harshly made his Parisian subjects feel the uselessness of their political quarrel. The last privileges of the Corporation of Water Merchants were abolished in 1672. All the official posts at the Hôtel de Ville were made open to purchase in 1681. This widened the gulf between the ordinary citizen and his official representatives, for though the election of magistrates and Provost of the Merchants

François Miron, Provost of the Merchants under Henry IV, contributed in great measure to the re-organization of the capital. Medallion by G. Paolo, 1606. From the Medals Cabinet of the Bibliothèque Nationale.

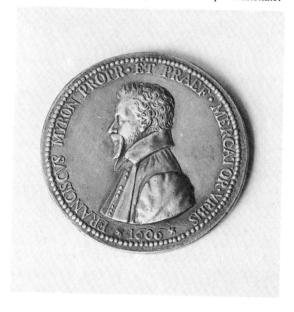

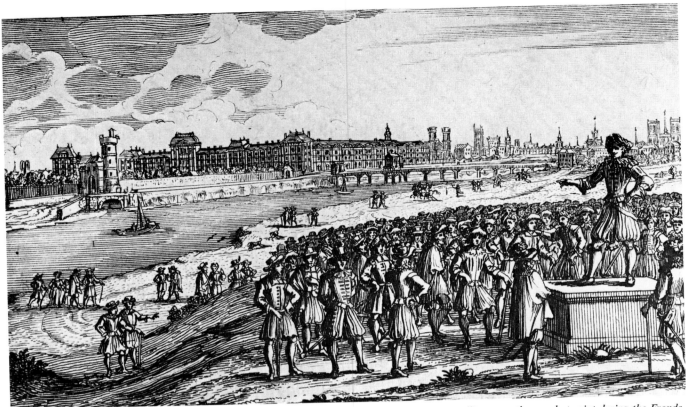

An agitator calling upon the people to riot during the Fronde.
Anonymous engraving, seventeenth century.
From the Bibliothèque Nationale.

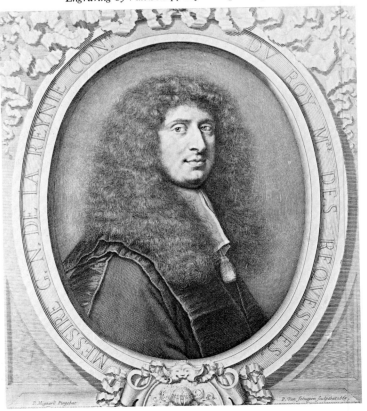

Nicolas de la Reynie, Lieutenant of Police,
who cleaned up Paris and ensured its internal safety.
Engraving by Van Schuppen from a painting by Mignard, 1665.

continued to exist, in practice only candidates backed by royal power ever won.

From thence onwards the capital was the docile ally of the monarch, though it did not suffer much (except in its pride) from a situation for which it was itself to some degree responsible. The growing power of the monarchy was of direct profit to Paris, despite the existence of Versailles. The royal administration never ceased to be interested in it and engaged in many useful municipal undertakings. Street lighting was steadily improved from 1667 onwards. Coaches for hire were made available to the public in 1662. Feudal justice was brought to an end in Paris in 1674. Procedures which had become utterly confusing were simplified, and the door was closed for ever on the Middle Ages. The General Hospital for the Poor of Paris, founded by the Company of the Holy Sacrament, became a royal institution in 1680 and did much to help resolve the difficult problems of poverty and vagabondage. Louis XIV and Colbert made *urbis securitas et nitor* their aim, and it was gradually becoming true. The decision to create the post of Lieutenant of Police was decisive in attaining this end. From 1667 onwards this royal functionary, disposing of infinitely wide powers, was the co-ordinator of nearly all the gear wheels of the complex machine which administered Paris. The first man to hold the post was Nicolas de la Reynie, who for nearly thirty years performed his functions with particularly happy results. His successors, men like d'Argenson and de Sartines, were equally filled with zeal.

The League, unhappy outcome of Parisian religious strife, had diminished the population by a quarter. Those missing had either been dispersed to other places or were the victims of the privations consequent upon royalist blockades of the city. In 1594 the number of Parisians did not quite reach 300,000, but the renewal of the population was swift, as the building fever of the first third of the seventeenth century shows. The influx from the provinces and from other countries was plain to see. In general terms the demographic advance continued virtually unchecked except during the days of the Fronde and for a few difficult years at the beginning of the eighteenth century, until the end of the monarchy. By 1640 the population had already risen to 400,000, and was above the 600,000 mark in 1789. Paris was divided in 1702 into twenty *quartiers*, which themselves derived from a long-standing division into sixteen *quartiers*. The centuries-old major division into *Ville*, *Cité*, and *Université* was still observed.

What kind of people were these Parisians? The different categories of inhabitants suffered no major change of any importance. Social structures accurately reflect the human factors needed to meet the demands of a capital city such as Paris: the need was for senior administrators, the higher magistrature, ever more numerous servants of the central power, who exercised their functions at Court and in all the civil service departments of a State increasingly tending towards centralization. It took a thousand people to keep the *Parlement de Paris* in being, with an additional few hundred serving in the Audit Office. The staff of the Châtelet, with all its police and judicial ramifications, could be compared in number with the population of a small town. The Paris municipality also employed many officials. These administrative workers collectively represented a large fraction of the middle classes, for long an essential element of the Parisian population. Above these middle classes, which had an infinite range of gradations within themselves, through representatives of all the trade and commerce of Paris to the artisan class, were some 4000 members of the aristocracy, including the élite of the French nobility. Versailles absorbed only a part of

The Place Royale, now the Place des Vosges, a new promenade on the east side of Paris, was inaugurated with a carrousel in 1612. Drawing by Claude Chastillon. From the Musée Carnavalet.

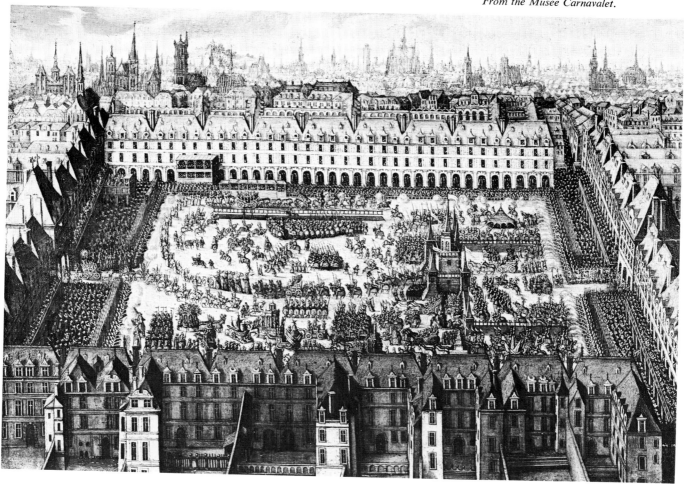

them, and then just for the time needed "to go to Court"; life in Paris had a much greater attraction for them. The aristocratic faubourgs stretched further and further into the countryside. Attached to the nobility and middle classes was another social group: servants were not far from making up the biggest single social class in the capital, and towards the end of the monarchy constituted almost one-tenth of its population. Labourers, though certainly not a rarity, remained the exception amongst manual workers, for industry advanced very slowly. In mid-eighteenth century they still numbered only 20,000. Also to be taken into account was the shifting population common to all cities, exercising the simpler crafts or just living the life of vagabonds.

The swift expansion of the population was inevitably linked with an ever-increasing rise in the number of settlers from the provinces. These were traditionally emigrants from the surrounding Ile-de-France, then from Burgundy, Picardy, and Normandy, but there were now many from Franche-Comté, Auvergne, and the Loire valley, though as yet there was no great migration from the further provinces to Paris.

There was more change in the framework within which this society existed than there was in the society itself. Changes contemporary with Henry IV and Louis XIII primarily affected the Cité and its immediate surroundings — completion of the Pont-Neuf, the first example in Paris of neo-classical architecture — the building of the Place Dauphine and of the Rue Dauphine, on the Left Bank. The yards and fields of what were still two separate islands, the Ile Notre-Dame and the Ile aux Vaches, were replaced between 1630 and 1650 by a residential quarter. This private building operation gave Paris what is now the Ile Saint-Louis. Henry IV became interested in the Tournelles quarter, farther out on the Right Bank. Between 1604 and 1612 the symmetrical pavilions of the new Place Royale (now Place des Vosges), which was intended for promenades and fêtes, were completed; the Place was the scene of a famous carrousel in 1612. Many town mansions (hôtels) were built between the Place Royale and the vicinity of the Temple, though after being very fashionable for a time this quarter (called the Marais) was abandoned by the aristocracy. However, magistrates and financiers, who did not have the same reasons for moving in closer to the Louvre and the Tuileries, went on living there for a long time. When the Palais du Luxembourg on the Left Bank was built for Marie de Médicis, a certain area of the surroundings of the University had to be tidied up. The true neo-classical city was really the work of Louis XIV and his Minister, Colbert; the latter was appointed super-intendant of buildings in 1664 and retained the post until 1683. Colbert's dream was to create a Paris worthy of the other glories of the reign. There was no longer any need to build, close in to Paris, strong defences against an enemy, so nothing now stood in the way of expanding the city beyond the old-fashioned enceintes, which would enable the suburbs to be more closely linked with the city proper. The Minister's creative forethought can be traced right across Paris in magnificent perspective views, with avenues and squares lined by examples of monumental architecture. It would almost seem that the town planners of this time could look into the future, for they gave breadth to their plans, thanks to which the capital has been able to live on into the age of the automobile. It is worth stopping for a moment to think on the value of their gifts to Paris: the splendid rise of the Champs-Elysées, the Invalides, the Observatory, the Ecole Militaire, the Place Vendôme. The dream city was to have included an avenue running eastwards from the Louvre out to the Château de Vincennes, which would have balanced the Champs-Elysées to the west. Of this, only the Place du Trône and the Cour de Vincennes were completed. The centre of the town, though, was not given the benefit of any such decisive changes. Just beyond the Louvre and the Hôtel de Ville the same old narrow streets continued to exist. The whole quarter was choked with tradespeople, and only a few changes were made in it. There was a new Place built in 1689 — the Place des Victoires. The Halle au Blé, the Cornmarket, was completed in 1672. The Palais-Royal and its neighbourhood were completely transformed towards the end of the monarchy. Nothing of any importance was done in the Cité, or along the Left Bank. The faubourgs continued to spread in all directions. The Faubourg Saint-Germain, the Faubourg Saint-Honoré, and the Chaussée-d'Antin became even more aristocratic and luxurious, but the Faubourg Saint-Antoine never wavered in its loyalty to the artisans. Lastly, taking advantage of vast empty plots made available to them, many new convents sprang up. No longer were they situated mainly on the Left Bank, but now made a sort of pious necklet all round the city. At this point Paris reached a satisfying size which remained static for nearly a century. The wall of the Farmers-General of Taxes was built in 1784. It was less a military defence than a customs barrier between Paris and the outside world. Its length was fifteen miles, which pinpoints the size of a city not yet grown inhumanly big.

Equally deep differences separated Parisian society of the Middle Ages from that of the Renaissance as separated the Renaissance civilization from that which grew up under the absolute monarchs. There is the same feeling for elegance and proportion throughout the whole of Paris

*D'Alembert giving a reading from one of his own books
in the salon of Madame Geoffrin.
Painting by Lemonnier in the Musée des Beaux-Arts in Rouen.*

of this era, from the stylish purity of line of the Place Vendôme to the flowering of French wit in the *salons* of the near-by Faubourg Saint-Honoré. Subtle changes came over Parisian life as society rapidly evolved once royalty had restored order. To this the changes which took place in the aristocratic town mansions *(hôtels)* bear witness. The *ruelle*, the little alcove in which ladies of quality received and where the *précieuses* quarrelled petulantly, gave way to the gallery, more ample in size but still a place serving many different purposes. Finally, in the eighteenth century, the process was completed: one room, the *salon*, was set aside solely for social gatherings. The change made it possible for the Court, the guardian of good manners, to impose upon a much wider society (including men of letters, philosophers, men of much learning, and artists) high standards of politeness and well-chosen language. A date, 1608, marks the beginnings of an era with the first of the great receptions given by the Marquise de Rambouillet. The part that the *salons* of Madame de Lambert in her fine *hôtel* on the Ile Saint-Louis, of Madame de Tencin and Madame Geoffrin in the Rue Saint-Honoré, of Madame du Deffand in the Rue Saint-Dominique, and of Mademoiselle de Lespinasse in the Rue de Bellechasse (to name but a few) played

in the moral, intellectual, and ultimately political history of the eighteenth century should not be overlooked.

The *promenade* became an equally novel form of entertainment for a great number of Parisians. Now that the streets of Paris were more airy and the numbers of squares and public gardens had greatly increased, and the ramparts of the days of Charles V had been transformed into fine boulevards, well shaded by trees and already on the way to being lined by dwellings, theatres, and cafés, people found great pleasure in using them as meeting-places. The *promenade* of the Cours la Reine called for the use of carriages, whereas in the Tuileries gardens the *promenade* was done on foot in order to exchange the universal smile and often ideas as well. The most thriving of the Parisian *promenades* at the beginning of the seventeenth century were those of the Place Royale to the east and the Tuileries gardens to the west, whereas towards the end of the pre-Revolution monarchy the wooden galleries and the gardens of the Palais-Royal drew the crowds and became a kind of capital within a capital. The same set of idlers would meet again in the cafés, a growing and peculiarly Parisian custom. There were cafés by the dozen in the seventeenth century and just before the Revolution they

23

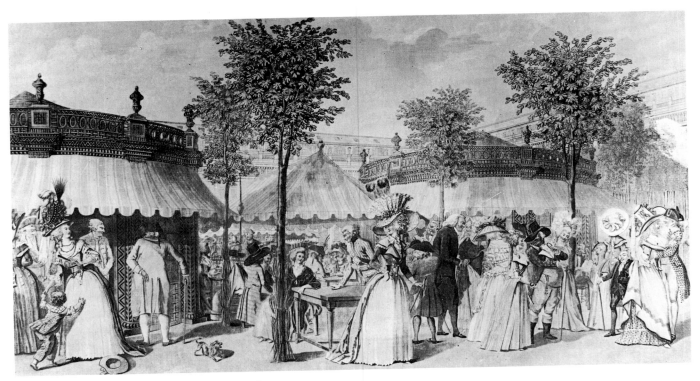

Gardens of the Palais-Royal, by Le Cœur.
From the Musée Carnavalet.

fairly pullulated, in particular around the Palais-Royal, the Rue Saint-Honoré, and the Rue Montmartre, along the boulevards, and, on the Left Bank, around Saint-Germain-des-Prés.

Society found sustenance for the mind in a traditional food — the stage. Theatres, or at least places where plays could be performed, abounded. The famous ones were at the Hôtel de Bourgogne, in the Marais, and at the Palais-Royal (where Molière presented his most celebrated comedies) and included the popular Comédie Italienne. All the highest traditions of the Parisian theatre ended by being synthesized in the Comédie Française, which, in the eighteenth century, grew into an institution of outstanding distinction and became a truly national theatre. The Opéra dates from 1672. The Opéra Comique oscillated between the Saint-Germain Fair and the Saint-Laurent Fair according to the season. Also the Parisians, in their passion for the theatre, were not above applauding from time to time some of the country troupes who came to try their luck in the capital.

To satisfy the needs of a broad-minded and inquiring public this period witnessed the birth and expansion of periodicals which kept the people informed of events at Court and in Town, and even in far-off countries. First, in 1631, came *Renaudot's Gazette*, followed in 1636 by the *Mercure royal*. The former was the only remaining newspaper until, in 1672, Thomas Corneille and his friends brought out the *Mercure galant*, which in the course of time became the *Mercure de France*. Their success encouraged others to begin publication until, in 1779, there were twenty-seven French and fourteen foreign newspapers on regular sale in Paris. Amongst them was the first daily newspaper, the *Journal de Paris*, which was launched in 1777. The information which these periodical publications contained was amplified and often misrepresented by the hand-written news-sheets which were extraordinarily successful in the eighteenth century. To some extent they were modelled on Pascal's *Provinciales* and the lampoons of the times of the Fronde. They usually circulated clandestinely, which added to their piquancy. The journalists who wrote them made a hotch-potch of approximately genuine news items and wrote them up in racy style to catch and hold the reader's attention. They helped the formation of public opinion.

However, this most classical of cities found its most perfect image in the literature of the times. The universality of the capital was its glory, but during these two golden centuries it also remained in the closest possible touch with the society in its midst. Parisian civilization had no more efficient emissaries throughout France and the whole of Europe than the classical writers, not only through their books but often through their own travels as well. One of the essential characteristics of classical literature is to oppose a light and witty touch to the heavy-handedness of the provinces. Even when the profound changes in the way of thought have been

The Académie Française, under the protection of the King, was installed in the Louvre in 1672. Engraving by Servin.

taken into consideration, there remains a common element of good taste and a certain manner in the expression of ideas which, together, give an impression of continuity all the way from Pascal to Diderot. The unifying element was no other than Paris itself, a fact of which the " Europe of Learning " was fully aware. Yet the long-lived glory of the capital, the University, now found no place for itself in this new world of the intellect. Now, more often than not, " classical " scholars were initiated into the disciplines of learning by those new bodies of educationists, the Jesuit and the Oratorian Fathers. Rightly, the Court came to be considered a much more useful school for writers than the Sorbonne, for it refined the writing of French as it refined manners. Now came the turn of the Right Bank to overshadow the Left Bank, at least as far as the Louvre and the Tuileries were concerned. It had become a much more learned intellectual centre than the Latin Quarter. An institution which clarified the changing ideas of the times was the Académie Française which, after some wanderings around the Right Bank, was now definitely installed by Louis XIV in the Louvre. This little republic in which rank and talent were intermingled gives a very fair indication of the authority the mind had acquired in this capital of the most powerful realm in Europe. Science also was making great progress, and Paris made it all her own. New scientific establishments came into being in Paris under the ægis of the State and in the enjoyment of the sovereign's favour. Amongst them were the Observatory, the King's Gardens (later to become the *Jardin des Plantes,* the botanical gardens), the School of Bridges and Highways *(Ponts-et-Chaussées),* the Mining School *(Ecole des Mines),* the Royal Library *(Bibliothèque Royale),* the Academy of Inscriptions and Humanities *(Académie des Inscriptions et Belles-Lettres),* and the Académie de Saint-Luc. In all these foundations the lion's share belongs to the seventeenth century. The splendours of the Paris of Notre-Dame were forgotten and Gothic art was rejected as barbarous.

There is another distinctive aspect of this neo-classical capital which deserves special mention: the soul of the city was reborn and for a time Paris was a city of the mystics. There was in the seventeenth century, and particularly during its first half, an efflorescence of pious foundations, of convents (to the number of some sixty between 1600 and 1639), and of charitable works founded by the new generation of saints with whom the élite of all Paris co-operated. The influence of a Vincent de Paul, of a Madame Acarie, of a François de Sales, and of a dozen other men of God was extraordinary. Their zeal led them in different directions. Some of the infinite needs of the sick were met by the founding, in 1612, of the Hôpital de la Pitié and, in 1634, of the Hôpital des Incurables. The regeneration of the clergy, who had fallen into a deep decline, was helped by the organization of seminaries. The most successful of the reformers were Bourdoise, Vincent

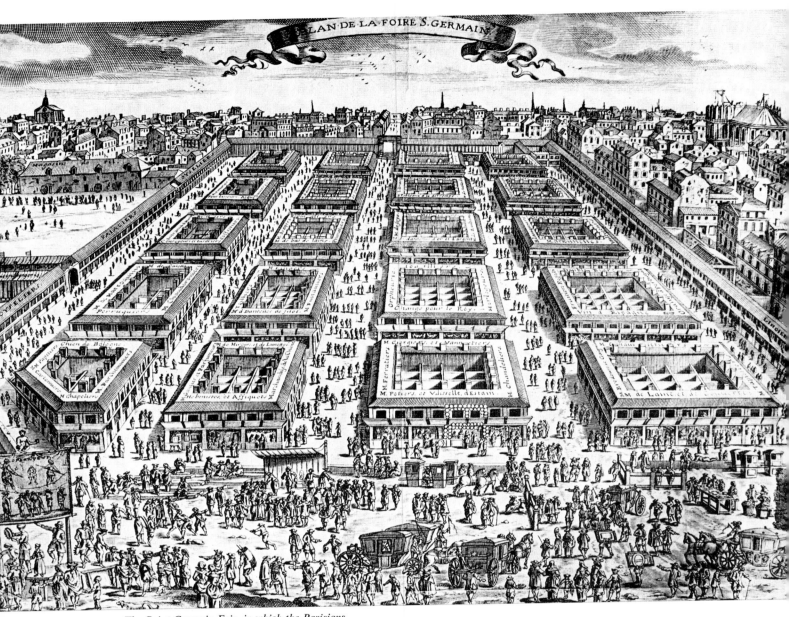

The Saint-Germain Fair, in which the Parisians found much entertainment, drew big crowds. Anonymous seventeenth-century engraving, from the Bibliothèque Nationale.

de Paul and his Lazarists, and Olier and his *Sulpiciens*, lay priests of the Society of Saint Sulpice. The severity of their thought and their lives was in complete accord with the spirit of classicism. This religious Renaissance did not come about without clashes and crises, and it was deeply affected by the Jansenist quarrels. There were times when these interfered with the life of a capital which had known political peace since the days of the Fronde. And now, for five whole years between 1727 and 1732, the tomb of François de Pâris, the Jansenist

Deacon, was the witness to scandalous scenes enacted by the Jansenist Convulsionaries until the cemetery of Saint-Médard in which it lay was closed. The sect, however, lingered on for long afterwards. Paris, too, was the place where the Ultramontanists and the Gallicans brought their quarrels into the open. It has to be admitted that moral unity proved unable to resist the onslaught of modern thinking in a capital city always avid for novelty in everything. It would be true, or at least very nearly true, to add that what remained standing until the

Revolution was only a hollow religious façade.

The economy which made it possible for this powerful city, this "abstract of all France", as Vauban called it, to rise to so high a destiny was based on immense commercial activity and an artisan class broadly organized into six Parisian guilds of tradesmen. Manufacturing industries could still only with difficulty be fitted into the city's activities. It was the luxury trades which multiplied and which at this time were in full expansion to meet the increasing demands of a wealthy society. Materially, the points of concentration of different trades had hardly changed at all since the Middle Ages. Bookbinders and book-gilders still haunted the streets of the Montagne Sainte-Geneviève. Booksellers and printers were still found along the Quai des Augustins and the Rue Saint-Jacques. There were dozens of tanners in the Rue Censier. Drapers congregated in the Rue Saint-Denis and the neighbouring streets, together with haberdashers and embroiderers. In 1789 there were about sixty joiners along the Rue Cléry, and two-thirds of all the cabinet-makers worked in the Faubourg Saint-Antoine. Although Paris had lost its Lendit Fair, it still kept its taste for these trade gatherings. The Saint-Germain Fair and the Saint-Laurent Fair were always crowded, as was the Fair of Saint-Ovide, originally held in the Place Vendôme but transferred in 1774 to the Champs-Elysées.

Finance, essential to all trades, developed very swiftly after the turn of the eighteenth century. The Parisian capitalist, the *rentier*, who came into being at the beginning of the sixteenth century, showed little sign of changing his set ways, even though the capital itself developed rapidly into a money market. The 'System' gave many the taste for speculation. The shock which the audacious experiences of John Law of Lauriston caused is well known, but in the end it proved useful. The opening of his Bank of Issue in 1716 marked the beginning of a new financial era. Credit operations multiplied, and by the end of pre-Revolution monarchy Paris had about fifty bankers. The Bourse, which came into unofficial being with the 'System', was reorganized and given a new home in the Rue Vivienne. The power of the Farmers-General continued to increase, as did their work as State bankers. At one moment they numbered sixty, all Parisians. The Caisse d'Escompte, a combination of issuing, discount, and deposit bank, was established in 1766 and greatly facilitated operations with other countries. Another significant sign of modernization was the introduction of fire insurance around the year 1750.

Speculation takes the city by storm: the mob in the Rue Quincampoix come to subscribe to Law's banknotes. Engraving by Humblot, in the Bibliothèque Nationale.

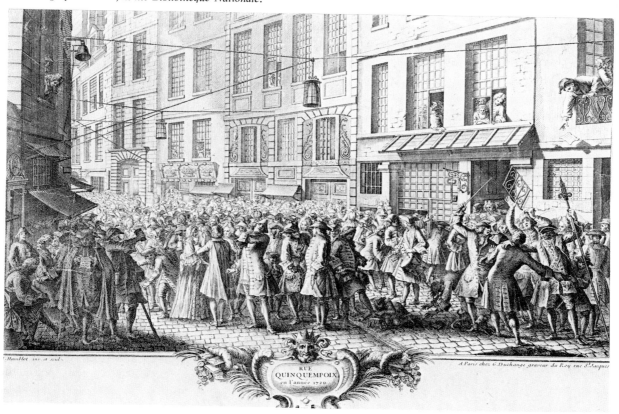

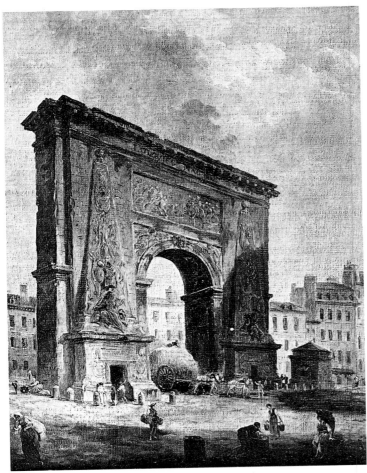

The Porte Saint-Denis, by Hubert Robert.
In the Nissim de Camondo Museum.

Despite the great strides forward in financial progress and the continuing development of trade, Paris was not yet converted to the idea of industrial growth. The kings thought about it and with their Ministers (men such as Sully and, most particularly, Colbert) did their best to increase the number and scope of industrial establishments in the city. Henry IV would have liked to create a spinning-mill for " silk, spun gold, and spun silver, as made in Milan ", to be situated at the Tournelles, but the project came to nothing. However, the royal Savonnerie factory for making " long haired carpets in the Persian manner " did come to new life in 1627 at the foot of the Chaillot hill. There are other sporadic industrial efforts also to be recorded, for on the eve of the Revolution the capital and its suburbs could boast of an iron foundry at Le Roule, a tin-plating plant in the Rue Saint-Denis, spinning-mills in the Rue de Charenton, four porcelain factories in the Chaussée-d'Antin, the Faubourg Saint-Denis, at Clignancourt, and at the Pont-aux-Choux respectively, the biggest wallpaper manufactory in Europe and a glassworks producing mirrors (both in the Faubourg Saint-Antoine), a chemical and pharmaceutical works in Javel, one for lead sheeting in the Rue de Bercy, and many other workshops producing such things as cardboard, mangles, gauze, and other materials. Such industries satisfied only a small part of the capital's needs. The provinces looked after the rest of its supplies, just as they kept it regularly provided with an influx of men.

A playing-card factory installed in a house on the
Place Dauphine, from which the Seine and the Pont-Neuf
can be seen. French School, end of the seventeenth century.
In the Musée Carnavalet.

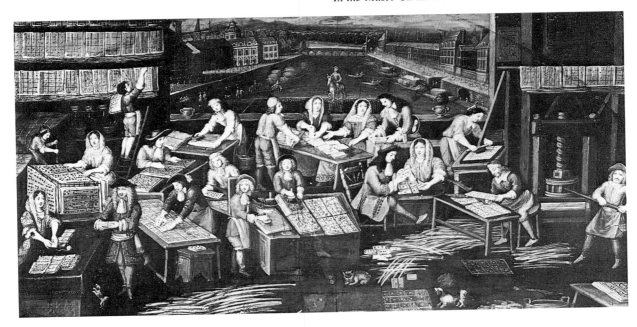

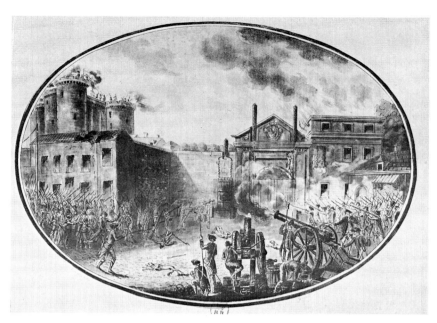

The first attack on the Bastille on July 14th, 1789.
Aquatint by Guyot, in the Bibliothèque Nationale.

END OF THE OLD
SOCIAL ORDER:
BIRTH OF A NEW PARIS
1789-1830

Is there anybody who would need reminding that the Revolution of 1789 was one of the very great dramas of French history and a no less violent crisis in the history of Paris? The Revolution, which lasted for ten years, very soon had every appearance of being a movement of political revenge. For over half a century a considerable section of public opinion in the capital had been underlining the defects of the monarchical régime and of the traditional social order. Little by little Paris, where, despite censorship and police control, everything was openly discussed, had already completed an intellectual revolution which considerably anticipated the political one. So much was made manifest by innumerable writings, by the conversations in the fashionable *salons*, by discussions in the cafés, by changes in habits and even in religious life. It is true that all this was exterior to the administrative circles dependent upon the powers of royalty, but it was perfectly clear that when the revolutionary process which had begun in near-by Versailles should touch Paris, the Parisians would quickly try to take complete control of their own destiny. The Parisians were powerful and they succeeded in attaining their objective. Thanks to its own clubs, newspapers, primary assemblies, National Guard, and working-class quarters, the capital was able to exercise successful pressure on successive National Assemblies and, indeed, on the whole machinery of State. The final uprising, which took place on August 10th, 1792, blew away all that was left of traditional authority. Dictatorship by the people was operated through the town hall. In the streets the power of the privileged gave way to the power of the *sans-culottes*, the poorest of the poor. Excesses committed by the revolutionary city council were

beyond number. They caused an equally brutal and complete reaction when Robespierre and his companions were swept away on the 9th *Thermidor*. Thereafter Paris, which had done so much to overthrow the monarchy, found itself reduced to political non-existence. France no longer accepted utter submission to a capital representing only one-fortieth of the total population and refused it the slightest autonomy. The centralizing town hall, the elected mayor and councillors, were replaced by a municipal body without authority other than the little the State might delegate to it. By virtue of the principles of strengthened administrative centralization, two all-powerful civil servants, the *Préfet de la Seine* and the *Préfet de Police*, controlled the

Newsmongers in the Café de Foix in August 1789.
Anonymous engraving.

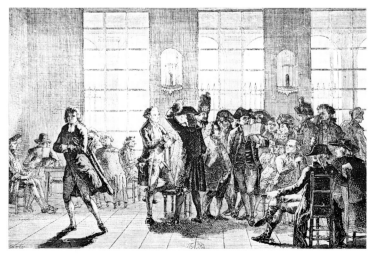

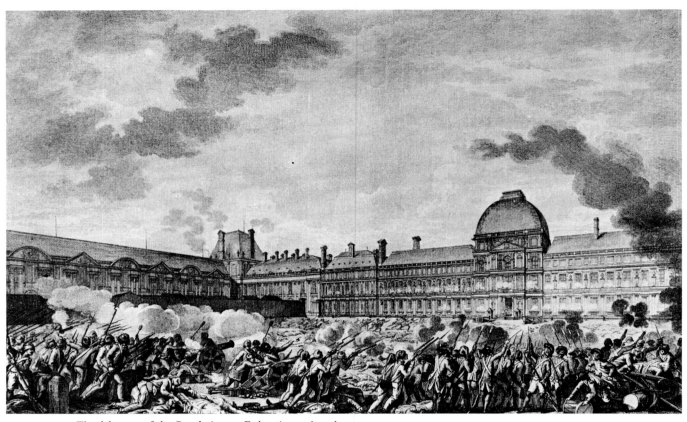

The delegates of the Revolutionary Federation and workers
from the suburbs of Saint-Antoine and Saint-Marceau
take the Tuileries palace by assault, August 10th, 1792.
Drawing by Monnet, engraved by Helman.
In the Bibliothèque Nationale.

life of the city from the year 1800 onwards. There-after Paris never threw off their tutelage except, from time to time, for a few fleeting hours at the end of a futureless revolution.

Moreover, the Parisians were tired of tumult and soon acquired the habit of submission. Even such stirring events as the fall of the Empire, a twofold and relentless occupation, and the return of the unpopular Bourbons provoked no effective reaction.

The contrast is enormous between the part played by the capital from 1789 to 1795 and the abasement which followed and lasted until the 1830 revolution. During the forty-year gap between the taking of the Bastille and the Three Glorious Days of July 1830 immense changes took place, yet the material evolution of the city remained a very slow process. Not until several years of the July Monarchy had passed by did the capital feel the varied consequences following upon its entry into what was to prove the industrial era. The Parisians of 1789 had brought a whole world crashing down about their ears, yet continued to live an unchanging way of life.

The Revolution irresistibly recalls the popular turbulent tradition of Paris, beginning with enthusiasm soon mingled with disorder. But then it carried on in an atmosphere of fear, nursing hatreds which no patriotic feeling could withstand. The

capital found itself caught up in the wheels of passion and, politically, was ground to dust.

The drama opened in Versailles with a prologue, but soon the scene shifted to Paris, in which agitation never slept. Inevitably it was at the Palais-Royal that the idlers, the agitators, and the news-mongers gathered. The dismissal of the popular Minister, Necker, generated a great effervescence on July 11th, 12th and 13th, and it turned into a revolt. The taking of the Bastille on July 14th proved to the people of Paris how feeble the one-time power of the régime had become; in other respects this doubtful exploit was without significance. The crisis raged on unabated, until the rabble of Paris marched against the Château of Versailles and its royal owners and brought about the ignominious return of Louis XVI and his family to the Tuileries palace (October 6th, 1789). In 1790, on July 14th, the festival of the Federation on the Champ-de-Mars led to a momentary belief in a general reconciliation of all Frenchmen, but it proved not to be one. In 1791, in the month of April, rioters invaded the Tuileries palace. In June the King, who had fled, was brought back to an increasingly hostile capital. In July a shooting incident in the Champ-de-Mars proved to be no more than a temporary check to the Parisian revolution. On June 20th, 1792, the Tuileries palace was again invaded and *Monsieur Veto* made to

endure the insults of the populace. On August 10th the monarchy fell to the *Sections* (the 48 Primary Assemblies in the Revolutionary government of Paris). The King was dethroned. On September 21st the Republic was proclaimed. All real power passed to the Revolutionary *Commune*. It is easy to see that in 1793 the new Republic was essentially Parisian and kept in power by the revolutionaries of the capital. The year began with the execution of Louis XVI on January 21st. This took place on the Place de la Révolution, where the guillotine was about to become a fixture. Politically inspired law cases, following one upon the other, held the Parisians breathless. In 1794 the Great Terror reached its height. Sessions of the revolutionary tribunal became frenetic. Executions were carried out on an immense scale. A few ceremonies were held to glorify the Revolution, the chief one, particularly desired by Robespierre, was in honour of The Supreme Being, but it failed in its purpose. Then, on 9th *Thermidor* (July 27th), came the fall of " the Tyrant ", his arrest, and the execution of the leaders of the *Commune* of August 10th. The dictatorship of the municipality was broken in 1795, but the city was still in the grip of a fever and was slow to return to calm. The days of *Germinal* (April 1st) and *Prairial* (May 20th) brought great armed crowds into the streets again, but these were their dying throes. Once more 20,000 Parisians besieged the Convention on 13th *Vendémiaire* (October 5th) — but this time it was a Royalist crowd. Then on September 4th, 1797, the Directory launched a *coup d'état* against elected royalists to show that the Revolution was not over, but Paris failed to react and left it to the army to solve its problems. As a result of the 22nd *Floréal* (May 12th) elections of 1798 more than 100 deputies were unseated, as too Jacobinist. On November 9th, 1799, the famous 18th *Brumaire*, came the last of the series of political somersaults, and Napoleon, as First Consul, acquired supreme power. Such, for a period of ten years, was the background to the life of a Parisian. Going from one crisis to another, from one revolt to another, from one political régime to an-

Festival of The Supreme Being on the Champ-de-Mars in 1794, by Naudet. From the Musée Carnavalet.

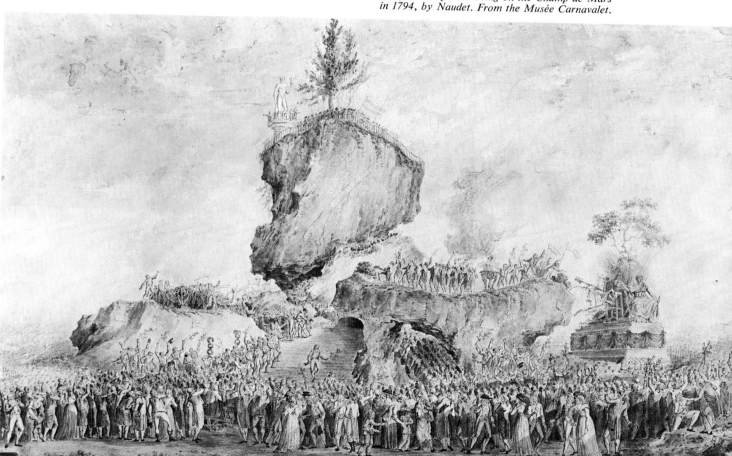

Napoleon I studying the plans for improvements in Paris suggested by Percier and Fontaine.
Painting attributed to Gosse, in the Morel d'Arleux Collection.

other, with wars, requisitions, and conscriptions, with money debased or almost unobtainable, with a general suspicion of everybody by everybody, and a lack of work in all the trades which had made the fortune and the glory of Paris, daily life must have been lived under interminable stress. All these consequences of the Revolution made the proud title of *citoyen* (which had replaced the older *bourgeois de Paris*) very hard to bear. It must not be forgotten also that the capital had led the opposition to the enemy and that Parisians were amongst the very earliest volunteers for the citizens' armies. The Consulate therefore took over a city which had suffered deeply. It set about getting things back into order without paying any attention to the demagogues. National victories helped the city to become its own self once again. Napoleon greatly loved his capital and tried to make it accept his politics by increasing the number of festive occasions and by looking after the wellbeing of Parisians. War came close to hand in the spring of 1814 and, something which had not happened for more than two centuries, enemies swarmed at the very gates of the city. The heights of Belleville and Ménilmontant, together with Montmartre and the Clichy barrier, were the scenes of bloody battles in which Parisians took part with honour in a resistance without hope. The Allies occupied the city for a time. After the Hundred Days and the June 1815 defeat at Waterloo, they submitted, this time without a fight, to a

The burial of General Foy, November 30th, 1825.
Lithograph by Villain, after Raffet.

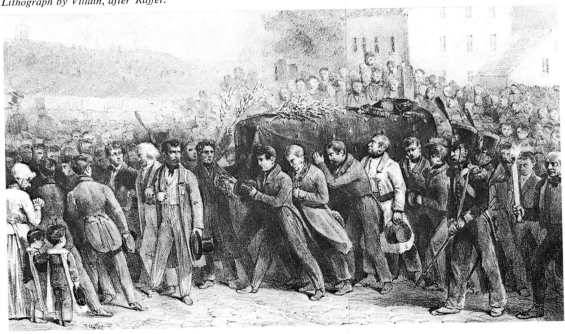

*March 31st, 1814: the Cossacks bivouac on
the Champs-Elysées after the fall of Paris.
Watercolour by Sauerweid, in the Musée Carnavalet.*

second occupation. For fifteen years the govern-
ments of Louis XVIII and Charles X had little
difficulty in keeping the population quiet. Just
occasionally there would be a few signs illustrating
the indestructibility of the revolutionary spirit.
Thus on November 30th, 1825, one hundred
thousand Parisians were to be seen following the
coffin of General Foy, a notorious enemy of the
people. A series of blunders by the Government,
and the publication in July 1830 of laws suppressing
one of the liberties nearest to the hearts of the Paris
middle classes, that of the freedom of the Press,
produced a great stir. Up went the barricades in the
narrow streets of the centre. During the morning of
July 28th insurgents took possession of many points
in the capital and of the Hôtel de Ville in particular.
Next day the Louvre fell into their hands. The
Army found it difficult to resist appeals for frater-
nity launched alike by workers, students, and middle
classes. Charles X left for Rambouillet on July 30th;
France had not had time to take sides and once
again acquiesced in an already accomplished fact.
With Louis-Philippe on the throne, Paris and the

tricolour came again into their own. The Three
Glorious Days had cost the insurgents 800 dead and
4500 wounded. If a new economic era had not been
opening at this very moment it seems doubtful if
this change of dynasty would greatly have affected
the destiny of the city. As it was, it introduced
great changes and turned the existence of many
Parisians topsy-turvy.

A revolutionary period beset by so many dif-
ficulties could not be favourable to the material
improvement of Paris, nor even to the simplest
forms of building. Trade was decaying, tradesmen
had no more customers as many of the inhabitants
fled from a city often short of food and at the mercy
of rival mobs. A Commission of Artists which was
supposed to take over the continuation of the
urbanization of the city begun under the monarchy
did work out a plan in 1793, but it remained just
a plan. Only when the Consulate restored good order
did some prosperity return. Napoleon, although he
had no previous links with the city, conceived
grandiose plans for it. They materialized only within
the limits of the money available at the time and of

*A fête at the Arc de Triomphe de l'Etoile on the occasion
of Napoleon's wedding to Marie-Louise of Austria on
April 2nd, 1810, by Debucourt.
From the Bibliothèque Nationale.*

the very short period which destiny allowed the Imperial régime. It is for these reasons that the mark Napoleon left upon the city, whilst not negligible, does not compare with the developments under Louis XIV. Yet to the Empire belongs the credit for beginning the gallery linking the north sides of the Tuileries and the Louvre, creating the western end of the Rue de Rivoli with its elegant arcades, beginning work on the Arc de Triomphe de l'Etoile and a new Bourse, the construction of the Arc de Triomphe du Carrousel, fitting out the Villette basin and the Canal de l'Ourcq, laying out the big cemeteries on the periphery of the capital, building three bridges, the *Halles aux Vins* (the great wine warehouses) and other warehouses on the east side of Paris, and adding no fewer than fifteen fountains. Frochot, who was Préfet de la Seine for over

twelve years, from 1800 to 1812, was a first-rate administrator. He showed excellent judgment in organizing the new municipal services, he improved the streets and the handling of the city's food, and decided upon numbering the houses. Chabrol, who was Préfet under the Restoration, in his turn gave his most careful attention to providing the essential facilities to a city undergoing substantial demographic expansion. The 1802 census showed a Parisian population of 550,000; that of 1817 had quickly risen to a figure of 715,000. At this latter date there were 27,371 dwelling houses in the capital.

These figures illustrate some fairly new social and economic facts. Those who had emigrated had now returned, and, at the same time, working people were beginning to migrate into the city; in 1807 they

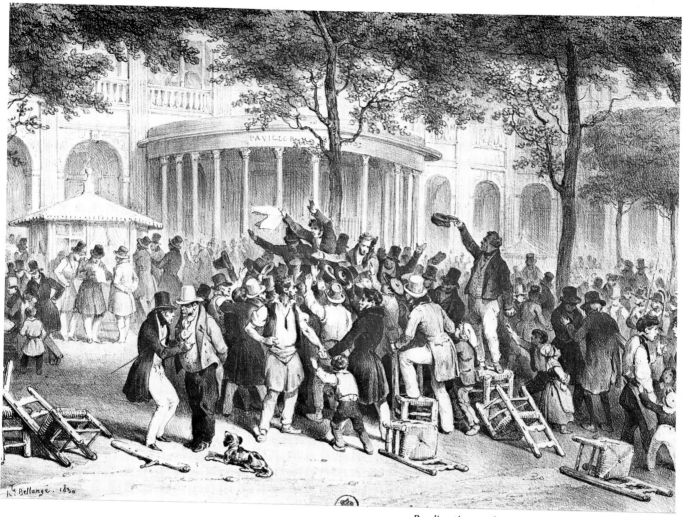

Reading the new laws in the "Moniteur"
in the gardens of the Palais-Royal, July 26th, 1830.
Lithograph by Bellangé, in the Bibliothèque Nationale.

already numbered 90,000. They found employment principally in Eastern Paris and in the suburbs. Paris now had its own factories for war materials, its own spinning-mills, foundries, plants for preserving food, and so on, and even a sugar refinery at Passy. A public exhibition of French industry and the articles it manufactured was held on the Champ-de-Mars as early as 1798, providing a glimpse of the future industrial capital of France. Mention, too, must be made of the invention of gas lighting in 1799 by an engineer, Lebon. From 1829 onwards his process was applied to street lighting and needed no fewer than four works to supply the gas. This restoration of the economic situation was at least in part due to the resumption of the specific functions of a capital city, once the storm had

passed — the social life and intellectual activity which had flourished so gloriously under the old monarchy.

The spirit of Paris of that time was no longer what it had been. Fashion had changed and, following the lead of Chateaubriand and the first of the romantics, had discovered very different means of expression from those of the declining years of neo-classicism. Romanticism was not itself solely linked with Paris, but it was a product indirectly deriving from the capital. One by one the *salons* of the Faubourg reopened, bringing together many of those on whom the years of exile had left their mark, but who launched out with joy on a new fashionable adventure. Writers and politicians took their places in the cafés once again. Fashionable

The Central Market (Les Halles) in 1828, by Canella. In the Musée Carnavalet.

restaurants became more numerous, and once again the leisure hours of Parisians were spent in the streets.

The Revolution had destroyed the University and the old system of education. Now it made the attempt to give back to Paris the same eminent place in scientific and intellectual life which it had previously held. The list of new foundations of schools and scientific establishments is a long one: the Museum of Natural History, together with the Jardin des Plantes (botanical gardens); the Ecole Normale, the Ecole Centrale des Travaux Publics (now the Ecole Polytechnique), the Conservatoire des Arts et Métiers, and the Archives Nationales, the Bureau des Longitudes, the Museum National (now the Musée du Louvre), and the Institut National des Sciences et Arts.

The taking of the Hôtel de Ville, July 28th, 1830, by A. Bourgeois. From the Château de Versailles.

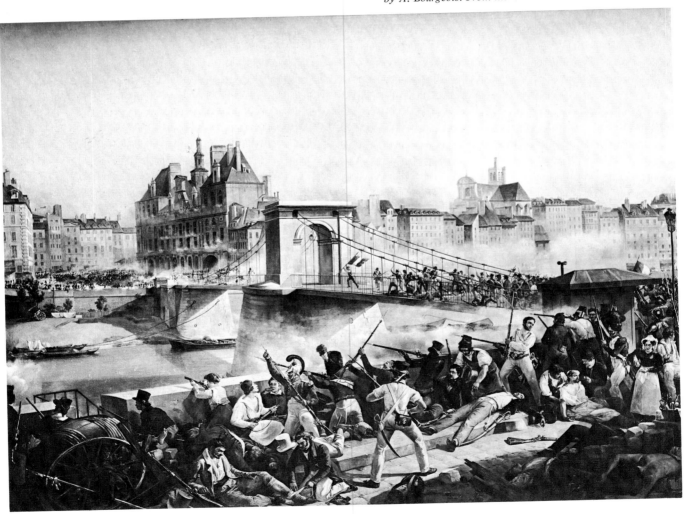

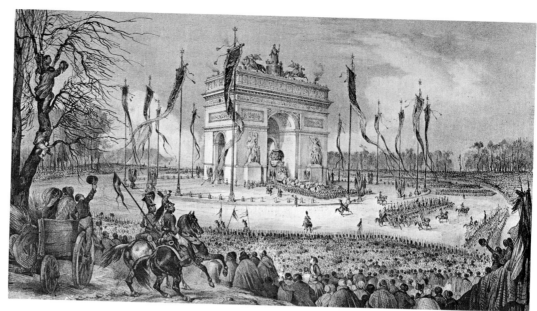

*The memories of Imperial glory lingered on.
Napoleon's ashes, brought back from Saint Helena,
are carried under the Arc de Triomphe (1840).*

THE INDUSTRIAL ADVENTURE: BIRTH AND GROWTH OF A METROPOLIS

The eighty-eight years which separated the Three Glorious Days (July 1830) from the 1918 armistice witnessed a transformation of the capital much more profound than that of the passage of the four or five previous centuries. Paris had not deserted her traditional rôle. On the contrary, one is aware of a hypertrophy of her administrative, intellectual, and artistic functions. More than ever before the city absorbed the lively minds of the provinces into her own service and for her own glory. There was one new, and important, feature. Gradually her economical functions had increased until she had become the industrial metropolis of France and a leading one by world standards. Huge factories had been added to the little workshops where *articles de Paris* had been made since the Middle Ages and to the modest factories seldom employing more than a few dozen workers which were already in existence. The new ones were situated at a more or less substantial distance from the city's centre, but despite this they coated it with soot, darkened its skies, and overflowed into still only partly developed suburbs. This big-scale and inexorable industrialization continued through four separate political régimes, separated by two major revolutionary

Lamartine faces the mob and rejects the red flag in front of the Hôtel de Ville on February 25th, 1848, by Philippoteaux. From the Musée Carnavalet.

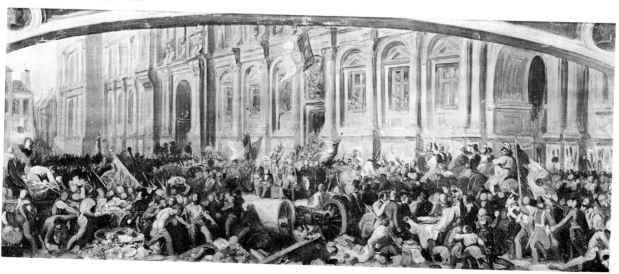

Galvanizing in a factory at Grenelle, 1859.
Engraving by E. Boudelin, in the Bibliothèque Nationale.

movements, of which the industrialization itself was in part the cause. To bring about this extra-ordinary change vast numbers of men were needed. Just how many they were can be judged by a glance at a few figures. In 1831 Paris had 750,000 inhab-itants. By the time the First World War had broken out this figure (but including the nearest suburbs) had risen to five million. Again including the nearer suburbs, the first million had been reached in 1836, the second thirty years later, the third twenty years after that, and the fourth by about 1905. In the face of such entirely new circumstances, what chance had the city of maintaining its social balance, its homo-geneity, its social structure, its way of living, and its way of thinking? At the end of a span of no more than three generations Paris could hardly recognize itself.

Chiefly responsible for this state of affairs was this phenomenon of industrialization, which need not have taken either this form or been on so huge a scale. After all, the Paris region has no coal and no iron, and no primary materials other than those used for the building trade. The metallurgical industry could only be supplied with difficulty and by costly means. This was also true of all the more

important chemical products. In fact it took a quite unpredictable event to change the future in this way. This event was the invention of the railway, and the way the French used it. The national railway net-work was, from the very beginning, conceived solely in terms of meeting the needs of the capital. This turned out to be rich in consequences no less important than the basic features which moulded the previous history of Paris — its geographical situation and the action of royalty throughout many centuries. The first railway line from Paris (to Saint-Germain-en-Laye), was opened on Octo-ber 25th, 1837. All the main-line railway stations, those new gateways to Paris, were built within a dozen years. Curiously enough, each one of them was built as a ' terminus ', journey's end, as if it were meant that arriving travellers should consider themselves Parisians for evermore. Parisians sub-scribed 80 per cent of all the money needed to complete the giant task; all France was asked to do was to provide the labour. Thereafter, regularly day by day, the railway brought in the labour needed for the new industries; at the same time, raw mate-rials were delivered to the very spots on which they were going to be absorbed in finished goods. In this

manner industries were developed, and in particular the metallurgical and chemical industries, which surpassed those of other of the country's industrial centres. Development of the motor-car industry and the manufacture of its ancillaries had made it an extremely important one by the end of the century, and this it continues to be. The outbreak of the 1914 war still further accelerated the concentration of industry in the Paris region, as it was of a kind to be able perfectly to meet the Army's urgent requirements. Shells, tanks, and weapons of all kinds flowed out for four years at an ever-increasing speed from all the factories of the capital, some of which had been purpose-built. Once victory was won, the factories remained, and this pole of the French industrial hemisphere has not shifted since. The little craft-based industries maintained their place just the same, and *articles de Paris* held their own position in the new economy. Around 1914 the number of industrial workers had exceeded the million mark, a figure ten times as great as it had been a century before. To provide adequate accommodation would have meant foreseeing as early as the days of Louis-Philippe both the speed and the scope of the great changes leading to the new circumstances. The administrators of the day lacked the needed imagination and foresight. The July

Monarchy (1830) brought to the benefit of the capital only the quiet wisdom of Rambuteau, Préfet de la Seine from 1833 to 1848. The whole of his activity was concentrated on the needs of the immediate future. To him Paris owed the creation of some new thoroughfares, the most important being the Rue de Rambuteau, the definite completion of the Boulevard, the final phase of the Place de la Concorde (in which the Luxor needle was set up in 1836), the completion of the Arc de Triomphe de l'Etoile, and the building of some hospitals, prisons, and schools, as well as four bridges (it should be pointed out in passing that the number of bridges in Paris increased from eleven to twenty-one between 1789 and 1848).

The revolution of 1848 and its stormy June days brought to light yet once again how difficult it was to protect a political régime in times of serious troubles in Paris. The narrow streets of the centre seemed made for the erection of barricades. There were other considerations, two of the most serious being that overcrowding had made proper sanitation in the city a doubtful possibility, and that the circulation of traffic was so intense that it seemed as if soon all movement would come to a halt. It was obvious as soon as Napoleon III came to the throne that he had already thought deeply on the problems

One of the new "gateways to Paris", the Gare de l'Est, in 1849. Anonymous engraving.

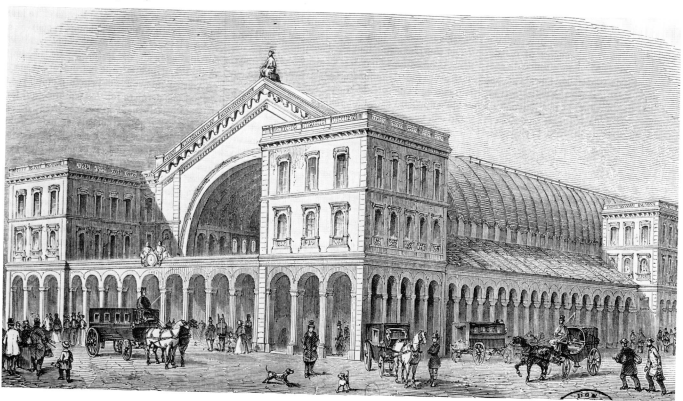

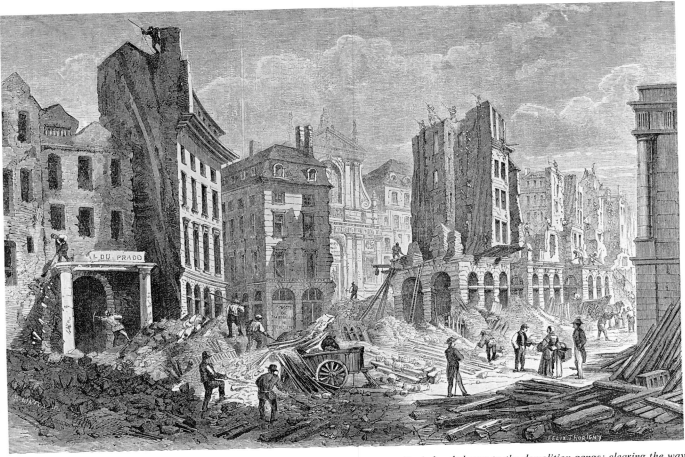

Paris handed over to the demolition gangs; clearing the way for the Boulevard du Palais. Engraving by Thorigny in the Musée Carnavalet.

Napoleon III handing to Baron Haussmann the decree annexing the suburbs on the periphery of Paris in 1859. By Yvon, in the Bibliothèque Historique de la Ville de Paris.

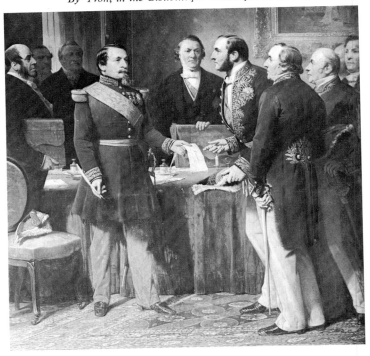

the rapid development of the capital had brought. He at once looked round for the means of solving them. Having found the energetic, methodical man needed in the circumstances, he put upon his shoulders this heaviest of burdens. Haussmann, Préfet de la Seine for seventeen years from 1853 to 1870, exercised omnipotent authority in his office. He put an audacious plan into operation without hesitation and without being deterred by any political or financial obstacle. From the still partly medieval city he cut away the decaying flesh. If town mansions and ancient monuments stood in the way of his new straight streets he tore them down. If ancient streets seemed too intricately tangled to justify alteration, he flattened the entire area. The result was successful in general terms, though if at times it was brilliant, at others it was deplorable. In all, the city gained a long respite from its besetting problem, traffic congestion, and one or two smaller ones besides.

The venerable Cité, the heart of Paris, was not spared by Haussmann's rage for the new. The whole island was handed over to demolition gangs with the exception of part of the old palace of the kings, the Sainte-Chapelle, Notre-Dame, and a few houses

The Cité and the Pont-Neuf in 1832, by Canella, in the Musée Carnavalet.

40

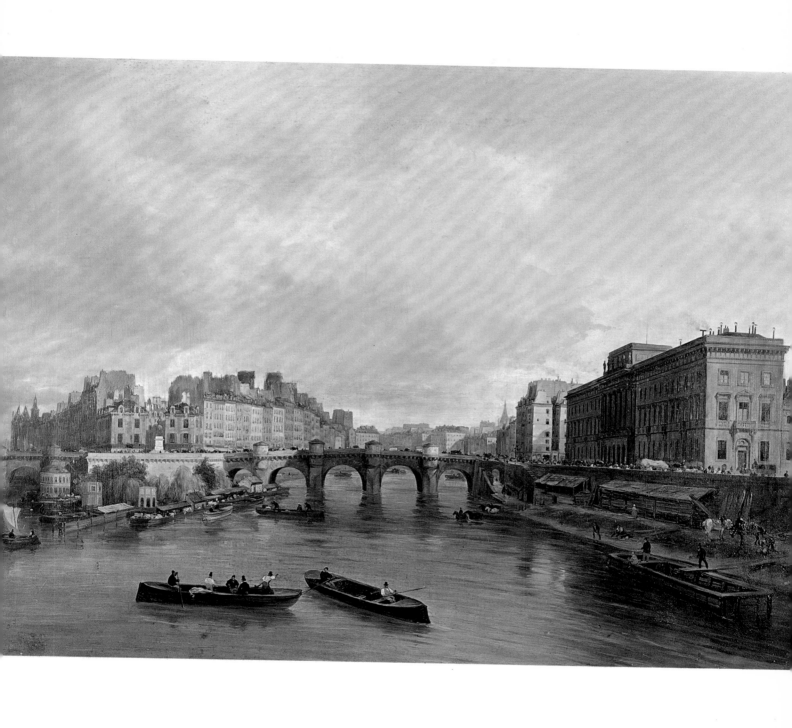

to the north of it. Soulless administrative blocks rose on the ground thus freed. In front of Notre-Dame a sea of asphalt appeared. Five bridges now linked the island to the mainland banks of the river. On the right bank a new through-road from north to south (Boulevard de Sébastopol and Boulevard de Strasbourg) ran parallel to the old streets (Rue Saint-Martin and Rue Saint-Denis). The straight line was continued south of the river by the Boulevard Saint-Michel as far as the Observatory. Again on the right bank, the Rue de Rivoli was linked to the Rue Saint-Antoine. A little more to the north, the Rue du Dix-Septembre (now the Rue du Quatre-Septembre) ran eastwards from the Place de l'Opéra and was prolonged by the Rue Réaumur. A beginning was made to the Avenue Napoléon III, now the Avenue de l'Opéra. On the east side of Paris three new road junctions were made at the Château-d'Eau (now Place de la République), at the Place du Trône, and at the Place de la Bastille. They were linked by wide boulevards. To the west eight new avenues radiated from the Rond-Point de l'Etoile, including the lovely Avenue de l'Impératrice (now the Avenue Foch). New residential quarters, the Chaillot hill and Passy, were given adequate roads. Similar operations went on south of the Seine. The Boulevard Saint-Germain, with its odd layout, both beginning and ending at the Seine, engulfed many records of old Paris. The Rue de Rennes led to the Gare Montparnasse; boulevards and avenues duplicated the outer boulevards at a certain distance from them. But Haussmann was not content just to organize traffic circulation, he also wanted to let some air into Paris. There was no means of doing this in the old city, and the Préfet, with Alphand, his right-hand man, had to be content with just arranging some open squares in that area. The suburbs, however, still had empty spaces, two of which went to the formation of two fine parks, the Buttes-Chaumont and the Montsouris. Lastly, beyond the fortifications of Thiers, the woods of Vincennes and Boulogne became magnificent promenades. Below ground, Haussmann's work still dominates subterranean Paris. Supported by an engineer, Belgrand, he arranged for a scheme of sewers which met the needs of the city, and built the network of pipes which brought pure water from quite distant parts. All this is entirely to the credit of the Second Empire. The rebuilding of the central markets was unfortunately carried out on the same site as before, but it does bear witness to the desire to improve the material wellbeing of Parisians. Immense results were obtained, and Paris was able to breathe for long afterwards, but it emerged disfigured from the Haussmann adventure. Whatever the future might

The Universal Exhibition of 1867, seen from the Trocadéro.
From a drawing in " L'Illustration ".

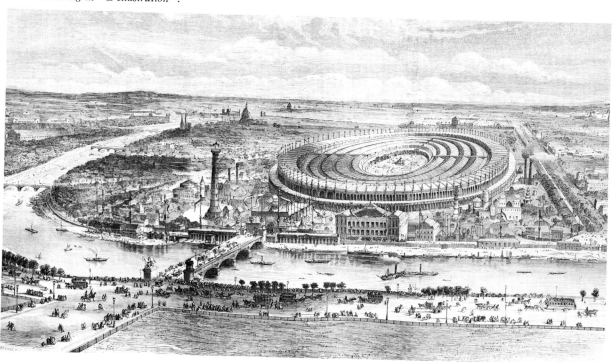

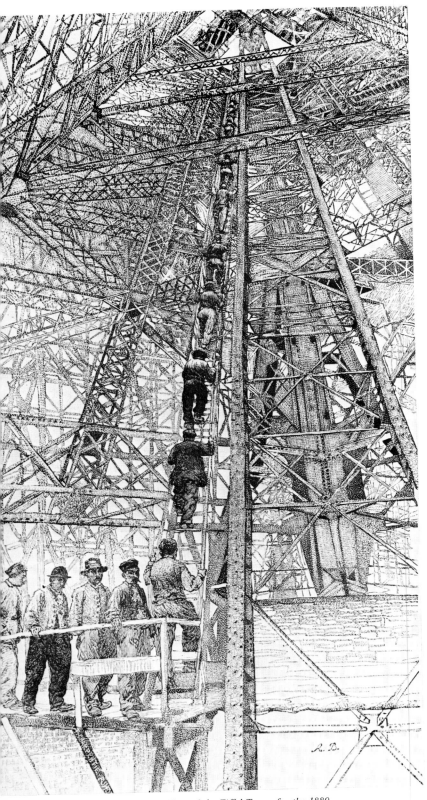

*The building of the Eiffel Tower for the 1889
Exhibition. Artist unknown.
Bibliothèque Nationale.*

hold, the best course would have been to finish the
work begun under the Second Empire, whilst
avoiding its worst excesses, and to continue to
administer Paris with the same zeal, whilst pre-
paring for a future which once more looked as if it
would be a difficult one. The Third Republic was
content, as Giraudoux has put it, " to set up house
with the furniture of the previous régime ", without
in the least concerning itself with the vast demo-
graphic wave which thundered on until the turn of
the century, nor foreseeing any of the consequences
arising from the birth of the motor-car. History has
failed to record the names of those responsible for
this grave neglect, which affects the capital right up
to the present day. Some decisions they had to take,
albeit very tardily, as a consequence of a piling up
of the ruins caused by the incendiaries of the Com-
mune. The Hôtel de Ville was rebuilt (1875-78) to
an enlarged version of the original design. The
Tuileries palace, however, was pulled down (1882).
Only to mark universal exhibitions were new public
buildings erected: in 1878, the Trocadéro; in 1889,
the Eiffel Tower; in 1900, the Grand Palais and the
Petit Palais. Then a new need was felt in this great
cosmopolitan city — hotels to harbour an ever-
increasing and ever-richer foreign clientèle ... to
which must be added the needs for departmental
stores and warehouses.

During this period of rapid change the size of the
capital altered considerably. The law of Novem-
ber 3rd, 1859, added, from land reaching out to the
circumvallation of 1841-44, eight new *arrondisse-
ments* to the twelve existing ones. In this way Paris
acquired all or part of the neighbouring suburbs,
an operation which the expansion of the city made
highly desirable. Many of these suburbs had already,
except in name, become integral parts of the great
city, and the others would soon have followed in the
same way. Thus, in one single operation, Paris
added 600,000 inhabitants to the one million it
already had. This figure alone shows the necessity
for an operation which admittedly created certain
administrative and economic problems, but which
solved many more. The area of the capital, which
had not changed for the better part of a century,
except for the addition of the Beaugrenelle quarter
and the village of Austerlitz during the first half of
the century, increased to 7088 hectares (17,514
acres). It is not unreasonable to believe that if a
similar operation had been carried out at the begin-
ning of the twentieth century it would have ensured
better control of the disorderly expansion of the
Paris region.

The physical history of Paris runs in harness with
its political history. Both are made up of periods of
feverish activity alternating with periods both
longer and more peaceful. The extreme centraliza-
tion of nineteenth-century France made the capital,

Barricades go up on the Rue Saint-Martin on the nights of February 23rd and 24th, 1848. Lithograph by Janet-Lange.

more than ever before, one with the rest of the country in all the nation's crises and successes, of which, on many occasions, it was itself the cause. The period of the July Monarchy, child of a fleeting revolt, was one when peace was troubled by some popular agitation in its earlier years. On July 14th, 1831, gangs of rioters sacked the church of Saint-Germain-l'Auxerrois; next day the Archbishop's residence was set on fire. In 1832 there were scuffles in the Cloître Saint-Merri. In 1834 troops had to be called to the Rue Transnonain. The attempt on the life of Louis-Philippe on the Boulevard du Temple by Fieschi (July 28th, 1835) was the outcome of a small-scale conspiracy. Calm was re-established, and lasted until the time that political quarrels developed once more. The capital had reached a state of boredom, and the Parisian's state of mind had undergone considerable deterioration as a result of social difficulties, which included shortage of work. The first reformist banquet was held in the Château-Rouge in July 1847. On February 22nd, 1848, barricades went up in the streets after another similar banquet had been banned. Unhappy incidents brought the working- and middle-class population into active revolt. A discouraged King left Paris, abdicating in favour of a grandson. Two other

facts should be added to the foregoing. First, that in 1832, during the reign of Louis-Philippe, the capital had suffered from a violent epidemic of cholera which claimed 39,000 victims. Second, that the arrival of the ashes of Napoleon I from Saint Helena on December 15th, 1840, had been an occasion for demonstrating French and Parisian unity.

It was a democratic republic which took the place of a property-owning monarchy. Discontent increased: the people wanted to go further still along the road of democracy, a desire that was reinforced by the poor economic situation of the capital. This time the working classes of the faubourgs found themselves facing both the Army and the middle-class National Guard. They gave up after four days of bitter fighting. All memories of '89, which for a few weeks had grown powerful, were suppressed. An ephemeral Mayor of Paris was turned out, and the two Préfets once again took over the running of the city. In December 1848 Prince Louis-Napoleon foisted himself upon a France distracted by the rioting in Paris and was elected Prince-President of the Second Republic. The *coup d'état* of December 2nd, 1851, transformed him into an Emperor. "The Empire means peace," proclaimed the new

43

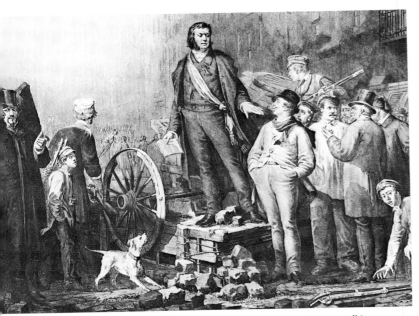

On December 3rd, 1851, the day after the coup d'état, Baudin, a Deputy, let himself be killed on a barricade in the Faubourg Saint-Antoine.
Engraving by E. Pichio, in the Bibliothèque Nationale.

electorate on the 26th. There were no forces of the legal Government remaining in Paris, and a horrifying struggle followed in which insurgent Parisians fought with the French Army for possession of the capital, a struggle which ended only on May 28th. There were countless victims of the fighting; 38,500 people were arrested of whom 11,000 were condemned. Many public buildings were destroyed, including the Hôtel de Ville. Such were the results brought by the Commune. It was a moral disaster not only for Paris but for the rest of France as well.

After that there was no more talk of insurrection and barricades. From the crushing of the Communards to the thunderbolt of mobilization in 1914, only on rare occasions does the political aspect of Paris demand attention. Exceptions are such events as the agitation the Boulanger affair gave rise to at

An appeal by the " Communards " to the " Versailles soldiers ".
Poster No. 395 issued by the Commune de Paris, dated 3rd Prairial, year 79 (22nd May, 1871).
From the Bibliothèque Nationale.

sovereign. It also meant dictatorship. For a period of eighteen years Paris enjoyed almost perfect calm. The attempt on the Emperor's life by Orsini (January 14th, 1858) was devoid of political consequences. The prosperity of France gave a further air of reality to the mirage of the Empire of Fêtes. Nevertheless Paris remained basically unchanged, a Paris given over to *frondes* and at heart Republican. This became apparent on January 10th, 1870, when the funeral of an enemy of the Empire, Victor Noir, shot by Pierre Bonaparte, was made the excuse for an enormous manifestation of hostility to the régime. Even before that, in May 1869, Paris had returned none but Republican candidates in the elections for the legislative assembly. After war on Prussia had been declared — a war ill-prepared and disastrous for France — Paris seized its opportunity. On September 2nd, 1870, Napoleon III was taken prisoner at Sedan. On September 4th, Paris overthrew the Empire and proclaimed a Republic, ahead of which lay a hard and testing time. Only a few weeks later the Germans began the siege of the city. It ended in a humiliating surrender. The Germans entered the capital on March 1st, 1871. The political climate had clouded over from the day the siege began. The Government of National Defence lost its popularity. Already on October 8th, 1870, there were demonstrations in favour of a Paris Commune. On March 18th, 1871, the insurrectional Commune took possession of the Hôtel de Ville and were confirmed in office by the

RÉPUBLIQUE FRANÇAISE

N° 395 LIBERTE — EGALITE — FRATERNITE N° 3

COMMUNE DE PARIS

LE PEUPLE DE PARIS

AUX SOLDATS DE VERSAILLES

FRÈRES!

L'heure du grand combat des Peuples contre leur oppresseurs est arrivée!

N'abandonnez pas la cause des Travailleurs!

Faites comme vos frères du 18 mars!

Unissez-vous au Peuple, dont vous faites partie!

Laissez les aristocrates, les privilégiés, les bourreau de l'humanité se défendre eux-mêmes, et le règne la Justice sera facile à établir.

Quittez vos rangs!

Entrez dans nos demeures.

Venez à nous, au milieu de nos familles. Vous ser accueillis fraternellement et avec joie.

Le Peuple de Paris a confiance en votre patriotism

VIVE LA RÉPUBLIQUE!

VIVE LA COMMUNE!

3 prairial an 79.

LA COMMUNE DE PARIS.

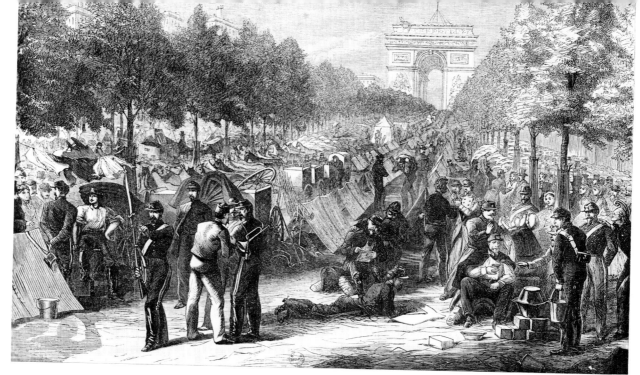

*French troops encamped on the Champs-Elysées.
September 1870,
From the Bibliothèque Nationale.*

*Gambetta leaving by balloon during the siege of Paris.
By Guiaud and Didier, in the Musée Carnavalet.*

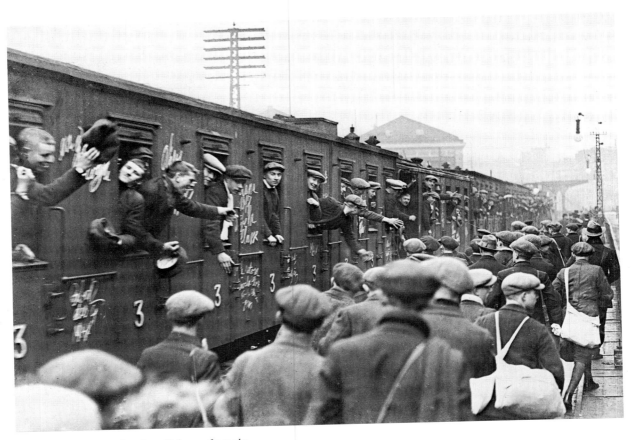

January 1916. Conscript class 17 leaves from the Gare Montparnasse.

the end of the century. It mainly concerned the parties of the right who were very powerful at that time in Paris. There was the Panama scandal, there was the Dreyfus affair and the Paul Déroulède nationalist campaign. Anarchist outrages culminated in 1894 with Vaillant throwing a bomb within the Chambre des Députés itself, which shook public opinion. Quite often a multitude of strikes on Labour Day (May 1st) generated a feverish atmosphere, which soon subsided. It was as if the political fire of Parisians were being damped by some obscure foreknowledge of the great European drama which was about to begin. Every eleven years more and more glamorous exhibitions made an excuse for rejoicings. They drew very great crowds. There were, for example, fifty million visitors to the 1900 exhibition. There were moments, too, of high emotion, as when powerful pacifist feelings were aroused by the funeral of Victor Hugo in 1885. The Great War had very varied and very considerable effects upon the capital. Thanks to Paris taxis and the victory of the Marne, the German army never succeeded in getting too dangerously close to the Paris region but bombs dropped from enemy planes and later the monstrous shells fired by "Big Bertha" killed 522 people. Of these eighty-eight were killed on Good Friday, 1918; they were crushed to death by falling masonry

when a pillar of the church of Saint-Gervais was hit by a shell.

Despite the wide differences in the mentality of the contemporaries of Guizot, Fourier, or Balzac and those men whom Faure, Jaurès, or Zola might be acquainted with, the foundations of Parisian life had hardly changed. Yet the destruction wrought in the times of Haussmann did cause a kind of moral break which was materialized by the new buildings which followed. Factory workers, artisans, and lower-grade employees were all thrown into the eastern parts of the city, or into the suburbs. It was the west of Paris — all the sixteenth and eighteenth and part of the seventeenth *arrondissement* — which drew the moneyed classes. Parisians who once were all happily mixed together now knew less and less of each other. People from the provinces, who for more than half a century had flowed in hundreds of thousands through the main-line stations, now came from quite different regions from those which had been usual before. The further parts of Brittany and eastern and southern France each sent huge contingents. From the time of the Second Empire foreigners thronged to the city. They were mainly Germans, Belgians, and Swiss, but there were also Britons, Americans, and Russians. Paris society became more cosmopolitan than ever, and a satisfactory fusion of all

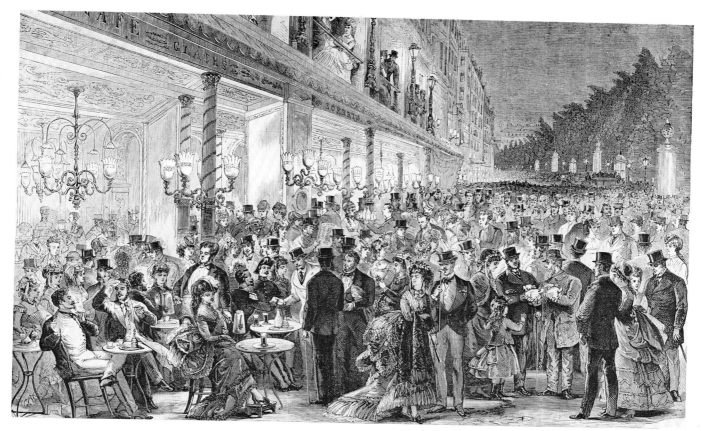

Boulevard Montmartre of an evening, in 1869.
Engraving by Pelcoq.

elements of the population was almost impossible.

Little by little the pleasures and the leisures of this society became changed. The streets still allowed the loiterer to dawdle along them with pleasure, as the Parisian had always loved to do. From the days of Louis-Philippe onwards outdoor life was mainly concentrated on the boulevards, and most particularly along the Boulevard des Italiens, while the Palais-Royal was deserted. Cafés pullulated, as did cinemas after 1895, the year of the Lumière brothers' experiments in the cellars of the Grand Café. Beyond the Boulevard Montmartre the cafés were displaced by popular theatres. The promenade along the Champs-Elysées continued in fashion. Bigger and bigger theatres were built to satisfy the growing Parisian taste for comedies and operas. In 1899, after a fire which caused many casualties, the Opéra-Comique was rebuilt. Under the Second Empire Garnier's Opera House was the glory of Paris. Shows and temporary exhibitions multiplied. Art became a lively passion with the *Tout-Paris*, which was a kind of social froth replacing the Court which

In the early years of the Métro.
Suffren underground station in 1907.

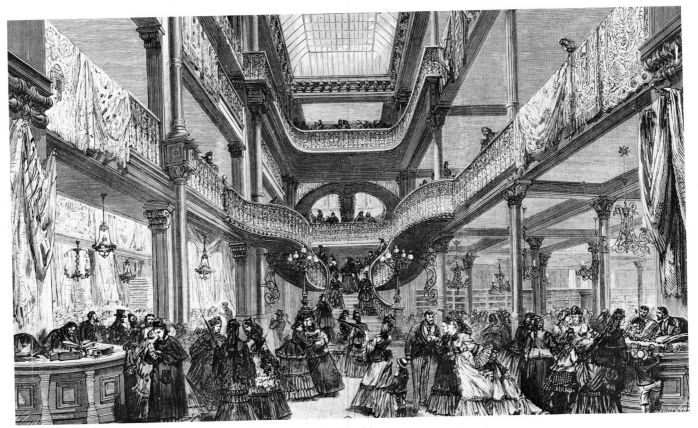

A new style of building for Parisian shoppers: the Bon Marché department store in 1872.
Drawing by Clerget and Vierge.

it had already almost absorbed in the days of Napoleon III. The *Tout-Paris* met in luxury hotels, establishments which had changed very greatly under the July Monarchy from what they had been under the Restoration. Now they had become meeting places of the worlds of literature and politics, places in which writers and artists forgathered, and for a time even musicians had their own favourite ones. Paris retained its age-old privilege of being the home of French intellect, and held all the country's major scientific institutions. All writers, all men of learning, pursued their careers in Paris. More than ever before in its history had Paris become the intellectual capital of the whole world. As a grey background to the city, social questions were everlastingly being brought forward by theoreticians and agitators and placed before a quite unconcerned society.

An economic growth such as Paris experienced grew from the development of institutions, the creation of an industrial centre of outstanding importance, and demographic progress. First and foremost, Paris became a financial market, attracting capital from a thousand different sources and making possible all the great enterprises of the moment. Financial operations were conducted in cathedral-like banks. The Banque de France itself occupied an entire quarter. The Bourse had

to be enlarged in 1903. The financial crises were Parisian rather than French and financial problems could only be solved in Paris. Commercial dealings were made possible by extensive credit. The food market handled a huge surplus which was redistributed all through France. Regional fairs disappeared.

Other expressions of commercial activity were the exhibitions, following one another at short intervals. National ones were held in 1834, 1839, 1844, and 1849. Immense universal exhibitions were organized in 1855, 1867, 1878, 1889, and 1900. Departmental stores increased considerably under and after the Second Empire, and played a truly Parisian part in the enormous commercial expansion of the metropolis.

Towards the end of this period of Parisian history the traffic problem became more and more acute and complicated as the motor-car took over the streets of Paris. The omnibus had existed since the days of the Restoration, and in 1875 horse-trams were added to the travel facilities offered by the horse-bus. In their turn horse-buses and horse-trams gave way to the motor-bus, introduced in 1905. The Métro, the underground railway of Paris, began running on October 19th, 1899, between Reuilly and Nation stations. It proved to be a greatly desired novelty.

Notre-Dame. Booksellers' display boxes
on the quayside.

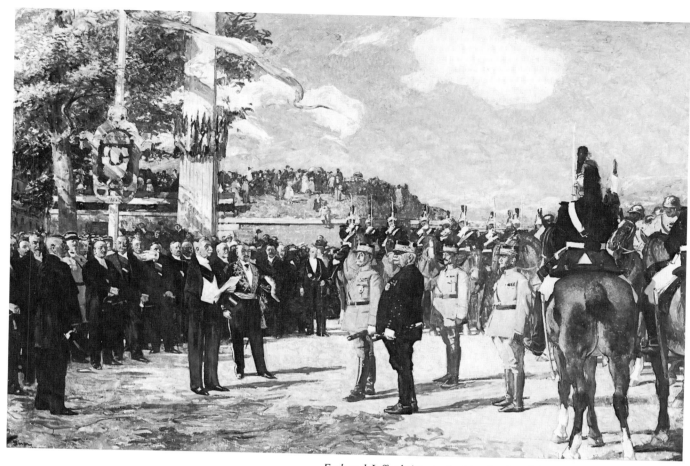

Foch and Joffre being received by the city of Paris at the Porte Maillot on July 14th, 1919.
By Lucien Simon, in the Musée Carnavalet.

END OF A WORLD: 1919-45

A Paris, delirious with joy, taking part in the apotheosis of the conquerors of Germany — that was on July 14th, 1919. Only twenty years separated this day of hope from another war, no less protracted and far more ruthless. During this short interlude Paris was never really at peace with itself. Social conflict alternated with political wrangles. Ill-planned industrialization piled difficulties upon a new-born scheme for organizing the Paris region. In addition the economic climate remained unfavourable, and became frankly bad after 1930 and the depression in America. Parties of the extreme left contended — often in the streets — with parties of the extreme right — the Action Française and the Croix de Feu.

From 1920 onwards the communists cut themselves adrift from traditional French socialism to follow the line of the powerful Soviet Komintern. Financial scandals were rife and, as political personalities were regularly involved in them, feelings ran high. This was so with the Stavisky case of 1933. It had many ups and downs until on February 6th of the following year an immense mass of protesters of all shades of political opinion gathered in the Place de la Concorde crying, " Stop, thief! Stop, thief! " As the crowd seemed to be threatening the Chamber of Deputies, the Garde Mobile opened fire and killed twenty. On the 9th rioting broke out. On the 12th the situation was further complicated by a twenty-four-hour general strike. The Republic, however, stood firm. In 1936 a dissatisfied electorate returned to the Chamber a large left-wing majority, which became known as the " Popular Front ". At this, nostalgic memories moved the immense Parisian proletariat, and in the minds of many workers hopes of revolution were born. Bitter strikes with occupation of factories led the Socialist government of Léon Blum to test a general confrontation of the working classes and the employers. The result was the Matignon Agreement of June 7th, 1936, after which there was a period of optimism, followed by further but less violent agitation. But the minds of Parisians, and indeed of all Frenchmen, were now occupied with other and deeper cares. Danger from the east was reborn in 1936, and with each month that followed was more precisely defined. Paris found itself at war again on September 3rd, 1939. The Germans began their offensive

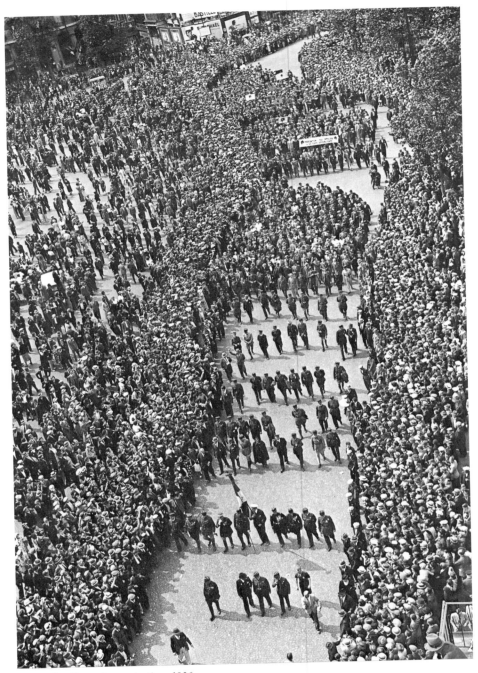

A Popular Front demonstration, 1936.

on May 10th, 1940, and in a few weeks crushed the French Army. For four years the capital lived through the nightmare of enemy occupation, of humiliation, of anguish of the spirit and of privations of all kinds. With the landings in Normandy (June 6th, 1944) hope returned. Parisians had for long been getting ready for the final showdown by means of a more or less clandestine resistance. At the first sign of the approach of Leclerc and his armoured division, up went the barricades and into ambush went the marksmen. From August 19th to 26th Paris in arms set to work to disorganize the German defence. By the time French troops were at the gates of the capital the enemy was already in flight. The German Command capitulated without delay. A few hours later the Provisional Government presented itself to the public. Then General de Gaulle headed a memorable procession from the Arc de Triomphe to Notre-Dame.

The period between the two World Wars, as far as the history of the material development of Paris goes, did not play a part of much importance. The

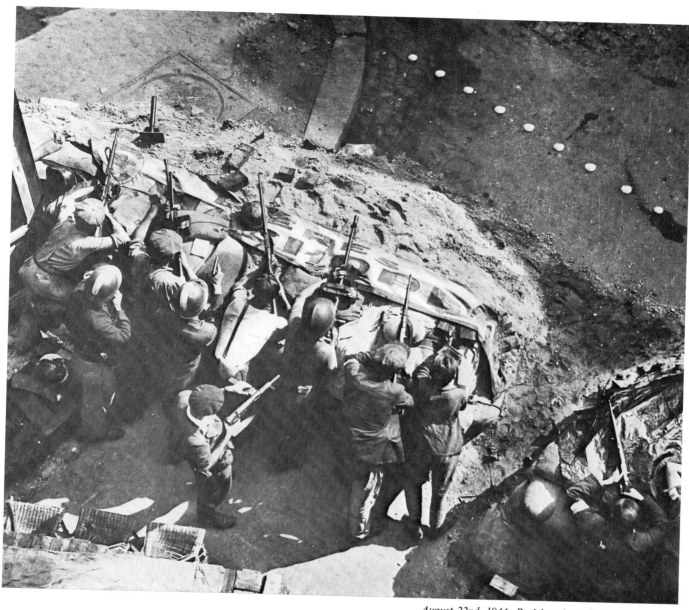

*August 22nd, 1944: Parisians in ambush
in the Rue de la Huchette.*

Paris of Haussmann, now nearly half a century old, called for immediate care, but had still to wait many years before Authority consented to spend the money needed to ensure its future. Renovations and rearrangements were sporadic and incoherent. The demolition of the fortifications of the Thiers era, undertaken from 1921 to 1930, was the most important of these operations. Had it been carried out with courage it could have given Paris a ' green belt ' which would have been highly advantageous to the pleasure and the health of the too highly concentrated urban population. It would also have permitted the planning of more effective communications between the urban centre and the suburbs. Financial considerations distorted the situation and the result failed to fulfil the promise. On the other hand, the creation of the Cité Universitaire on the Boulevard Jourdan was entirely successful, and this happy experiment could have borne repetition. Responding to a new demographic situation, the *Chantiers du Cardinal* (masons' yards for the building of new churches) were everywhere to be seen, and the faithful entered into possession of many new places of worship. Some prestige-earning successes were obtained by interesting exhibitions, though they did not have the same wide scope as those of the previous century. In 1925 came the Decorative Arts Exhibition, situated on the river

Paris liberated! A tank of the Leclerc Division in front of Notre-Dame, August 1944.

between Concorde and Alma. In 1931 there was a Colonial Exhibition at the Porte Dorée. In 1937 there was an Exhibition of Arts and Techniques, stretching from the Invalides to the Trocadéro, for which the Palais de Chaillot was built, replacing the 'temporary' Palais du Trocadéro built for the Exhibition of 1878. The administrators of those days deserve credit for other things too, such as the creation of open squares and gardens on the city boundaries and the building of hospitals and schools. The Zoological Gardens were opened in 1934 on the edge of the forest of Vincennes. In all it proved to be but a modest record. Should one find it surprising?

Those responsible were harassed daily by the gravest difficulties. Paris suffered more and more from inadequate housing. Traffic congestion demanded measures whose urgency was exceeded only by their impossibility of realization, for both the population and the number of cars on the road increased at too rapid a rate. Although the Métro system was barely forty years old it was already failing to meet the requirements of the day. The city administrators' main efforts were concentrated on providing underpasses to alleviate traffic conditions at the gates of Paris and on the main thoroughfares.

From all the vain attempts, from all that had been successfully accomplished (however insufficient that was), the true needs of the capital had at last been established. It now became clear that the city was ready to take its place as a Greater Paris, with all that this implied in continued urbanization and its effects upon the lives of those residing in it.

How can one, in only a few lines, describe this idea of a Greater Paris subjected to new techniques? How can one portray quickly a society suddenly thrust into a mass civilization? The people's ways of life and ways of thought were revolutionized by the almost immediate application of extraordinary scientific discoveries, some of them made in Paris itself. The atom was tamed. From May 20th to 27th, 1927, Lindbergh linked New York and Paris in one unbroken flight. Radio was quickly perfected and made its way into millions of homes. Films improved, and cinematographic techniques were transformed. In 1934 the 'talkies' were ready: in Paris actors and producers quickly took full advantage of the new possibilities. Drama underwent a renaissance and Paris was won over by the *avant-garde* theatre. Once more Paris proved worthy of itself as the capital of letters. The work of great authors (Proust, Gide, Valéry, Claudel) was brought to its end in Paris, or in Paris came to fruition. The *Belle Epoque* was over. Paris continued to fulfil its main functions with increasing authority, but none the less often appeared to be seeking a new way of life.

THE NEW ERA:
A METROPOLIS ON
A EUROPEAN SCALE

The real problem today for Paris is to find her proper place in the new Europe which was born of the War. Swept along by technical advances, thrown into confusion by an irresistible urbanizing and centripetal force, Paris — now a thousand years old and by some miracle intact — finds that she has to face problems not even thought of in 1939. Either she will respond yet once again to the challenge of new times and remain faithful to her mission, or else witness the dimming of her glory.

What is the situation of the capital of France at this point in history? In terms of space this has been defined by recent administrative reorganization.

Although the idea of a *Grand Paris* had been studied previously, its boundaries had not been clearly fixed. This is no longer the case since the publication of the law of August 2nd, 1961. This brought into being the " District of the Paris Region ", which covers a fairly wide area, including the old *départements* of Seine, Seine-et-Oise, and Seine-et-Marne (area: 4633 square miles). At the head of the District and in charge of 9,000,000 'Parisians' spread over eight new *départements* from Pontoise to Melun, from Provins to Rambouillet, will be a regional *Préfet*. The Paris agglomeration proper covers about 580 square miles of high-density population — a far cry indeed from the days when 25 acres sufficed for all the Parisii!

Such is the framework within which the Greater Paris should function and where the metropolis of European co-equality should be established. Just

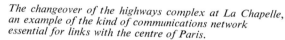

The changeover of the highways complex at La Chapelle, an example of the kind of communications network essential for links with the centre of Paris.

principal town of an administrative area under a Préfet

recently created developments

principal future tertiary centres (administration, public services, etc.) outside Paris

Main lines of new urbanization

BOBIGNY

Les Halles

La Défense

Map of the District of the Paris Region (from the " Schéma directeur d'aménagement et d'urbanisme de la région de Paris ", 1965).

as in 1860, when the city found in the take-over of the outer suburbs the means for its future development, so by this present reform will it ensure for itself the room needed for it to fulfil its national and its international rôle. The history of Paris during the last few years is in reality that of the efforts made to adjust the essential functions of the capital to its new dimensions: these are the lasting and decisive events of the period. Two examples explain this. First, moving the central market to Rungis repeats after an interval of eight centuries the operation by which Louis VI moved the traders who were encumbering the Cité out to Champeaux. For many reasons the solution of this grave problem means much to the life of Paris. The passions it arouses prove the fortunate persistence of the spirit of Paris. Second is the scattering of the University throughout the region, which demonstrates how very unsuitable the capital has become for the performance of one of its functions. The Latin Quarter now looks forward to extending its boundaries to the confines of the new District. The Sorbonne and the Cité Universitaire will soon be reduced to little more than symbols. Pending the opening of another ten or so new faculties, Nanterre and Orsay are already taking a portion of the 160,000 ' Parisian ' students. Each new faculty will have its own campus.

A part of the big-scale architectural complex at Sarcelles.

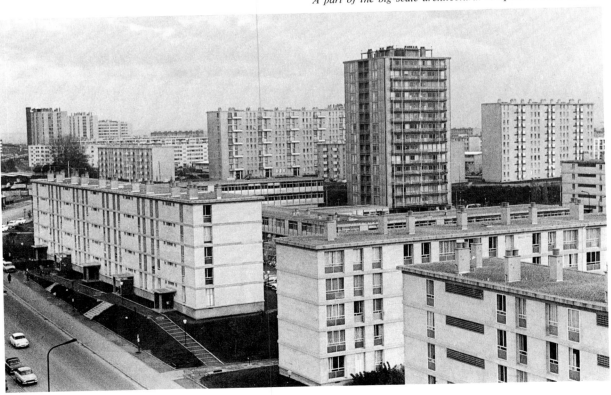

The campus of the Faculty of Letters and Humanities at Nanterre. The intellectual functions of Paris are now to a substantial extent exercised in the suburbs.

As the city spreads, many material features of its old appearance are changed, and many new features are added. In the very style of the big new buildings can one read the signs of history on the march — glass cages, in many of which a whole and ever-increasing race of office employees works; towers pointing to the skies encircle the cradle of Lutetia at Belleville, at Montparnasse, along the Seine, farther out at La Défense, and even beyond that until they make a high wall to block the distant view. The same signs can be seen elsewhere, in all that pertains to ensuring liberty of movement in the main arteries of this giant Paris — in motorways, in express roads, in flyovers and underpasses.

Until the outburst of student and labour troubles no event of great importance since the Liberation had disquieted the capital. The war in Algeria and in Vietnam provoked a few outrages and demonstrations. From time to time stoppages in public transport revealed the existence of unrest arising from economic causes. Suddenly the people of Paris were surprised and frightened by the great shake-up of May 1968. It is obvious that it was an essentially Parisian affair, with Parisian causes and an intensity which only Paris could produce. The first incidents had for their background the Faculty of Letters at Nanterre, just outside the city. There the " Movement of March 22nd " was born. For a time the fire

The Maine-Montparnasse complex, built for some living accommodation but mainly for offices.

just smouldered. On May 3rd the student and revolutionary dispute spread to the Sorbonne. After many ups and downs first the Sorbonne and then the Odéon theatre were occupied for some weeks by students in revolt not only against the University but also against society itself. Riot followed upon riot. On each occasion the streets of the Latin Quarter were blocked by barricades. Two enormous demonstrations were held, the first (on May 13th), by revolutionary and working Paris, from the Place de la République to Denfert-Rochereau, and the other (on May 30th) by Parisian Gaullists. At the beginning of the month the situation had led to a general strike of indefinite duration, with occupation of factories. The social conflict was stilled by the " Grenelle Agreement " of May 27th, which seemed like a faint echo of those " Matignon Agreements " of 1936. In June the agitation gradually simmered down, work began again, and the Sorbonne and the Odéon were evacuated.

Thus did the " May Revolution " come to an end, making an odd and perhaps still incomplete page in the history of Paris. It had uncovered the true

face of youth — at first unquiet youth, then of youth in a fury in a Paris suddenly paralysed, without Métro, without taxis, with machines everywhere idle, with shops often shut, and the people with nothing to listen to in their homes but the noises of the street. Two and a half million workers returned to office, workshop, factory, or shop. The voice of the professor was once again being listened to in the amphitheatre of the University.

On the threshold of the atomic era the future of the capital looks as though it will be a difficult one. However, often in the past the course of the capital's magnificent history has been punctuated by periods of doubt. The conditions needed for success exist. It is for the French people, and first and foremost the people of Paris, to unite in the determination to ensure success. In the days of the Sun King a Parisian jurist wrote that Paris was " the France of France ", in the sense that Paris is the quintessence of France. Would it be too presumptuous to think, in today's circumstances and in the light of all the centuries of yesterdays, that this, the capital of universal genius, could well become the quintessence of Europe, " the Europe of Europe " ?

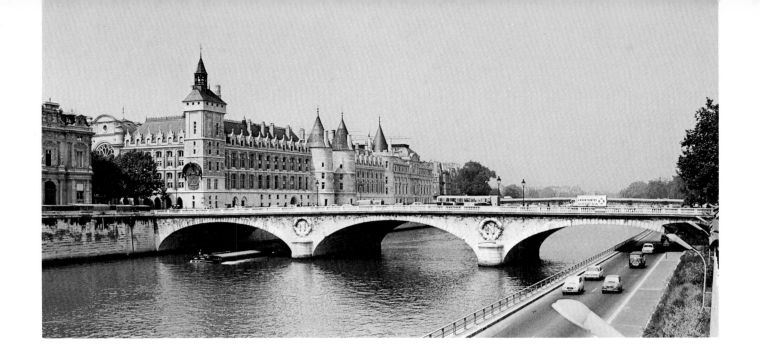

ART IN PARIS

Alike to the delighted eye of the interested sight-seer and to the indifferent eye of the casual passer-by, a scene unfolds as the Pont du Carrousel is crossed which includes every period of the architectural evolution of Paris.

Every century since the Middle Ages has contributed to the composition of this picture, for long one of the world's finest views, and even now, when one of the fast Paris throughways has been added to it, the change is not very great. Water, and stone-work, the sky of the Ile-de-France — at times a flax-flower blue, at others a pearly grey — and the matt patches of colour of the trees, green or gold, all contribute to it.

This agglomeration of buildings has succeeded in preserving some treasures, but it is also the silent witness of the wealth and abundance of fine buildings which have disappeared, and the reminder that once Paris was second only to Rome in the list of towns with the greatest number of spires and belfries, pinnacles and towers. It is inevitable that when generation succeeds generation on the same limited area they are forced to destroy in order that they may rebuild. In older days, though, every good feature that was lost was replaced by another as good.

That, alas, ceased to be true from the second half of the nineteenth century onwards. Daguerrotypes and the earliest of photographs show Paris as a city with an antiquated and slightly provincial air. To this almost intact town, in which the old was the framework to the new, Haussmann, encouraged by Napoleon III, brought the wielders of pick and shovel for reasons more political than æsthetic. The venerable remains of ancient churches, convents, and private houses which had escaped the ravages of the Revolution and of the First Empire, in front of which all the great historical characters of their times had paraded, were tumbled to the earth by the unforgiving sledge-hammer blows of the demolition squads.

In their place were driven new, straight thoroughfares, ruler-drawn and banal, having no life and no soul. They were prolonged out into the new wards just being created on the city boundaries, which now found themselves right inside the city. Demolition has gone on ever since then, and new buildings have gone up to the accompaniment of high-sounding phrases: progress, hygiene, and even morality. In most cases these phrases hide self-interest, speculation, ignorance, and even a lack of reason. As if the evil were not enough in itself, judicious lessons learned from an old principle were misinterpreted until a few years back; the old principle has become the modern science of urbanism and has been applied with greater or lesser discernment. In the name of urbanism and with the excuse that it would make the victim easier to see and appreciate, the Hôtel de Sens has been totally disengaged from its neighbours, isolated, and given some very strange surroundings. Indeed, in the name of this misunderstood urbanism too many excuses have been made for, and too much encouragement has been given to, bad taste and ugliness.

As if this evil were not great enough in itself, it has been further augmented since the end of the

New buildings rise in the neighbourhood of La Défense.

the city — the destruction of some of the mansions of the Faubourg Saint-Germain, the destruction of the Théâtre de l'Ambigu, the destruction of buildings which, though unpretentious, were attractive examples of the work of past centuries. It is also, despite a nominal vigilance, the placid indifference with which is accepted the disappearance or alteration of old elements which once helped to compose the charm of some particular spot. It is, furthermore, the erection of the monstrous and oppressive buildings of the *Maine-Montparnasse* and *Front de Seine* complexes, the sudden appearance and the rapid multiplication of gigantic towers which deform and dwarf all else. A whole new district flaunting its excessive modernity and certain to date all too quickly can be allowed to spring up and develop on the outskirts of the city, as at La Défense, where there is nothing of historical or artistic value. But what is going to happen when the wholesale market has been moved out to Rungis and a major development is begun in the Halles quarter, the very heart of Paris? What will happen to the architectural treasures, often as yet undiscovered, to be found scattered around the stimulating pioneer works of Baltard? How will the projects for a hotel, for a congress centre, and for the reconstructions of blocks of flats at the Porte Maillot actually be carried out? Will these be groups of buildings by means of which the second half of the twentieth century will add to the remaining fine buildings of earlier centuries something worthy of them, or will it be a purely commercial operation with all the æsthetic risks that go with it? The decrepit and unhygienic buildings along the Avenue d'Italie, the Avenue de Belleville, and the Avenue de Ménilmontant must come down. Will they not eventually be replaced by barrack-like houses for workers, at low rentals *(habitations à loyer modéré)*, or banal 'luxury' flats, along rectilinear streets without any visual element such as the unexpected twists of an old street or odd period details which give a district life and character? The future will tell. The future will undoubtedly also prove how deplorable it is that the need for general discipline and a common understanding, once freely accepted by all as in the general interest for the creation of a charming group of buildings worthy of a capital or for their embellishment, should now be misprized.

Is it possible to go on forgetting that if middle-class Paris, royal Paris, imperial Paris, cosmopolitan Paris, has watched the development of all the procedures and all the techniques of art and seen them prosper, it has on its side conferred upon them a background of unequalled charm and perfection? Has not her artistic history, as is the case with her intellectual history, been the history of the entire nation? Should not Paris remain the symbol and the synthesis of true taste and of the French genius?

Second World War by problems set by a volume of traffic which grows more overwhelming every day. A still further aggravation has been added in the shape of the relentless pursuit of profit, provoked by the persistent shortage of living accommodation, the scarcity of building land, and its high price.

Perhaps the time has come to ask, in our distress, if the present era is not turning Paris into a new Alca. "Houses were never thought to be tall enough and were endlessly being made even higher, being built up to thirty and forty storeys...and all the time ever deeper tunnels and basements were being excavated..." Thus wrote Anatole France of Alca in *Penguin Island*.

The all too ephemeral whiteness of the principal public buildings is not what distinguishes the Paris of today, nor the attempts at renovating the Marais quarter, but the insidious, continuous destruction of

The frigidarium of the thermæ attached to the Hôtel de Cluny.

FROM THE END OF THE GALLO-ROMAN PERIOD TO THE END OF THE CARLOVINGIAN PERIOD

However interesting or important the traces of the Second Iron Age discovered in Paris may be, or the coins dating from the last days of independence during the struggle against Rome, the history of art in Paris cannot be said to have begun before the latter period. In fact one has to look for it in the first century A.D., when Paris was a true town in miniature, enjoying full prosperity. Already overflowing the narrow confines of its birthplace on the Ile de la Cité, it was spreading along the Left Bank of the Seine and, despite the marshes, several parts of the Right Bank were being settled. Served by roads going from north to south and from east to west, Paris though only a secondary agglomeration — a biggish provincial township — had a palace in which visiting Roman emperors stayed. It was on the west of the Cité, where the Palais de Justice now is. Temples had been built and some monuments erected whose rare remains lead one to believe that very early, from the first century onwards, many sculptures were being carved for them; they are noteworthy for their imitation of Roman models, though they are often associated with substantial elements of local inspiration. A votive pillar erected during the reign of Tiberius (A.D. 14-37) was

unearthed from under the choir of Notre-Dame in 1711. It had been presented by the *Nautæ Parisiaci*, the Seine Boatmen, who must have been very active commercially and had won high prestige. These powerfully executed carvings are to be seen in the Cluny Museum. Amongst other major fragments are a tall, quadrangular pillar carrying the effigies of four gods (discovered in 1784 near the Pont-au-Change) and the *Pilier de la Gigantomachie*, exhumed in 1829 from under the old church of Saint-Landry-de-la-Cité, where it was in the foundations of the fortified wall of the times of the Byzantine empire. A temple consecrated to Mercury doubtless occupied the heights of Montmartre whose slopes were studded with rich villas. More numerous, however, were the houses on the Left Bank, particularly at the beginning of the present Rue Gay-Lussac. They had important buildings as their near neighbours: there was a basilica in the neighbourhood of the present Rue Soufflot, a theatre near the Lycée Saint-Louis, *thermæ* by the square which now exists alongside the Collège de France. There was an aqueduct, too, a pagan necropolis in the vicinity of the Observatory, and, between the Boulevard Saint-Michel, and the Avenue

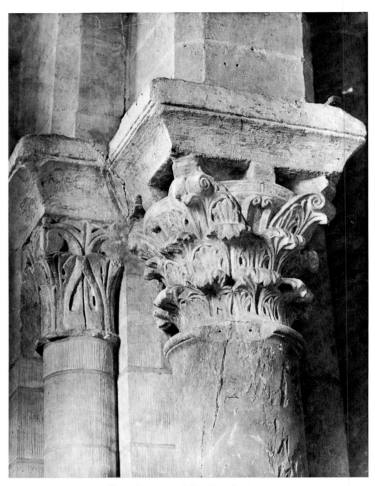

Capitals in the nave of the church of Saint-Pierre-de-Montmartre.

into the walls, fashioned into the likeness of prows of stout ships, relieved on the sides by bas-reliefs of tritons. Fixing holes tell that long ago metallic ornaments, now vanished, had decorated them. One presumes that they might have referred to the *Nautæ Parisiaci*. It is possible that the Boatmen presented this thermal establishment to the city, unless indeed it was one reserved for their own use.

The Romans lost Gaul towards the end of the fifth century and were replaced by the Franks. The recently converted Clovis made Lutetia (which had recently become Paris) his capital in 508. He built the basilica of the Holy Apostles on *Mons Lucoticius*, which later took the name of the patron saint of Paris, just as the basilica itself became the church of Sainte-Geneviève in the ninth century. After Clovis, his sons abandoned the city, but despite this churches sprang up everywhere. About the year 543 Childebert built the churches of Saint-Vincent and the Sainte-Croix. In the seventh century the burial-place of the Merovingian dynasty, the abbey of Saint-Germain-des-Prés, was built. A predecessor of the present cathedral, a church of Notre-Dame-de-la-Cité, is attributed to Childebert. It was in part situated where the Place du Parvis is now, and it was richly ornamented. A few fragments of the great mosaics, with a red and black design on a white background, which decorated the floor are to be seen at the Cluny Museum. To the east of this church was a fourth-century oratory dedicated to Saint Stephen: it could have been the Bishop's chapel. It was rebuilt by Charlemagne in the ninth century. To return to the sixth century, there would appear to have been an oratory of Saint-Martin at the end of the Grand-Pont, and on the Left Bank there was the church of Saint-Julien, probably Saint-Julien-le-Pauvre, a church of the then separate township of Saint-Marcel. On the Right Bank there was a basilica (Saint-Laurent) and the church of Saint-Gervais-Saint-Protais.

After the accession of the Carlovingians, and despite the fact that Charlemagne, the son of Pépin the Short, chose to reside at Aix-la-Chapelle, new sanctuaries continued to spring up in the eighth and ninth centuries. There was a new church of Notre-Dame in the Cité; a Saint-Merri, a Sainte-Opportune, a Saint-Germain-le-Rond (later to become Saint-Germain-l'Auxerrois) on the Right Bank; there was a Saint-Séverin on the Left Bank. They were first built of wood, and were destroyed by fire. They were rebuilt in stone, and were devastated during political warfare or Norman invasions. Nothing remains of all these old churches with the exception of a few colonnettes in the triforium of the choir at Saint-Germain-des-Prés, and some capitals with stylized acanthus leaves, presumed to be Merovingian, at Saint-Pierre-de-Montmartre.

des Gobelins, a Christian cemetery. Before the year 280 the Left Bank part of the town was destroyed by barbarians. The survivors of this disaster took refuge in the Ile de la Cité behind a wall built of the stones and other material salvaged from the ruins. The only monuments more or less spared out of all those put up at various times are the Arena in the Rue Monge, which seated more than 10,000 people, and the *thermæ* buildings alongside the Hôtel de Cluny, now the Cluny Museum. Their purpose was for long a matter of controversy, but excavations carried out from 1946 to 1956 proved that they were in fact public baths, built in about the second century. There were the three traditional rooms of Roman baths: the *frigidarium* or cold room, the *caldarium* or hot room, and the *tepidarium* or cool room. Of these, only the first is still complete but there are substantial remains of the other two and of the installations, corridors, sewers, and water pipes. It makes a fairly considerable rectangular building with small hewn stone courses relieved by narrow brick courses, broken by bays and recesses and covered by barrel vaults and groin vaults. At the bases of the vaults consoles are sunk

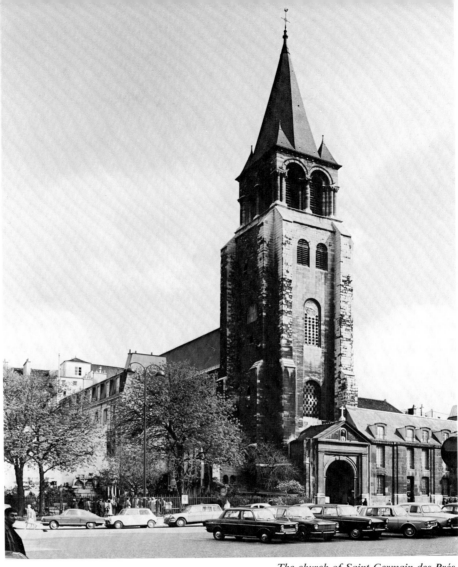

The church of Saint-Germain-des-Prés.

ARCHITECTURE

In 987 Hugh Capet became King and installed himself on the island in the palace of the Cité. Paris, having thus been placed at the head of the royal domain, rose from its ruins and grew in size. The generosity and piety of the princes who succeeded the founder of the dynasty led to the construction of many new religious buildings. The group of concepts to which, taken together, we give the name of Romanesque style, was not absent from them. Nevertheless the style remained rudimentary in the Ile-de-France, where there was no counterpart to the changes and developments which characterized it in more favoured provinces. Paris has not kept a single complete Romanesque monument: all that is left is wreckage. One can only mention, in that part of Paris which was then the town itself, the chapel of Saint-Aignan, built in about 1115-18 by Etienne de Garlande. It remains the sole example of the little churches of the Cité and has been restored quite recently. Some capitals and parts of the bell-tower of Saint-Germain-l'Auxerrois date from this epoch.

Vestigial remains of some of the great abbeys once situated close to the city walls have come down to us. The Clovis Tower, once part of the abbey of Sainte-Geneviève, has no more than a Romanesque base. Its importance is far eclipsed by the remnants of the abbey of Saint-Germain-des-Prés. It was built on the site of the old Merovingian basilica and begun between 990 and 1004. It was completed in the second quarter of the eleventh century.

The bell-tower porch of Saint-Germain-des-Prés, one of the oldest in France, dates from 1040, but only the lower part remains. Two other towers, one each side of the choir, were destroyed, except for their bases, in 1822. They show a Rhineland influence. The plan introduces no particular innovations and remains that of the Carlovingian period, including a nave with five bays (these were altered in the seventeenth and eighteenth centuries). It is flanked by plain aisles, with a salient transept and a choir consisting of a central apse in semicircular form with four absidal chapels of uneven depth. Despite all the additions and rebuilding which have altered the appearance of Saint-Germain-des-Prés, the south crossing has retained two eleventh-century windows. The same is true of the north crossing, but

with the addition that it shows a few columns of that same period.

Similar upheavals have completely changed the priory church of Saint-Martin-des-Champs, now an exhibition hall in the Conservatoire des Arts et Métiers. It was consecrated in 1067 and presented to the Cluniac order in 1078, and became a priory. Excavations carried out in 1913 brought to light on the east side of the tower (which lost its second storey in 1809) the southern apsidal chapel of the church as it was when consecrated in 1067. It is presumed that it was covered with barrel vaulting, continued by a semi-dome, and lit by three windows.

At Saint-Germain-des-Prés, at Saint-Martin-des-Champs, and at Saint-Pierre-de-Montmartre the experiments and trials which led to the first swift unfolding of the nascent style destined to end as the fully developed ogive can be observed. Saint-Pierre-de-Montmartre was rebuilt between 1137 and 1147 and was thus contemporary with Suger's basilica at Saint-Denis.

As far as the architecture of Paris was concerned, the eleventh century had been a period of waiting. The twelfth century was to be one of accomplishment, and a sequence of trials which cleared the way for the incomparable developments of the thirteenth century. The ogival transept made its appearance in the choir of the priory of Saint-Martin-des-Champs (rebuilt by Abbot Hugues I between 1130 and 1142) and in Saint-Pierre-de-Montmartre, but was not yet used for the rest of the building. The general appearance of Saint-Martin-des-Champs continued to be Romanesque, but the pointed arch made an appearance in the arcades whilst the arches of the windows remained semicircular. A fact no less significant than the use of the pointed arch was the use of inner buttresses for the first time in France to help stabilize a building.

In the years immediately following, these new methods of building asserted themselves at Saint-Pierre-de-Montmartre whose single ogival vaulted bay in the choir may be dated with certainty as having been put up in 1147; the choir of Saint-Germain-des-Prés, of 1163, can be dated with equal certainty. The constituent elements of Gothic architecture were taking firm shape and already demonstrating a fully coherent way of building when the masons' yard of Paris's new cathedral was opened in 1163 on the occasion of the laying of the first stone of the choir, Notre-Dame de Paris being, in effect, one of the last in date of the four or five major religious buildings of the twelfth century in the royal domain. It was, with Laon, which preceded it only by a little, to become one of the most outstanding and one of the best known. The two have certain points in common: sexpartite vaults, which were usual in Normandy, cylindrical columns,

galleries above the side-aisles shouldering the vaulting, and other features in the same tradition which, taken all together, make each one's individual participation in the evolution of architecture all the more important. However, Notre-Dame as it stands in the twentieth century, with all the changes which have been wrought and the restoration work done in modern times, no longer corresponds with what it was at the time it was begun. It underwent many retouches between the second half of the twelfth century and the second half of the fourteenth century, which, with many additions to the structure, have determined its final appearance. It is the successive steps in the changes which it is important to recall, in the absence of a much more profound study than is possible here.

Thanks to the enterprise of Maurice de Sully, Bishop of Paris, the choir and its double side-aisle were finished in 1177, except for the roof. Five years later the Papal Legate was able to consecrate the High Altar. Towards the end of the century work was proceeding on the roof of the nave and its five double bays, though by that time substantial alterations had been made to the original conception of the cathedral. Its total length was to be 426 feet, the width of transept 157 feet, and the height to the vaulting 128 feet. Galleries supported the ogival vaulting of the choir, and stayed the outer walls. Apart from wall buttresses, the stability of the ogival vaulting of the nave was strengthened by flying buttresses, which also allowed it fuller expression. The originals were amongst the very first flying buttresses to be used, but were altered in the thirteenth century.

The first bays of the nave and the façade were still missing when Maurice de Sully died in 1196. The façade was not completed until 1250. Its grandiose and balanced design, the simplicity and harmony of its general arrangement, its double system of vertical and horizontal divisions framed and completed by two massive, steeple-less towers (perhaps they were never intended to have steeples), make it one of the loveliest of Gothic façades. It was completed at the end of four building campaigns. The lower part up to the Gallery of Kings was built from about 1200 to 1220. The rose window stage took from 1220 to 1225. The south tower was built from 1225 to 1240. The fourth stage, the north tower, lasted from 1245 to 1250. This front measures 134 feet across and is 141 feet high to where the towers proper begin, and 207 feet high to the top of the towers.

Meanwhile between 1220 and 1230 the top windows of the façade were lengthened to make good a lack of light. The number of chapels intended to be dedicated by wealthy people and guilds had proved insufficient, so soon afterwards (from 1235 to 1250) others were established along the side-aisles by pushing out the walls of the nave as far as the abut-

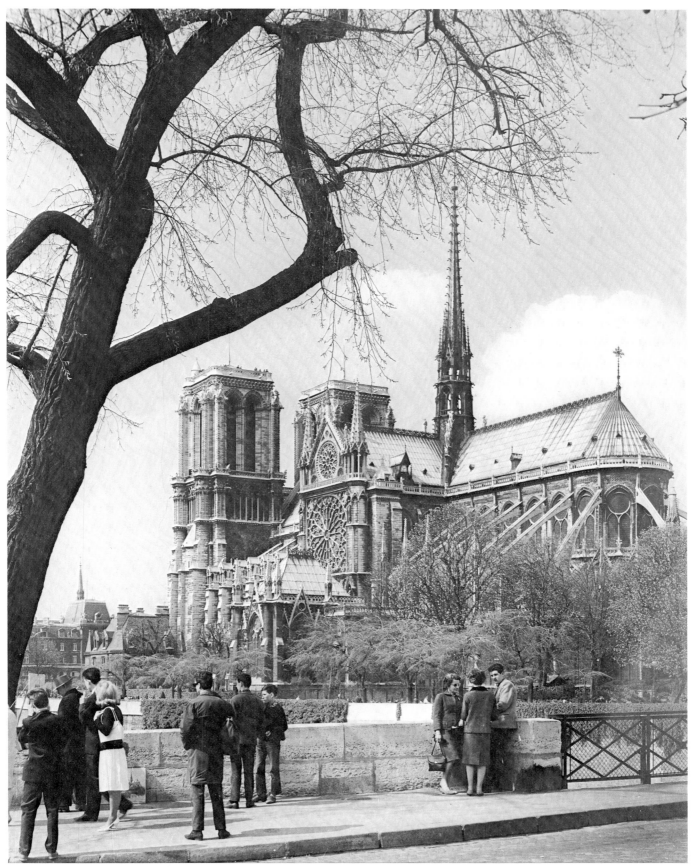

Notre-Dame de Paris.

Detail of a frieze in the Sainte-Chapelle.

ments supporting the flying buttresses, which now rose in a single flight. With these additions the transept walls were no longer in alignment and had to be moved. The designs for the new façades were provided by Jean de Chelles, the first of the architects of Notre-Dame whose name has come down to us. Deriving inspiration from the innovations introduced into the Sainte-Chapelle, in whose walls empty spaces daringly outmeasured the solid, he began the north crossing in about 1250 and the south crossing in about 1258. The work was not interrupted by his death, for Pierre de Montreuil (or Pierre de Montereau) continued it. He himself disappeared in 1267. The features due to the talent and ingenuity of these two illustrious master-masons, whose personal contributions have been well authenticated, are: the façade of the crossings, their open porch under an archivolt, surmounted by a great pierced gable accompanied by smaller gables, the series of blind arcades and the glazed gallery above them, the two incomparable rose windows, miracle of lightness and science, as indeed is all the rest of the façade, the triangular gable pierced for roses, the counterforts with niches, and the pierced lanterns with sharp-pointed flèches. Pierre de Montreuil completed the chapels edging the choir which had been begun under his predecessor; he also replaced the flying buttresses of the choir.

At the beginning of the fourteenth century Pierre de Chelles built the rood screen (about 1300 to 1318), which the eighteenth century destroyed. From about 1296 he had begun the chevet chapels. Jean Ravy was his successor from 1318 onwards. Work for which he was responsible includes the enlargement of the windows in the choir gallery and the replacement of its flying buttresses by arches of 45 feet diameter rising in a single flight. He also began the choir screen, which was continued after his death by his nephew Jean Le Bouteiller, and finally completed in 1351.

Thus nearly two centuries were needed for the fashioning of Notre-Dame de Paris. Its very simple plan — a great Latin cross, rounded at the top and flanked by a double side-aisle and a belt of chapels — both summarizes and expands the cycle followed by Gothic architecture, from the moment of its emergence from Romanesque to its highest pitch of perfection.

Whilst the new Notre-Dame was being fashioned and completed, older churches and sanctuaries were being rebuilt or enlarged and new places of worship were being built. Both old and new responded to the inevitable and sometimes deep influence of the Paris cathedral with its new ideas and its success. Towards 1170 the monks of the abbey of Longpont decided to rebuild the old chapel of Saint-Julien-le-Pauvre, which belonged to them. It has been asserted that lack of money forced them to keep to the plan, the foundations, and possibly part of the original walls of the early chapel. Also through shortage of funds the work had to be limited to the ground floor of the choir and to the apsidal chapels, each of which included a straight bay (doubled for the apse and the southern apsidal chapel) and a hemicycle. The upper parts of the choir could not be completed before the beginning of the thirteenth century (*c.* 1210-20). The whole choir, made up of two bays in tierce-point crowned by a sexpartite vault, presents what Monsieur Huisman has called "a perfect example of the application of the Gothic style of Notre-Dame to a building of only medium size". Originally the nave must have been covered by a wagon roof of plaster or wood which, from the second quarter of the thirteenth century, was supported by side aisles with ogival vaults. The front, dating from the middle of the thirteenth century, was altered in the course of the rebuilding of 1651 when two of the six bays were eliminated. This change contributed to a considerable degree to a transformation of all the interior of the church. Since 1889 the church has been given over to the Melchite sect.

Saint-Julien-le-Pauvre was not the only church in which elements of the flourishing Gothic style replaced or were added to the out-of-date efforts of its first builders.

The first apse of Saint-Pierre-de-Montmartre is supposed to have been a semi-dome, but, probably at the end of the twelfth or the beginning of the thirteenth century, was replaced by a five-sided chevet with vaults made up of six ogival branches formed by a quirk between two tori and joined by a key in the form of a claw-footed cross.

The essential elements of thirteenth-century Gothic architecture were now finally determined and were the more widely used wherever a church was less than normally anchored to the past or was the object of a total rebuilding. Towards the beginning of the century it was to be seen at Saint-Denis-de-la-Chapelle, once the parish church of a separate village, but now well within the town. It appeared

Saint-Pierre-de-Montmartre and the Sacré-Cœur.

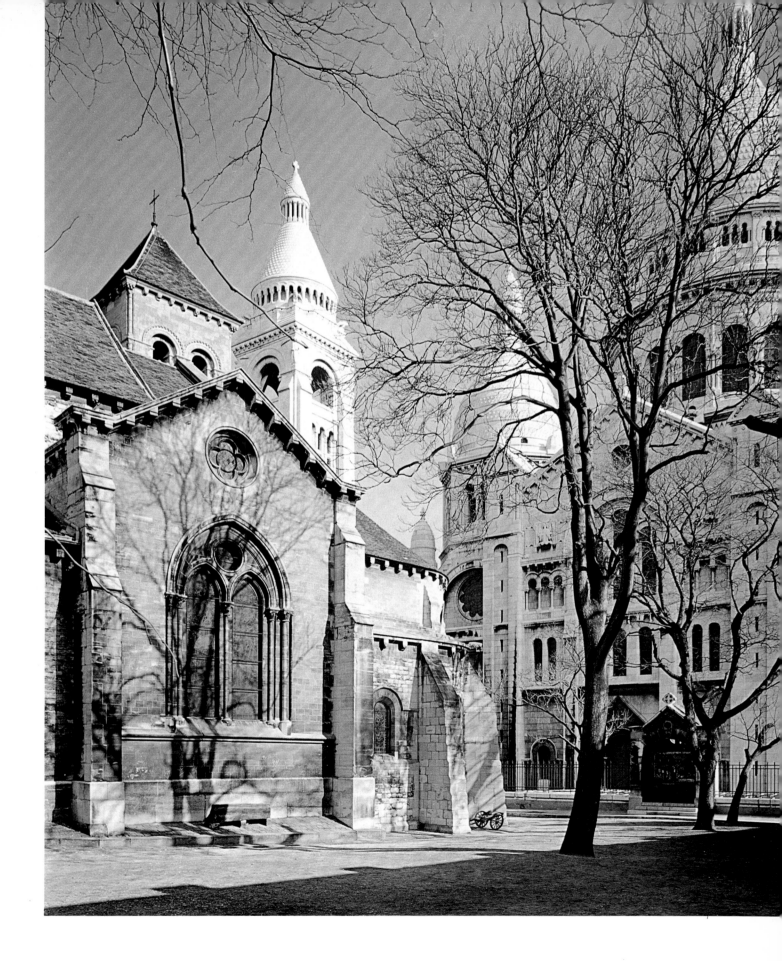

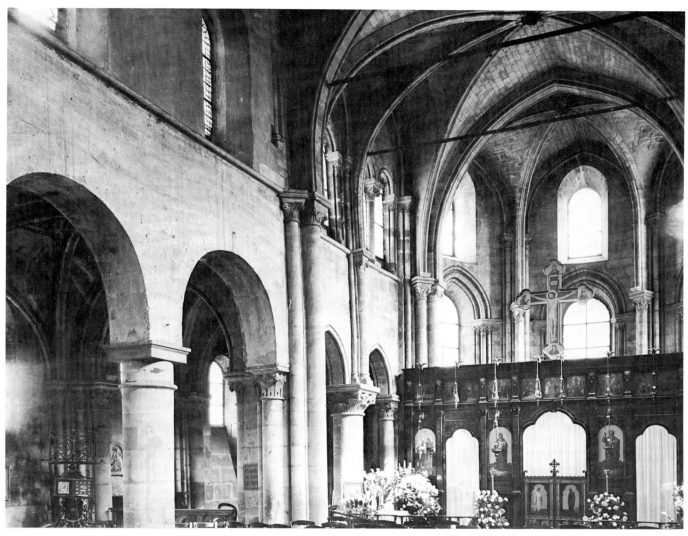

The nave of Saint-Julien-le-Pauvre.

again a little later at Saint-Séverin, with the first south side-aisle and its vaultings and the three first bays of the nave with arcades in tierce-point, in imitation of Notre-Dame and of Saint-Julien-le-Pauvre. The second floor includes a triforium with twinned bays accompanied by colonnettes decorated with crotcheted capitals which are the best of those still to be seen in Paris. The portal of Saint-Séverin is none other than that which once served the church of Saint-Pierre-aux-Bœufs. The older church was situated in the Cité and dated from the middle of the thirteenth century. The portal was rebuilt on its present site in 1837. The bay under the bell tower of Saint-Germain-de-Charonne dates from the end of the century; the tower itself was rebuilt in the last quarter of it. Its destiny was to prove similar to that of Saint-Denis-de-la-Chapelle.

Meanwhile one of the vital works of the thirteenth century had been built in Paris. It was the Sainte-Chapelle, masterpiece of the rayonnant style and the apogee of Gothic architecture. Built for the purpose of enshrining the relics of the Passion which

the Emperor Baldwin of Constantinople had pledged to Saint Louis (Louis IX of France), it was begun in January 1246 and consecrated on April 25th, 1248.

Situated in the Cité amidst the buildings of the royal palace (which was succeeded by the Palais de Justice), it consists of two superimposed chapels behind a two-level porch and beneath the huge east-end rose (rebuilt in the reign of Charles VIII). The upper chapel could be reached directly from the King's apartments which were on the same level, or from the ground by means of a monumental staircase which no longer exists. This chapel was reserved for the King and those close to him. The lower one was for the use of lesser members of the palace staff, and for entombments. Both comprised a single nave of four bays, and a seven-sided apse. In the lower chapel, pillars of identical pattern whose capitals are relieved by carvings of foliage are strengthened by interior pierced flying buttresses and support the spring of the vaults, making room for a narrow collateral. Three-cusped blind arcades

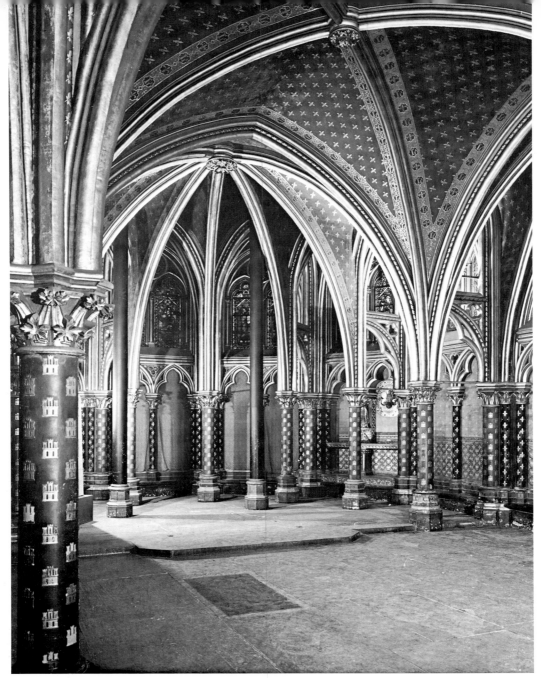

The lower chapel of the Sainte-Chapelle.

with scuncheons relieved by historiated medallions, motifs in coloured glass paste, and cabochons embellish the walls. The vaults of the upper chapel cover a quadrilateral space, the length of the sides being dissimilar. Outside it is supported by light abutments and inside by thin, free-standing clusters of colonnettes carrying statues of saints. The daring of this vaulting and the boldness of its execution make the whole construction quite breath-taking. A low wall, also relieved by three-cusped blind arcades and leaf-pattern ovolo mouldings, takes the place of foundation courses. The remainder of the elevation consists only of walls of multicoloured and historiated stained glass. These turn the entire upper storey into one immense reliquary, the vast shrine which its founder intended the relics to have.

Was the architect Pierre de Montreuil, as has been claimed? Nothing is less certain. This being the case, there is nothing left to do but to recognize the merit of genius in the work of the anonymous master-mason who, while drawing up his plans for the Sainte-Chapelle, was able to endow Gothic architecture with the lightness of touch, the elegance, and the abundance of light of which it stood in need.

At least in part, the attribution of this masterpiece to Pierre de Montreuil arose from the rare perfection of the buildings for which he was known to be responsible and which count as the outstanding ones of the reign of Louis IX. Saint-Denis being outside Paris and therefore outside the scope of this book, his other work only must be recorded here. In addition to Notre-Dame he built the refectory

of the abbey of Saint-Germain-des-Prés (1239-44) which, together with his Lady Chapel (1245-55), has now been all but totally destroyed. Remains of the latter in the shape of a portal and a few blind arcades may still be traced in the Square de Cluny and the Square de Saint-Germain-des-Prés. Pierre de Montreuil was also the designer of the refectory of the priory of Saint-Martin-des-Champs in which is now to be found the library of the Conservatoire des Arts et Métiers which has a magnificent nave covered by two bays of vaults whose ribs fall to seven median columns. The whole, including the lector's stall, is of a rare perfection.

As the thirteenth turned into the fourteenth century architects no longer strayed from the norms which the science and mastery of their predecessors had established. Light and lightness became obligatory once the Sainte-Chapelle had led the way, but the search for them sometimes became laborious and they were acquired at the cost of a certain monotony and lack of feeling. The ground plan of churches varied hardly at all. The collaterals were surrounded by ever more numerous chapels, often intercommunicating. Vaults were no longer made sexpartite but became unequal quadrilaterals. External flying buttresses increased in size and in daring.

These changes are more or less obvious in all the Paris churches of the end of the thirteenth and of the fourteenth century which have been preserved.

The nave of the priory church of Saint-Martin-des-Champs was built at the end of the thirteenth century, at about the same time as the choir, apse, and western portal of Saint-Germain-l'Auxerrois were rebuilt. So too, it is believed, was the Lady Chapel, which was four bays long and separated from the nave by a screen. The rebuilding of Saint-Leu-Saint-Gilles was begun in 1319, though later it was altered on several occasions. The inherent interest of these buildings would seem to have been surpassed by that of the chapel of the Collège de Beauvais, the foundation stone of which was laid by Charles V in 1375. It was built by Raymond du Temple, architect of the Louvre, and consecrated in 1380. Saint-Jean-de-Beauvais was inspired by the Sainte-Chapelle. The nave had five bays and a five-sided apse. It was superbly decorated with sculptures, paintings, and stained glass. Now virtually no trace remains of its past splendour. Nevertheless it ranks with the refectory of the Collège des Bernardins (Rue de Poissy), begun in 1346 and now a fire brigade station, and the much later tower of the Collège de Fortet (Rue Valette) as a reminder of the intellectual centres founded in Paris in the course of the Middle Ages.

Monastic architecture of the period is no better represented, except for the odd building to be noted in passing — for example, the thirteenth-century

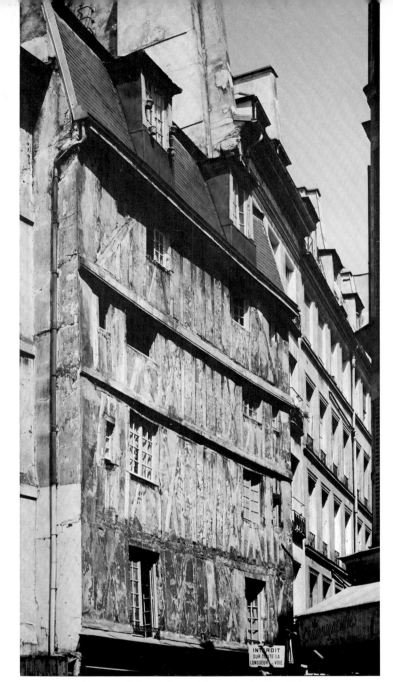

Beam-and-plaster-fronted house in the Rue Volta.

kitchens and refectory of the abbey of Sainte-Geneviève, now part of the Lycée Henri IV. The same is true of military architecture, often inseparable from civil. None of the examples of these two is older than the twelfth century, and even then consists only of fragments of the unbroken wall, " well supplied with turrets and fortified gates ", built in 1190 or thereabouts by Philip Augustus to protect the northern part of Paris, and later prolonged along the Left Bank of the river, then carried round the city and completed before the year 1209. Again it is from the twelfth century that the fortifications of the priory of Saint-Martin-des-Champs date, though these were much altered in the thirteenth century. Much-changed corner towers and a turret remain from the later century. The Louvre,

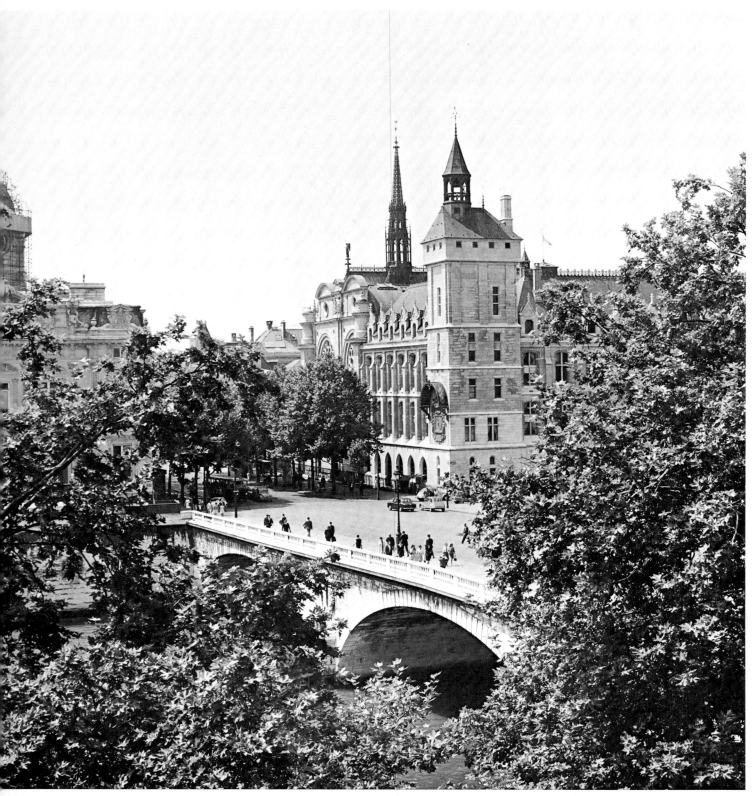

The Sainte-Chapelle, the Palais de Justice, and the Clock Tower.

built by Philip Augustus at the point where four of
his fiefs met, corresponded to the Grand-Châtelet of
Louis the Fat (Louis VI). It was altered under
Charles V, under Louis XII and again under
Louis XIV, and was finally demolished in 1810. Like
the tower of the Knights Templar (c. 1265), it
suffered the common fate of lay buildings, which
were much more susceptible to demolition as the
consequence of the growth of civilization and
changes in taste than were religious ones. The keep
of the Louvre and its outbuildings are represented
today by an outline on the flags of the square court,
by a cistern, and by a room roofed with six ogival
vaults, and some short, stout pillars. These were
uncovered from under the Salle des Cariatides in
1882-83. The capitals of the pillars were carved as
late as the reign of Louis VIII or Louis IX.

The Salle Saint-Louis, the Saint-Louis Kitchens,
and the Guard Room of the Conciergerie despite
their names do not belong to the time of Saint
Louis. They are contemporary with the Great Hall
of the Capetian palace, completed on the upper
floor in the days of Philip the Fair (1268-1314),
with two pillared naves arcaded in tierce-point and
a double wooden wagon roof, destroyed by the fire
of 1618. They combine to make one of the finest
specimens of French civil architecture of the four-
teenth century. Originally they made up the ground
floor of the north front of the Conciergerie. This was
the residence of the *Concierge*, the direct represent-
ative of the King in major judicial, military, and
financial affairs, later to be known as the *Bailli
du Palais*. In the Tour d'Argent, Tour de César, and
Tour Bonbec, the Conciergerie has retained the old
military exterior. As for the rectangular Clock
Tower (Tour de l'Horloge), it dates from the end of
the reign of Philip the Fair (about 1310-14), but was
rebuilt between 1843 and 1852.

The Paris of Charles V had even more reason
than the Paris of Philip the Fair to be proud of the
sumptuous houses of princes and rich citizens which
completed its monumental aspect. To those which
had been built nearly a century before around the
Louvre, the Rue Saint-Honoré, or Les Halles, such
as the Hôtel de Flandres (c. 1285) or the Hôtel
de Bourbon (c. 1303-13), were now added the
fruits of the enterprise of this son of John the Good.
According to Christine de Pisan (authoress of
*The Book of the Acts and Good Manners of King
Charles V*) he was himself a true "architector" and
did not hesitate to advise the men of this art: he
very willingly abandoned the Palais de la Cité for
his Hôtel Saint-Pol, built some time after 1350.
It was protected by the castle of Saint-Antoine
(c. 1369-82), later known as the Bastille. The Louvre
also had his favour. At the King's desire and for his
own use, Raymond du Temple transformed it into
a luxurious palace. Nothing remains of these

*The tower of Jean sans Peur, part of the Hôtel de Bourgogne,
in the Rue Etienne-Marcel.*

The Conciergerie: the Saint-Louis Kitchens.

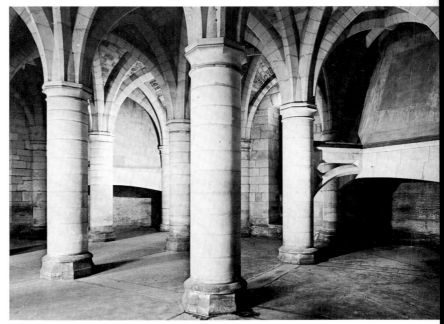

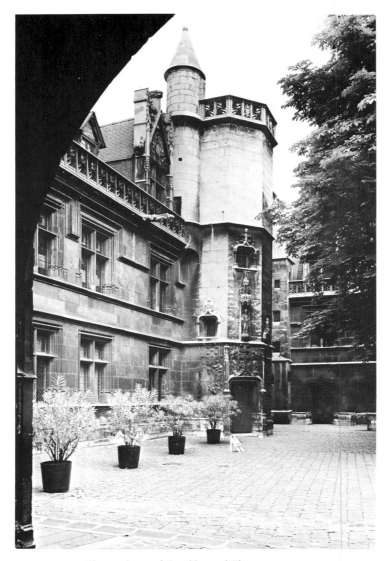

The residence of the abbots of Cluny.

already in being, the last transformation of Gothic, the flamboyant. The first signs of it can be perceived in the work of the last quarter of the fourteenth century, and its influence was prolonged into part of the sixteenth. Without forsaking the principles which the previous century had accepted, it simplified basic structure whilst complicating ornamentation to the point of excess. Changes were made in the general arrangement of churches. Capitals disappear and the new style is characterized by elaborate interpenetration of mouldings in their place. Additional ribs, lierne ribs, and tiercerons were added to ogival intersections. Pendants made their appearance. Basket arches and ogee arches were used in conjunction with tierce-point. Designs for the backing of windows became more complicated, and pinnacles and sharply pointed gables were used with abutments and porches.

Despite all the subsequent mutilations, transformations, and alterations, complete examples, or remains, of these changes can still be found in some Paris churches: the choir of Saint-Laurent, refashioned in the first quarter of the fifteenth century and dedicated in 1429; Saint-Nicolas-des-Champs, probably enlarged after 1420; the façade and the nave of Saint-Médard (about the middle of the fifteenth century). The nave and the aisles of Saint-Germain-l'Auxerrois had to be rebuilt between 1420 and 1425, whilst the transept and the chapels to the north of the nave are contemporary with the porch, which has three ogival

The Hôtel de Sens.

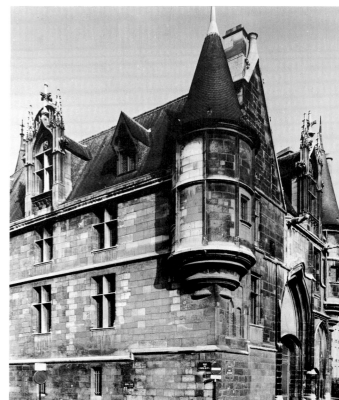

remarkable buildings but descriptions, household accounts, and some rare pictures. Materially all that is left is a spiral staircase in the Louvre, and a doorway with turrets ending in pepperpot roofs in the Hôtel de Clisson (*c.* 1371) in the Rue des Francs-Bourgeois, which in the eighteenth century was itself taken into the Hôtel de Soubise which now houses the National Archives. These are the sole heritage of Parisian architecture of the times of the monarch who has received the honourable title of Charles the Wise.

The first third of the fifteenth century was a time of misfortune and misery for Paris. The struggle between Armagnacs and Burgundians and its consequences, the horrors of the *Cabochien* excesses, were followed by the great plague of 1418 and the English occupation which lasted from 1420 to 1436. Though this long succession of disasters severely limited architectural activity, it did not completely stop its evolution or its widening scope. By the time more peaceful days had returned a new style was

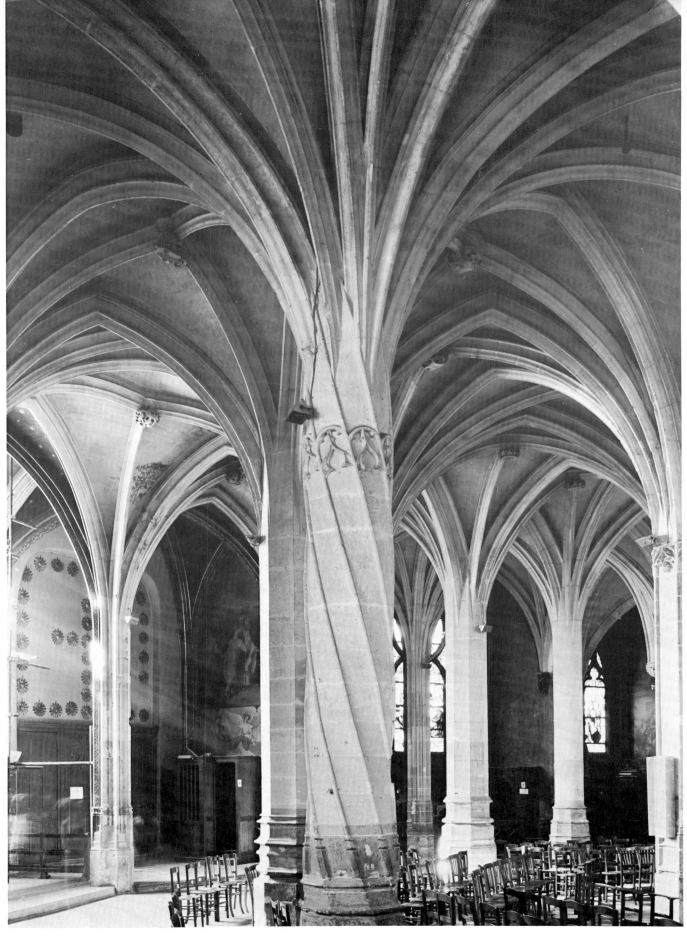

The deambulatory of the church of Saint-Séverin.

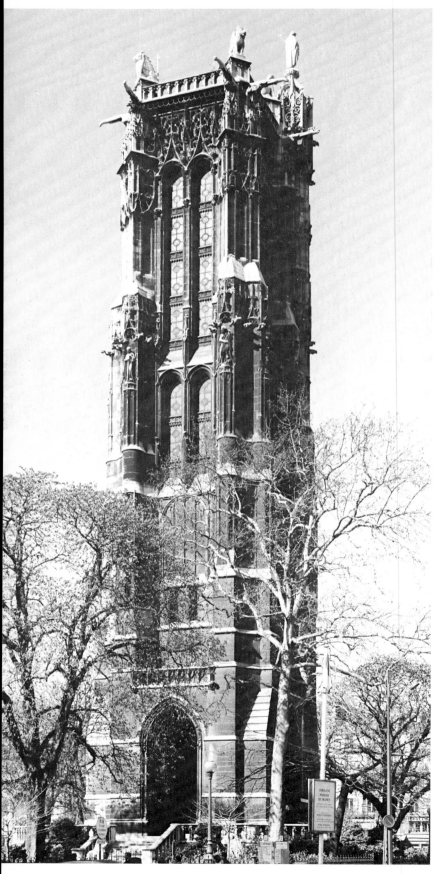

The Saint-Jacques tower, sole relic of the
church of Saint-Jacques-la-Boucherie.

vaults, built in about 1435-39, and is unique amongst
Paris churches. Saint-Germain-de-Charonne also
shows the changes, dating from when it was entirely
rebuilt in the middle of the fifteenth century, and so
does the tower of the treasure house of Saint-
Gervais-Saint-Protais, of the end of the fifteenth
century. The principal flamboyant Gothic church
in Paris is, however, Saint-Séverin, which is the
most interesting of them all.

The five last bays of the nave, the double aisle
on the north side, the second south side-aisle, and
the upper part of the east frontage were all rebuilt
about 1450. Particularly noteworthy is the double
deambulatory surrounding the apse (*c.* 1489-94),
the vaults which Joris-Karl Huysmans, nineteenth-
century realist writer turned Catholic mystic,
praised for their many ribs falling to the cluster of
colonnettes spiralling round the shaft of the central
column sited on the axis of the apse. The ossuary
stretches south of the choir. It dates from the end
of the fifteenth century, but was much restored in
the twentieth. It is irregular in plan and has an
ogival vaulted gallery, with pendants. This is the
only survivor of all those which once existed in
Paris. In the same way the Billettes cloister (post-
1427), with its tierce-point arcades, and the refec-
tory of the Cordeliers in which the Musée Dupuytren
has been housed since 1815 are all that is now left to
recall the monastic buildings of the fifteenth
century.

Flamboyant architecture was as much a lay as a
religious or monastic art. Changing neither in
feeling nor in decorative detail but adapted to civil
use, it is to be seen at its best in Paris in the private
hôtels, or town mansions. An *hôtel* was essentially
a group of buildings round a courtyard, being, as
Professor Pierre Lavedan has described it, " the
adaptation and the reduction for town use of the
feudal castle or country house ".

The thirteenth-century Hôtel de Bourgogne in the
Rue Etienne-Marcel came into the possession of
John the Fearless, Duke of Burgundy, son of
Philip II, the Bold, of Burgundy, and prime cause of
the wars between Burgundians and Armagnacs, at
the beginning of the fifteenth century. He added
considerably to it, but all that is left of these addi-
tions is a crenellated tower, or rather the remains of
it. In it is a spiral staircase whose centre post spreads
out in oak branches in a way that recalls the one at
Saint-Séverin. On the other hand, the Hôtel de Sens
(1475-1519), as rebuilt by Tristan de Salazar, still
flaunts its aristocratic façades on the corner of the
Rue de l'Hôtel de Ville and the Rue du Figuier,
with conical-roofed, corbelled turrets at either end,
and still shows its mullioned gable windows and its
big doorway in tierce-point. The Hôtel de la Tré-
moïlle (rebuilt from 1489 to 1499) in the Rue des
Bourdonnais was unhappily destroyed in 1841. Some

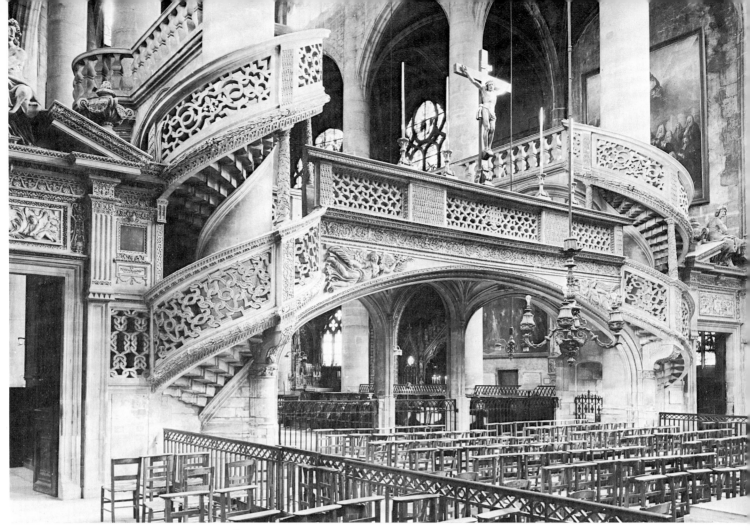

The rood-screen and rood-loft of Saint-Etienne-du-Mont.

remains of it are to be seen in the courtyard of the Ecole des Beaux-Arts.

The *hôtel* of the abbots of Cluny (*c.* 1485-98), thanks to big-scale restoration by Albert Lenoir in the nineteenth century, is still a complete specimen of fifteenth-century Parisian private architecture. The enclosing wall is crenellated, supports picturesque gargoyles, and is pierced by two doorways. Beyond it, the principal block dominates the inner courtyard. It has two return wings and towards the angle of the right wing incorporates a flattened-angle turret with bartizan covering a spiral staircase. On the ground and first floors are windows with stone bars, and above a flamboyant balustrade with gargoyles. The balustrade hides a sentry walk and shares the attention one has to give to the dormer windows, surrounded by stones cut to elegant shapes, and to the tall chimneys overlooking the sharply pointed roofs. The vaults of the various halls and rooms and, above all, the chapel tucked away in a little corbelled turret on the first floor complete the interesting features of this magnificent dwelling which underlines the mastery and the capabilities of French architects just before the Renaissance. The luxury of this house provides a contrast with Nicolas Flamel's older one (*c.* 1407)

in the Rue de Montmorency, decorated with inscriptions and little bas-reliefs, and with a house in the Rue Volta with stone foundations and wooden walls above. It has *échoppes*, covered stalls, the very last traces of a medieval Paris which the events soon to come would slowly sweep away.

In the sixteenth century flamboyant Gothic had not yet spoken its last word. For a long time to come Parisian religious architecture was to remain attached to its ideas and essential principles. This attachment can be interpreted as a form of resistance to æsthetic ideas being brought in from Italy and to the new ideals of the Renaissance, but it could also have been due to purely material reasons or to reasons arising from the form of the acts of worship.

The persistence of the traditions of the previous century was not confined to the completion of or alterations to old churches, such as the side-aisles of Saint-Leu-Saint-Gilles and the side-chapels of Saint-Séverin and Saint-Laurent. It shows undeniably in the structure of Saint-Jacques-la-Boucherie, whose markedly flamboyant tower built between 1509 and 1523 still stands. It shows again in the structure of the church of Saint-Gervais-Saint-Protais, completed in the seventeenth century, and again, despite certain indications to the contrary,

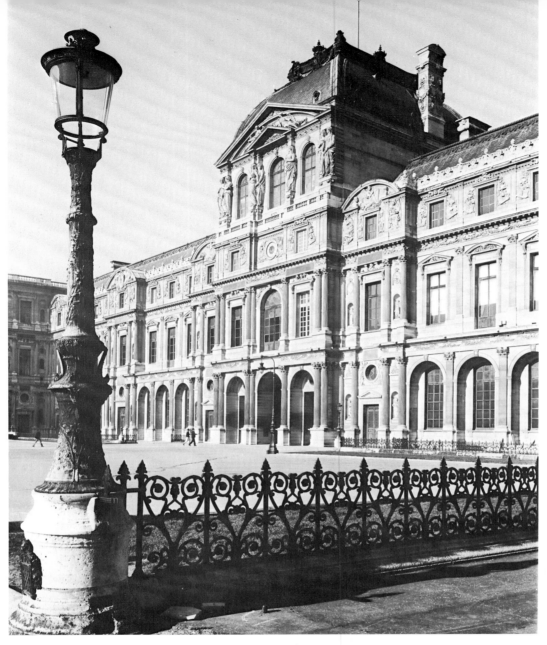

*Clock Pavilion and façade by Pierre Lescot of the
Square Courtyard of the Louvre.*

in Saint-Etienne-du-Mont and Saint-Eustache.

The other tendencies shown by these two last churches are limited to certain constructional features and to decoration. At Saint-Etienne-du-Mont the semicircular arch of the nave is neighbour to the pointed arch of the choir. The original feature in this church is its rood-screen and loft, once attributed to the reign of Henry IV but now recognized as being earlier, part at least belonging to the reign of Francis I. Ornamenting the scuncheons on the side of the transept are two figures of Fame bearing palms. At Saint-Eustache, the building of which began in 1532 and lasted for a century, the orders have been given greater importance and are superimposed. The ossature however remains Gothic and the ground plan derives from that of Notre-Dame.

The taste for the Renaissance was introduced into Saint-Germain-l'Auxerrois through decoration. The rood-screen of Pierre Lescot and Jean Goujon (1539-44) exists no more, but on the north side a lateral door with fluted pilasters and triangular pediment is still to be seen. It is contemporary with the adjacent chapels (1569-71). There is a delicate doorway inspired by a drawing published in 1567 in Philibert Delorme's *Traité d'Architecture* on the south side of Saint-Nicolas-des-Champs, built between 1576 and 1586. The influence of the King, whose taste in architecture was made manifest in the châteaux built for his use in the Ile-de-France, necessarily hastened the break with the past.

This was confirmed by the rebuilding of the Louvre, which was begun in 1546 but in the main carried out during the reign of Henry II. This is perhaps the very essence of the second Renaissance, the French Renaissance.

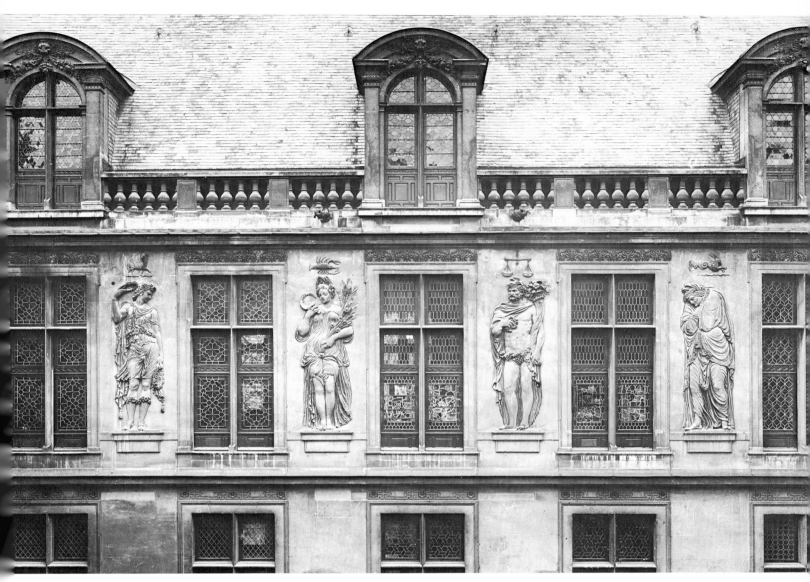

The Hôtel Carnavalet: façade decorated by Jean Goujon.

To replace what was left of the old fortress of Philip Augustus and Charles V, Pierre Lescot built the western wing of the Louvre (which houses the Salle des Cariatides), then went on to the corner pavilion on the river side, and ended with the first building of the return wing on the Seine. This last was continued by Charles IX.

The Lescot façade on the courtyard reaches perfection by the precision of its proportions and the harmonious association of architecture with sculpture. It is also outstanding for its symmetry, underlined by three projections with curved pediments. Fluted pilasters go with the semicircular bays of the ground floor. Other pilasters on the first floor separate windows with alternately curved and triangular pediments. The problem set by the crowning of the superimposed orders is ingeniously solved by the use of the Attic. The roof is resolutely French, but its coping is edged with acroteria and ornamented along the ridge.

Pierre Lescot had not been disinclined to listen to the advice of Italians, though this was soon being neglected. Philibert Delorme, Jean Bullant, and others took much deep thought whose results formed the basis for a long-lived tradition.

Antiquity became the only source of inspiration to be admitted. The accuracy of proportions and the exactitude of orders entailed the adoption of certain principles and the forging of certain rules. The Tuileries, on which Delorme began work in 1564 and in which he attempted to introduce a French order which was said to have haunted the theoreticians of the reign of Louis XIV, disappeared in the conflagration of 1871.

Attention must be drawn to certain specific buildings through which one can follow the evolution of thought which motivated the master-masons and architects working in Paris during the second half of the sixteenth century, and to understand the experiments and the gropings which finally opened the way to classicism. First is the Hôtel de Lignéris of 1544 (now the Carnavalet). In this Pierre Lescot

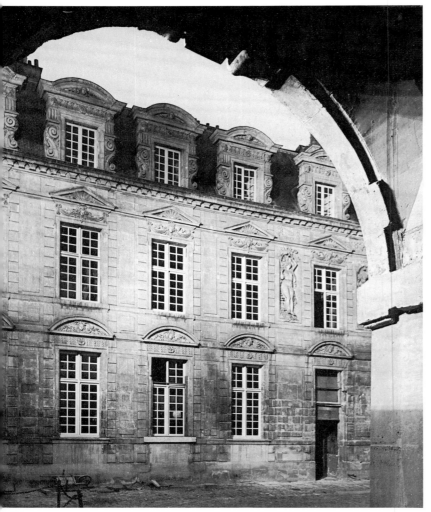

The Hôtel de Sully (1624-30).

was followed by Jean Bullant. The latter built the Hôtel de Catherine de Médicis, near what is now the Bourse de Commerce, between 1574 and 1581. The only piece of it remaining is a single fluted Doric column. Some remains dating from the times of the last Valois kings still exist: from the reign of Charles IX, six arcades rebuilt in the garden of the Ecole des Beaux-Arts which came from the Hôtel Torpanne in the Rue des Bernardins; and the Hôtel de Diane de France (by Lamoignon, 1581) in the Rue Pavée (Henry III). This was the first experiment in Paris with the Colossal order — that is, one whose columns rise through several storeys. The same disposition is to be seen at the Great Gallery of the Louvre, almost completed in 1607 at about the time when the old brick and stone courses used in the abbatial palace of Saint-Germain-des-Prés (1586) began to be associated with the new development of architecture in Paris.

Another chapter in the story of civilization was being written at the turn of the seventeenth century. It was not long in developing and was greatly influenced by the evolution of social life. The scorn of past ages and their legacies became more and more general. New architectural concepts saw the light of day, turning previously accepted ideas upside down. Reason was about to take charge and to impose submission to prearranged plans which were soon to change the look of Paris. These plans called for uniformity, the controlled arrangement of open spaces, perspective views, and the creation of vast architectural groups. Their new-style monuments not only adorned new districts but often created them, for the city was growing fast. After the internal strife, comparative peace marked the reigns of Henry IV and Louis XIII. Paris was the seat of royal power and thus became the true centre of the monarchy, a capital which brought together all the principal institutions and grouped the élite of the kingdom round its king.

The effects of the Counter-Reformation and the renewal of the old faith caused churches to spring up everywhere. Between 1600 and 1660 the following churches were begun: Notre-Dame-des-Victoires (1629-1740), Saint-Roch (1653-1736), Saint-Sulpice (1655-1777), Saint-Nicolas-du-Chardonnet (1656-1763); during the same period the chapels of the Saint-Louis hospital (1607-10), of the Oratorians (The Oratory, 1621-30), of the convent of the nuns of Saint-François (Sainte-Elisabeth, 1628-30), Port-Royal (1646-48), and of the Noviciate of the Oratorians (Hôpital des Enfants-Assistés, 1655-57) were also begun. Nor must the continuation of the work on Saint-Eustache be overlooked, the alterations or additions to Saint-Merri, Saint-Leu-Saint-Gilles, and Saint-Germain-des-Prés. Despite all the interest each individual building of this era presents, it is not possible to describe them all, though an exception must be made for the façade of Saint-Etienne-du-Mont, remade in 1610 in the Renaissance style, when the usual model for new frontages was the Italian baroque exemplified by the Gesù church in Rome.

The basilical plan with a single nave was first transplanted to Saint-Joseph-des-Carmes (1613-20) and copied at the Oratory (1621) and Notre-Dame-des-Victoires (1629). Also imitated were the dome and façade on two levels linked by inverted consoles and accompanied by superimposed orders. At Saint-Gervais Salomon de Brosse (or possibly Clément Metezeau) invented a variation by putting up three storeys (1611-21) in a sort of conventional patchwork which aroused much discussion. The same disposition is to be found at the Maison Professe des Jésuites, designed by Derand, which became Saint-Paul-Saint-Louis (1627-41). But the main novelty, and the one which most vividly struck the imagination of the people because it so changed the urban skyline, was the dome with wide drum raised on pendentives above the transept crossing. It had an unhappy beginning at the Augustins Déchaussés (1608, now the chapel of the Ecole des Beaux-Arts) and at Saint-Joseph-des-Carmes

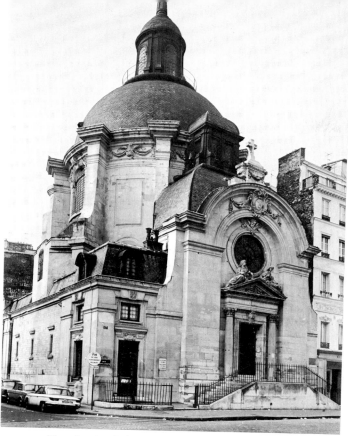

The church of the Visitation, now the Protestant church of Sainte-Marie (1632).

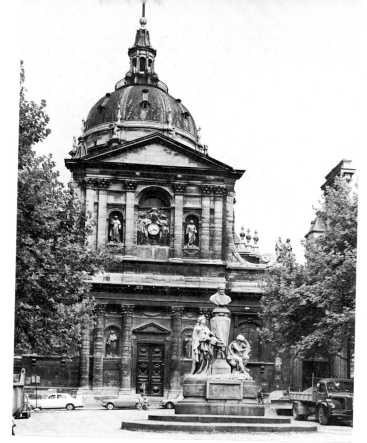

The chapel of the Sorbonne (1635-53).

The Val-de-Grâce chapel (1645-70).

Chapel of the College of the Four Nations, today the Institut (1662-68).

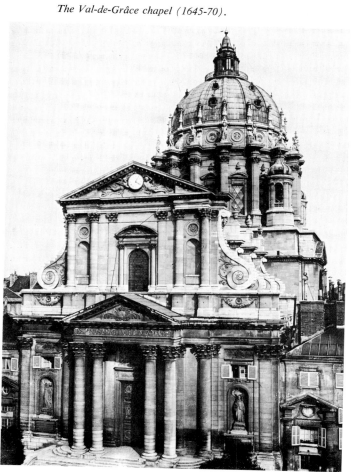

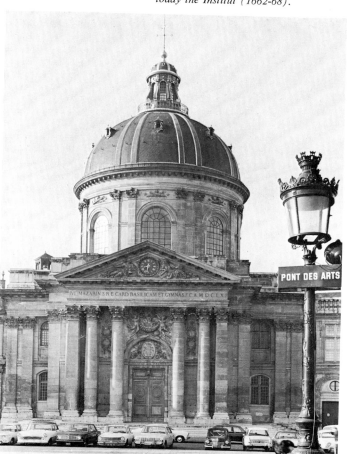

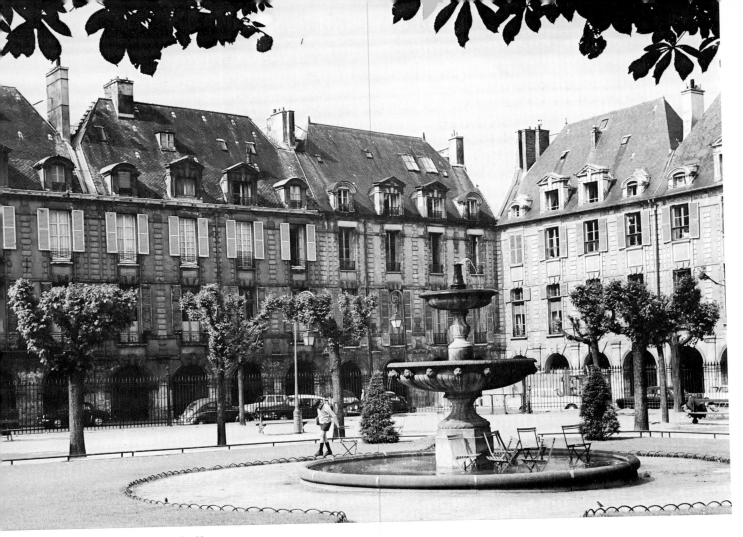

The Place des Vosges.

(1613), but more regularly built at the Maison Professe des Jésuites, and properly integrated in the case of La Visitation by F. Mansart (1632), now the Protestant Church of Sainte-Marie. It reached its full importance and development with the church of the Sorbonne by Lemercier (1635-53) and above all at the Val-de-Grâce, by F. Mansart and Le Muet (1645-70).

A dome dominates the chapel of the College of the Four Nations by Le Vau (1662-68), now the Institut, and the same is true of Errard's church of the Assumption (1670), Saint-Louis-des-Invalides by Jules Hardouin-Mansart (1679-1706), and the later Sainte-Geneviève (now the Panthéon) by Soufflot (1758-89).

On the other side, civil architecture was not inactive. At the Tuileries and at the Louvre the activity which internal struggles had interrupted was renewed. The Pavillon de Flore was completed, and the riverside gallery both begun and completed (1608). Returning to an abandoned project, Lemercier prolonged the Lescot wing by duplicating the original on the far side of a central pavilion (Pavillon de l'Horloge), crowned by a quadrangular-

based dome (1624-27) supported by eight caryatids.

The great gift which civil architecture in the first half of the seventeenth century brought to Paris is, however, to be found elsewhere. It is to be found in the thirty-eight houses of brick and stone, with pillared arcades, geometrical façades, and steep roofs, of the Place Royale (1605), now the Place des Vosges, in those of the Place Dauphine (1607) for which they were the inspiration, and in the palaces for the great and the town mansions for the rich which consolidated the neo-classical doctrine.

A long series of imposing private residences began with the Luxembourg, which Salomon de Brosse, designer of the Great Hall of the Palais de Justice (1622), built for Marie de Médicis between 1615 and 1625. The use of bossage underlines its resemblance to the Pitti Palace, which was what the Queen desired, but the basic idea of a courtyard with buildings on three sides and the fourth closed by a monumental gateway remains obstinately French. It is difficult to be precise about the Palais-Cardinal (later to be the Palais-Royal) which Lemercier built between 1624 and 1636, for all that survives untouched is the Galerie des Proues

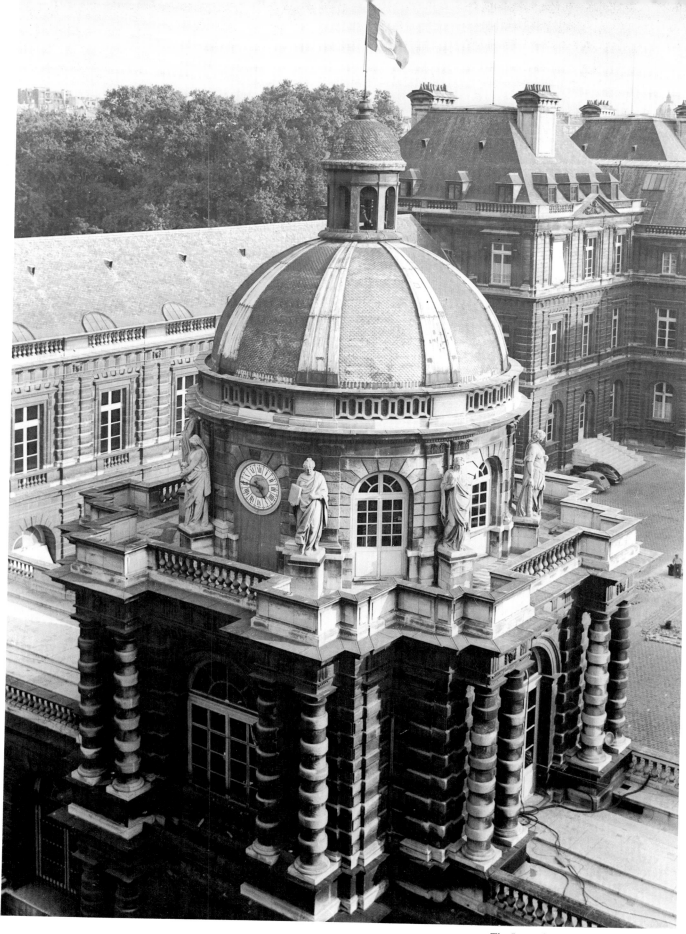

The Luxembourg Palace.

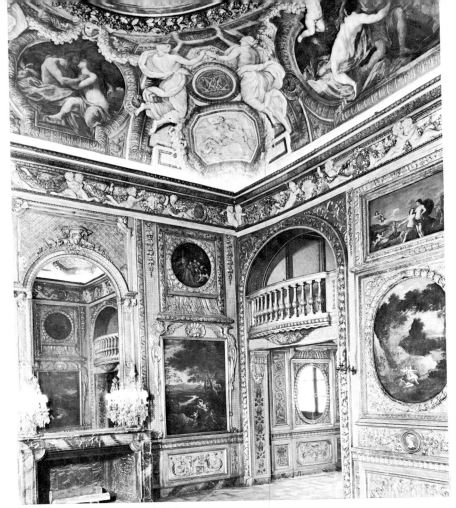

The music salon of the Hôtel de Lauzun.

(with ornamental sculptures of ships' prows), though other rooms do exist in a more or less mutilated condition. They show that the intention was to create a sober exterior based on perfect proportions and a rational use of the orders. Here and there on courtyard and garden façades the touch is less solemn, perhaps precisely because the individual buildings were more or less isolated from each other by these courts and these gardens. The interior decoration was sumptuous and included marble overlays, the use of stucco, and much woodwork, carved, and painted and gilded.

Architects brought many variations (which it would be by no means impossible to classify) to the planning of these mansions, from the Hôtel de Chevry of 1635 to the Hôtel de Beauvais of 1655. The former first became the Hôtel de Tubeuf and, as the latter, was then incorporated in the Palais Mazarin, which in its turn has become the Bibliothèque Nationale. It was not built by Le Muet but by an almost unknown master-mason, one Jean Thiriot. The Hôtel de Beauvais was designed by Antoine Le Pautre, who used the irregularity of the ground to produce an ingenious effect. The hôtels built in the Marais, or in the Faubourg Saint-Antoine, or on plots of land on the Ile Saint-Louis, or on the site of the old Fossés-Jaunes circumvallation, or behind the gardens of the Palais-

Cardinal, adopted the classic orders, or some freer style, and could equally easily be plain or overladen with decorations, all according to the personalities of such notorious or notable Masters as Jean du Cerceau the First, Pierre Le Muet, François Mansart, and Louis Le Vau. This last built the Hôtel Lambert (1640) and the Hôtel Lauzun (1642-46) whose elevations, and perhaps even more whose beautiful apartments, place them in the first rank of the outstanding examples of Parisian architecture of the middle of the seventeenth century.

Ten years after Louis XIV took personal charge of his kingdom, the founding of the Royal Academy of Architecture in 1671 set the seal of approval on ' fine architecture ', which had become both an end and a beginning. It represented the triumph of a quest for an almost convulsive grandeur, which meant blind submission to a common mathematical discipline, and the authority of dogmatic, abstract theories derived from antiquity, all pressed into the service of royal prestige.

Paris as much as Versailles was expected to be a mirror to the solemn majesty of the reign of Louis XIV and to participate in the cult of his person. These considerations provided the city with some of its finest monumental buildings.

The work on the Louvre of Louis Le Vau and Claude Perrault seems, at a quick glance, to be

The Palais de l'Institut and the Pont des Arts.

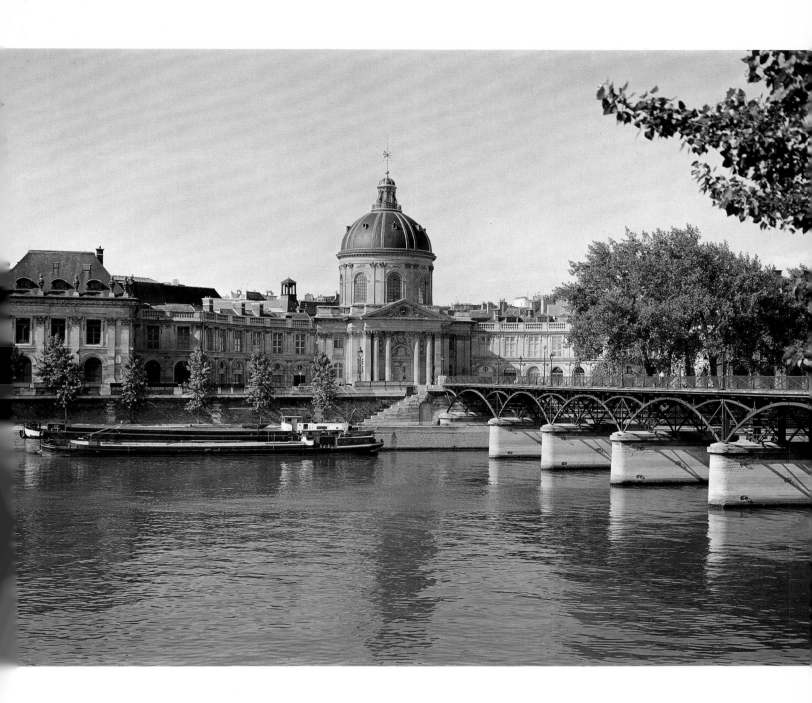

The Hôtel Lambert.

and the octagonal Place Louis-le-Grand (now the Place Vendôme) of 1699. Though to some extent now disfigured, these *Places* do in their own way still proclaim the glory of the sovereign, as does François Blondel's Porte Saint-Denis (1672) and Pierre Bullet's Porte Saint-Martin (1674). Other gates, such as the Arc de Triomphe of the Faubourg Saint-Antoine (1670) by Claude Perrault, remained unfinished. The ostentation of the times, the rational and learned æstheticism, were just as vigorously supported by means of more utilitarian buildings: the Salpêtrière general hospital (1660) by Le Vau, Duval, and Le Muet, the College of the Four Nations (now the Institut) by Le Vau and d'Orbay (1668), the Observatory by Claude Perrault (1668-72), and the buildings of Les Invalides from designs by Libéral Bruant (1670).

During the second half of the seventeenth century adoration of the terrestrial king did not involve forgetfulness of the celestial one. Witness to this is borne by the building of Saint-Louis-en-l'Ile (1664-1726), the chapel of the Salpêtrière (1670-77), the church of the Assumption (1670-76), the Noviciate of the Jesuits, now Saint-Thomas-d'Aquin (1682, completed in the eighteenth century), and Notre-Dame-des-Blancs-Manteaux (1685).

The Hôtel de Beauvais.

overwhelmed by the Colonnade (1667-73), although theirs is more subtle. Their project was born after Bernini's plans had been thrown out and was not the work of Claude Perrault alone as was long believed, nor of François d'Orbay, as was thought, but of Le Vau, Le Brun, and Perrault together, a triple collaboration desired by Colbert. For some little time past it has been thought proper to precede it by trenches and balustrades in order to give it the appearance it may once have had. In any case, it makes a set scene, more Italian perhaps than native, grandiose, well-balanced with its high windows in the lower walls, its projecting centre with pediment, its pairs of columns making a peristyle, and a flat roof edged with balustrades covering the whole. In fact we have there the façade which suits the temple of a god, unseen but present none the less — a temple whose altars are the statues situated in the vast open spaces which were expressly designed to set them off.

This is a characteristic creation of the seventeenth century. It was renewed in the eighteenth in the Place Louis XV. The outline of the programme was set in 1605 by the Place Royale (now Place des Vosges) and to a lesser extent by the Place Dauphine (*c.* 1607). Under the guidance of Jules Hardouin-Mansart ostentatious houses with the antique orders emerged in the rounded Place des Victoires (1685)

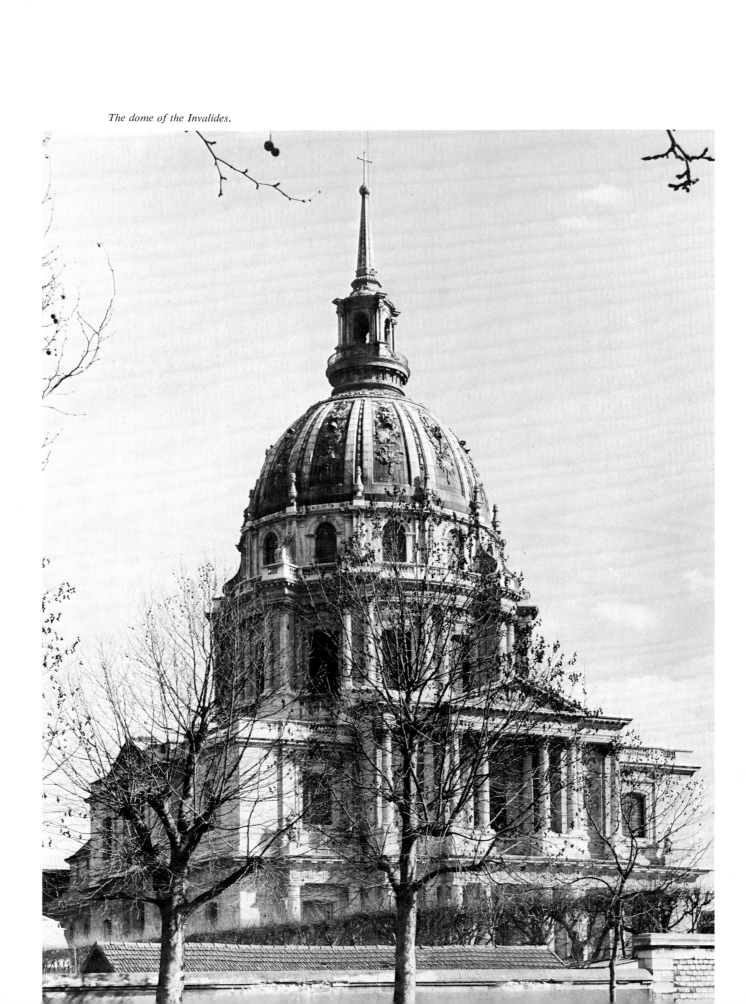

The dome of the Invalides.

The Hôtel Guénégaud.

The principal religious building of the reign of Louis XIV was the church of the Dôme des Invalides (1679-1735), duplicating the Soldiers' Church by Libéral Bruant. Comprising two superimposed orders, Doric and Corinthian, its façade ends in a Roman-style terrace, once occupied by statues, which serves as a pedestal to the polygonal dome. It is remarkable for the soaring impression it gives. It is pierced by twelve windows between columns, has an Attic storey, and finally a cupola supporting a lantern bearing a pyramidal capping which serves as a base for the cross. The interior is in the form of a Greek cross, with a number of chapels, in which orders, sculptures, paintings, marbles, and gilding are all brought together without a single discordant note being struck.

Meanwhile the building of private mansions went on in much the same quarters as before, but at a rate slowed down by the installation of the Court at Versailles. The Faubourg Saint-Germain and, later, the Faubourg Saint-Honoré took their place in the eighteenth century, when another building fever raged.

Styles in interior decoration were on the move during the last twenty years of the reign of Louis XIV, and perhaps even a little earlier. Whilst innovators and traditionalists fought their battles, the pompous began little by little to retreat before a lighter touch, introducing mirrors and adopting finely carved woodwork, and light paintwork relieved by gilding or delicate colouring. Ornamental motifs were made more graceful. The curve replaced the straight line. A whole new decorative repertory came into being. At the same time the size of apartments was reduced, show and constraint were forsaken to give place to convenience and comfort. At the same time, façades turned towards a greater discretion, often abandoning the orders and being satisfied with excellence of proportions, with ornamental masks and keystones, through which traditional forms were given a forgotten air of youth.

This move led to the style of the French Regency (1715-23), though it was far from conforming to the actual dates of the Regency but could be held to begin with the building of the Hôtel de Soubise (1706-14), by Delamaire, and to have come to an end not long after 1715, date of the death of Louis XIV.

From 1710 to 1730 and even later the number of *hôtels* went on increasing. Princes, members of the great families, and financiers called for the services of the collaborators and successors of Jules Hardouin-Mansart. His brother-in-law, Robert de Cotte, was the architect of the Hôtel du Lude (1710), the Hôtel d'Estrées (1713), and the Hôtel du Maine (1716). Boffrand, the expert decorator,

The Hôtel de Soubise.

The Hôtel Biron, now the Musée Rodin.
To the right, Rodin's statue, " The Thinker ".

worked on the apartments of the Duchesse du Maine in the Arsenal (1725-28) and in the Hôtel de Soubise (*c*. 1735) and got an *hôtel* built for himself in 1713 (now the German Embassy), as well as building or rebuilding a number of others. Praise for the Hôtel d'Evreux (1718) must go to Claude Mollet. It is now much altered and known as the Palais de l'Elysée. Jean Courtonne designed the Hôtel Matignon (1721) and the Hôtel de Noirmoutiers or de Sens (*c*. 1724). Cailleteau, called l'Assurance, designed the Hôtel de Roquelaure (1722), now the Ministry of Public Works. The Palais-Bourbon was begun by Giardini in 1722 and continued by Aubert, and particularly by Jacques Gabriel (1728), who also made the plans for the Hôtel Peyrenc de Moras, or Hôtel Biron (1728-31), which was taken up again by Aubert in 1738. " So many buildings, too numerous to name, which helped to make up groups worthy of note, relics of the Louis XV style, were covered over with twisted rococo shapes, with exuberant additions put there out of pure pretentiousness, responses to the call for exoticism, forerunners announcing the Louis XVI style, all in order to conform to feminine influence and to make these residences into ' enchanting and delicious places in which to live '. " (Patte, quoted by R. Schneider.) The enchantment

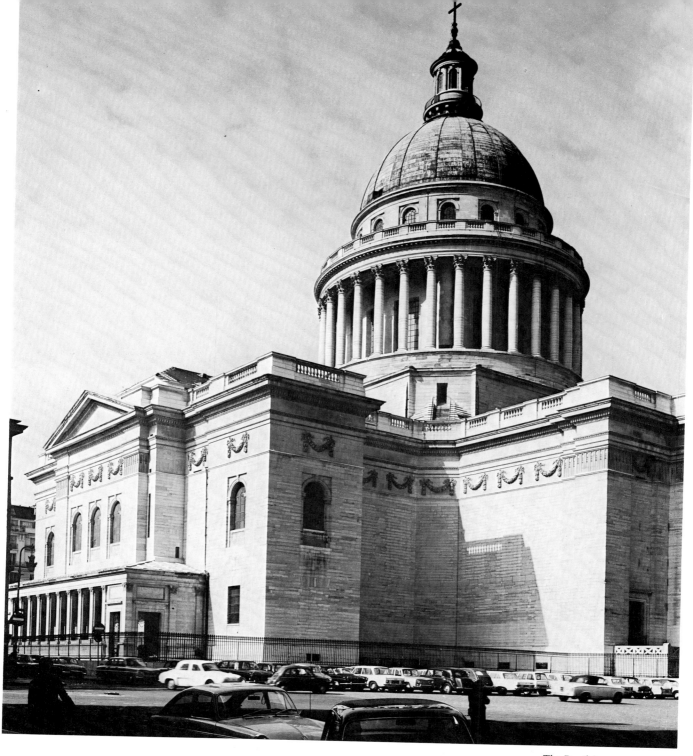

The Panthéon.

of lay buildings no doubt led to some neglect of pious foundations. Religious architecture for the greater part of the eighteenth century was comparatively less preponderant in Paris than in the provinces. When it was not following in the wake of lay architecture in its rebuilding of claustral structures for many religious communities, it often exercised ingenuity in upsetting and modernizing the venerable remains, as happened with the choir of Notre-Dame from 1699 onwards, which was

transformed to conform with the Vow of Louis XIII. Intentions less worthy of respect, arising from a hatred of Gothic art, led to the same unhappy mistakes fifty years later at Saint-Merri (1750-52), Saint-Germain-l'Auxerrois (1756), and Saint-Nicolas-des-Champs (1775). On the other hand, respect for the baroque derived from the Gesù church did not diminish. This style was scrupulously retained by Oppenordt for the south lateral frontage of Saint-Sulpice (1719), by Robert and Jules-

The Hôtel de la Monnaie.

period was on a fairly large scale, but went all the other way during the second period. Whatever may have been the sources of inspiration, the way of building which often brought together an archaic structure and realism of decoration displayed a sober elegance not without grace.

It fell to Jacques-Ange Gabriel to keep the balance between memories of the classical spirit and the needs of present times. For the Ecole Militaire (1751-75) he chose a peristyle of eight Corinthian columns for the central pavilion. It was separated by a triangular pediment from the quadrangular base of the dome which crowned it. For the two symmetrical buildings of 1754 on the Place Louis XV (now Place de la Concorde) he followed the Perrault colonnade at the Louvre, but isolated the columns.

For the church of Sainte-Geneviève (1764 to the Revolution; now the Panthéon), on the other hand, Soufflot attempted to " unite the lightness of Gothic construction with the magnificence of Greek architecture ". He achieved an ensemble of prodigious breadth of style, joining together reminders of antiquity with those of the Italian Renaissance. It is distinguished on the exterior by a peristyle with six Corinthian columns supporting a triangular pediment and a dome encircled by thirty-two columns.

During the last thirty years of the century, as R. Schneider has pointed out, a hesitant archæological impulse replaced Gabriel's and Soufflot's eclecticism. Once the discipline of neo-classicism had been accepted, first with prudence and then relinquished to all its logical consequences, it brought to most of the contemporary public buildings of Paris, according to their individual styles, its peristyles, columns, orders (amongst which the Greek Doric was favoured), and its ' sublime ' bareness. Some have now disappeared, but there was an imposing number of them. They included the Monnaie by Antoine (1768-75), and the Palais de Justice, rebuilt by Antoine, Desmaisons, Moreau, and Couture after the fire of 1776; scientific establishments such as the Ecole de Chirurgie (1769-86) by Gondouin, the Collège de France (1778) by Chalgrin; hospitals, with the gateway of La Charité (c. 1776) by Antoine, the Cochin Hospital (1780), and the Beaujon Hospital (1784); in the way of theatres, the Théâtre Français (1779-82), now the Odéon, designed by Peyre the Elder and Wailly; and finally the buildings of the town wall (1785-97) of the Farmers-General of Taxes, by Ledoux, imaginative in the extreme, but of which only the pavilions of the Place de la Nation and the Place Denfert and the rotundas of La Villette and the Parc Monceau remain. However, Louis, who designed the buildings which it was intended should enclose the gardens of the Palais-Royal

Robert de Cotte for Saint-Roch (1756), by Pierre Caquet for Notre-Dame-des-Victoires (1739) and the Oratoire (1745), and by Brother Claude for the Billettes (1758) and Saint-Thomas-d'Aquin (c. 1765-69). Greater liberties were taken with the elliptical porch supported by Ionic columns of the chapel of the Irish College (1738) and the semi-circular pediment of the chapel of the Convent of Pentemont, by Pierre Contant d'Ivry (c. 1747). But Thomas Germain, the goldsmith, went altogether too far with his fantastic ideas for Saint-Thomas-du-Louvre (finally destroyed at the beginning of the nineteenth century) with a multiplicity of curves and counter-curves. They were in absolute contrast to the façade with peristyle and marble-faced columns which the Italian decorator Servandoni designed for Saint-Sulpice (1733-45). This immense décor, radiating an atmosphere of serenity, was not long to remain an isolated example.

From 1750 onwards French art began to feel the effects of an inevitable reaction, strengthened by the excavation of the ruins of Herculaneum and Pompeii. The arts of antiquity which had been neglected for quite a number of years were once again remembered. The Louis XVI style characteristic of this perpetual looking backwards was in full growth well before 1774. Later it became more Greek than Roman and at times barely avoided the archæological pastiche. Decoration during the first

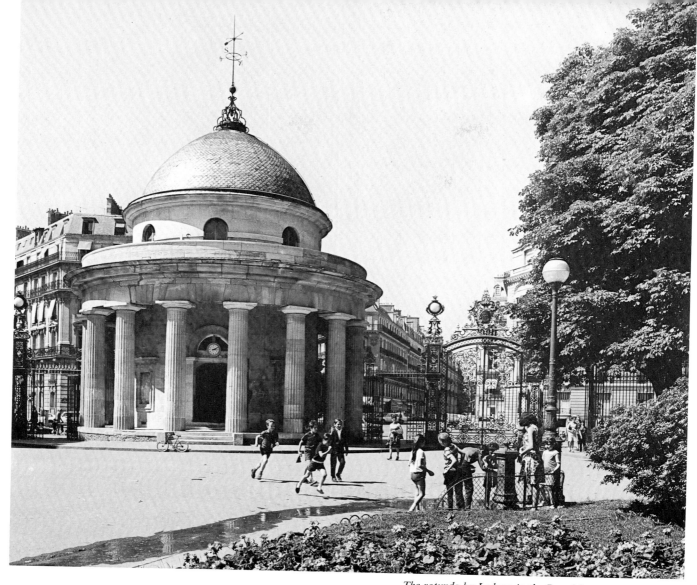

The rotunda by Ledoux in the Parc Monceau, part of the town wall of the Farmers-General.

(1781-84) on three sides and englobe the Théâtre de Beaujolais (1784, now the Théâtre du Palais-Royal) and the Comédie Française (1785), was later than others in adopting composite fluted pilasters in the Corinthian style.

As in the immediately preceding periods, the second half of the eighteenth century saw the building of many new dwellings: the Hôtel de la Vrillière (1767) by Chalgrin, the Hôtel de Fleury (1768), now the Ecole des Ponts et Chaussées, by Antoine, the Hôtel du Châtelet (1770), now the Ministère du Travail, by Cherpitel, the Hôtel de Galliffet (1775) by Legrand, now the Italian Embassy, the Hôtel de Montholon (1775) by Soufflot, the Hôtel de Salm (1781) by Rousseau, now the Chancellery of the Legion of Honour, the Hôtel de Monaco (1784), the Hôtel de Bourbon-Condé (1787), the Hôtel de Masserano (1787-88) by Brongniart, and the Hôtel d'Hallwyl (1787) by Ledoux. Either they are the result of a search for the heights of good taste and derive their effect from the play of masses whilst observing the rules of orders, or else they illustrate no more than a desire to create examples of refinement through simplicity. In the newest quarters, the Roule and the Chaussée-d'Antin, and in the more refined of the faubourgs, architects under the leadership of Cherpitel, Ledoux, Bélanger, and Brongniart drew their inspiration from the antique world and from Palladio in order to satisfy the taste of the day. For financiers, for the bored and wealthy, for the young ladies of the Opéra, they built miniature temples, rotundas, follies, and lovenests, which were not always free from eccentricities but invariably outstanding for the attractiveness and perfection of their interior decoration. For the most part, both kinds have now disappeared.

Religious architecture followed the same trend and abandoned the formal Jesuit style. Though taking some liberties with the style, it adopted the Christian basilica as a model, following the pattern Chalgrin imposed on Saint-Philippe-du-Roule. He slightly preceded Brongniart, who designed a

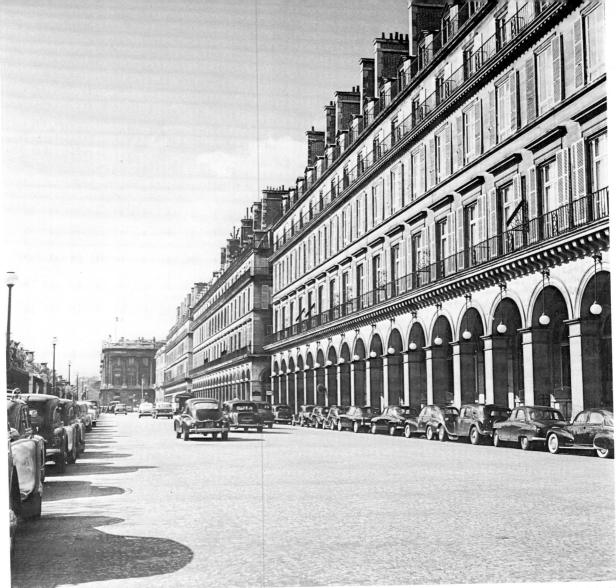

The Rue de Rivoli.

Nineteenth-century decorations on a door, Rue de Provence.

Doric Atrium by way of cloisters for the Capuchins of the Chaussée-d'Antin (1781), now the courtyard of the Lycée Condorcet. By reducing the chapel to a nave, a side-aisle, and a choir with a straight bay and a semi-dome, he managed to squeeze it into one of the two corner pavilions with triangular pediments. These made a matching pair at the two ends of the convent's cold, stiff front elevation. With it, two important centuries for Parisian architecture came to an unexpected ending.

Napoleon wanted to make Paris " not only the most beautiful town in existence, but the most beautiful town which could ever exist ". The results his ambition desired, involving projects huge in scale, would be well worth a few sacrifices. Thus began what Professor Pierre Lavedan calls " destructive urbanism " — that is to say, " the systematic demolition of part of a town already built, entailing the disappearance of often considerable works of art ". Whilst mansions, convents, and churches

The Place de la Concorde.

88

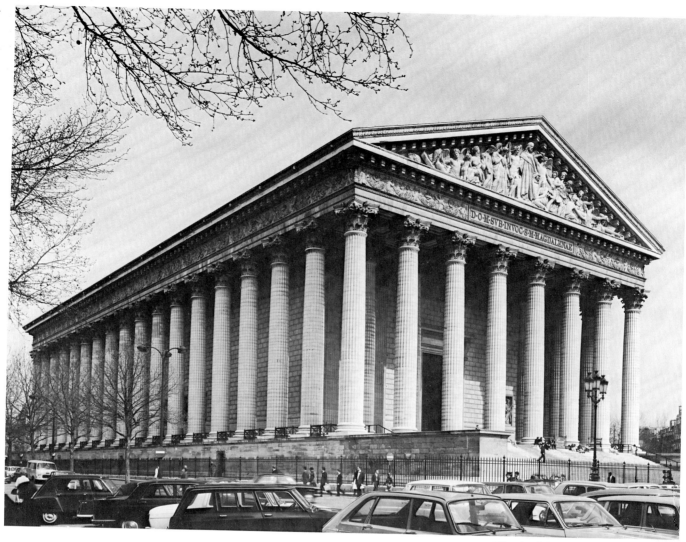

Church of the Madeleine.

deconsecrated by the Revolution were given over for use as offices or by public services, or (in the case of churches) handed over to the Reformed Faith — such was the case of the Visitation Sainte-Marie, the Oratory, which had replaced Saint-Louis-du-Louvre when the latter was demolished to give more room round the palace, Les Billettes, and the Pentemont Church (though only in 1845) — buildings of other religious communities and their surroundings were razed to the ground. This ground was used for helping to open up new streets. One of these was the Rue de la Paix, another the Rue Castiglione, and a third the Rue de Rivoli, though this last was not completed until after 1850.

The cold style of the arcades of the Rue de Rivoli make one think of the rows of porticoes in Graeco-Roman towns. Nothing could be more exact than this doubtless premeditated backward-looking effect. The will of the Emperor to make the splendours of the antique world play their part in the glories of his reign and the beauty of his capital — the capital of a new Roman Empire — found a powerful ally in the architectural æsthetics of the time.

The suppression of the Royal Academy of Architecture by the Republican Government left the field free for those who wished to purify the doctrine still farther by submitting without reserve to the dictates of antiquity. This was a certain way to encourage the practice of the pastiche, and this, inevitably, was what happened. Then the expedition to Egypt led for a while to a search for a style supposedly contemporary with the Pharaohs. Memories of this expedition led to the pseudo-Egyptian décor of a house (*c.* 1799) on the Place du Caire which included one of those *passages* for which later the Restoration was to have such a predilection, accounted for the peristyle of the Hôtel de Boffrand in the Rue de Lille — renovated by Eugène de Beauharnais in 1803 and now the German Embassy — and explained the arcades of the Rue des Colonnes and the Fontaine du Palmier (palm-tree) of 1808 in the Place du Châtelet. None the less, the monuments of ancient

Greece and Rome continued to be the most widely followed models and, of them all, the temple was the most widely appreciated. It was adapted to all kinds of uses. It became the Temple of Glory, later to be the church of the Madeleine, by Vignon and Huvé (completed in 1842), and it became the Bourse (1808-26) by Brongniart. It inspired the façade of the Palais-Bourbon (1804-8) by Poyet, home of the legislative assembly. The triumphal arch came second only to the temple. The Arc de Triomphe du Carrousel (1806-08) by Denon, under the direction of Fontaine and Percier, is an imitation of the arch of Septimus Severus. With it go French soldiers under arms — grenadiers, light infantrymen, and others — and items of military equipment figure in the decoration. The Arc de Triomphe de l'Etoile was not freed from its scaffolding until 1836, during the reign of Louis-Philippe, although it was begun by Raymond and Chalgrin in 1806. The Colonne Vendôme (1810), by Denon, under Gondouin and Lepère, completed the commemoration of the exploits of the *Grande Armée*, and is a pastiche of the Trajan column. It is again a column which is the essential part of the Fontaine du Palmier designed by Bralle.

The sudden fall of the Empire did not interrupt the development of the neo-classical style, which was in fact particularly influential in the religious architecture favoured by the Bourbons. The lead was given by the Expiatory Chapel (1815-21) by Le Bas from plans by Fontaine, and thereafter neo-classicism was responsible for a long series of churches in the basilican form reflecting the declining days of Roman architecture. This form had made its appearance in Paris before the Revolution with Saint-Philippe-du-Roule and was adopted again for Saint-Pierre-du-Gros-Caillou, by Godde (1822-25), and still again for Notre-Dame-de-Lorette (by Le Bas, 1823-36). Its use continued with Notre-Dame-de-Bonne-Nouvelle (1825-30, also by Godde), with Saint-Vincent-de-Paul (Lepère and Hittorf, 1824-44), in which Doric and Corinthian pilasters have their part, with Saint-Denis-du-Saint-Sacrement (Godde, 1826-35), and with Sainte-Marie-des-Batignolles (Auguste Molinos, 1828-29). Antique styles reigned supreme also for utilitarian buildings; this is best illustrated by the Unloading Hall of the Octroi in the Rue Chauchat (A.-L. Lusson, 1821-25), very simply rearranged by Gau to become the church of the Redemption (1842-43). The Gymnase and the Ambigu theatres (1827) have porticoes with columns like Cellerier's Théâtre des Variétés (1807).

By 1830 architects trained towards the end of the eighteenth century and faithful to an inflexible classical doctrine had disappeared. The rising generation had shown less intransigence and more originality. New theories were being outlined and developed, and their respective influences continued to be felt in Paris until the last years of the century.

Gothic was by no means ignored in the last years of the eighteenth century, and when Lenoir's Museum of French Monumental Architecture (1791, opened in 1795) had helped to make it better known the Romantic movement adopted it with enthusiasm by way of reaction against a classicism which aped the antique. In different ways literature — and not least Victor Hugo's *Notre-Dame* — the formation of the Historic Monuments Commission (1837), the more or less faithful restoration of Saint-Germain-l'Auxerrois (1838-45) by Lassus and Baltard, and of the Sainte-Chapelle by Duban, Lassus, and Viollet-le-Duc (1845-64), stimulated the production of pastiches of ogival art. Discreetly used for the Anglican Chapel (British Embassy Church) in the Rue d'Aguessau (1833), they are to be seen in a more fully developed form at Sainte-Clotilde (by Gau, a French nationalized Rhinelander, and Thomas Ballu, 1846-56), and at Saint-Jean-de-Belleville (1848-59), by Lassus and Truchy. In the case of Saint-Laurent too ready an acceptance of Viollet-le-Duc's maxim that buildings should be restored to the point of completion, even one " which perhaps did not exist before ", entailed replacing without demur an honest seventeenth-century main frontage by an ice-cold pastiche of the fifteenth century (1860-65). The Gothic style was still used for Saint-Bernard-de-la-Chapelle, by Auguste-Joseph Magne (1858-61) and even as late as for Notre-Dame-du-Perpétuel-Secours of 1892-96. Lay architecture did not disdain very free copies of the ogival style. Under the July Monarchy, after the *hôtels* in the antique manner of the " New Athens " quarter at the time of the Restoration, Paris had houses for letting with Gothic details. In 1859, Hittorf rebuilt the *Mairie* of the first *arrondissement*.

The ' Gothics ', though, remained a minority. Administrative buildings, hospitals, and utilitarian buildings of all kinds during the reign of Louis-Philippe, including ministries, town halls and prisons, the enlargement of the Collège de France by Letarouilly (1832), the rearrangement of the Luxembourg Palace (1836), the Institution des Jeunes Aveugles (1837) by Philippon, the Ecole Normale Supérieure (1840) by Gisors, the Sainte-Geneviève library (1843) by Labrouste, and even the rearrangement of the Place de la Concorde (1836) with the Luxor obelisk placed in its centre, gave the architects of the second quarter of the nineteenth century the opportunity of demonstrating different trends. Indeed, under the Second Empire these were to become the dominant trends.

A few classicists tried to free themselves from a fake antiquity by going back to antiquity itself. Hittorf exercised his imagination on the poly-

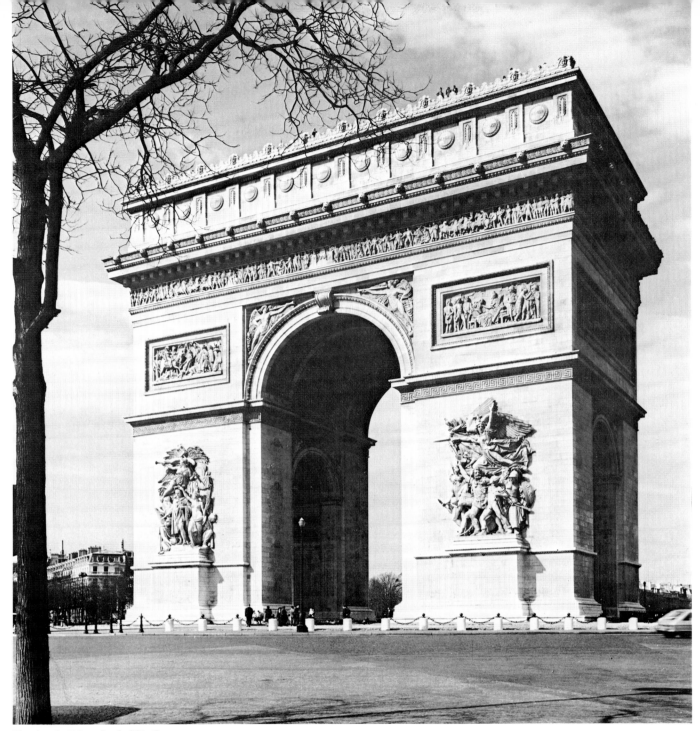

The Arc de Triomphe de l'Etoile.

chromy of Greek temples, confirmed by excavations in Mesopotamia, in such buildings as the Diorama (1838), cafés in the Champs-Elysées (1833-40), and the Cirque d'Eté (1841-43). On Saint-Vincent-de-Paul (1824-44) he used plaques of enamelled lava, but these were removed in 1861. Duc had an idea of adapting antique décors to the Palais de Justice building (1842) and in the courtyard of the Ecole des Beaux-Arts Duban got busy (1834-50) in combining fragments of buildings of different periods which he took from the Museum of French Monuments.

This eclectic classicism included subtle distinctions and shades of difference, and was destined to grow and to last a long time. Borrowings from the Renaissance dominate Duban's Hôtel de Pourtalès (1836) in the Rue Tronchet, Maignan's Hôtel Païva (1856-62) in the Champs-Elysées, Bailly's Tribunal du Commerce (1860-64), Davioud's theatres on the Place du Châtelet (1862), Ballu's church of the Trinité (1863-67), and the plutocratic *hôtels* of the Plaine Monceau.

These are not the only examples. In the Paris of Napoleon III and Haussmann, rent asunder by

The Hôtel Païva on the Champs-Elysées.

strategic roads, laid open by the flattening of ancient boundary walls and the annexation of the territories which lay behind them, a new capital was in process of formation which was quickly to become a cosmopolitan one in which a different old style was attributed by the eclectics to each different category of building. Just as Gothic had been, Romanesque in its turn was brought back to the churches. It reappeared in varying forms at Saint-Honoré-d'Eylau (1855), Notre-Dame-de-la-Gare (1855-64), Saint-François-Xavier (1861-74), at Ballu's Saint-Joseph (1867-74), and at Notre-Dame-des-Champs (1867-76). Two churches stand out from amongst the monotonous mass: Ballu's Saint-Ambroise (1865-69), which has an imposing façade, and Vaudremer's Saint-Pierre-de-Montrouge (1863-72), more rationalist than eclectic, cleverly marrying reminders of Italian basilicas to those of Byzantine churches.

Turning again to lay buildings, one comes to Lefuel, who completed the link between Louvre and Tuileries (1852-57), on which Fontaine and Percier had worked for Napoleon I, as they had done on the Cour Carrée (1805-10). A heavy-handed and pretentious style mars Charles Garnier's Opéra (1861-75). By drawing upon nearly every one of the architectural and decorative styles known to man and underlining them by polychrome marble, bronzes, and gilding, he finally created a "Napoleon III style".

About the same time, as a result of developments in the metallurgical field, the nineteenth century was able to add malleable iron and cast iron to traditional building materials. Their arrival was not unforeseen. It would be easy to follow the progress of their use in Paris from the roof trusses of the Salon Carré (1785) to those of Louis's Comédie Française (1786), and on to the Pont des Arts (1803), the Pont d'Austerlitz (1806), and the dome of Bélanger's Halle aux Blés (1809). Duban left the metallic elements exposed in the library of the Ecole des Beaux-Arts, and so did Labrouste in the Bibliothèque Sainte-Geneviève. Viel with the Palais de l'Industrie (1855) and Baltard with Les Halles (1854-66) gave dazzling displays of all that might be expected of the new materials. Baltard used them again for Saint-Augustin (1860-71), which was inspired by the Italian Renaissance in an attempt, unique under the Second Empire, to break away from both Romanesque and Gothic ecclesiastical architecture. This was not the case with Lusson and Boileau at Saint-Eugène (1854-55), where their pastiche of fifteenth-century architecture was supported by a cast iron and soft iron framework.

Most of the rationalists supported the use of the new materials. They were disciples, at a great distance, of Durand, a teacher at the Ecole Polytechnique round about the turn of the century. He held that the aim of architecture was (according to Hautecœur) "utility, not beauty". Train, at the Collège Chaptal (1867), and Vaudremer, at Notre-Dame d'Auteuil (1877-88), at the Lycée Molière (1888) and the Lycée Buffon (1890), showed how new problems could be solved by new materials. These solutions were then applied to all kinds of new buildings to make them more functional. Examples include Hittorf's Gare du Nord (1863), Labrouste's book stores and his reading room at the Bibliothèque Nationale (1868), Boileau's Bon Marché stores (1872), Lich's Gare Saint-Lazare (1885-89), and, for the Universal Exhibition of 1889, Formigé's Palace, Dubart's Gallery of Machinery, and the Eiffel Tower.

The Universal Exhibition of 1878 gave Paris Davioud's Trocadéro, which was fundamentally altered for the 1937 Exhibition, where the apparent eclecticism of the décor masked rationalist intentions. These, too, are not by any means as completely absent as one might imagine from the Sacré-Cœur — Romanesque, Byzantine, Périgourdin all at the same time — built from 1875 onwards to plans by Abadie, with a campanile by Lucien Magne.

Pastiche took the offensive on too many occasions during the last quarter of the century for them to be mentioned in detail. Neo-Greek and pseudo-antique marked Bouvard's Bourse du Travail (1891) and Ginain's façade for the Ecole de Méde-

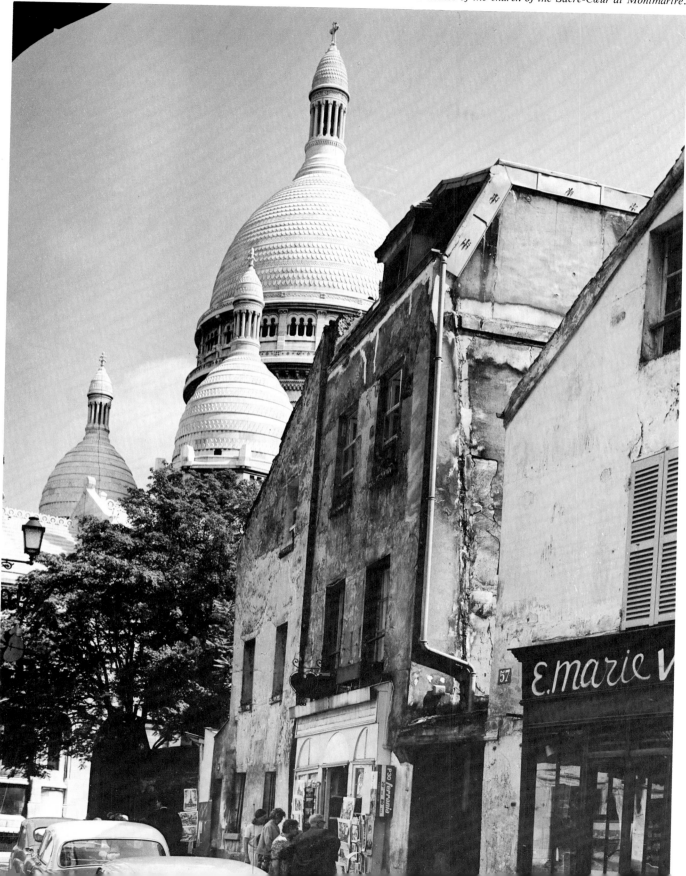

The domes of the church of the Sacré-Cœur at Montmartre.

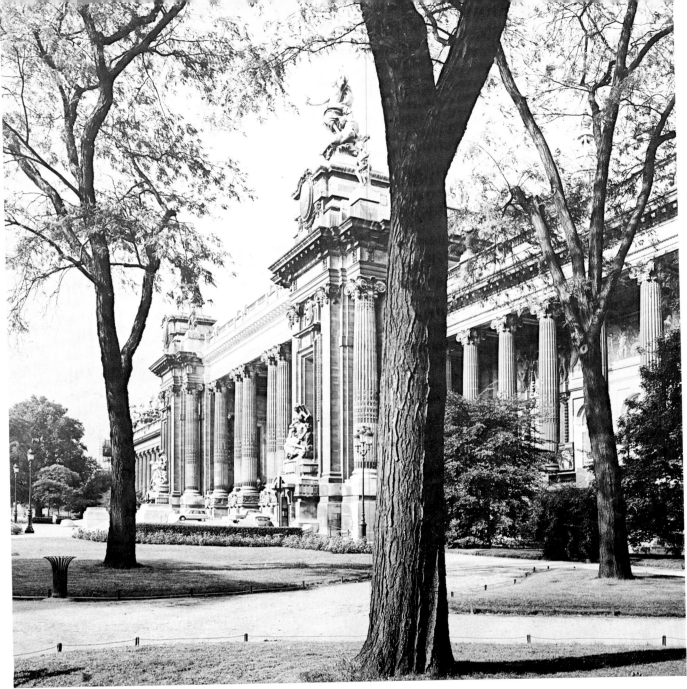

The Grand Palais, built for the 1900 Exhibition.

cine (1900), edging the Boulevard Saint-Germain. The basis chosen for the Hôtel de Ville by Ballu and Deperthes (1874-82), for Ginain's Galliera Museum (1876-88), and Rouyer's Mairie for the tenth *arrondissement* was the Renaissance. The Pasteur Institute by Brebant (1878-89) is in the style of Louis XIII, and Girault's crypt (1885) covering the tomb of the famous scientist is Byzantine.

If there were a few exceptions to pastiche, other than in Nénot's Sorbonne (1885-1900), some *Lycées*, some scientific establishments, and some railway stations, amongst which was the Gare de Lyon (1899), heavily over-ornamented and with a clock-tower belfry, they are rare indeed.

The 1900 exhibition brought the Grand Palais by Deglane, Louvet, and Thomas, the Petit Palais by Girault (better fitted to being what its final destiny made it, a museum), and the Pont Alexandre III, by Real and Alby, but it did little more than to emphasize that which it would have been better to avoid altogether.

On the whole, the Universal Exhibition of 1900, turning away from iron in favour of stone, and even more of stucco and of staff, with which outlandish things could be done, marked a retrograde step in architecture rather than an advance. For a time its influence and its over-abundant, soft and pliant decorations dominated the scene. This style

was often clung to for too long, and always in worsening rather than improving taste. Inevitably this provoked a reaction of exactly contrary ideas. These were expressed in terms of an absence of decoration and the enhancement of the value of the structure itself: for this, other countries provided the models.

A profound change, a veritable Renaissance, was on the way in architecture. Its totally predominant feature was the abandonment of iron, in many ways an inconvenient material to handle, and the adoption of another material which as yet had been little used — reinforced concrete — thought up about fifty years before by a Frenchman. Until it is replaced by something else, an eventuality not to be excluded from the list of possibilities, reinforced concrete will prove to have been the one great building material of the present century. It was first used in Paris by a disciple of Viollet-le-Duc, A. de Baudot, for the church of Saint-Jean-l'Evangéliste (1894-1904). The experiment was continued in a block of flats and a garage. Then came a telephone exchange in the Rue Bergère which proved to be a specimen of rationalized architecture perfectly adapted to its functions (by F. Le Cœur, 1912), and this was followed by the Théâtre des Champs-Elysées (1911-13) by the brothers Perret. This really started the use of reinforced concrete for big-scale architecture. As was to be the case with a majority of the most important later buildings, the material itself served only as a framework and was hidden by casings of a richer material or by bas-reliefs.

After the 1914-18 war, great changes followed the demands for increased numbers of office buildings and banks, for newly founded scientific institutions, and for modern hygiene. These demands were met as far as was possible, or rather as far as was financially possible, which was evidently farther in the private sector than in the public sector.

In general terms, the trends and personalities of leading architects made for a wide diversity in the application of their art and in their ability to maintain their pre-eminence. The academicians brought pastiche back into service to hide the techniques of progress and had no hesitation in putting up in the Rue Michelet an Institute of Art and Archæology with a brick front — derived from heaven knows what style, though the inside was linked with the Romanesque era. The whole thing seemed to be the realization of an ambitious dream. The traditionalists, however, were attempting to forge a link with the great periods of architecture, to return to the lessons taught by the masters, to study yet to avoid copying their forms, and to subordinate the building to the use to which it was going to be put. This led to the completion of some buildings as perfect as the Mobilier National

The Théâtre des Champs-Elysées by the Brothers Perret (1911-13).

(1934-35) on the Rue Berbier-du-Mets. The modernists, always willing to hide the structure under some kind of cover, were looking to the outside of their buildings to provide wide, unbroken surfaces. They had a deep feeling for what Le Corbusier described as the " judicious, correct, and magnificent interaction of connate volumes in the light ". They created the Swiss pavilion at the Cité Universitaire (1930-32).

Following the custom dating from the second half of the nineteenth century, International Exhibitions gave Paris some new monumental buildings. The 1937 Exhibition brought a Musée des Travaux Publics, but also the somewhat unfortunate Musée des Arts Modernes which time has proved to be not well suited to its purpose, and transformed the Trocadéro into the Palais de Chaillot. The Colonial Exhibition left behind another museum, the Musée de la France d'Outre-mer, France Overseas — but that was 1931! The opening up of the so-called Cardinal's stone-masons' yards had differing effects on church architecture.

For long, blocks of flats in Paris had gone on being built on the same lines as those left by the Second Empire — that is, in bricks and ashlar dressed up in an ostentatiously trite manner to give them the

Flats at 26 Rue Vavin (1911).

air of decent respectability and solid wealth which was much appreciated. At the beginning of the twentieth century and thereafter curves and protuberances and bow-windows began to show the influence of the Modern style in all its excesses. Similar trends were observable in most other countries. The use of ceramics, wrought iron, and stained glass and the co-ordination of all the decorative detail by the site foreman (as with Guimard for the Castel Béranger in the Rue La Fontaine) succeeded in giving them a place of their own in the long list of styles and fashions.

Nevertheless the first block of flats for letting, in reinforced concrete with a sandstone facing, was by the Perret brothers and dates from 1903. This was indeed a preview of the world to come, as was the brick wall of Le Cœur's telephone exchange on the corner of the Faubourg Poissonnière and the Rue Bergère (1912). About the same time the desire for greater comfort and more light became more explicit

and soon found solutions of considerable interest, like the 1911 stepped building with the floor areas diminishing with each added storey, at 26 Rue Vavin. These desires and their satisfaction became more and more widespread and highly developed. Here again, after the 1914-18 war, the trends and personalities of architects ensured great variety, despite frustrating limitations imposed by municipal authorities. This variety was facilitated by a much greater choice of facing materials which had become available. The search for simplicity and harmony of line dominated all else. Perhaps in reality these buildings are models of what private architecture could accomplish during the first half of the present century. This was attained even more through the care and attention given to interior arrangement, adaptation to the circumstances of modern life with all its economic and social changes, and the efforts made to simplify the daily problems of existence, than through any other factor.

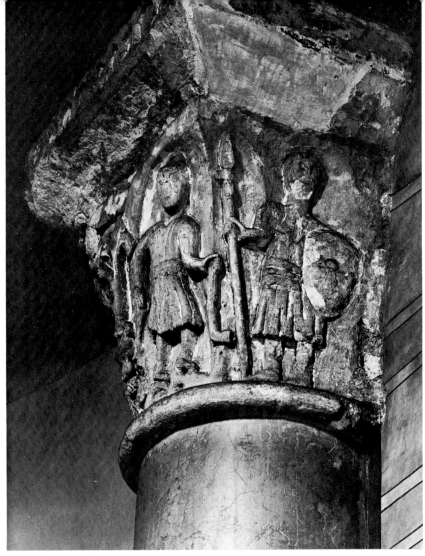

One of the oldest capitals in the church of Saint-Germain-des-Prés.

SCULPTURE

Like the art of the architect in the Paris of the eleventh century the art of the sculptor remained somewhat passively devoted to old conventions.

The capitals of Saint-Germain-des-Prés are the essential expression of Parisian sculpture during the Romanesque period. With one single exception they have all been taken down and carried off to the Cluny Museum. Some carry stylized ornamentation: acanthus leaves, interlacings, foliated scrolls, and palm leaves, treated in separate planes. Others, to the number of seven, are historiated. At first sight the general run of the carving seems to show little ability in portraying drapery or the human figure, but they are none the less of great importance. They summarize, H. Focillon has said, " the uncertainties and early experiments of the first years of the century ", for " below the surface of the diversity of subjects can be traced already a concern for a monumental style and its rules ".

Again like the architecture of its time, Gothic sculpture was born at Saint-Denis. It had not yet entirely freed itself from its subordination to architecture, but it was beginning to abandon low relief for high relief and to show a tendency towards sculpture in the round. Although carried out by lay artists, these sculptural works fitted into a strict iconographic programme laid down and supervised by a clerk in Holy Orders. This applied to all major ecclesiastical buildings. The sculptors' work transformed the face of the great cathedrals into a monumental encyclopædia, holding " a mirror to the world ", summing up not church doctrine alone but the spiritual and material existence of man in all its aspects.

Despite all the mutilation it suffered in 1793, the west front of Notre-Dame, with its three portals rich in carving of subtle inspiration, still remains a book in which is recorded the evolution and efflorescence of Gothic sculpture of the Ile-de-France and of Paris in particular. Here only the essential passages of it can be told.

Built between about 1220 and 1240, it included

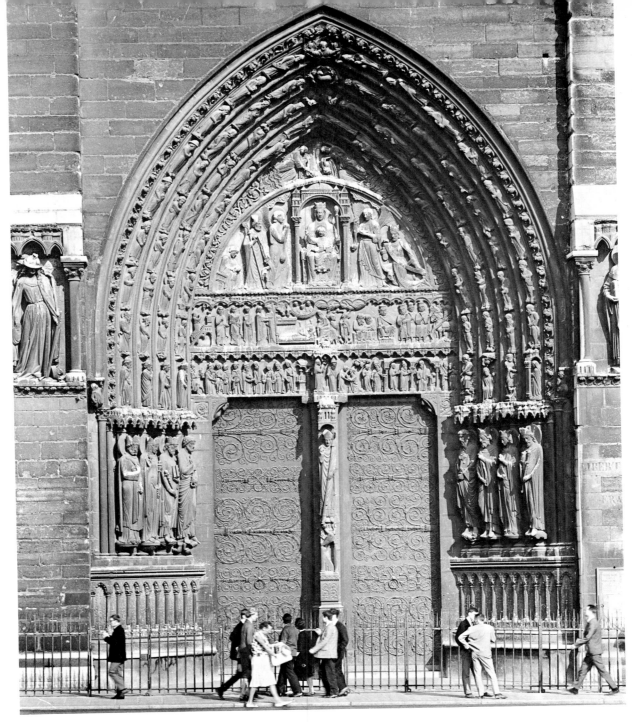

The Sainte-Anne portal of Notre-Dame de Paris.

some important elements which go back to the second half of the twelfth century. The south side-door, dedicated to Saint Anne, deserves to be the first to be described.

The tympanum is given over to a Virgin, who dominates a twelfth-century upper lintel relating her life, and a thirteenth-century lower lintel telling the story of Saint Joachim and Saint Anne as well as that of the Virgin's marriage. There on the tympanum she sits, hieratic, beneath an architectural canopy of purely Romanesque inspiration,

tightly enfolded in a dress of symmetrical pleats, holding the Child on her knees. An angel swinging a censer is on her left and another on her right. Behind them, on their knees, appear Louis VII and Maurice de Sully, founder of this sanctuary, and with them is a clerk, perhaps transcribing the deed of gift.

The north door is the counterpart to this one, but the result of deeper thought and an art altogether more fully evolved and more flexible. This is the Virgin's Portal of the beginning of the thirteenth

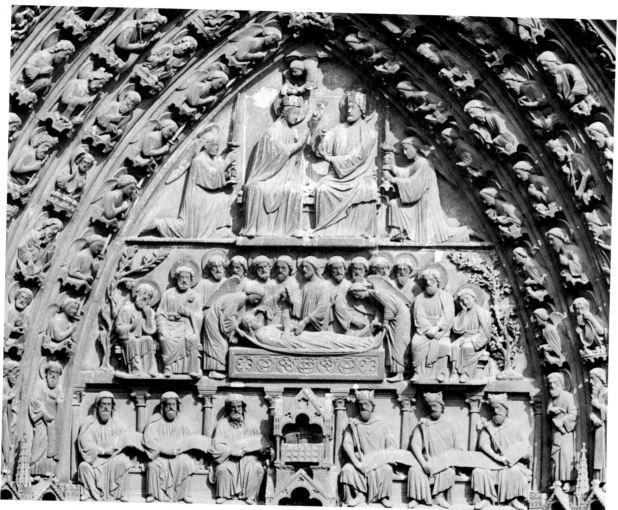

Detail of the Portal of the Virgin of Notre-Dame de Paris.

century (*c.* 1210-20). Instead of the Virgin in her majesty, the theme here is the death and apotheosis of Mary, a theme first appearing at Senlis in about 1183 and here renewed and given an unforgettable grandeur. In the lower register three Kings of Judah and three prophets sit by the sides of the Ark of the Covenant, a reminder of the Virgin's ancestry, of her mission, and of those who had foretold her coming. Above is a scene often referred to as the burial of the Virgin, but which is almost certainly her awakening into eternal life, her resurrection in the presence of her divine Son and the apostles. In the upper register the Virgin is shown between two kneeling and torch-bearing angels, whilst a third, just descended from heaven, is placing a crown upon her head. Jesus is alongside her, presenting her with a sceptre. Even compared with the most perfect groupings which the art of antiquity has to show, this is an exceptional work, outstand-

ing for the lucidity of its composition, the discretion and the depth with which feeling is expressed, and the simplicity and harmony of the draperies.

After the carvings on the coves and the splays, many details of which would justify description, as would those of the scenes from the life of Saint Denis, one sees a series of small restored or remade medallions on the engaged piers at the foot of the big statues. They show the signs of the zodiac and the labours proper to each calendar month. They vividly recall scenes of daily life and work in town and country. Used almost everywhere, either as a surround or an infilling, the flora of the land is faithfully recorded. It adds the theme of nature's perpetual renewal, recorded with incomparable perfection — a theme already used in a more stylized form in the decoration of the choir.

The centre door is, by tradition, concerned with the Last Judgment. This one was carved between

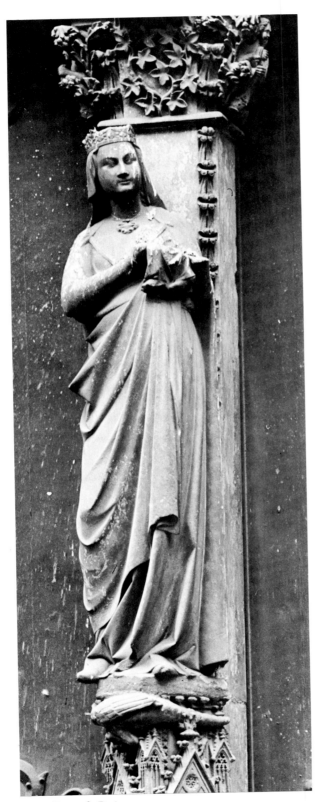

Notre-Dame de Paris:
the Virgin of the north door.

1220 and 1230, badly mutilated at the instigation of the Canons in 1771, deprived of its statuary during the Revolution, and in its greater part remade in the nineteenth century under the directions of Viollet-le-Duc. One fragment of the original tympanum, much damaged, is in the possession of the Cluny Museum. What remains on the original site is not much: Christ judged, the Virgin and Saint John, a few segments of arches with a double row of cherubs who are restraining their natural turbulence by leaning on the edge as if it were the balustrade of a balcony, and some patriarchs, martyrs, confessors, and virgins. Bases of the vaults contrast the terrifying punishments of Hell, treated with ruthless realism, with the happiness of the elect received into Abraham's bosom. These are the punishments and the rewards of vices and virtues shown on the restored medallions at the bases of the remade statues.

The transept doorways mark a new period of Gothic architecture. The pier of the main north door holds the only statue in the cathedral remaining intact in its original position. It dates from about 1260. Everything that can be said about this statue of the Virgin has been said. Under the weight of the Child Jesus she leans a little to one side. The statue of the Child has disappeared. Many have been the praises sung of the individuality and animation of the face, her well-bred, elegant, and graceful air, the happy pride of motherhood fulfilled, the skill with which the wide folds of the gown have been portrayed. The lintel presents scenes of the life of Mary, whilst the tympanum relates at length how Our Lady snatched Theophilus the Clerk back from the claws of the Evil One, to whom he had imprudently sold his soul in exchange for the glory of this world. Not far from the doorway to the cloisters, the little Red Door (*c.* 1260) is garlanded with heavy mouldings of leaves and dog-roses alternating with wild-rose leaves. These are considered a form of signature, presumably of the architect, Pierre de Montreuil. On the arches the Virgin is being crowned in the presence of Louis IX, the future Saint Louis, and Marguerite of Provence, kneeling. On the arches are scenes from the life of Saint Marcel.

The south door of the crossing is slightly earlier and glorifies Saint Stephen. It was begun in 1258 by Jean de Chelles and completed by Pierre de Montreuil. It fixes the principal events of Stephen's life, not without a very obvious search for picturesque effects and details. The same applies to the eight bas-reliefs on the buttresses. What they represent has never been explained, but it has been suggested that in them can be recognized scenes from the wild lives of students in Paris — students watched over and controlled by the Rector of the University acting as the Bishop's representative.

*Virtues and Vices, on the centre doorway
of Notre-Dame de Paris.*

The desire to narrate increased with the coming of the fourteenth century. With it came a greater freedom of movement — even a little preciosity — and interpreted with almost dramatic gestures the state of mind of the figures who people the seven bas-reliefs in honour of the Virgin on the north side of the apse.

As with other cathedrals, so in Paris the completion of so monumental a work gave rise to renewed opportunities for bas-relief, which now turned towards the anecdote and towards realism. Both are present in the decoration of the choir screen, which had once been continued on the rood screen. When the latter was destroyed many important pieces were destroyed with it, but not the Descent into Limbo, which is to be seen today in the Louvre Museum. On the other hand, the History of Christ from the Annunciation is still to be seen on the north side, and the Appearances of Jesus after His

Death on the south side. These carvings were begun on the north side under the direction of Pierre de Chelles between 1300 and 1318 and continued by Jean Ravy, foreman mason, from 1318 to 1344, and finally made 'super perfect' by Ravy's nephew, Jean Le Bouteillier, in 1351. On the whole they reflect the proper balance and counterbalance in the tradition of the thirteenth century, but are not always free of a taint of the mannerism which became frequent in the fourteenth century. They exercised a great deal of influence and for long served as a source of inspiration for ivory carvers, miniaturists, and painters. It even reached the point that about 1420 there was performed " the very pious mystery of the Passion of our Lord from life, as it is illustrated round the choir of Notre-Dame de Paris ".

A new spirituality developed in the fourteenth century which gave impetus to the work of the

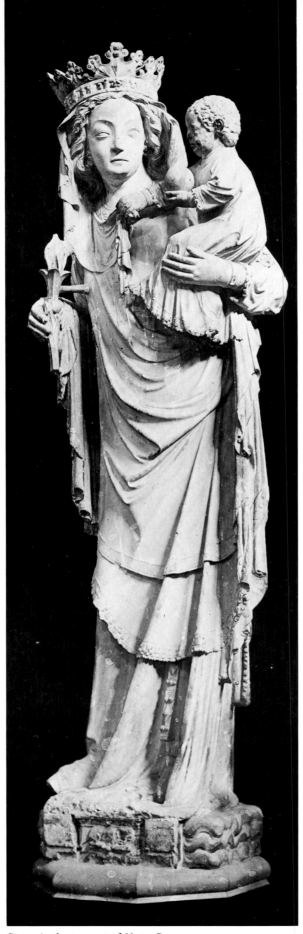

Statue in the transept of Notre-Dame, known as Our Lady of Paris.

carvers of images. The cult of the Virgin became humanized, as is exemplified by the statue on the south-west pillar of the transept of Notre-Dame, to which the name of Notre-Dame de Paris was given. It came from the Saint-Aignan chapel in the Rue des Ursins and there was also an increasing amount of devotion to the saints. Many new churches were founded in which sculpture figured prominently. Particularly rich in sculpture, as is well known, was the chapel of the Petit-Bourbon, built between 1303 and 1312 by Duke Louis I of Bourbon on the site of the present colonnade of the Louvre, and enlarged by his son. Other chapels were built for noble families, for wealthy bourgeois, and for religious confraternities. The chapel of the Hôpital Saint-Jacques, built from 1319 to 1323 between the Rue Saint-Denis and the Rue Mauconseil, possessed effigies of the apostles carved by Robert de Launay and Guillaume de Montriche. The remains of some of these were uncovered in the nineteenth century and are now to be found at the Cluny Museum and on the façade of the building bearing the number 133 in the Rue Saint-Denis. Specialists relate them to thirteenth-century tradition and to the statues of the Apostles in the Sainte-Chapelle.

Gothic sculpture, though, was not the exclusive prerogative of religious buildings. It was also magnificently displayed in the royal or princely homes of Paris. Philip the Fair, whose equestrian statue (or what was supposed to be his statue) once stood in Notre-Dame, commissioned statues of the kings for the Great Hall of his palace in the Cité: increased in numbers by the King's successors, they were all utterly destroyed in the great fire of 1618. In the days of Charles V the chapel of the Hôtel Saint-Pol was furnished with twelve figures " representing the Apostles, each one four and a half feet high ". Raymond du Temple, the King's architect, completed the great spiral staircase of the Louvre in 1364, enriching it, " to render it even more superb ", on the outside with " small figures and ten big stone figures, each covered by a canopy, placed in a recess, and carried on a pedestal ". Round the cage, on the outside, figures of the King, the Queen and their male children were placed, not in any kind of order but quite haphazardly and with no attempt at symmetry. They were the work of Jean de Liège, Jean de Launay, Jean de Saint-Romain, Jacques de Chartres, and Guy de Dampmartin. It is known that for each figure they received by way of salary " twenty gold francs, or sixteen *livres parisis* ".

It is also known that the statues of Charles V and Jeanne de Bourbon were still in existence in the seventeenth century, but, like the staircase itself and many other works once in the Louvre, they and the others have disappeared. It has been supposed, which is likely enough, that they must have been in

appearance if not in style close to two other effigies of Charles V and Jeanne de Bourbon, for long believed to have been likenesses of Saint Louis and Marguerite of Provence and originally decorating the doorway of the Célestins chapel begun in 1364 and consecrated in 1370. Thanks to Lenoir they were preserved and transferred to the Musée des Petits-Augustins, and are now in the Louvre Museum. Nobody knows whose sculptures they were. Were they the work of a Jean de Liège, or an André Beauneveu, or some other master? They are, in any case, lively portraits and, one can be sure, faithful ones. They underline the breakaway of sculpture from convention, the attention now being given to direct observation, and the desire to reproduce reality without prettifying or idealizing it. As with the funerary images one can study at Saint-Denis, in which the faces are death-masks, these

Detail of the doorway of the upper chapel of the Sainte-Chapelle.

Statue of Charles V from the Célestins chapel, now in the Louvre.

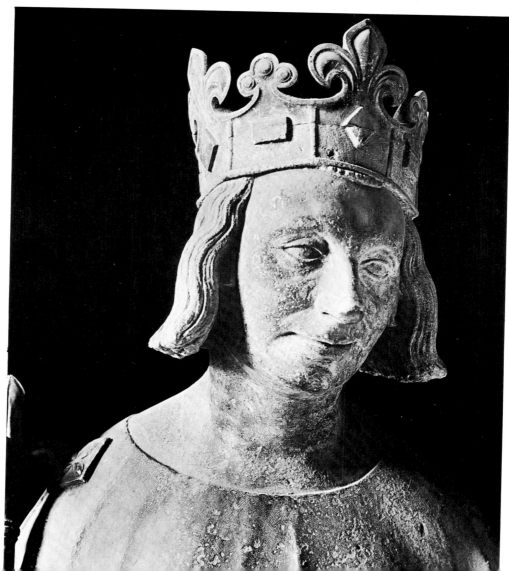

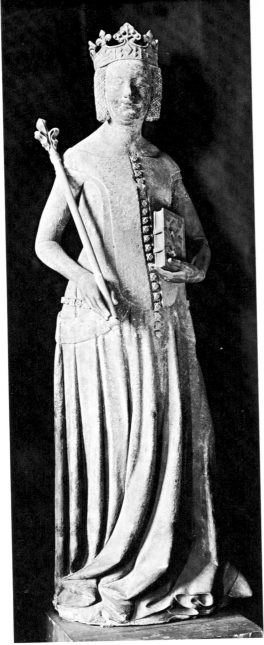

Statue of Jeanne de Bourbon from the Célestins church, now in the Louvre.

statues are valuable documents. They not only demonstrate sculpture as it was at that time; they also foretell the future.

In fact, the sculpture of the Middle Ages had completed its cycle in Paris by the beginning of the fifteenth century, and by the end of it the ultramontanes had begun to spread the gospel of the Italian Renaissance. Today little remains of the sculpture of the period between the two; in any case it was very limited, owing to political circumstances. Those works that do remain are, for the most part, utilitarian or purely decorative associated with the flamboyant style in churches and private mansions. They are mostly distinguished by their verve, naïve and racy realism, and their anecdotic value. At Saint-Germain-l'Auxerrois, for example, the brackets and the counterforts of the flying buttresses which support the side-walls are decorative exhibitions of wild beasts, madmen, hippopotami, lions, monkeys, a sow feeding her young, and rats chewing a terrestrial globe. Picturesque gargoyles keep them company, and these are also to be seen on the Hôtel de Cluny, where chimeræ roost on the dormer uprights. People holding streamers figure on the arches of doorways, together with monsters playing amidst detailed foliage and the grape clusters of the vineyard.

Jean Goujon, the greatest and most original of the sculptors of the French Renaissance, was characteristic of the new times. He was also the one who displayed the greatest activity in the enrichment of the capital. In 1544 he produced *Our Lady of Pity* and *The Evangelists*, now in the Louvre, for the rood-screen and loft of Saint-Germain-l'Auxerrois, with which his collaboration with Pierre Lescot began. Although the ultramontanes already had studios at the Petit-Nesle, from which Benvenuto Cellini was preparing to return to his native land,

Detail of a sixteenth-century capital in the chapel of the Hôtel de Cluny.

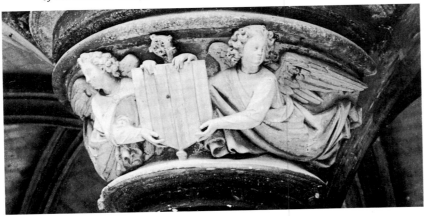

the presence of these artists had had no direct effect on the realm's leading city. That subtle theoretician Jean Goujon showed himself in fact to be much less interested in adapting the Italian taste of the moment than he was in adapting the art of the old Masters themselves. Certainly in his early days he did not escape the modern influence of the canon established by the Fontainebleau school. However, after spending some time at Ecouen and completing some allegorical figures on the façade of the Hôtel de Lignéris (later the Carnavalet) he turned back to an ancient sarcophagus for the tritons and nereids he needed for a bas-relief on the Fontaine des Innocents (1549). This fountain had first been placed at the corner of the Rue aux Fers and the Rue Saint-Denis. It was rebuilt on the present site in the eighteenth century, when some clever pastiches were made to go with it. Pajou, their creator, was successful in imitating the slender elegance of Goujon's nymphs, their light draperies, and the way the water in their urns seems to trickle away in capricious, undulating folds. Goujon brought *Astronomy*, *Geometry*, *Trade*, *Mars*, *Minerva*, *Agriculture*, *Abundance*, the *Ocean*, some genii, and some captives to the pediment of the Lescot façade of the Louvre in equally perfect taste. Allegorical figures framing the small, circular windows are also attributed to him. He went back to his classical models also for the serene and noble caryatids " of the Great Hall of the Louvre in the manner of the ancients ". They are sisters to the caryatids of the Erechtheum. Goujon also did some wood carvings of the signs of the Zodiac for the Hôtel de Ville. They were destroyed in the fire of 1871, but are known from mouldings. This work was done just before his acceptance of the tenets of the Reformed Church obliged him to fly to Bologna in 1567, there to end in silence a life of mystery and intense spirituality.

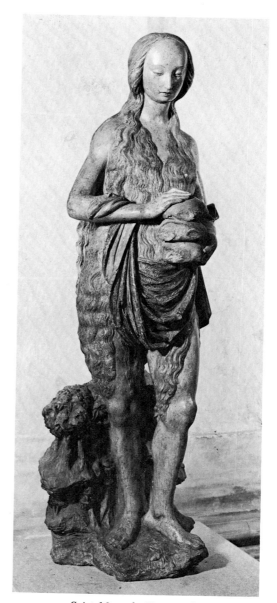

Saint Mary the Egyptian from the porch of Saint-Germain-l'Auxerrois, now in the Louvre Museum.

Jean Goujon's bas-relief of tritons and nereids for the Fontaine des Innocents, now in the Louvre Museum.

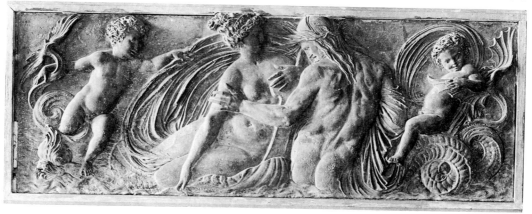

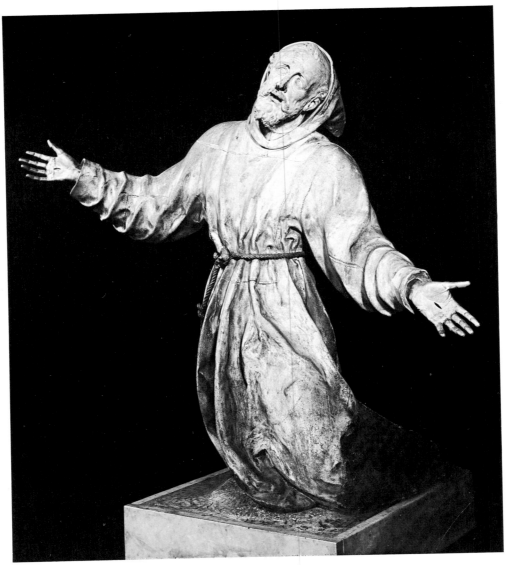

*" Saint Francis in Ecstasy ", by Germain Pilon, in the church
of Saint-Jean-Saint-François.*

At the time that Goujon left the scene of his
efforts, with Pierre Bontemps, who was also a
fugitive for the sake of religion (his statue of Charles
de Magny of 1556 for the Célestins church is the
only one of his works to find mention here), Paris
was about to discover another remarkable inter-
preter of the art of sculpture — Germain Pilon.

It would be easy to contrast Goujon with Pilon.
The former remained an idealist, modelling bas-
reliefs in gently accentuated planes for use in an
architectural setting. The latter, the son of a stone-
mason, expressed his power and keen sense of
observation through work in the round. The great
work of his early days, the *Monument for the Heart
of Henry II* in the church of the Célestins (1561) with
three Graces (since baptized *The Theological
Virtues*), and the four wood carvings for the shrine
of Sainte Geneviève at Saint-Etienne-du-Mont, by

no means completely represent his true gifts. Much
better than the remains of the Saint-Denis rotunda,
scattered in various Parisian churches, or the marble
Virgin at Saint-Paul-Saint-Louis (with a poly-
chrome terracotta version in the Louvre), or the
Saint Francis in Ecstasy at Saint-Jean-Saint-
François in the Marais, the realism of his busts,
medals, and funeral effigies reveals the true Pilon.
The bust of Chancellor de Birague, with unforget-
table face, body wrapped in a magistrate's cassock
once painted in red, is to be seen at the Louvre,
having originally been cast in bronze for Sainte-
Catherine-du-Val-des-Ecoliers, together with the
tomb of the Chancellor's wife, Valentina Balbiani.
Others no longer exist, and these include the statue
of Abbé Joseph Foulon for the abbey of Sainte-
Geneviève (1587), and the mausoleum of Saint-
Mégrin at Saint-Paul (1588). This last was com-

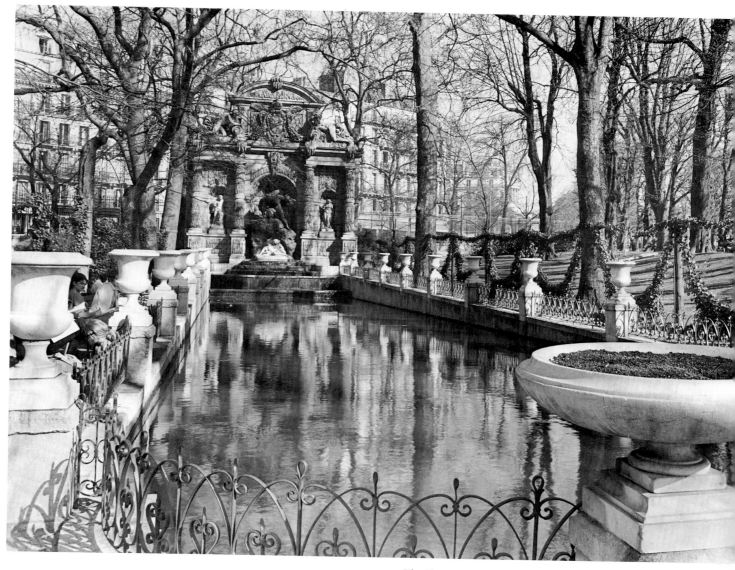

*The Fontaine Médicis by Salomon de Brosse
in the Luxembourg Gardens.*

pleted only two years before Pilon's death. He appeared at the very time the artists of the generation of the new classical era were beginning to assert themselves.

At the beginning their progress was slow. There were few sculptors of importance in Paris during the reign of Henry IV. Pierre Biard was chosen to complete the carvings for the rood-screen of Saint-Etienne-du-Mont (1600) and to make an equestrian statue of the King (1605-8) for the entrance of the Hôtel de Ville, which was destroyed at the time of the Revolution. Together with Barthélemy Prieur, the brothers Lheureux, and Barthélemy Tremblay, he took part in the ornamentation of the new Louvre. For the equestrian statue of the King, destined for the Pont-Neuf, Queen Marie de Médicis called upon Jean de Bologne, an Italianate Flemish artist who contented himself with creating the horse and left the rider to be sculpted by Pietro Tacca. Another of his pupils, Pierre Francheville, from Cambrai, was brought back from Italy by Henry IV in about 1601. He was commissioned to carve the chained slaves round the pedestal, whilst Tremblay and Thomas Boudin were reduced to sharing the bas-reliefs. This same Boudin, according to Sauval, completed the funeral effigy of Diana of Poitiers for the Minims of the Place Royale at Saint-Denis. In 1620 Guillaume Berthelot became busy with the Luxembourg Palace.

Sculpture in Paris did not recover its vitality until the second quarter of the century, approximately between 1630 and 1660, with the return from Italy of Jacques Sarrazin and Simon Guillain, who soon formed a school, and with the arrival in Paris of several artists from northern countries — Van

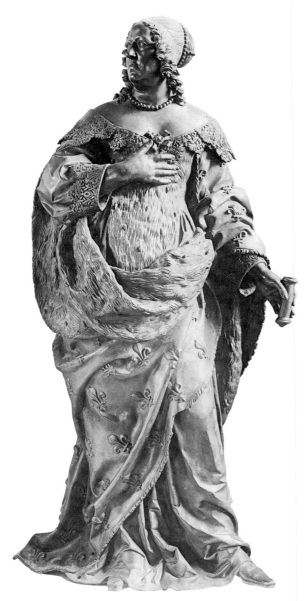

*Bronze statue of Anne of Austria
by Simon Guillain, in the Louvre Museum.*

Saint-Louis), the Sorbonne, the Val-de-Grâce, the new churches of the Rue Saint-Honoré and the Faubourg Saint-Germain, as well as others. The bronze statues of Louis XIII, Anne of Austria, and Louis XIV as a child (in the Louvre Museum), once part of a group erected at the new Pont-au-Change (1647) by Simon Guillain, and the busts executed by Jean Warin, who was also an eminent engraver of medals, all show the same naturalism to which the artists' talent adds a remarkable intensity of life.

Portraiture continued to be preferred to funerary sculpture, though most of the professionals took part in the latter, each according to his capabilities. Some amongst them came up through craft work to become members of the Academy from its foundation in 1648 and to be amongst the first sculptors of statues for the Versailles gardens.

This was the case with Philippe Buyster, designer of the tomb of Cardinal François de la Roche-foucauld (1656), now at the Hospice d'Ivry, and with Gilles Guérin. He carved the tomb of the Duke and Duchess de la Vieuville (1653) for the chapel of the Minims in the Place Royale at Saint-Denis, the Descartes medallion for the abbey of Sainte-Geneviève-du-Mont (now disappeared), and the statue of Louis XIV in Roman attire, treading the Fronde underfoot, for the Hôtel de Ville of Chantilly (1654). Buyster, Guérin, and others took part in Jacques Sarrazin's work, or were taught by him.

Sarrazin's return to Paris has already been mentioned; it makes 1628 one of those key dates to which, perhaps, art historians give too high a value. None the less the reputation acquired by Sarrazin in Rome brought him many commissions for the Louvre, for churches, and for private individuals. Overloaded with work, he had to have help. For this reason he appears as " the leader of a group, if not of a school ". Therefore his innovations in the way of funerary sculpture were all the more far-reaching and significant. In the monument to the Cardinal de Bérulle (1656-57) in the Carmelite chapel of the Rue Saint-Jacques (now in the Louvre) Sarrazin tried to express the spirit without neglecting the physical likeness. His career ended with the mausoleum (*c.* 1663) for the heart of Henry II, Prince of Condé, made for the Maison Professe des Jésuites, cast by Perlan, and remade at Chantilly. It brings together bronze allegorical figures and bas-reliefs inspired by the *Triumphs* of Petrarch.

By the second half of the seventeenth century the tendency towards symbolism in funerary sculpture had ceased to be exceptional. In fact it increased, finding inspiration (after 1670) in an ephemeral taste for pompous monuments to royalty and princes, imitated from Italian originals introduced by Jean Berain, the inventive designer of Louis XIV's bedroom and study. Statues materializing their

Obstal, Jean Warin, and Buyster. Influenced by Italy and perhaps even more by the Low Countries, sculpture began to express itself more abundantly, more robustly, and more naturally. This can be seen from the Sarrazin stuccos in the galleries of the Hôtel de Bullion (1634) to those of Michel Anguier on the ceilings of the Queen Mother's apartments in the Louvre (1654-56). Also in the façades and the decoration of the churches whose building underlined the renewal of faith, such as the chapel of the Maison Professe des Jésuites (Saint-Paul-

merits and their virtues, together with metaphors most flattering to the pride of survivors, were now added to the effigies of the dead ones praying, or " in the act of offering themselves to God ". Most sculptors untiringly sought inspiration in the entire iconological repertory, half Christian, half pagan, so that from under their chisels came, indifferently, Religion, Prudence, Fidelity, Faith, or Peace. All, of course, were carefully adapted to the Academic rules. This is what Girardon did for the tombs of Olivier and Louis de Castellan at Saint-Germain-des-Prés (1678), of Cardinal de Richelieu in the chapel of the Sorbonne (1675-94) and, in collaboration first with Martin Desjardins and then Van Clève, for the tomb of Louvois in the Capucine chapel (1693-99), later moved to the Hôpital de Tonnerre. In collaboration first with J.-B. Tuby for the tomb of Colbert at Saint-Eustache (1686), then with Le Hongre and Tuby for the tomb of Mazarin at the Collège des Quatre-Nations (1689-93), now at the Louvre, Coysevox did the same kind of thing. And so did Simon Hurtrelle and Mazeline for the tomb of Le Tellier at Saint-Gervais (c. 1683). Not one of these pompous set pieces came near to equalling the moving simplicity of the tomb of the mother of Charles Le Brun at Saint-Nicolas-du-Chardonnet (1688), designed by this the foremost painter of his time and carried out by either J.-B. Tuby or Collignon.

The ever-increasing pathos of funerary sculpture ended by its being interwoven with psychological intentions. These were intended to express the " effects of the passions ", corresponding to the " movements of the soul ", as discovered by Descartes and imposed on the world of Art by Le Brun in the course of his Academic lectures. The importance now acquired by sculptured busts undoubtedly in part accounted for his recom-

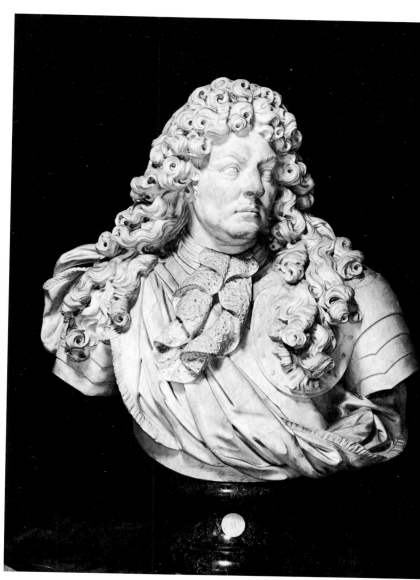

Louis XIV, by Coysevox, from the collection of the Duke de Polignac.

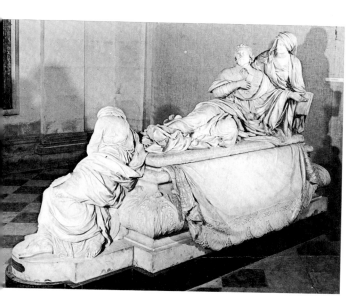

Richelieu's tomb in the chapel of the Sorbonne, by Girardon.

mendations. They renewed a tradition which it would not be unfair to label 'national' as opposed to Italo-antique importations. They reached their highest contemporary expression with a series of works undertaken by Coysevox about 1670 and continuing until his death in 1720.

The sculptured tombs and busts produced by the principal representatives of the Versailles team in their workshops at the Louvre — the finest exponents of the academic doctrine which monarchist art had mobilized in the service of the sovereign — must not blind one to the other work that these men

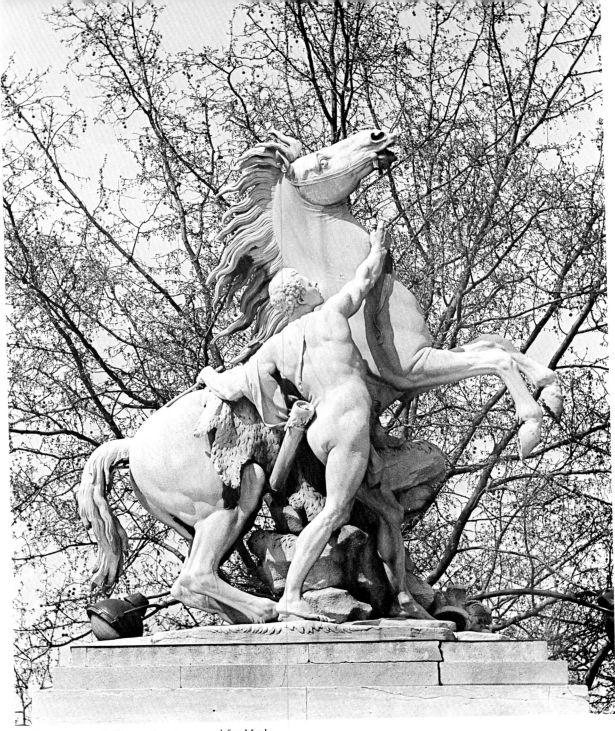

One of the horses Guillaume Coustou carved for Marly,
now in the Champs-Elysées.

did which was more closely connected with the city of Paris. Girardon and Coysevox are examples of this.

In his early days Girardon worked with the de Marsy brothers and Thomas Regnaudin on the vaults of the Apollo Gallery in the Louvre (1663-64). Later, with Tuby, Lerambert, and Regnaudin, he did the stucco work of the King's study and bedroom at the Tuileries (1666). He undertook to decorate the Saint-Denis gate, at which Michel Anguier replaced him in 1674. After Martin Desjardins' pedestrian statue of Louis XIV in his coronation attire for the Place des Victoires (1686), Girardon prepared an equestrian statue for the Place Louis-le-Grand (now the Place Vendôme). The King was portrayed in Roman attire, but wearing a periwig. This statue was cast by the Kellers in 1699. At the same time Coysevox, in view of the achievement of *The Vow of Louis XIII*, began to get busy on the figures intended to complete

the High Altar rebuilt by Jules Hardouin-Mansart in the disrupted choir of Notre-Dame. Forced by political circumstances to abandon and then take up his labours again, it was not until 1714 that he completed the *Descent from the Cross* and the statues of Louis XIII and Louis XIV, with the help of his nephews Nicolas and Guillaume Coustou.

With the Coustou brothers we are well into the eighteenth century. Delivered from the constraint of Versailles, the pupils of Girardon and Coysevox could more freely follow their own inspiration and vary their work. Without entirely breaking with the past, the Italy of Bernini and the fire of Puget urged them on to leave grandeur aside in exchange for freedom of movement. This became their primary consideration, together with the observation of nature. The dynamism of eighteenth-century sculpture, the way it was attracted by contorted postures, and its virtuosity are particularly apparent in works submitted for reception by the Royal Academy of Painting and Sculpture; this was the case right up until the Revolution. Nothing gives a better idea of the change in ideals than the confrontation of the winged horses Coysevox designed for the watering trough at Marly (put either side of the Tuileries terrace in 1719, and serving as mounts for Fame and Mercury) with Guillaume Coustou's impetuously rearing horses, whose grooms can hardly hold them, which face them at the lower end of the Champs-Elysées. They too were designed for Marly (1740-45).

The same vibrant vitality, though more restrained and more picturesque, is shown by the *Horses of the Sun* over the stable door of the Hôtel de Rohan, slaking their thirst from a storm cloud. They were carved by Robert Le Lorrain who, with the Slodtzes, father and son, the Adam brothers, and Jean-Baptiste Lemoyne, decorated the oval room of the Hôtel de Soubise (1735-40), which is a perfect example of the carving and plasterwork of the time.

Eighteenth-century religious sculpture was so absorbed in the loud-voiced Berninesque, its declamations, and its set scenes that most sculptors made no effort to get away from it. This applies also to some members of the generation which flourished after 1750, though in general they are better known for their level-headedness than for their exuberance.

A *Saint Jérôme* by Lambert-Sigisbert Adam (1746, now at Saint-Roch) and a *Virgin* by Pigalle (1746, now in Saint-Eustache) are all that remain of the statues of the Dôme des Invalides. The latter preceded another *Virgin*, carved for Saint-Sulpice, commissioned in 1754 and delivered only in 1776.

A marble statue of *The Annunciation* (1762) by Jean-Baptiste Lemoyne for Saint-Louis-du-Louvre has disappeared. He has been much criticized for his experiments in polychromy. The supple flesh and mastery of execution of his *Baptism of Christ* (1737),

" Horses of the Sun ", by Le Lorrain, from the entrance to the stables of the Hôtel de Rohan.

begun by his uncle Jean-Baptiste Lemoyne the Elder, only underline his mannerism. Originally this group was in Saint-Jean-en-Grève but is now at Saint-Roch, where it has as neighbour Falconet's *Christ in Agony*, the wreckage left by time of a once famous calvary.

The lack of feeling for simplicity and for movement is nowhere made more fully apparent than in the funerary sculpture. Thanks to the individualism distinguishing the Minister's features, the Coustou brothers' statue of Cardinal Dubois (*c.* 1725) is still an imposing work. It was first in the church of Saint-Honoré and is now in that of Saint-Roch. Twenty years later the *Comtesse de Feuquières* (*c.* 1743) by Jean-Baptiste Lemoyne the Younger demonstrates more elegance and preciosity than feeling. This was made for the mausoleum of the lady's father, the painter Mignard, in the Jacobins' chapel, but became *Madeleine* when it was transferred to Saint-Roch. In the tomb of Languet de Gergy by Michel-Ange Slodtz (1753; in Saint-Sulpice) the sculptor reaches the heights of tumultuous and dramatic intensity. With the tomb of the Comte d'Harcourt (1769-76) in Notre-Dame, even Pigalle sacrificed his art to the same excesses.

Reaction against the baroque began well before the return to antiquity and the hardening of Academic ideas. It became apparent in Paris with

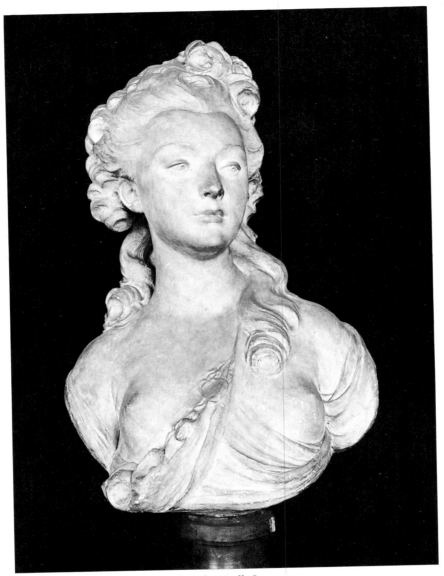

Bust by Caffieri, presumed to be of Mademoiselle Luzy.
In the Bibliothèque Municipale at Versailles.

Bouchardon's fountain in the Rue de Grenelle (1739-45). This well-balanced and simple work was both a tardy follower of a certain style and the precursor of a second version of it, though remaining at the same time very much a work of the era of Louis XV. It had the delicacy of his bas-reliefs *The Seasons*, recalled by *Children's Games*, and also its petrifactions. For the Place Louis XV, now the Place de la Concorde, Bouchardon placed his statue of Louis XV, the Well-beloved, sculpted in the best manner of the ancients, on a pedestal, with allegorical figures. Death did not allow him to complete the work, which was finished by Pigalle and unveiled in 1763.

Once again moulding their styles on antiquity, Parisian sculptors were responsible for some major works, but not without occasionally falling into the contemporary fashion for prettiness and gracefulness, before ending up with cold pastiches. Work which contributed to the adornment of Paris rather than the kind usually submitted for exhibition will be noted here. These works, sculpted by masters of the highest grade, or just below it, departed but little from the fashion of the day, from Pajou's sculptures on the pediment of the Palais-Royal (*c.* 1767) and the Palais de Justice (after 1776), the pediment of the Hôtel des Monnaies (1770-71) by Edme Dumont and J.-J. Caffieri, Bridan's pediment

The Place Louis XV, by J.-B. Le Prince.
In the Beaux-Arts Museum at Besançon.

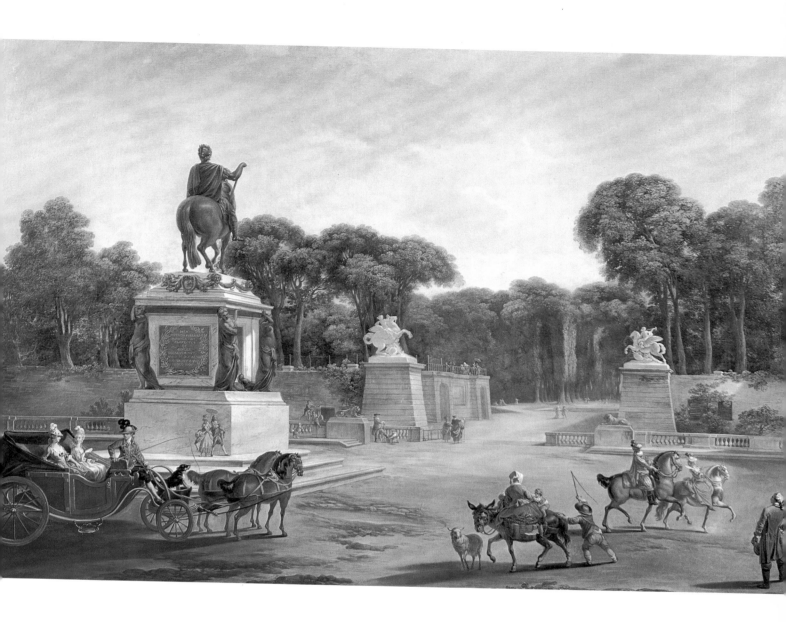

Madame Houdon, by Houdon, in the Louvre Museum.

and frieze for the new Ecole de Médecine (*c.* 1785), Clodion's bas-reliefs for private mansions, follies, and a love-nest in the Rue de Bondy (in the former Doucet collection and the Decorative Arts Museum), to Roland's frieze and motifs (*c.* 1783) for the Hôtel de Salm, where the figures on the portal might well have been accepted by the First Empire as its own.

During the reigns of Louis XV and XVI, Parisian, which means French, sculpture remained associated with portraiture principally in the shape of busts, as were, in their different ways, painting and engraving. Whether in marble or terracotta, plaster or bronze, they all revealed the personality of the sculptor and of the model, individual variations in technique and taste, and every shade of human expression. They explored all the possibilities of their material, which under chisel, sculptor's boaster, or human thumb became warm and living flesh. Their charm and their interest put them amongst the treasures of the century, whether they be signed by Jean-Baptiste Lemoyne, Michel-Ange Slodtz, Pigalle, Vassé, J.-J. Caffieri, Pajou, Houdon, or lesser names.

After the Revolution the monumental works planned by Napoleon and the decoration of buildings in course of alteration or construction made the beginning of the nineteenth century an era of prosperity for Parisian sculptors, though it was not one

" Mercury attaching his heel-wings ", by Pigalle.
In the Louvre Museum.

" Sappho ", by Pradier. *In the Louvre Museum.*

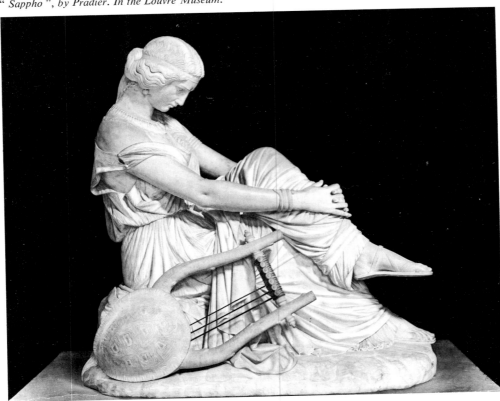

which gave birth to outstanding works. Everything conspired to incite them to conform to the classical ideal: the attachment of the men of the Revolution and the Empire to Rome and to Greece, the pastiches of the ancient their forerunners had perpetrated, the evolution of sculpture during the previous forty years, the antiques brought home by the Republican and Imperial armies to be shown at the Napoleon Museum. Sculptors, whether survivors from the eighteenth century or newcomers to the art, made no effort to free themselves from it, but adopted it alike for official work and for work to be submitted for exhibition.

Amongst the work of the artists employed at the Louvre, Moitte's major contribution was a pediment of the Lemercier wing. The pediment of the restored and renewed Colonnade was given to Lemot to carve, and his subject was *Minerva crowning the Bust of Napoleon* (1808), though later the bust was changed for one of Louis XIV. Cartellier carved the *Peace* bas-relief (1807). Cartellier, Ramey the Elder, Désenne, and Corvet were employed on the Arc de Triomphe du Carrousel. The shaft of the Vendôme column, historiated with a spiral of bas-reliefs by the painter-engraver Pierre Bergeret, was

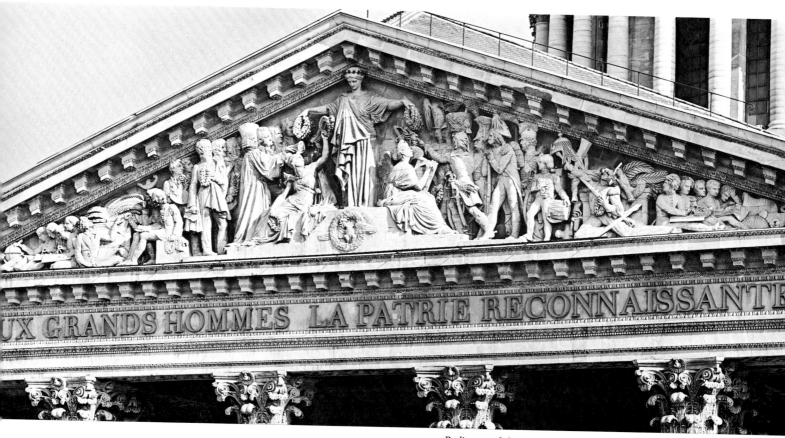

Pediment of the Panthéon, by David d'Angers.

first topped by a statue of the Emperor in Roman costume, by Chaudet (1810).

Ten fountains were planned to enable Parisians to benefit from the waters of the Ourcq — the most acceptable gift Napoleon ever gave to the city — but only one was completed, the Fontaine du Palmier, with figures by Boizot, and a *Fame* by Bosio, in gilded bronze. A second one, intended for the Place de la Bastille, never got beyond Bridan's mock-up of his *Elephant* (Gavroche, Victor Hugo's Paris street arab in *Les Misérables*, found good shelter in it). In 1830 the July Column was built close to this site. Imperial commissions for a series of Great Men, in imitation of the one begun by the Comte d'Angeviller towards the end of the monarchy, produced thirty statues for the Senate and twenty busts for the Tuileries, all of very mediocre interest. The number of busts of contemporaries being produced did not diminish, but they no longer showed the individualism of the previous century. Chinard, a Lyonnais, was the exception. He may well have carved the graceful and stylish bust of Madame Récamier in Paris. The aged Houdon became a convert to the conventional, and it was from the very champion of international neo-classicism, the Italian Canova, that Napoleon commissioned his own effigy and those of his nearest.

Louis XVIII, at the Restoration, had the statue of Henry IV on the Pont-Neuf remade by Lemot (1818), and that of Louis XIII on the Place des Vosges by Cortot and Dupaty (1828). The statue of Louis XIV in the Place des Victoires (1822) bears the signature of Bosio, originator in 1828 of the quadriga on the Arc de Triomphe du Carrousel. The groups carved by Bosio and by Cortot (*c.* 1825) for the Chapelle Expiatoire, and the colossal statues of 1828 designed for the Pont de la Concorde, relegated in 1837 to the Versailles courtyard and since dispersed, bring this list to an effective end. Exhibition catalogues could give details of other works of the times, which showed all too often the result of the intransigence of the classical spirit.

Geneva-born Pradier was still showing its influence under the July Monarchy. He produced some agreeable statues of women and an impersonal *Marriage of the Virgin* for the Madeleine church. However, the statues of *Lille* and *Strasbourg* for the Place de la Concorde and the twelve *Victories* for Napoleon's tomb in the Invalides (1845) show Pradier in a more satisfying vein.

Hard though it tried, the Romantic movement never found the sculptor of genius for which it was looking, though it believed it had found him in David d'Angers. More often than not, his inspiration remained classical, though for the pediment of the Panthéon (1832-36) he threw out the traditional draperies and clothed his Great Men in their normal wear. The Great Men had come to receive crowns from a grateful Motherland, supported on one side by Liberty and on the other by History.

115

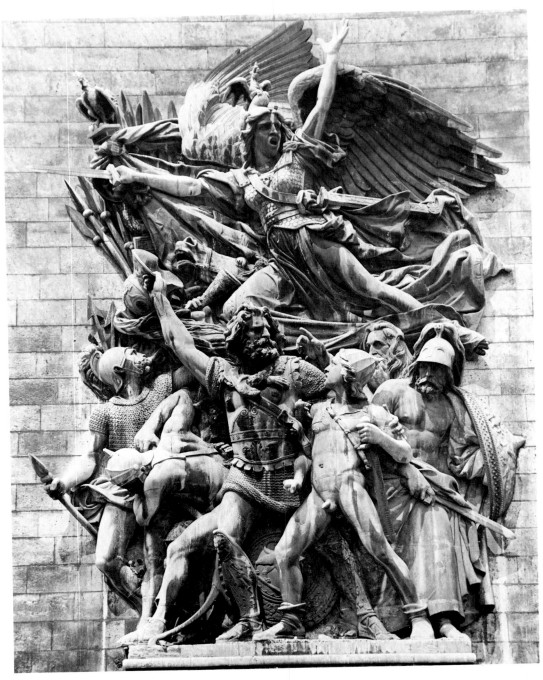

" The Marseillaise ", by Rude,
on the Arc de Triomphe de l'Etoile.

Small medallions by David d'Angers portray contemporaries who had their place in the literary and artistic fame of Paris. These constitute some of the best examples of his work.

François Rude was in a different class from David d'Angers. An admirer of past masters, he became linked with the Romantics by the fire and the spirit of his *Volunteers of 1792* which he created for the Arc de Triomphe de l'Etoile, with his volunteers transformed into warriors of unknown countries and into Roman legionaries, with the whole group dominated by the epic, fierce, and terrible figure of the Motherland in danger urging on her children to the battle and to glory; it is best known as *La Marseillaise* (1833-36). An equal ardour animates the statue of Marshal Ney, on the Observatoire crossroads (1833), whereas serenity and peace are the keynotes of the funerary effigy (1847) of Cavaignac draped in his shroud, in the Montmartre cemetery. The sober grandeur of these works should not be allowed to overshadow his *Prometheus* (1835) for the façade of the Legislature, the *Baptism of Christ* (1841) for the Madeleine church, or the dramatic calvary (1852) for Saint-Vincent-de-Paul.

The same vital force permeates the works of

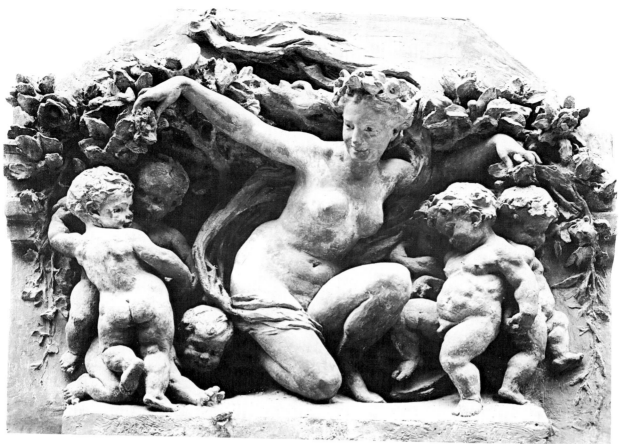

Flora's Triumph, by Carpeaux.

Barye, whose usual models were wild beasts. His small bronzes and wax models have no less power, no less breadth of conception, than his *Lion* (1840) at the Bastille, or his *Seated Lion* (1867) at the gates of the Tuileries, alongside the quay. During the reign of Napoleon III Barye composed groups of allegorical figures for the façades of the new Louvre (1854-60) which, with the new opera house, was about all the collective work done by the State for Paris in which the plastic arts entered.

In 1859 Carpeaux, the most likeable of the sculptors of the Second Empire, carved *The Dance* for the new Opera House. It was closely followed by the *Fountain* for the Observatoire (1867-72), in which the rhythm and the flexibility of form peculiar

to him make their first appearance, though his vitality and gay exuberance do not. The latter are to be seen, though, in *Flora's Triumph* (1866) for the Pavillon de Flore at the Louvre. Carpeaux was also a sculptor of busts, created with an all-pervading vivacity which makes them comparable to certain similar eighteenth-century works. His example and influence proved fruitful for the sculpture of the end of the century.

In general terms sculpture since 1850 had become more and more widely separated from architecture, and, thus deprived of guidance, was seeking unconsciously to take advantage of its relative independence by displaying the utmost variety of concepts. Official academic pieces rubbed shoulders in the

Tiger walking, bronze by Barye.
In the Bonnat Museum, Bayonne.

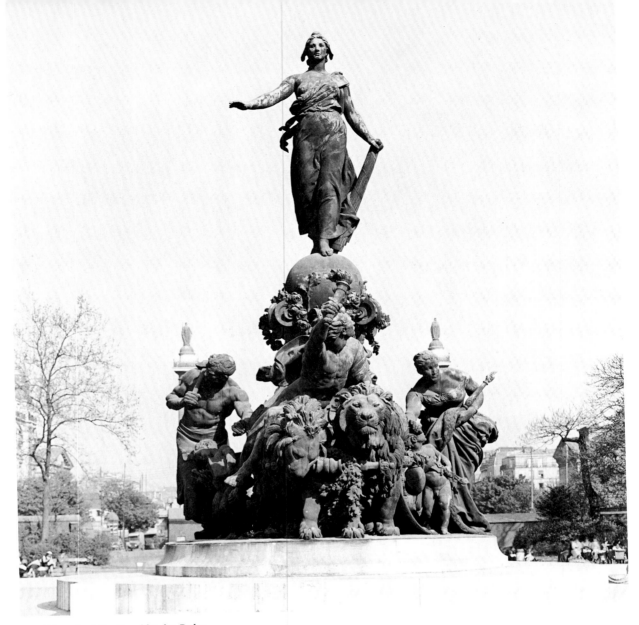

The Triumph of the Republic, by Dalou,
in the Place de la Nation.

streets with a sort of historical romanticism which Frémiet, a nephew of Rude, adopted for his *Jeanne d'Arc* (1874) in the Place des Pyramides, with Crauck's *Coligny* (1889), and with Dalou's naturalistic *Triumph of the Republic* (1879-99) in the Place de la Nation. After the German occupation of Paris only a few specimens remained of the multitude of statues of the most varied kinds which, from 1871 onwards, had been stuck on pedestals in the middle of Paris squares and circuses. It is not possible really to regret it even though, despite over-ornamentation and grievous mediocrity, Rame's *Chappe* (1893), Lormier's statues of *Pelletier* and *Caventou* (1900), and Bartholdi's *Balloon* (1906) at the Porte des Ternes, were precise (though possibly deceptive) evidence of the æsthetic preferences of an era.

Under the Third Republic the plastic arts, though thriving, did less and less for the city, despite all the building that was going on. Sculptors wished to be thought of as Florentines, or Parnassians, or Symbolists, concentrating more and more on works for art exhibitions and hardly at all on works which would adorn and decorate the city, despite all the banal sculptures. Rodin was an isolated and passionately adulated, passionately opposed. He had only one work of his set up on a public thoroughfare, about forty years ago. This was his *Balzac*, a grandiose sketch, but still no more than a sketch, of the work that might have been. Those who did not wish to risk being considered Philistines accorded it unlimited admiration. Only a single return to the style with which the nineteenth-century cycle closed is to be seen — Bartholomé's *Monument aux Morts* (1889-99) at the Père-Lachaise cemetery. Nevertheless a sculptural renaissance was taking place in the early years of the twentieth century, made noteworthy by Bourdelle's

freedom. Despiau was asserting himself with busts in which the life and personality of the model are expressed in a serene splendour of form. There were others who won appreciation, particularly in the Salon des Tuileries, which was founded in 1922. Joseph Bernard took as his method of exteriorization the rhythm of his conception of a return to the style. Maillol was a solitary who reduced his interpretation to essentials, stood away from his subject, and preferred immobility to mobility. His reputation has been done a disservice rather than a benefit by the recent implantation of some of his works in the Carrousel gardens, at the end of the Tuileries, in a situation which is not suitable for them. No less frequently imitated is François Pompon, who was late in being recognized by the public, and who has given himself over to animal studies. He finds pattern in surface relief and looks more for the semblance than the reality of volumes. Whilst the Independents were working and innovating, mastering their art and acquiring influence, the representatives of 'official' sculpture — former winners of the *Prix de Rome* and now members of the Institute — became relatively firmly attached to the scholastic world or else were making efforts to prove that they were not entirely indifferent to problems arising outside their own fields. Running parallel with this, Cubism was introducing its distortions and daring syntheses into the world of the plastic arts.

Statue of Mickiewicz, by Bourdelle.

Bas-relief by Bourdelle on the Théâtre des Champs-Elysées.

bas-reliefs for the Théâtre des Champs-Elysées (1912). Not far from it is the Place de l'Alma, where his monument to Mickiewicz, which looks like an enlarged drawing-room figurine, was erected in 1927.

Bourdelle's influence was bound to prove inescapable, for sculpture had been held at arm's length by architecture, or cut down by it to a poor-relation status. The sculptor's need to construct, to balance masses, to chisel straight into the block, all of which was a reaction towards Impressionism, became more and more generally felt. And yet Bourdelle, sculptor's assistant to Rodin, has been called the last of the Romantics. He made a show of a certain Greek and medieval archaism and ended with a monumental art of a lyricism not devoid of intellectuality. His ascendancy was less than that of a Schneeg (who disappeared all too soon) and his band, seeking greater stability and

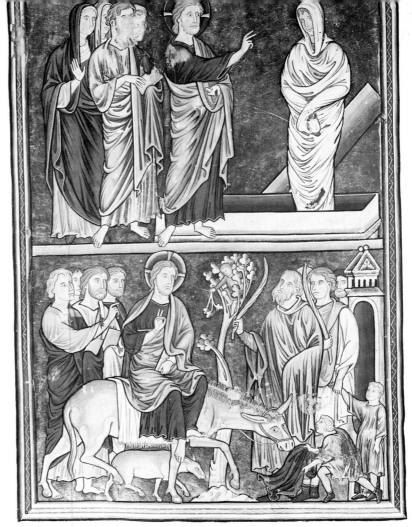

Psalter of Queen Ingeborg: the Resurrection of Lazarus and the Entry of Christ into Jerusalem. In the Condé Museum at Chantilly.

MINIATURES

AND

PAINTINGS

In the twelfth century the art of the miniature was still being practised only in monasteries. In Paris, manuscripts were being illuminated in the abbey of Saint-Martin-des-Champs and the abbey of Saint-Victor. Not until the thirteenth century was a lay school of illuminators founded in the city, but once established it soon became a highly developed one. There were many different reasons contributing to its rapid rise, first amongst which were the increased importance of the university and the favour of kings, Saint Louis (Louis IX) in particular, who seems to have built up a library in the chapel of the Palais de la Cité in imitation of Oriental princes. One of the special features of the Paris schools of miniaturists was the influence on it of stained glass, above all in the matter of colouring, in which purple and blue predominate in a range of dark tones.

In the first half of the thirteenth century the ornamenting of psalters was much to the fore, such as the one with a gold background belonging to Queen Ingeborg, wife of Philip Augustus (now in the Condé Museum at Chantilly). Then there was the *Psalter attributed to Marguerite of Burgundy* (now in the Bibliothèque Sainte-Geneviève) and the *Psalter named after Blanche of Castille* (now in the Bibliothèque de l'Arsenal). In this last-mentioned one, the miniatures are arranged two by two in medallions, linked by an ornamental frame which for the first time brought techniques used by glass workers into the field of illumination. In the case of the *Psalter of Jeanne de Navarre*, this borrowing is increased and enriched (this psalter is now in the John Rylands Library, Manchester). At this time the miniature Bible — which was an innovation — became quite widespread.

During the course of the second half of the thirteenth century the influence of stained glass gave way before that of architecture and sculpture. The miniatures imitated pinnacles and gables, motifs for windows and rosettes. As more detail was incorporated, so realism increased.

Miniature from the Froissart Chronicles. Paris in mid-fifteenth century: the Cité, the Porte Saint-Jacques, and Philip Augustus's circumvallation. Bibliothèque Nationale.

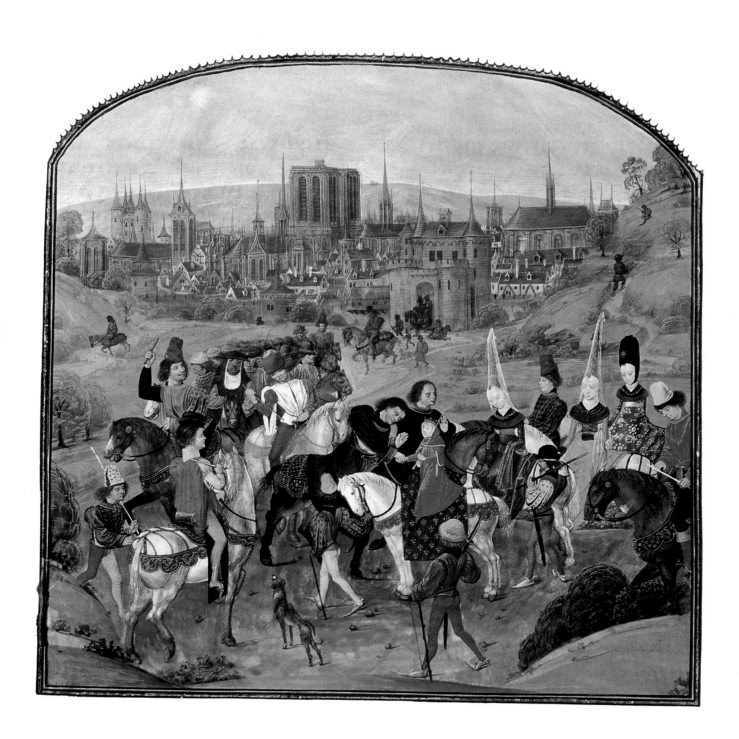

Figures became much more delicate and finely drawn and the range of colours became lighter in tone.

These tendencies are underlined by the work commissioned by Saint Louis for the Sainte-Chapelle — the last leaves of the *Gospels for the Principal Feasts of the Year* (c. 1270), and the *Lectionary*, in which there are a few little comic scenes; both of these are now in the Bibliothèque Nationale — and by the two *Psalters of the King*, one (c. 1254) now in the Bibliothèque Nationale and the other (c. 1270) in the former Yates Thompson collection. They both still have magnificent self-gold backgrounds.

In 1292 Paris boasted seven illuminators settled in various quarters on the Right Bank, whilst on the Left Bank there were no fewer than twelve miniaturists. They were to be found near Saint-Séverin, round about the University and in the Rue Erembourg-de-Brie, which later became the Rue Boutebrie. One of the most highly honoured of them was Master Honoré; together with his son-in-law, Richard de Verdun, he painted the illustrations for the *Breviary of Philip the Fair* (1296), in the Bibliothèque Nationale. The increase in the number of lay artists and the competition between them had a decisive influence in stimulating the evolution and progress of the art of the miniature.

Great activity was shown between 1320 and 1390 in the studio of Jean Pucelle, pupil of Master Honoré. His masterpiece, after the *Latin Bible*, in the Bibliothèque Nationale, copied by Robert de Billyng in collaboration with Anciau de Ceus (or Cens) and Jacques Maci, and after the *Heures de Pucelle* in which Mehuet Ancelet and J. Chevrier had a hand, was the breviary made for Olivier de Clisson and his wife, Jeanne de Belleville (c. 1343), called the *Bréviaire de Belleville* and now also in the Bibliothèque Nationale. His figures are idealized, but his feeling for nature and his realism are manifested in the marginal ornamentation. Here foliage and flowers are combined with animals and insects, burlesque designs, and scenes of common life. Amongst the characteristics of the Breviary are the disappearance of the golden background, a preference for grisaille, a preoccupation with form, the trouble taken to ensure the differentiation between full daylight and the shadows of evening, and an Italianate touch in the portrayal of buildings.

Under John the Good (Jean II) and Charles V, who kept his library in the tower of the Louvre, production became more and more abundant. Work on the miniatures for the *Bible of Jean de Sy* (c. 1356) was suspended after the battle of Poitiers and the capture of the King. These were the work of the *Maître aux Boqueteaux* (Master of the Spinneys), so called for his partiality for including groups of trees and bushes in his pictures. Some part of the illustrations of the *Grandes Chroniques de France* (c. 1375-79) are attributed to him, amongst them in particular the reception of the Emperor Charles IV by King Charles V. Many remarkable works saw the light of day in the reigns of the latter and of Charles VI. They include both religious and profane subjects, as well as historical and contemporary scenes, which were much on the increase. Artists of the old Parisian school like Pierre (or Perin) Remiet carried on their own work in their own way, whilst masters of the art came down from the north to compete with professional illuminators. In a few years they transformed and gave

Miniature from the de Belleville Breviary, in the Bibliothèque Nationale.

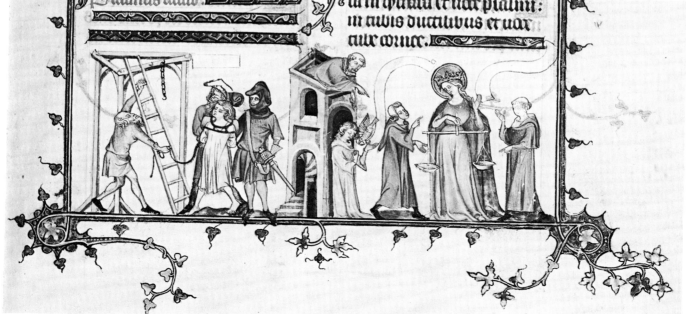

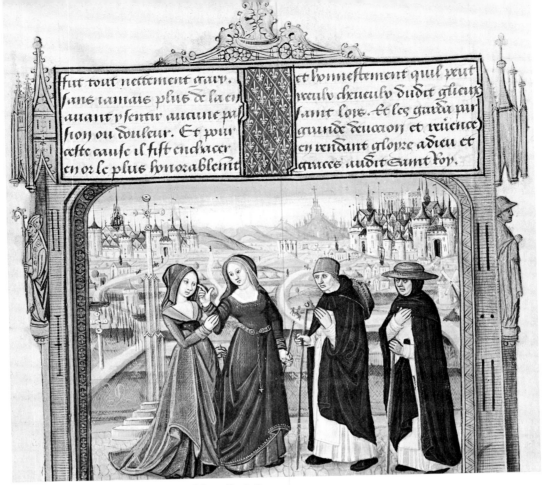

Scene from " The Life and Miracles of Saint Louis ".
Behind the figures, Paris as seen from the Saint-Denis plain.
In the Bibliothèque Nationale.

new life to the art of the miniature. André Beauneveu was followed by Jacquemart de Hesdin and the master of the *Boucicaut Book of Hours*, who was doubtless Haincelin, the Alsatian from Haguenau. All three worked for the Duke of Berry, brother of Charles V. A passionate lover of the arts, this Prince also had in his service the most eminent of the Franco-Flemish illuminators, Pol de Limbourg and his brothers, who had a most flattering reputation amongst Parisian miniaturists. They were faithful interpreters of nature and authors of the *Très riches Heures du duc de Berry* (in the Condé Museum, at Chantilly), that incomparable Book of Hours whose illustrations are the very triumph of Gothic miniature.

Whilst the miniature was completing its cycle, painting began a development which, with varying fortune, continues into our own days.

Gothic religious architecture, which ended with empty spaces becoming more important than the solids, necessarily limited the use of paintings. Monumental painting was reduced to a minor decorative element, used only to give a vivid polychrome cover to the inner walls of churches. Sky blues and poppy reds carried all before them; they were as bright in colour as possible, for they always had to stand up to the gleaming colours of the stained-glass windows beside them. The finely restored paintwork of the Sainte-Chapelle can enable one to imagine how some Parisian churches may have looked. Also at the Sainte-Chapelle the backgrounds of the little frescoes evoking certain saints are themselves ornamented with tablets of blued glass, set off with gold. Thus the subordination of the painter's art to that of the glassmaker was complete.

All the same, some mural paintings continued in production. Scenes in the life of Saint Louis were commissioned for the lower chapel of the Sainte-Chapelle, for the cloisters of the Franciscans of Lourcines, and for the Carmelite convent in the Place Maubert. A little before this, Jean d'Auteuil, who had finished painting a chapel for Saint-Jacques-le-Pèlerin, worked for the King in 1322 at the Hôtel de Navarre. As private architecture continued to provide fairly vast wall areas, monumental painting was able to continue on its way. Very large works were painted for Charles V as decorations for the Hôtel Saint-Pol; nothing could be more magnificent than the Queen's Gallery in which figured most prominently " a great forest full of trees and shrubs, laden with fruit and intermingled with flowers ". In about 1366 Charles V commissioned paintings for the Louvre to decorate

*The central part of " The Narbonne Altar Frontal "
in the Louvre Museum.*

the Great Hall, or Lower Hall, " enhanced by birds and animals playing in open countryside and accompanied by the likenesses of deer ", a work which must most certainly have been carried out with all the refinements of the art, but of which only descriptions remain.

At the time these big works were finished the easel picture — that is to say, one painted on a mobile panel — had been in existence only for a short time. This type of picture came into being in Paris, where the refinement of the Valois Court was not without its influence in augmenting the attraction the city already had for painters. In the main these painters were French, but many also came from countries like Flanders which were attached to the Crown of France. Others, less numerous, had come from Italy, or had been living there, or had acquired knowledge of the arts of Italy. So great was the faculty for assimilation and expansion which characterized French art — and most particularly the French art which originated in Paris — that despite these differences of origin a school of painting arose which could be described both as national and international, for it had widespread influence not only in the provinces but beyond the frontiers as well.

Attention should be called to two major works, the *Portrait of King John* (*c.* 1360) and the *Narbonne*

Altar Frontal (between 1364 and 1377), rather than to the series of minor pieces, incorporating with some preciosity gables and finials, all somewhat arid in style, though including elegantly dressed people, which are presumed to be Parisian in origin.

In the portrait mentioned the royal face in profile appears to have been reproduced with a faithful simplicity which shows it unmarred by physical defects. The background is of raised gold with chequered ornaments in relief. Although it is based on a wooden panel covered by a plaster-impregnated cloth, it is none the less a work deriving from mural painting. It has sometimes been attributed to Girard d'Orléans, and might have been painted in England during the King's captivity, following the battle of Poitiers. Girard d'Orléans died in 1361. He belonged to a dynasty there will be occasion to follow into the fifteenth century. Its founder was Everard d'Orléans, who was already established in Paris before 1292 and in 1304 was the first recipient of the title of Painter to the King.

The *Narbonne Altar Frontal* was intended for use in Lent, like a mitre to be seen in the Cluny Museum; it is a grey-black monochrome on white silk and dates from between 1364 and 1377. Below an architectural pattern of pointed arches including the figure of Church and Synagogue, King Charles V and Queen Jeanne de Bourbon kneel on either side

Detail from the " Descent from the Cross " once in the abbey of Saint-Germain-des-Prés. In the background the abbey, the Louvre, and the hill of Montmartre can be seen.

of a Christ on the Cross. It has been pointed out that this composition has many points of design and composition in common with miniatures. Certain affinities with the work of ivory-carvers and with the traditions of monumental work have also been pointed out. It has been attributed most often to Jean d'Orléans, brother or son of Girard, who succeeded him. He was not the only master of the arts to be employed by Charles V, who came to the throne in 1364. Amongst the painters and miniaturists from the north who worked for him were André Beauneveu, equally famous as a sculptor, Everard de Hainaut, Jean de Bondol or de Bandol, called Jean de Bruges or Hennequin. They also worked for other prominent people such as the King's brothers, the Dukes of Burgundy, Anjou, and Berry, each a Mæcenas with a home in Paris as ostentatious as any they kept in their own provinces.

Until the end of the century Paris remained a centre for easel painting which outshone all other schools. Its sphere of influence was certainly increased when an association was formed in 1391 grouping twenty-five painters and five sculptors. In it can be seen, far, far in advance, the beginnings of an Academy of Painting, an institution which in fact was not founded until the middle of the seventeenth century. Amongst those who signed the statement of objects of the group as being " anxious to preserve the integrity and purity of their art " were Jean d'Orléans (he lived until 1418, helped in his latter days by his son François), Colard de Laon, future creator of works for Isabelle of Bavaria (1405-6) and the Paris Parlement, and Etienne Langlier or Lannelier, titular Painter to the Duke of Berry. We know little about the results of their efforts, for however significant they may have been they must all have been obliterated by the political events of the reign of Charles VI. From the very beginning of the fifteenth century these caused the decline of painters' studios in Paris. Revolts and invasions sped the dispersal of artists, which had the effect of contributing to the prosperity of regional centres.

The Paris of Charles VII was ravaged, impoverished, placed under foreign domination, or deserted by the Court; in it, the arts vegetated. Death was present everywhere, its hideous triumph portrayed in the *Danse Macabre* of 1424 painted on the wall of the Cimetière des Innocents and doubtless made widely known by the copies on vellum in the Cabinet des Estampes and, at the end of the century, by a series of engravings. The liberation of the city in 1436 and the return of peace failed to bring the Paris studios back to life, for the King made only rapid visits and the Court remained firmly devoted to the banks of the Loire. It made Paris seem no more than a provincial centre. Its pictorial production in those days can be summed up in the great panel in the form of a frieze which for long was at Notre-Dame and later in the Louvre. Painted between 1445 and 1449, it showed, with a certain baldness of style, Jean Jouvenel, his wife, and their eleven children. A few painters came back to Paris to live after 1450, but they were far from bringing it back its previous lustre. Colin d'Amiens was employed by Louis XI on a number of occasions, and the names of Yvon Fourbault and Jean de Boulogne crop up. The *Retable du Parlement* dates either from the end of the reign of Charles VII or the beginning of that of Louis XI. Different specialists attribute it to different artists. In the far background of the scene of the Calvary with Saint John the Baptist, Saint Denis, Saint Louis, and Saint Charlemagne are two views of Paris. More painters

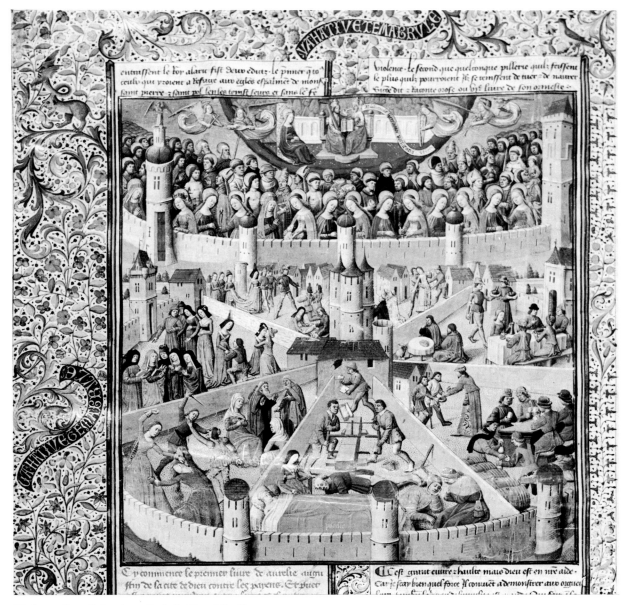

Miniature from Saint Augustine's " City of God ".

are heard of after 1490. Anne of Brittany bought a *Virgin* from Jean de Cormont in 1493, and Robin Richet and Antoine Sélicourt are mentioned. More or less to this time belongs a *Descent from the Cross*, belonging to the abbey of Saint-Germain-des-Prés and now in the Louvre. It shows views of the abbey, the Louvre, and Montmartre; also belonging are the fragments of a retable from the Master of Saint-Gilles, to which a Parisian origin has been attributed because of the background of his remarkable works.

Unlike painting, the miniature retained its vitality during the greater part of the fifteenth century. The professionals of the miniature carried on working for Queen Isabelle of Bavaria all through the occupation (she died in 1435) or for the Duke of Bedford, leader of the English party. They continued to conform to the rules of a graceful art in which truth and realism had their place. It was

through the Bedford connection that the *Psalter of Henry VI, King of England* came to be made (now in the British Museum) and the so-called *Salisbury Breviary* (now in the Bibliothèque Nationale). Nor were the miniaturists idle once the English occupation was over. They undertook a *Missal* (*c.* 1434, in the Bibliothèque de l'Arsenal) for Jacques Le Chatelier, Bishop of Paris, which was completed for his successor, and were also able to bring to a successful issue the illumination of *The Dunois Book of Hours* (former collection of Henry Yates Thompson). Jean Haincelin, who worked for the Duke of Orléans between 1448 and 1450, must have been one of those artists who were as clever at keeping on the right side of whoever was in power at the time as they were at wielding a brush. Without stopping to pursue the career of Jean Fouquet, who must have been in Paris, though only for a short time, we find Guillaume Alixandre following

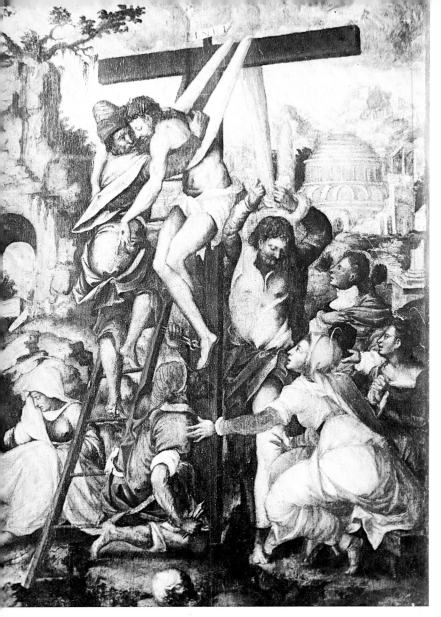

" Descent from the Cross " by Jean Cousin.
In a private collection.

Jean Haincelin. We know that he was miniaturist to Jean d'Armagnac, Duke of Nemours. At this point come also the delightful works of the Master François studio, with the team producing enchanting illuminations. From this team came the illustrations for *The City of God* (1475, in the Bibliothèque Nationale). This kind of production was current until printing and engraving were far enough advanced to take the place of the illumination of manuscripts.

Meanwhile a number of wealthy men who wanted for themselves paintings in the style of those they had been admiring across the Alps during the wars in Italy were the cause of a number of artists from Italy coming to settle in Paris. Once the example had been given, royalty was not slow to do the same. Under the guidance of Rosso, Francis I brought a whole colony of Italians to work on the decoration of the château at Fontainebleau. He later chose Primaticcio, who remained in favour under Henry II.

The work of these two and their helpers set the fashion for historical painting. Paris was too close to this art centre at Fontainebleau not to call upon the team which worked there, or upon French rivals equally steeped in Flemish influence. Primaticcio decorated the chapel of the Hôtel de Guise. One Jean Cousin (there were two of them) worked on the preparations for the reception of the Emperor Charles V, in 1531, and prepared cartoons for hangings or stained glass. Antoine Caron collaborated with Germain Pilon for the ceremonies in 1573 in connection with the solemn entry of the future Henry III, elected King of Poland. They also prepared the drawings for *The History of Artemisia*, which were later used for a tapestry. These, however, are exceptional or isolated cases. The true representatives of pictorial art in Paris during the greater part of the sixteenth century are the Clouets, father and son, who doubtless came down from the north to live in Paris. Jean, often called Jehannet, was succeeded by his son François. Linked with their names are those of Benjamin Foulon, Jean Decour, and, later, the Quesnel family, and, later still, the Dumonstiers. These were all creators of portraits from life and frequented the world of great men and of royalty itself. Their output met with extraordinary favour and put all other forms of painting out of favour. At first their pictures were painted in oils after having been sketched in. They soon became almost entirely crayon pictures (carbon and red

Louis de Rohan, Duke of Montbazon.
by Benjamin Foulon,
In the Bibliothèque Nationale.

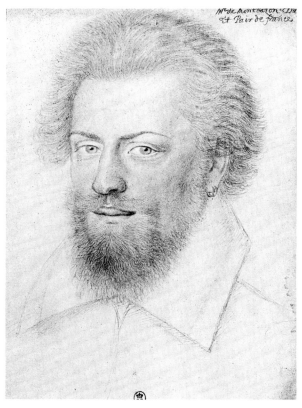

chalk) which ultimately were highlighted by touches of other colours. Before they fell into the repetitious, the conventional, and the exaggerated, their originality, simplicity, and honesty of means made them essential links in the history of French art. They are indeed witnesses to the vitality of the French artistic tradition at the time when the Renaissance was blossoming.

French painting in the first half of the seventeenth century made an effective contribution towards first the superiority and finally the artistic hegemony of Paris. It had tended to make itself into an organized and coherent unit — a school which was to become the classical school of the second half of the century. Until about 1625, or even a little later, there was no decisive development from which the future could be foretold. The French or Flemish painters to Henry IV, members of the second Fontainebleau school and apparently much influenced by Italy, had so far been engaged at the Louvre on works of no particular power. What they did do turned out to be fated for rapid destruction. By 1620 all the principal painters had died a longer or a shorter time back. Toussaint Dubreuil died in 1602, Henri Lerambert, painter of cartoons for tapestries, in 1609. Jacques Bunel, the Blois-born Protestant, had been no more since 1614. It was he who had painted, amongst other works, the vault of the Little Gallery on the first floor of the Louvre (c. 1600-7), from an original by Dubreuil. With the help of his wife, Marguerite Bahuche, he peopled it with kings and queens and princes. Martin Fréminet followed him to the tomb in 1619. None of these decorators left a successor. For this reason Marie de Médicis, who already had her own Flemish portraitist, Frans Pourbus the Younger of Antwerp, commissioned Rubens to paint the story of her life (1621-25). *The Actions of Henry IV*, also intended for the Luxembourg Palace, were never completed by the master from Antwerp.

Such approximately was the situation of painting in Paris in 1627, when Simon Vouet, after fourteen years in Italy, returned to Paris and was appointed First Painter to the King. Is the origin of the classical French school to be attributed solely to his return, as has often been claimed? The question is not one to be discussed here. Nevertheless it is certain that if one studies not only his own works but also those of his pupils — Le Sueur, Le Brun, and Mignard — it is clear that Vouet's activity, even if not his influence, was preponderant. Orders poured in. Almost all the decorative work he did in Paris is known to us only through engravings and tapestries, and what is known is only a part. With his pupils playing their part, he completed the chapel and the *Gallery of Illustrious Men* (1632) in the Palais Cardinal, a work shared with Philippe de Champaigne; *The Labours of Ulysses* (1634) in

Robert Arnaud d'Andilly, by Philippe de Champaigne, in the Louvre Museum.

the upper gallery of the Hôtel de Bullion, with stucco work by Jacques Sarrazin; paintings for the Hôtel Séguier (1634-40); works at the Palais de Justice for the Cour des Enquêtes (Preliminary Investigation) and Cour des Aides (Board of Excise), and at the Palais-Royal for Anne of Austria's bathing apartments (c. 1643-44). His historical and mythological pictures, his religious canvases for churches and convents, which multiplied rapidly after the Counter-Reformation, were innumerable. They show his somewhat superficial facility and his flexibility in adapting and assimilating methods borrowed from the leading Italian masters of the end of the sixteenth and beginning of the seventeenth centuries, from which his own differing styles sprang. Nevertheless, despite appearances, he did depart from the baroque in many ways.

Vouet was not alone in combining different decorative elements, particularly for galleries in which both paintings, and statues were housed. These were then frequent in Paris mansions in imitation of Italy. Jacques Blanchard, known as the French Titian, would have been a serious rival to Vouet but for his premature death. In rivalry with Vouet he painted the lower gallery of the Hôtel Séguier (1634). The gallery of the Hôtel de la Vrillière (1634), restored without taste in the nineteenth century, was by François Perrier.

The family meal, by Louis Le Nain, in Laon Museum.

Mazarin brought his compatriots Borzoni and Grimaldi to Paris for the upper and lower galleries of his new Palace (*c.* 1646). They were accompanied by Romanelli, who, on the occasion of a second visit, painted Anne of Austria's apartments in the Louvre (*c.* 1655-57). Charles Le Brun was responsible for the gallery of the Hôtel Lambert (*c.* 1650-58), one of the earliest amongst his immense decorative pieces. Lastly, it was the composition of big-scale paintings for the Great Gallery of the Louvre which brought Poussin away from his Roman retreat for a short stay in Paris (1641-43). Poussin, this complex, unparalleled genius, searched for a doctrine for his classicism which he never found but remained obscurely oracular.

The eclectic, try-anything-once Sébastien Bourdon and Eustache Le Sueur are two more to be included amongst the decorators, the first at the Hôtel de Bretonvilliers (1663; the work has ceased to exist), the other at the Hôtel Lambert (*c.* 1645), at other private dwellings, and at the Louvre. A pupil of Vouet, Le Sueur had never lived in Italy but had drawn his inspiration from Raphael and from antiquity. Apart from the pure and fresh grace with which he endowed his *Muses* at the Hôtel Lambert (now in the Louvre Museum), he was also able to express a frank and ingenuous religious sentiment, as can be seen in the episodes of *The Life of Saint Bruno* which he painted for the Carthusian monks (1645-48, now in the Louvre Museum). The gentleness of his pious compositions makes a contrast with the gravity of Champaigne's sacred pictures. The latter had cast aside his memories of Flanders and torn himself away from Italianism and the baroque, to end in coldly idealistic austerity. A very active man, he had played his part in the decoration of the Palais-Royal, the Tuileries, and the Val-de-Grâce convent (1643), as well as the dome of the Sorbonne (1642-44). He was a religious painter, an historical painter, a mythological painter, a painter of allegories, yet in our times is appreciated more highly as a portraitist than in any other rôle.

Following on after the crayons of Lagneau and de Dumonstier, the elegant and formal portraits of *Les Précieuses* (of which Charles David's engravings give a good idea), and Guernier's miniatures, and either before or at the same time as the worldly style used by the Beaubruns and later by the Elles, Mignard, and François de Troy, Champaigne took up again the stately portrait launched by Pourbus. He stripped it bare and ennobled it with his own deep sincerity. Occasionally he would return to the style of the Flanders and Netherlands painters and paint groups of people. Examples are *The Provost of the Merchants* and *The Paris Magistrates* (1649, 1652 or 1656), but the absolute mastery of his art is best shown in his penetrating and stern likenesses of *The Recluses of Port-Royal* and their companions.

The portrait managed to survive in relative independence. It retained some of the Champaigne tradition and something of the style of the Le Nain brothers, who do not come within our scope. Later it may be seen as an opposition to the academic

classicism which reigned over painting from 1660 to 1690.

At the time of its constitution in 1648 the Royal Academy of Painting and Sculpture was no more than a group of privileged artists working for the Crown who were anxious to defend themselves from the unreasonable demands of architects and master-masons, and at the same time to improve their own profession by undertaking a teaching rôle. Charles Le Brun was its Director and Chancellor from 1655 onwards. He was made Chancellor for Life in 1663, and Director in 1683. He was First Painter to the King from 1662 onwards, Director of the Crown Furniture Manufactory at the Gobelins (1663 and 1667), Custodian of the Royal Collections, and, in addition, a Member of the Academy of Architecture. He exercised a restraining influence on all the arts, major and minor alike, almost until his death in 1690. Le Brun, with the approval of Colbert, who was Superintendent of the Fine Arts, turned the Academy into an organization devoted to the creation of a monarchical art, able to translate into the language of the arts the grandeur and the brilliance of the reign of Louis XIV, and to enhance them. The Academy on the one hand worked for the future by founding the French School of Art in Rome in 1666, and on the other hand kept a watchful eye on the present by establishing its own doctrine. The authority of the ancients, transmitted by means of antique remains, the lessons learned from Poussin, the examples left by Raphael and the Bolognese, as well as borrowings from the Cartesian system, all converged to produce "indisputable rules". The hierarchy of the disciplines and the primacy of form over colour were both part of the dogma, and operated a strict control over subject and composition. The restraint arising from this, sternly maintained by Le Brun, served Versailles miraculously well, and as a result the capital was somewhat deserted. However, before the work of decoration of this new royal city began, monumental painting, which headed the disciplines, had further occasion to display itself in Paris. The Apollo Gallery, a replacement of the little Bunel Gallery at the Louvre, which had been burnt down, was begun in 1661. It gave Le Brun the opportunity to display his grandiose ideas, which included every detail down to the design of the locks and every piece of wood-work. The team of painters which he called on included Léonard Gontier, Jacques Gervaise, Jean-Baptiste Monnoyer, and Jean Lemoyne; as well as painters, a team of sculptors was engaged, including Girardon, Gaspard and Balthazar de Marsy, and Regnaudin. Then, from 1664 onwards, the bulk of those later to be found at Versailles, old-stagers or newcomers, were at work on the apartments of the Tuileries Palace: Nocret, Noël Coypel, Houasse, Charles Errard, Vignon, Sébastien Bourdon, Philippe and Jean-Baptiste de Champaigne, Jouvenet, and Charles de la Fosse.

In order to work on the dome (1663) of the Val-de-Grâce convent, much praised by Molière, Le Brun's rival Pierre Mignard forsook for a time his portraits and his gentle religious pictures, his *Virgins*, which gave a new adjective to the language, *mignarde*, a form of daintiness. Academicians and historical painters worked away at the Gobelins, translating drawings and sketches by Le Brun into cartoons for tapestries; they were Houasse, Henri Testelin, the Corneilles and the de Sèves, Bonnemer, and Claude Audran. Specialists were attached to them who were normally engaged on more personal works: the Flemish Van der Meulen, Baudouin, and Genoels and the French Etienne Allegrain concentrated on landscape, Pierre Boels and Nicasius of Antwerp on fruit, Jean-Baptiste Monnoyer and Blin de Fontenay on flowers, and Guillaume Anguier on architectural subjects.

After the death of Colbert (1683) his successor Louvois pushed Le Brun aside. The latter died in 1690. Mignard took his place, although he was almost eighty, and inherited his prerogatives and his offices. Then he too died in 1695, having had the last satisfaction of seeing all that Le Brun had built begin to crack, clearly showing that total collapse was imminent.

In fact, long before the end of the reign (1715), " high art " and " lofty taste " characteristic of the reign of Louis XIV had fallen into neglect and been abandoned. The official doctrine imposed by Le Brun could not continue to exist after his death and, sooner or later, was bound to create a reaction. The prestige of the Bolognese diminished, and what they lost the Venetians gained. The influence of the Flemish, and after them of the Netherlanders, became paramount, for, from the year 1625, a permanent colony of northern artists lived around Saint-Germain-des-Prés.

Though there were both innovators and laggards at the end of the seventeenth century and the beginning of the eighteenth, it is true in general terms that change was not instant but gradual and continuous. Its speed was accelerated after the turn of the century when newcomers took their places beside those who had been the collaborators and the pupils of Le Brun. Yet his teaching was not forgotten by some, such as Charles de la Fosse, yet even he when working on the dome of the church of the Assumption (c. 1676) and the dome of the church of the Invalides (1705) showed himself to be a resolute colourist. The chapels of these churches were painted by Noël Coypel, Michel-Ange Corneille, the Boullongnes, and Jouvenet. The last mentioned retained a pious fervour of the kind with which the eighteenth century could not be bothered. Although it was not entirely cast aside, religious

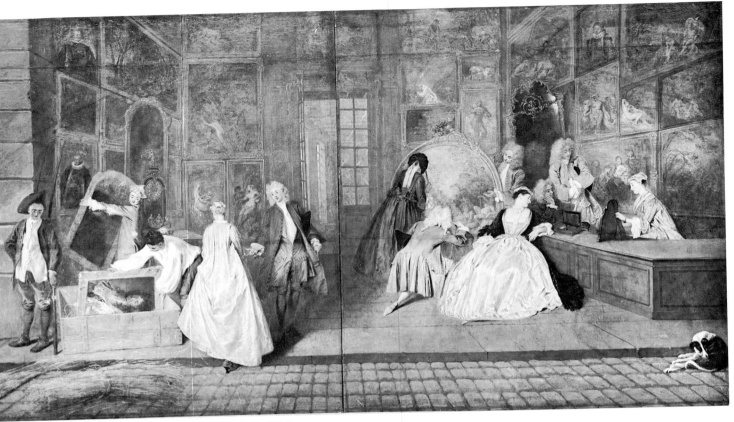

*" L'Enseigne de Gersaint ", by Watteau.
In the Charlottenburg Museum, Berlin.*

painting declined in importance. The *Mays* of Notre-Dame — the pictures presented each year to Notre-Dame by the Guild of Goldsmiths — which in the seventeenth century had included canvases by Lallemand, Aubin, Vouet, Blanchard, La Hyre, Bourdon, Le Sueur, and Le Brun, ceased in 1707. For a short time the *Mays* of Saint-Germain-des-Prés took their place, but other than Van Loo and Jean Restout, nephew of Jouvenet, only pictures by second-rate artists were presented. The ceiling of the choir of the Jacobin chapel in the Faubourg Saint-Germain (church of Saint-Thomas d'Aquin, 1723) and the dome of the Virgin Chapel of Saint-Sulpice (1731) by François Le Moyne are no more than attractive specimens of decorative painting. This art form as applied to palaces and private mansions, had undergone profound changes. Between the completion of the Gallery of the Palais-Royal and the compositions for the Chancellerie d'Orléans (which have been dismantled) with Antoine Coypel's delightful glimpses of nudity (1700-16) and the *History of Psyche* arranged by Natoire in the compartments of the oval *salon* of the Hôtel de Soubise, customs, æsthetics, and tastes had all been transformed. Painters were deprived of royal commissions now that Versailles was finished, and took

the road back to Paris, there to rediscover their own personalities. Princes and financiers and wealthy bourgeois were their patrons for the decoration of their homes, large and small, which were now being made all cosy and comfortable, and ornamented with panels and overdoors in gentle and pleasing compositions, painted solely for the pleasure of the eye. Arabesques, a form of ornament brought back into use by Berain and again by Claude Audran III, by Gillot, and by Watteau, were so successful that Christophe Huet had no hesitation in introducing amongst their complexities a troop of monkeys parodying human actions, even though it was for the Hôtel of Cardinal de Rohan (*c*. 1730).

Rubenists won the day from the Poussinists. Historical painting was treated with disdain. Flemish carousers and domestic anecdotes were imitated by Parisian artists, who imitated Flemish techniques as well. When the brief existence of Watteau came to its close in 1721, barely six years after the death of Louis XIV, the break with the past — that is, with the Academy — was complete. Watteau, who gave life to military scenes, to genre paintings, to scenes from the theatre, to a picture such as *L'Enseigne de Gersaint*, dreamlike and realistic at one and the same time, remains above

Still Life by Oudry, in the Louvre Museum.

all the painter of *L'Embarquement pour Cythère* and *Les Fêtes galantes*, in which satin-clad lovers in a park whisper secrets in each other's ears under unreal though precisely indicated foliage, or listen dreamily to snatches of melody from a guitar and the gentle splashing of a fountain. The heritage he left, deriving from Venice and Flanders, transmuted by his own invention, dominated the remaining years of the century until reaction set in with David.

How can one condense into a few lines the great variety of painters, from Watteau to Boucher and David, who worked in Paris during the reigns of Louis XV and Louis XVI? Paris in the eighteenth century had become the intellectual and artistic centre of Europe, a town as pre-eminent as once Rome had been. Foreign monarchs vied with each other to secure the services of its painters whilst their own subjects came to Paris to be initiated into the practice and secrets of an art held to be unrivalled.

Pater and Lancret were less well known, minor masters, who went on painting the gay parties. Boucher, a decorator whose talent was as prolific as it was facile and whose colours were bright and lustrous, painted endless overdoors and piers as an excuse for showing pretty female bodies with rosy

" Tea in the English manner in the Salon of the Four Mirrors at the Temple ", with the Prince de Conti's whole court listening to the young Mozart, in 1766. By Ollivier, now in the Louvre Museum.

and pearly flesh in a flutter of drapery and a profusion of loving attitudes, turning at times to pastoral scenes and pretty shepherdesses.

Huge conventional compositions and suggestions for Gobelins tapestries were painted by de Troy, Charles-Antoine Coypel, and Carle Van Loo. Parrocel was the painter of battles. Desportes and Jean-Baptiste Oudry were painters of animals and landscapes. Joseph Vernet was the painter of seascapes, and Chardin was the inimitable still-life painter, brought to public attention by showing at the Annual Youth Exhibition in the Place Dauphine, where he triumphed with his subtle colour sense and his middle-class interiors. There was Greuze, moralizing, lachrymose, or displaying innocent ambiguities. Then there was the fiery Fragonard, who flirted with nearly every genre, imitated everybody, and resembled nobody. And there was the whole crowd of so-called secondary painters,

François Gigot de la Peyronie, by Rigaud. In the Faculté de Médecine, Paris.

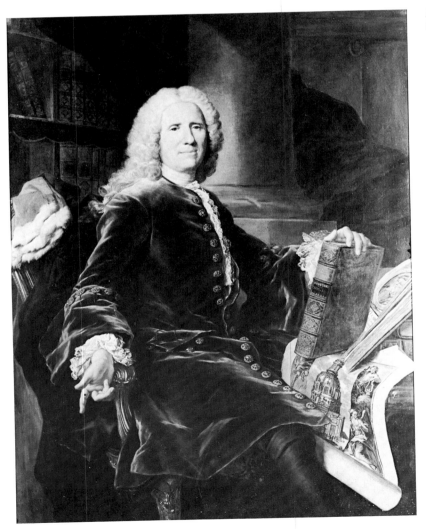

who in fact had no rivals to fear beyond the very great masters. And lastly there were the portraitists.

Onwards from the middle of the eighteenth century the tradition of the portrait was maintained and pursued without flagging. Portraiture having been given an inferior position in the academic hierarchy, it made its own laws, and demanded direct observation from life. This allowed it to develop a little outside the limits of official dogma, with which it nevertheless remained linked through the accepted theories on the character of feelings and their effects on the facial features. Most of the theoreticians were penetrating portraitists — not excluding Charles Le Brun himself. Jean-Baptiste de Champaigne and Claude Le Febvre provided a connecting link with François de Troy, Rigaud, or Largillière.

Their dates make them belong as much to the seventeenth as to the eighteenth century. Like de Troy, expert at portraying feminine beauty, and Largillière, who liked working on " body pictures ", in the manner of the Netherlanders, Rigaud was attracted by the artists of the north and by their colours. The emphatically hieratic quality in his work conflicts with the dynamism shown by eighteenth-century art. Sought after by kings and princes, he expressed their majesty by posing them in noble attitudes and by dressing them in sumptuous clothes with rich accessories made by members of his own studio team. Rigaud's intention was to lift portraiture by these means out of its lowly position and elevate it to the same rank as historical painting. An identical line of thought inspired Nattier, who followed the lead given by Mignard and de Troy in giving his sitters mythological roles.

Regularly from 1737 onwards the art of the portrait was admitted in the Salons and was appreciated for its own inherent qualities. Towards

Portrait of Madame Chardin. Pastel by Chardin. In the Louvre Museum.

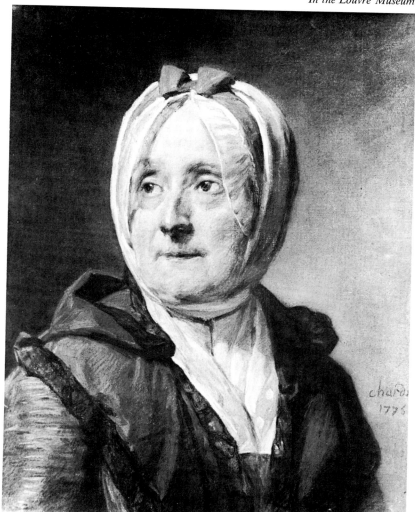

Portrait of Mademoiselle Fel; preparatory work in pastel by La Tour. In the Musée La Tour at Saint-Quentin.

1750 it began to discard the stagey setting, to omit the symbolic, and to abandon draperies. It began to have its own masters, its own specialists. The state portrait, the fashionable portrait, the portrait of the upper middle classes were dealt with by Tocqué, Aved, the Van Loo brothers, and François-Hubert Drouais. Under Louis XVI clever foreigners such as the Swedish Wertmüller and Roslin, settled in Paris to rival with Duplessis, Vestier, Callet, and with the lady academicians, Madame Labille-Guiard and Madame Vigée Le Brun. Following in the steps of Watteau, Boucher, Greuze, and Fragonard, all three occasionally painted portraits which were to be counted amongst their finest works.

Towards the evening of his life Chardin turned to pastels and made a number of portraits which bear comparison with the most brilliant specimens in this medium. The technique was little known in Paris until the Venetian Rosalba Carriera arrived there in 1720. A pioneer in its use was Joseph Vivien, who took up permanent residence with the Electoral Court of Bavaria, and at one time

Nanteuil had experimented with it. In the second half of the century, however, thanks to Vigée, Lenoir, Valade, and Ducreux, it spread quickly, and owed its ultimate success as much to Perronneau as to Maurice Quentin de la Tour.

La Tour limited his pastel portraits to the royal family, the nobility, writers, and fellow artists, leaving the middle-class clientèle to Perronneau, who also painted in oils and was imbued with a deep sense of colour learned from the Netherlanders; he also knew how to give his sitters character. La Tour had the gift of getting deep down inside the minds of his models without their being aware of it. He absorbed them completely. His preference was for the mobile countenance, changing with every new glance. He excelled even more in his preparatory stages than in the finished product, which was often spoiled by having been worked on too much. He was more gifted at recording impressions, the fugitive result of a " succession of thoughts ", than he was at portraying the " affections of the soul ". He succeeded in providing posterity with the features

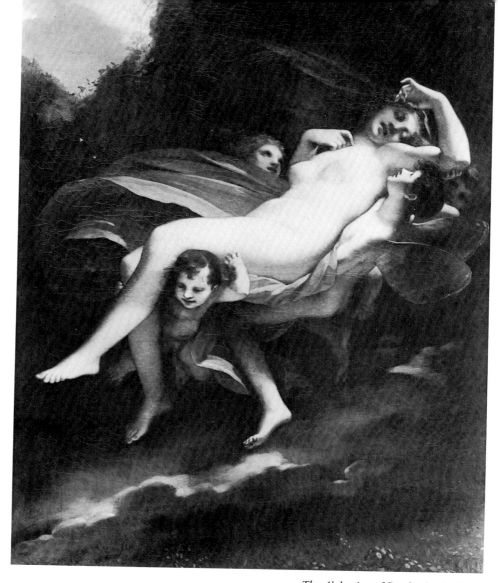

The Abduction of Psyche, by Prud'hon.
In the Louvre Museum.

of the most witty society there has ever been, catching them unawares in the warmth of conversation and the heat of argument.

When La Tour died in 1788, troubled in spirit, Prud'hon, still unknown, had been back in Paris for a year. Hubert Robert continued to find decorative themes in ruins, which did not prevent him from portraying events in the daily life of Paris, of which Boilly made himself the narrator. At the instigation of the Count of Angiviller, Director of Buildings, Pierre, Lagrenée, and Doyen brought historical pictures back into favour. Vien sought inspiration in the works of art uncovered at Pompeii and Herculaneum. With them to guide him he prepared in haste a pictorial translation of this return to the antique world which Winckelmann had been propounding as indispensable for the regeneration of art. With his pupils, Suvée, Vincent, and Regnault, he campaigned for his ideas and within the limits of his means put them into practice. In order for them to command respect, they needed the backing of a master. In the 1785 Salon, David showed his *Oath of the Horatii*, and after the Revolution became the uncontested head of the new school.

As the nineteenth century was born neo-classicism had just reached its apogee; by the time it ended Impressionism had triumphed. Between these two periods, these two extremes, the French school of painting passed through the most brilliant, the most glorious, and also the most turbulent period in its history. Paris was almost the only scene of the long struggle in innumerable episodes of which the first prize was freedom to paint.

David was fifty-six years old when he was made First Painter to the Emperor in 1804. Without forgetting his own doctrine and his own theories, the painter of the *Oath of the Horatii* and the *Sabines* found himself obliged to be more concerned with his own times. As the pictorial analyst of Napoleon's successful striving for the throne, he painted the *Coronation at Notre-Dame* and the *Distribution of Eagles*, an event which took place on the Champ-de-Mars. The former provides the better proof that

David was a portraitist without equal, even though the group was never completed. There are many other examples of his talent in this direction. These works must be considered as amongst the most accomplished of his entire production. For their style, for their research into the human face, they belong to the French tradition in all its purity and in all its brilliance. And like him the greater number of his best-known contemporaries became excellent and often remarkable portraitists.

As a convinced, undeviating admirer of the antique, and unchallenged head of a school, David inevitably exercised a heavy-handed tutelage over painting, though this did not prevent resistance to his direct influence, and this was true even of artists who had been his pupils or who had frequented his studio. Leaving aside Guérin, who had been taught by David's rival, Regnault, Gérard for quite a long time almost forsook historical painting in favour of portraiture; Gros was the epic painter. In his Napoleonic battle pictures and in the *Plague-stricken Sufferers of Jaffa*, he dealt fearlessly with the effects of movement, light, and colour.

A whole series of minor masters, genre painters, kept up influences surviving from the eighteenth

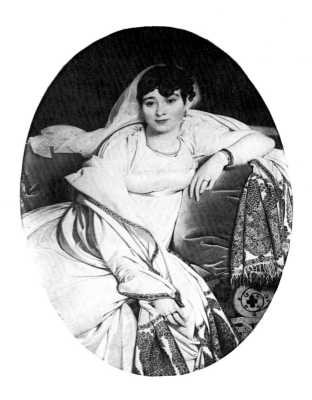

Portrait of Madame Rivière, by Ingres. In the Louvre Museum.

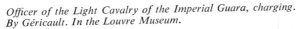

Officer of the Light Cavalry of the Imperial Guara, charging. By Géricault. In the Louvre Museum.

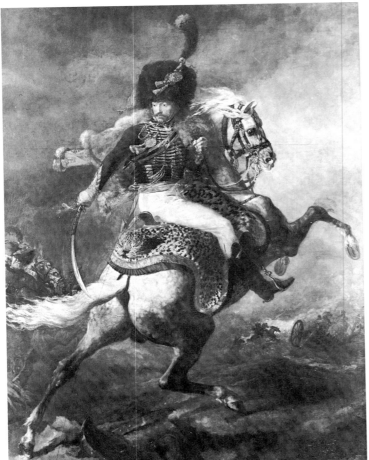

century in this branch of the art. Cochereau is worth mentioning only for his *View of David's Studio*. Louis Boilly continued to tell in pictorial form of the happenings in Paris streets, and to depict the places in which the people lived. Drölling the Alsatian, Defrance from Liège, and Demarne from Brussels remained faithful to the Dutch with their familiar interiors and their fairs. Others were painters of animals, landscapes, or battles. Jean-Baptiste Isabey was a miniaturist, Pierre-Paul Prud'hon, who bridged the two centuries, never turned his back on antiquity but gave it a poetic image, and was still influenced by memories of his own admiration for Correggio. *Justice and Divine Vengeance pursuing Crime*, now in the Louvre Museum, was intended for the Palais de Justice and shown in the 1808 Salon. It opened a vista on the future from which Géricault's *The Raft of "La Méduse"* (1819) bravely tore away the last concealing veils. Géricault, always passionately attached to life, was also a painter of horses, a landscape artist, and a painter of portraits. Ingres at this time was living in Italy, where he had been for the past fifteen years. He had just finished studying the primitives and was still considered a revolutionary. At the famous Salon of 1824, in which the English School was a revelation, and in which a painting by Heim figured, he showed his *Henry IV playing with his Children* as well as his *The Vow of Louis XIII*.

The Coronation of Napoleon I, by David. Detail: Pope Pius VII and Napoleon. In the Louvre Museum.

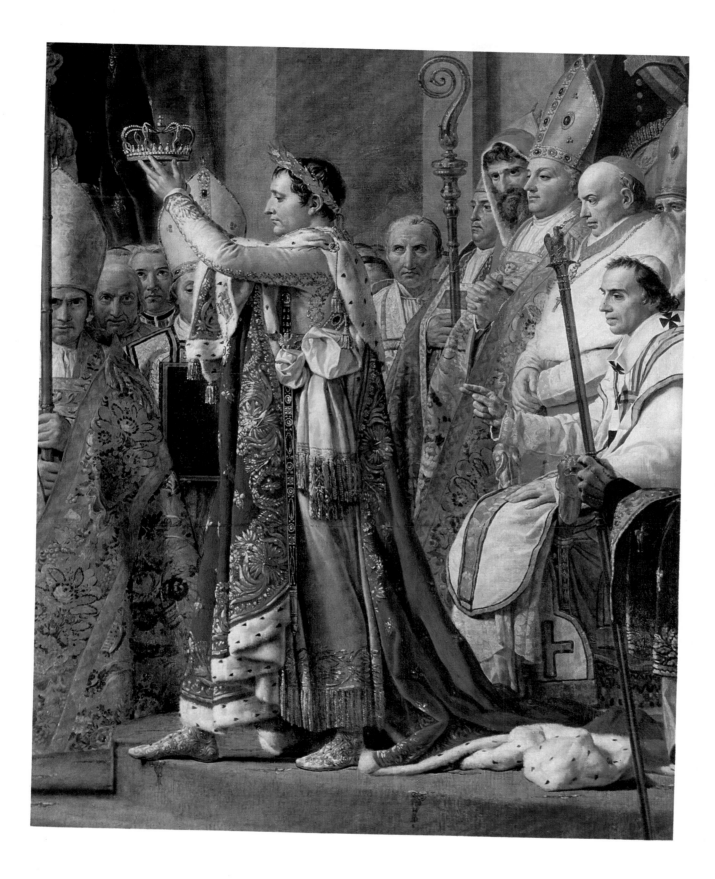

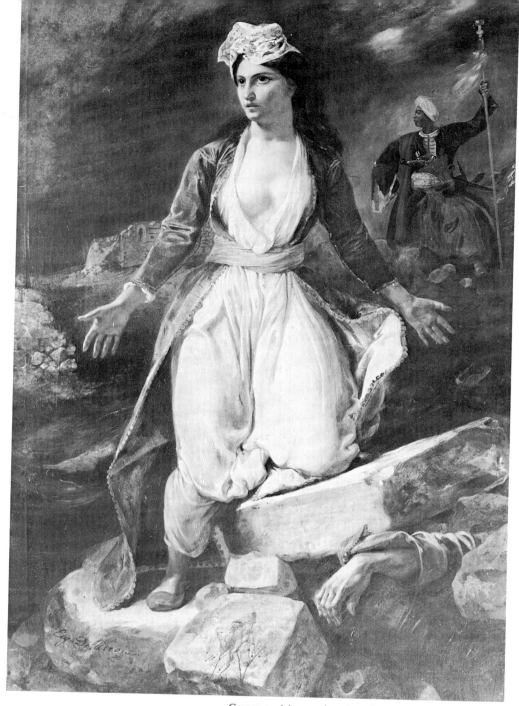

Greece expiring on the ruins of Missolonghi, by Delacroix.
In the Musée des Beaux-Arts at Bordeaux.

With them was shown *Massacre at Chios* by another young painter, Eugène Delacroix. For Ingres colour was only incidental and design was paramount. The *School of Athens*, a ceiling piece for the Louvre (1826), removed in 1855, groups round Homer the men who represent the spiritual links between the generations. They were chosen only after a rigorous process of selection, which did nothing to improve the picture's chill feeling, its stiff and impersonal composition, its poverty of colour tones " scattered like confectioners' hundreds and thousands over the top of a well-cooked cake ". There is no indication in the *School of Athens* of the search for femi-

nine beauty which was Ingres's constant concern and which produced his famous nudes. Ingres's career is marked by portraits of excellent execution, like so many examples cited here of the principal masters of the French School at all periods and all following different tendencies, being none the less scrupulous observers of nature. From his studio came Paul Flandrin, who decorated a chapel at Saint-Séverin (1840) and made a fresco for the nave of Saint-Vincent-de-Paul (1853), and for the choir and the nave of Saint-Germain-des-Prés (1842-46), and Victor-Louis Mottez, busy with the chapels at Saint-Séverin (1846), Saint-Sulpice

Three ladies in a barouche, by Constantin Guys.
In the Musée des Arts Décoratifs.

(1862), and Saint-Germain-l'Auxerrois. He made use of his experience with frescoes on the porch of the same church, on a gold background, but bad weather soon spoiled it.

Paul Delaroche and Théodore Chassériau take their places between Ingres and Delacroix. Delaroche knelt at the feet of both. At one moment he attached himself to the painter of the *Apotheosis of Homer* and decorated the hemicycle of the Ecole des Beaux-Arts (1839). At the next he would be searching the shops for accessories for his historical pictures. Chassériau was much taken with classical nobility and through his reading and his circle of friends was attracted to Romantic lyricism. Wishing to disengage himself from Ingres, he could not, after a long conversation with him, do aught else but be drawn to Delacroix, and therein lay the drama of his life. Even later, when he had asserted his own personality, his contemporaries and their successors could only see him as a man oscillating between two poles. He was an excellent portraitist, creator of a new feminine type — an incitement to dreams — and he was also a great decorator. At Saint-Merri he painted the life of Saint Mary the Egyptian (1841), at Saint-Philippe-du-Roule a *Descent from the Cross* (1852-56), and at Saint-Roch the chapel of the baptismal fonts (1854).

His principal work was one of the most considerable decorative efforts of the nineteenth century, *War* and *Peace protecting the Arts* (1834-38) for the Cour des Comptes on the Quai d'Orsay, which has suffered more from sheer negligence than from the fires lit by the Commune. It allowed Chassériau to bring life back to traditional pictures. He died at thirty-seven years of age, and had no time to undertake all the projects he had in mind: " To portray one day, in monumental painting or in individual pictures, some very simple subjects taken from the history and the life of mankind, and in them to allow oneself to be moving, truthful, and free ".

A little later Puvis de Chavannes, born in 1824, joined Chassériau. He only reached his best under the Third Republic when there was a desire to efface all trace of the convulsions of 1871. This was the wish of the powers who were to play their part in the enrichment of Paris by means of new buildings — lay buildings, scientific buildings, municipal buildings. This desire was much to the advantage of monumental painting. At the Panthéon, Puvis de Chavannes recalled the history of Sainte Geneviève with his *Scenes from the Life of Sainte Geneviève* (1874-77), his *Sainte Geneviève keeping Vigil over Paris* and *Sainte Geneviève provisioning Paris* (1897-98). For the Grand Amphithéâtre of the Sorbonne

he painted the allegorical *Holy Wood* (1887-89). At the Hôtel de Ville his main work was *Summer and Winter* (1890-93). The noble grouping of his compositions, their intellectuality quite stripped of literary sentimentality, their plastic expressiveness, and their delicate colours had profound repercussions, whose echoes were heard by Odilon Redon and Albert Besnard.

One must go back in time to be able to observe how realism became the successor to romanticism, a succession hastened by the influence of the Netherlands and of Spain. Daumier, a masterly painter but one behind his times, whilst never ceasing to be a lithographer, formed an attachment to the baroque and its strongly opposed light and shade. Millet went to live at Barbizon to paint the figures of peasants. Urged on by Proudhon, Courbet, an authentic realist, used realism to further social reforms. He rather forgot about these whilst he was in Franche-Comté, but found other occasions for rousing public clamour. His exceptional technical gifts were not of a kind to be appreciated by his contemporaries of the Second Empire and the beginning of the Third Republic, who were too easily enticed by academic painters — men such as Paul Baudry, brilliant decorator of several mansions, including the Hôtel Païva in the Champs-Elysées (1863). He also decorated the foyer of the Opéra (1866-72) with Cabanel, Bouguereau, Chaplin, Jules Lefebvre, and Henner, the conscientious exploiter of a sure-fire formula: auburn hair, ivory-tinted flesh, a background of turquoise blue. Amongst the genre painters, Gérome specialized in a neo-Grecian style and Meissonier in retrospective scenes done with the aid of a magnifying-glass. A minor master was Constantin Guys, a witty observer who in a few quick strokes could perpetuate the memory of the Baroness d'Ange and her "darling friends" taking a drive in the Bois de Boulogne sitting at their ease behind a pair of spanking horses, and filling the barouche with their crinolines.

By a strange whim of fashion it needed a foreigner, the Bavarian Winterhalter, to be followed by others (Stevens, Boldini, La Gandara, or some contemporary Netherlander), to win the favour of the highest Parisian society (which perhaps was the worst) as the chosen portrayer of Parisian elegance.

These portraits are really very little concerned with the course of French pictorial art in the nineteenth century, which was in a state of perpetual agitation and given over to perpetual seeking for new forms of expression, which resulted every quarter of a century or so in the imposition of a new æsthetic ideal. This had been classical, romantic, and realist. Now the time had come for it to be "impressionist". It was given this name in derision

Quai des Orfèvres, Notre-Dame, and the Pont Saint-Michel, by Corot. In the Musée Carnavalet.

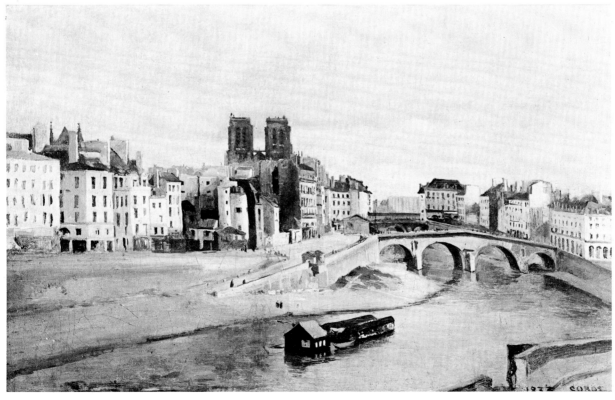

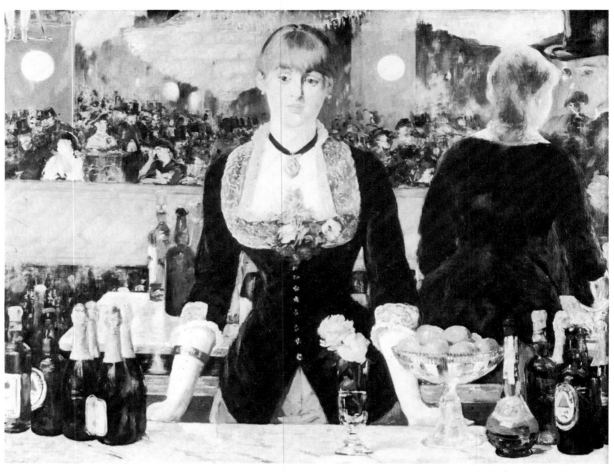

Bar at the Folies-Bergère, by Manet.
Courtauld Institute, London.

Orpheus, by Gustave Moreau.
In the Louvre Museum.

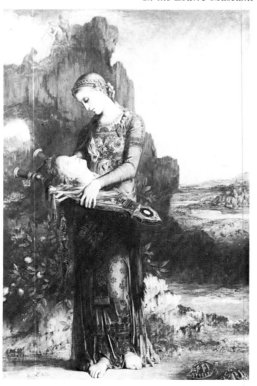

after the exhibition in 1874 organized by the Artists, Painters, Sculptors, and Engravers Company Limited. Its first manifestation dates from the Salon des Refusés of 1863, in which Manet exhibited his *Déjeuner sur l'herbe*, the famous, startling picnic. And what is Impressionism? In few words, the substitution of light-filled, open-air painting for the heavy tones of the studio-painted picture. After all the static reproductions of various themes came the recording of ephemeral changes in light. These suggestive pictures, which went as far as to forget form altogether, portrayed the varying aspects that the changes give to all things. Substantial and sometimes very deep divergencies characterized and separated the various members of the group — Manet the realist, who only co-operated with his last pictures, though he was the precursor, Claude Monet, Renoir, Degas even, Pissarro, Sisley, Jongkind the Dutchman, Berthe Morisot, Bazille (killed in the 1870 war), and, the nearest to Degas, the American Mary Cassatt. Many of them found their inspiration in Paris, in its buildings and its streets and its oddities, and they found it as much at the bar of the Folies-Bergère and in the dancers at the Opéra as in the Moulin de la Galette.

Impressionism caused a great to-do, which echoed round the world and went on echoing into the

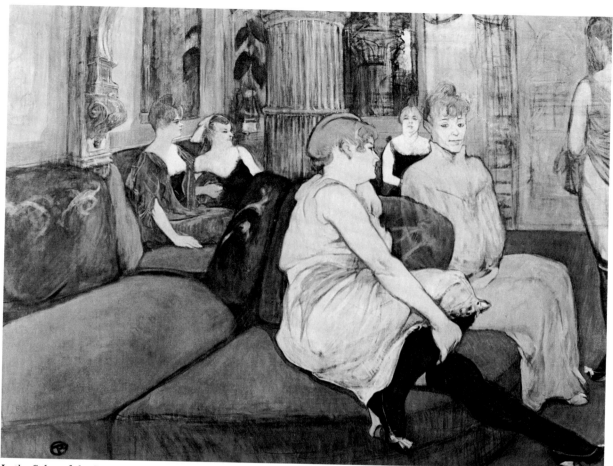

In the Salon of the Rue des Moulins, by Toulouse-Lautrec.
In the Toulouse-Lautrec Museum at Albi.

Young woman powdering herself, by Seurat.
In the Courtauld Institute, London.

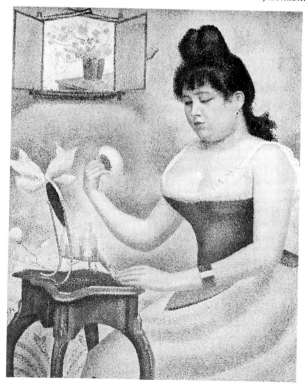

twentieth century. What its sympathizers, its adversaries, and its gainsayers did is not something to be dealt with in a few lines. The tendencies, the explorations in opposite directions, the systems, all confronted each other in Paris — or ignored each other. All this gave an intense vitality to the paintings of the end of the nineteenth century. In the tumult it generated, the decorators claimed Puvis de Chavannes for themselves in order to retain some degree of the intellectuality which Gustave Moreau was to confuse with a hermetic esotericism. Realism found its way into the Ecole des Beaux-Arts. Fantin-Latour, a man with a diversity of talents and many differing ways of looking at things, composed collective portraits and created a realism of intimacy. Carrière, concerned with his own inner life, enwrapped his *Maternity* in mists. Toulouse-Lautrec, by a process of elimination and analysis, contrived to humanize and raise to the position of recognizable universal human types some of his models from the Moulin-Rouge and other places. Seurat's neo-Impressionism recognized the division of colours. Trying to establish rules for it led him to re-create productive discipline for artistic creation. It produced giants, standing high above the crowd — Cézanne, Van Gogh, Gauguin. Although in fact their principal works

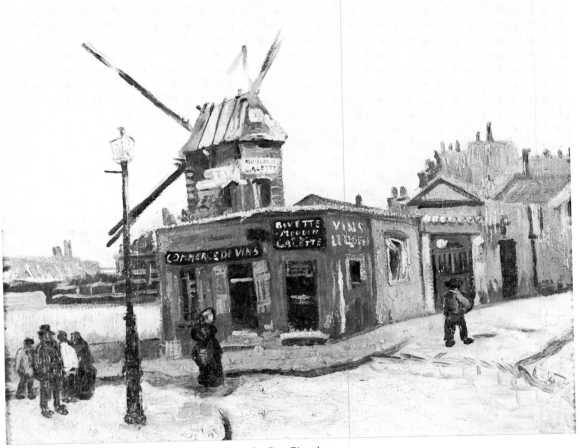

*The Moulin de la Galette, seen from the Rue Girardon,
by Van Gogh. In the National Gallery, Berlin-Dahlem.*

were carried out elsewhere, it was in Paris that they had worked and found enthusiastic support.

Impressionism has not yet said its very last word, and if the classics are not entirely to be neglected, it is to Seurat we must turn our attention. It was in 1864 that Seurat completed his *Bathing Place at Asnières*. This was his first application of division and juxtaposition of touches with the brush, based on recently established scientific facts. It was in trying to establish the rules of his method that Seurat re-created a discipline.

Intellectual research took the place of Impressionist sensualism. From this time forward the mind was to have as large a part to play as brushwork in the many theories which were entering the lists. They followed each other in swift succession. They triggered off reactions and counter-reactions, and all they had in common was the brevity of their lives and the fact that their names all ended in 'ism'. Only the 'Nabis' were the exception: they were prophets sensitive to symbolism, mirrored the pre-Raphaelites, shared the visions of Redon, Puvis de Chavannes, and Gauguin. They were anxious to restore painting to its proper place and exhibited for the first time in 1891 at the Le Barc de Boutteville Gallery in the Rue Le Peletier.

Fauvism on the other hand set out to express everything by the orchestration of pure colour. In part it came from Gustave Moreau's studio, where, in 1892, Matisse joined Rouault; later the studio was to welcome Marquet, Manguin, and Camoin.

From Symbolism and Fauvism came Cubism and its variants, the negation of the world and of the object through its reconstruction, Expressionism, and Futurism, which at more or less long intervals engendered Dadaism and Surrealism and the Abstract.

Around the year 1905, at the time of a banquet given in honour of 'Douanier' Rousseau, creator of Naïve Art (which had not a few echoes), many foreigners were arriving, had just arrived, or were about to arrive in Paris. Kupka arrived in 1898, Picasso in 1900; then Marcoussis, Pascin, Juan Gris, Modigliani, Severini, Lipchitz, and Zadkine in 1908; Chagall came in 1910 and Soutine in 1913.

They were out to abolish convention and the imitation of nature and dedicate themselves to forms of painting arising from their various places of origin, their sensitivity, and their æsthetic sense. Together they formed a school, the Paris School, which, after an interruption, or at least a lull, during the 1914-18 war, reached its apogee around 1925.

*Ball at the Moulin de la Galette, by Toulouse-Lautrec.
In the Art Institute, Chicago.*

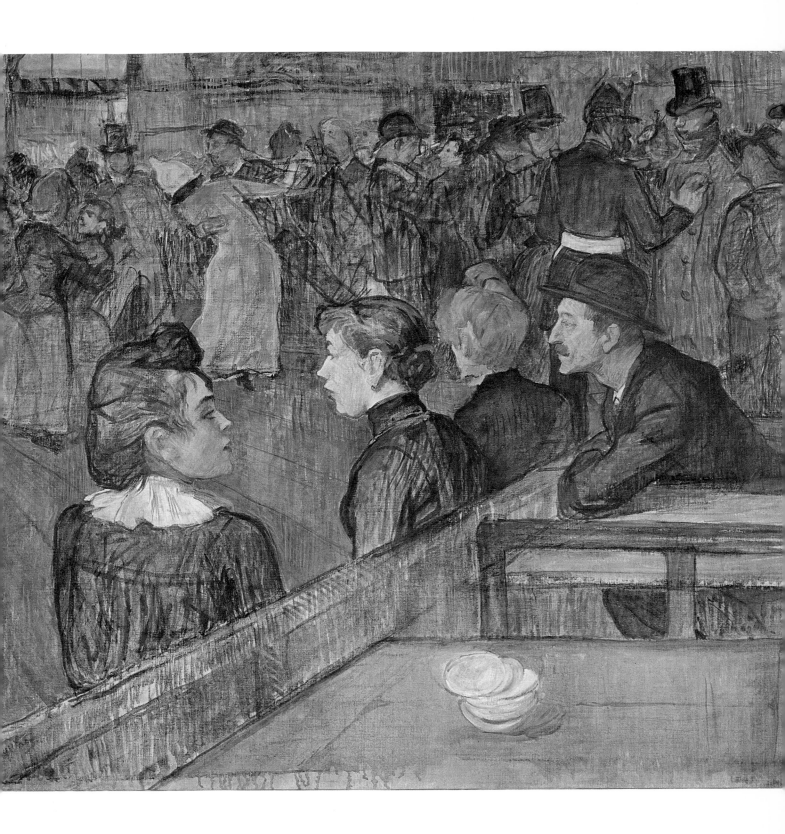

Ilexi quoniã exaudiet dominus
vocem orationis meæ.
Quia inclinauit aurem fuam mi
hi:& in diebus meis inuocabo.
Circundederût me dolores mor
tis:& pericula inferni inuenerunt me.
Tribulationé & dolorèm inuêni: & nomen do-

The Triumph of Death; woodcut from " The Hours of Geoffroy Tory ". Paris, 1525.

ENGRAVINGS
AND BOOKS

The art of engraving began to spread at the end of the fifteenth century and to create its own rules and traditions independently of painting, upon which it was none the less in some ways aesthetically dependent. It was used for the diffusion of religious images, for isolated individual composition, for pictorial series, and for playing cards. It became, almost at once, the inseparable accompaniment to books from the moment that these were made widely available through the use of printing machines — that is, in Germany from 1457, in Rome from 1465, in Paris from 1470, in England from 1471, and thereafter throughout Western Europe.

The first illustrated book to be published in Paris was put out by a printer, Jean Dupré. This example was followed without any loss of time, and the trade quickly multiplied. Edition succeeded edition at an ever faster rate, from the presses and across the counters of Dupré, Guy Marchand, Pierre le Rouge, Antoine Verard, Simon Vostre, and Pigouchet. Their scenes, sacred and profane, their initials, their historiated borders with scrolls and flowers,

all belonged to the tradition of the illuminator. It was not long before the search for ideas took a more precise direction. Contributions from abroad, deriving from books imported from Naples and, above all, from Venice, took pride of place and were duly assimilated.

A little timidly at first, then quite resolutely, making headway against entrenched Gothic survivals, books introduced the Italianate touch, starting with Simon Vostre's *Hours* at the beginning of the sixteenth century. Through Geoffroy Tory there was a renewal of ideas and decorative features in about 1525. With equal good taste and moderation, Tory fell under the influence of the classical, taking antique architectural motifs for his frames, with palm leaves, scrolls, and arabesques. Sometimes he would show his taste for nature and add flowers, insects, and animals. His new ideas were followed by emulators even before any new principles were involved. When these did appear they were perfected by the efforts of three Parisian publishers — Denis Janot, Etienne Groulleau, and Gilles Corrozet — in their little books liberally

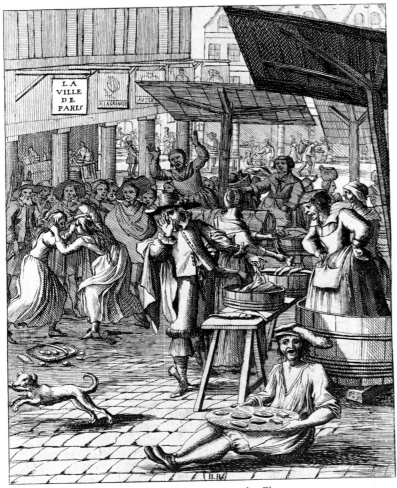

*The City of Paris; engraving by Chauveau,
in the Bibliothèque Nationale.*

illustrated with vignettes. All the same, the purity of decorative feeling faded with time and by the end of the century had begun to give way to over-elaboration. As soon as copper-plate engravers became more numerous the bond between illustration and text was lost. Before that, though, some works had appeared fully worthy of the high reputation they have achieved, such as *Le Songe de Poliphile*, which was to be bought from Jacques Kerver (1547), *La Relation de l'Entrée d'Henri II à Paris* of 1549, with woodcuts by Jean Cousin (1560), and *Le Livre de Pourtraicture* (1571) by the same Jean Cousin. Already engravers of the Fontainebleau School were busy accumulating ornamental plates to make known all aspects of the decorations carried out in the château. They were followed by many other artists who worked in Paris; René Boyvin, Pierre Millan, Etienne Delaune, and Jacques Androuet du Cerceau were amongst them. Anxious to publicize their inventiveness and to stir the feelings of often not very imaginative artisans, these 'ornamentalists' contributed to the dissemination of the style whilst at the same time aiding the development of engraving and its techniques. Etching and the etcher's needle, which they had now adopted for ordinary use, began their conquering march towards uncharted destinations. Wood engraving fell into desuetude once the political troubles were over which had given a momentary importance to satirical popular drawings of a simple, racy realism, " printed, cried,

*The Quai des Augustins and the Pont Saint-Michel.
Engraving by Israël Silvestre, 1658,
in the Bibliothèque Nationale.*

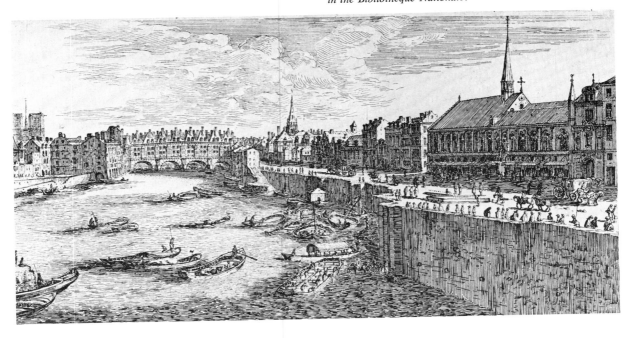

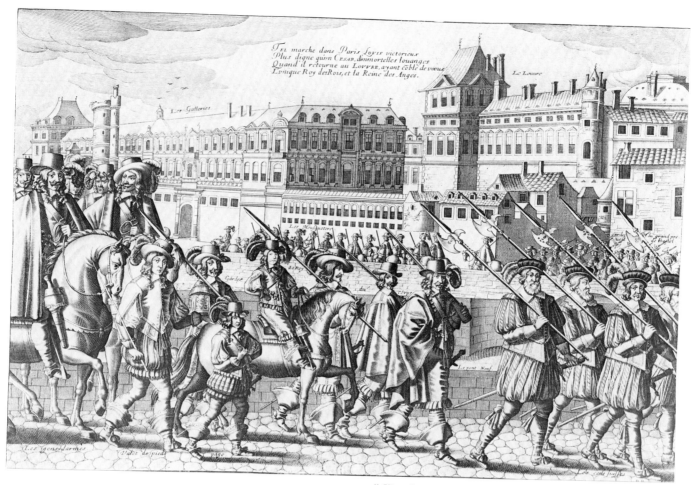

"King Louis XIII on the March"; engraving by Bertrand for "The Miscellany of Reproductions of Ceremonies and Triumphal Entries". In the Bibliothèque Nationale.

preached, and publicly sold in Paris at every street corner and crossroads " at the time of the League.

Engraving filled an important chapter in the history of French art in the seventeenth and eighteenth centuries. Nearly all engravings were produced in Paris, which was continually increasing as a centralizing power, even in the domain of graphics. Through the two centuries the engravers themselves came from Paris, or from the provinces, or from other countries, and from Flanders in particular. They were far too numerous for it to be possible to mention any but the most important. There were many specialists amongst them, giving brilliance in many different styles to ancient and modern and to sacred and profane history, to allegory and mythology, to landscapes and portraits. To this list could be added the engraving of architectural features, of festivals and fashions, and of the purely decorative or ornamental which exercised a lasting influence.

Incised engraving on copper was the next offering to exercise the virtuosity of the burinists and etchers, taking the place of the relief wood engraving of the sixteenth century. The uncontested master of acid etching was Jacques Callot from Nancy, who on the occasion of his stay in Paris from 1628 to 1630 made pictures of the Pont-Neuf and the Tour de Nesle and exercised a fruitful influence on the development of the print. Amongst the etchers who until the end of the seventeenth century continued to follow in his footsteps were the Cochin family, Pierre Brebiette, the Florentine Stefano della Bella (called Etienne de la Belle), who stayed in Paris from 1640 to 1650, François Chauveau, Israël Silvestre (etcher of Paris views), and Sébastien Le Clerc. Even though he was taught by Callot himself to be an etcher, the Huguenot Abraham Bosse integrally preserved his originality and did no copying of other people's work. His favourite themes were manners and customs, and this applies equally well to his Old Testament pictures as to those of contemporary life. They were the subject matter of plates which make very exact records of the times of Louis XIII and Richelieu. Etching was taken up by Michel Dorigny and by François Tortebat, sons-in-law and interpreters of Vouet; Jean Morin, whose speciality was the reproduction of the works of Philippe de Champaigne, introduced stippling into his style of etching; painter-engravers were enticed by its ease; yet in the long run it did no harm to engraving.

145

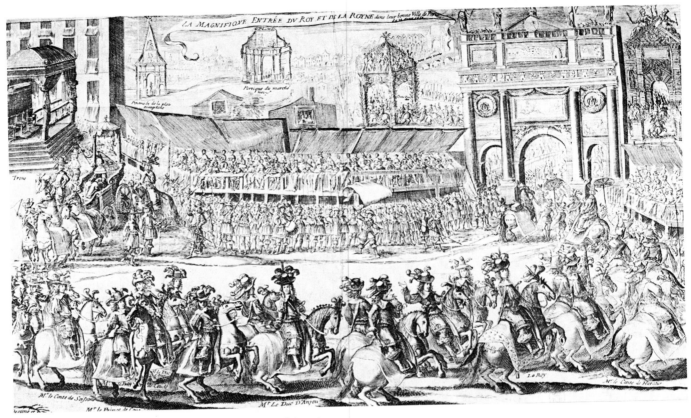

" Entry of Louis XIV and Marie-Thérèse of Austria
into Paris, 1660 ". Engraving by Ladame,
in the Bibliothèque Nationale.

Indeed, in terms of output, the needle continued to have a greater following than acid.

The principal seventeenth-century engravers interpreted the works of Simon Vouet, Jacques Blanchard, Nicolas Poussin, Jacques Stella, and many lesser painters, as well as their own originals. They were Claude Mellan, advocate of parallel lines and opposed to cross-hatching, Michel Lasne, swayed by every new influence, and Pierre Daret, followed by Charles Audran, Jean Lenfant, Jean Pesne, Guillaume Chasteau, and Claudine Bouzonnet-Stella.

Like the painters and the sculptors, French engravers of the seventeenth and eighteenth centuries made portraits which have no equivalent in any other school. Without neglecting accessory features, they concentrated principally on the head in order to scrutinize at their leisure that " mirror of the soul ", the face. In such a short presentation as this Thomas de Leu and Léonard Gaultier (who began at the turn of the sixteenth century), Mellan, Lasne, Antoine Masson, and a few others can be seen only as having prepared the way for Nanteuil.

The works of Nanteuil justify his great reputation by their material beauty, natural poses, and their revelation of the inner life of his models. He was a pastellist and a burinist. He got himself established in Paris around 1647, and before he died in 1678

he had been honoured by having Louis XIV sit for him several times and by having all the most important people at Court and in the city come to his studio. With Nanteuil's work the fixing of firm principles for engraved portraiture was completed. They were adopted by his disciples and pupils, Nicolas Regnesson, his brother-in-law Van Schuppen, Pierre Simon, and Louis Cossin (who has been much underrated). Nanteuil's example was not unanimously followed, however. Gérard Edelinck abandoned original work and concentration on a drawing from life of his model in order to return to dependence upon paintings as subjects for his engraver's needle. This did not prevent him from handling that needle with all the desirable vigour and polish.

From 1660 onwards, under the influence of the current academic doctrine with its own laws and hierarchy, engravers — at this date almost all professionals — by their training and the strictly limited opportunities they were offered in the exercise of their art, had become little more than interpreters. They had fallen to the rank of practitioners, of craftsmen with no ambition beyond reproducing the religious and mythological subjects of paintings which followed the infatuations of the moment. They too worked in the service of royal propaganda, multiplying for the Miscellanies of the

King's Cabinet (made to be given to people of importance) recitals of the wartime exploits of Louis XIV, pictures of his royal residences, of his entertainments, of his paintings, his statues, his medals, and his art collections.

Gérard Audran was the last in the long list of the great seventeenth-century engravers. He was the principal contributor to the King's Cabinet, for which, from Le Brun's originals, he engraved *Alexander's Battles*. His mastery of a technique all his own — a cunning mixture of engraving and etching, through which he created his personal style — marked an epoch in the history of engraving. Opposed to the set style of engraving, devoted to stylish and living art, he originated the ' free engraving ', concerned with general impressions and more flexible renderings. It did much to bring to life his interpretations of the friendly, smiling, and highly coloured pictures by eighteenth-century artists.

The tradition of the immortal Audran remained lively even after the disappearance of the last of the engravers who had begun their careers in the reign of Louis XIV — the Simonneaus, Laurent Cars, Nicolas Tardieu, Charles-Nicolas Cochin the Elder — and was further perpetuated, first by his pupil Nicolas-Henri Tardieu, then by Philippe Le Bas and his school. Some thirty engravers emerged from it, including Charles-Nicolas Cochin the Younger and Moreau the Younger.

They dealt with the most varied subjects by means of their technique of thin strokes and much play of light and shade. They collaborated freely in the great Miscellanies of the eighteenth century, for which the fashion was set in 1710 by the *Galerie du Luxembourg*, followed by the *Cabinet Crozat* (1729-42), the *Recueil Julienne* (1734), and the *Grande Galerie de Versailles* (1752). They also devoted their efforts to the task of reproducing the works of such highly appreciated painters as Watteau, Lancret, Pater, Boucher, Chardin, Lépicié, and Greuze. Fragonard's and Baudouin's scenes of gallantry (in the French sense) also took a high place amongst the publications covering the works of good eighteenth-century representatives of the Parisian school of engravers, whose list of names begins with survivors from the seventeenth century, G. Duchange and J. Audran, and ends with Flipart, Nicolas de Launay, and Beauvarlet. Broad and spacious at first, the style thinned during the first half of the century and after 1750 tended towards the minute, to " engraving in miniature ".

About the same time new processes of reproduction took on a particular importance. Before stippling arrived from England, Jean-Charles François (*c.* 1740) and Demarteau (*c.* 1755) were using the pencil touch with which facsimiles in black or sanguine could be made. It was perfected by

La duchesse d'Humière, engraving by N. Bonnart, 1693. In the Bibliothèque Nationale.

Louis-Marin Bonnet, and could be used to imitate pastels, for the eighteenth century was not content just to oppose black to white, but was looking for colour. It found it either with the help of dabber or tampon or by careful registration of simple colours. The latter process needed a separate plate for each tint used and called for exceedingly delicate manipulation. After experiments by Le Blon (*c.* 1738) of Frankfurt and the Gautier-Dagotys, Janinet, Descourtis, Chapuy, and Debucourt used it with consummate skill. Finally, the wash or aquatint used by J.-F. François (*c.* 1756), François-Philippe Charpentier (1758), and J.-B. Le Prince (*c.* 1768) produced the likeness of water-colour.

Although etching was practised by the greater number of eighteenth-century painters, including Gillot, Watteau, Boucher, and Fragonard, as well as by many amateurs, only one exceptional talent stands out — that of Gabriel de Saint-Aubin. With an almost feverishly trembling hand he produced as unrestrainedly as a man doodling quite priceless scenes of Parisian life.

Amongst all the historical subjects and the landscapes and the ornamental works of the engravers of the Rue Saint-Jacques, where stood the portrait? The ceremonial portrait kept its laurels, although

Frontispiece of " Cyrus the Great ", from Chauveau.
In the Bibliothèque Nationale.

books both sacred and profane being published in Paris after 1625 soon preceded other illustrations by the same hand — which might be that of Léonard Gaultier, Jaspar Isaac, Abraham Bosse, the Davids, Mellan, or Lasne. Their pictures could on occasion be saltier than one could have expected. Poussin contributed many compositions of great nobility which contrasted very pleasantly with the narrow mythology, the pompous allegory illustrating gentlemen in periwigs, of the time of Louis XIV. These compositions were prepared for the *Imprimerie Royale*, the Royal Printing Works, founded in 1640. Amongst the far too abundant and hasty production of François Chauveau a few exceptions show the persistence of a realism adapted to family and popular life, and merit some attention. After the death of Chauveau in 1676, Sébastien Le Clerc began to establish his position, which, artistically, was half-way between the Callot of the little scenes briskly etched for *The Light of the Cloister* or *The Life of the Virgin* and the eighteenth-century illustrators. Amongst the many things the eighteenth century has been claimed to be is the " Golden Age of the Vignette ". From the Regent's *Daphnis et Chloé* of 1718, or *The Fables of La Motte*, with illustrations by Gillot (1719), to Prud'hon's drawings for Lucien Bonaparte's *The Indian Tribe* (1799), productions in this particularly French means of expression were beyond counting. In French hands it had a delicate and lively grace, an enchanting spontaneity far from the finical and the insipid. Head of the list of famous illustrated publications comes the 1734 *Molière* with drawings by Cars, from Boucher, then the *Boccaccio* of 1757, *The Tales of La Fontaine* (1762), know as *The Tales of the Farmers-General of Taxes*, followed by *Marmontel's Moral Tales* (1763), *Dorat's Kisses* (1770), *The Songs of La Borde* (1773), and the *Works of Rousseau* (1775-83). The drawings are signed Gravelot, or Eisen, or Moreau the Younger, or Marillier, illustrious amongst the most illustrious vignettists. Choffard must be added to this list of names as the unique specialist of the thumbnail sketch and page ornament.

For illustration work and for engraving, as indeed for all the other arts centred on Paris, the nineteenth century proved to be a highly complex period.

Engraving was about to adopt manifold and widely differing forms and the utmost variety of techniques, and this would be a faithful mirror of the æsthetic doctrines and the disputes between painters of the times, and would on occasion foretell them.

Copper-plate engraving was for long reserved for engravers of reproductions and for artists faithful to the tradition of Bervic and his pupil Henriquel-Dupont, who had no hesitation in using aquatint

the second half of the eighteenth century delighted in the familiarity of the portrait-medallions, even if their inspiration was from the antique. They were carried out in great numbers by Cochin, their ' inventor ', Moreau the Younger, and Augustin de Saint-Aubin. Pierre Drevet, the interpreter of Rigaud, was the successor to Edelinck in support of the formal portrait, and followed by Pierre-Imbert Drevet, Jean Daullé, and Baléchou. Bervic was a disciple of the German Wille and an adept at the clean-cut lines which distinguished the more formal engravings. He exhibited a majestic Louis XVI, from an original by Callet, at the Salon of 1790, and ultimately became official engraver to the Empire and the Restoration.

Illustration in the seventeenth century still had some surprises up its sleeve, though it had long been looking for a set of rules of its own. Belonging to a few clearly defined types, frontispieces of

and preparations of nitric acid; then, too, there were Léopold Flameng and Ferdinand Gaillard, engravers of remarkable original portraits, who between them brought back into use the free style of engraving. But the innovators of this period preferred to experiment with dry-point, the aquatint, soft varnish, and acid.

Nitric acid etching came back in about 1830 after having been neglected during the first quarter of the century. The first signs of this renaissance were quickly followed by others. So complete was its success that, quite apart from the professionals, most painters took an interest in meting out the acid, amongst them Delacroix, Charles Jacque,

to accept the leadership of a school of etching, and the place that was rightfully his was filled by Félix Bracquemond (who died in 1914), the perfection of whose production reflects a man of universal spirit.

After 1850, although the etching of reproductions was still far from neglected, original etchings returned to popularity. The founding in 1861 of the Etchers' Society, under the influence of Cadart the publisher, played its part in this return to favour. The best-known artists of their generation worked with newcomers on his publications. They contributed towards maintaining the feeling of emulation which had the great advantage of drawing into the field of original etchings not only painters of the most

The Newsmongers, engraving by G. de Saint-Aubin, in the Bibliothèque Nationale.

Hervier, Millet, Chassériau, and Decamps as well as the great landscape painters — Corot, Daubigny, Rousseau. Whilst the etchings of these masters consist mainly of simple sketches, mere notes, one professional, Charles Meryon, signed some that for importance of subject matter and technical perfection are worthy of ranking amongst the very finest creations of the engraver's needle. His *Views of Paris* (1850-54) are today very properly admired for their freedom of vision, skill of execution, and their mysterious and compelling evocation of districts which have now disappeared. Ill-health forbade him

divergent tendencies — Meissonier, Bastien-Lepage, Ribot, Degas, Manet, Marcellin Desboutin, and Pissarro — but also sculptors such as Carpeaux, Barye, and Rodin, and amateurs such as Jules de Goncourt.

A new procedure, lithography, was added to the etching needle and acid of the engraver, a process so simple and so ingenious that any designer could use it. Its beginnings in Paris were nevertheless slow as it was considered more advantageous commercially than artistically. The first two lithographic printing shops were opened by the Count of Lasteyrie in 1813 and G. Engelmann in 1816.

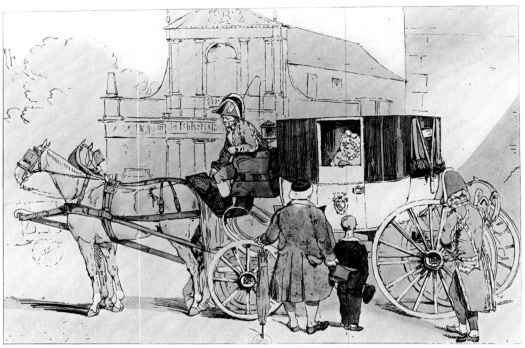

The Faubourg Saint-Germain, by Lami.
In the Bibliothèque Nationale.

" Seven o'clock in the Evening "; engraving by Devéria,
lithographed by Fonrouge. In the Bibliothèque Nationale.

Delacroix made some experimental lithographs as early as 1817. In 1828 his illustrations for *Faust* created a sensation and confirmed the interest, and the value, and the expansion of the process. Its swift development is made clear by the place it soon took in various forms of the arts. *Picturesque and Romantic Travels in Old France*, begun by Baron Taylor in 1820, set the tone for lithographed landscapes. The excesses of Romanticism and the attraction Satanic themes had for it live on in the works of Louis Boulanger and the titles of the novels of Célestin Nanteuil. Géricault, who died in 1824, used the process for his pictures of horses and hunting scenes. Carle Vernet used it as a medium for portraying many aspects of hunting and horse-racing, as well as habits and customs. Fashionable life, its background and its actors, found skilful interpreters in Eugène Lami and Achille Devéria. As portraitist, genre painter, and designer of fashion plates, the latter had serious rivals in Grévedon and Jean Gigoux.

Lithography also succeeded in encouraging exploration of many kinds of theme which until then had been neglected or completely ignored. It turned many painters who were searching for subjects for realism (which had been under a cloud since the death of Géricault) towards scenes of popular and of military life.

The Napoleonic era, the high deeds of the Grande Armée, fed the verve of Charlet, Raffet, and Bellangé. Caricature also owed its development and its acceptance to lithography. After tentative

150

approaches by Boilly and Pigal, Henri Monnier was one of the first of his time to make a frontal attack on contemporary morals. Rabidly anxious to show up the failings of the middle classes, he created an immortal character, Monsieur Prudhomme, Parisian cousin of the Monsieur Homais, the immortal *petit bourgeois* of Flaubert's *Madame Bovary*. Grandville ridiculed Louis-Philippe, the " Citizen-King ". Grandville was a tormented spirit, beset by dark shadows. There were times when his work appears to be the herald of Surrealism, which made its way into the world of art in the works of Decamps (thirteen only of his pictures are caricatures), Gavarni, and Daumier.

Gavarni worked for *La Mode*, the " review of the fashionable world " founded by Emile de Girardin, and for *L'Artiste*. Later he was attached to *Le Charivari* (*Punch* was founded as the *London Charivari*), and he became the creator of " the pencilled comedy of manners ". Not without a certain caustic malice and witty irony, highly

professional, of great personal charm, he published a number of series which brought certain Parisian social strata to life, particularly *The Students* (1839) and the ladies of easy virtue, *Les Lorettes* (1841-43). From the wings of the stage he went on to the middle classes in their boxes, returned to masked balls at the Opéra with *Les Débardeurs* (1840) — the Longshoremen, a favourite fancy dress — and the *Paris Carnival* (1841) before visiting the regulars at Clichy, which was the debtors' prison (1840-41). Daumier surpassed Gavarni. During nearly half a century he disseminated the infinite resources of his talent through 4000 lithographs. With the sure touch and the precision of his drawing he achieved a kind of daring synthesis through his deep knowledge of values and volumes, to which he added an incomparable professionalism. Though inspired by the events of the day, his choice of subject was spread over an extreme variety. There were portraits commissioned for *La Caricature* and plates for *Le Charivari*, which criticized public life with

" Marguerite at the Spinning-wheel "; lithograph by Delacroix. In the Bibliothèque Nationale.

vehement passion. Then there was *La Rue Trans-nonain*, bearing witness to the tragic grandeur involved in the repressive measures taken during the riots of April 1834. A law voted in 1835 condemned without appeal all political caricature, and this turned him towards satire of customs and morals. In turn he lashed the middle classes, the supporters of the July monarchy, magistrates, shady financiers (incarnated in the stage character Robert Macaire), blue stockings, and women divorcees. With deep and instinctive distrust he reacted against modern ideas and modern progress.

There was no direct heir to either Daumier or Gavarni. After them lithography fell into somnolence and torpor, being mostly used for reproduction. Painters attracted by its technical ease took it over in the eighteen-eighties. They included Renoir and Degas, Fantin-Latour and Carrière,

Odilon Redon and Toulouse-Lautrec (with his astonishing command of line), Steinlen, who collaborated on *Gil Blas Illustré*, *Le Rire*, and *L'Assiette au Beurre*, and finally Forain, who believed himself to be the Daumier of the Third Republic and showed it rather too openly.

The high days of the illustrated poster were made possible by 'chromolithography', lithography in colour, beginning with Chéret, who had "the secret of making blank walls less sad", and Toulouse-Lautrec. They were the true pioneers, followed by Steinlen, Grasset, and Mucha, a Czech, who was trumpet-blower for Sarah Bernhardt. For long their posters enlivened the streets of Paris with their daring ideas and violent colours. Cappiello and Loupot were still to come before the verve ran out in the middle of the twentieth century. That was the moment when our present times began

" Parisians appreciating more and more the Advantages of Macadam "; lithograph by Daumier.
In the Bibliothèque Nationale.

Les Parisiens appréciant de plus en plus les avantages du macadam.

Jane Avril; lithograph by Toulouse-Lautrec,
in the Toulouse-Lautrec Museum, Albi.

An illustration for " Gargantua ", by Gustave Doré.

" A Duel after the Ball "; lithograph, after J.-L. Gérome.

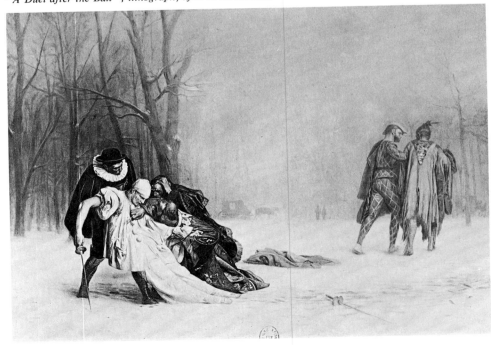

154

with the use of photographic reproduction for nearly everything, used with a mock-childish simplicity and an aggressive eroticism.

Towards the end of the eighteenth century the art of wood-engraving had been revived by Thomas Bewick, an Englishman, who took up a method used by a playing-card maker in Lyon. His technique was based on the use of end wood, cut across the grain instead of with the grain. Charles Thompson brought it to Paris. The method attracted some excellent vignettists amongst whom was Tony Johannot, interpreted by Poiret, who illustrated many romantic books. Wood-engraving now appealed to such masters as Gavarni and Daumier. Even Gustave Doré came to use it for his vignettes. He carried out the graphic adjuncts to Balzac's *Contes Drolatiques* (1856), Dante's *Inferno*, and *Don Quixote* (1863) with staggering imagination. The wood block was adopted for news magazines in imitation of the English ones and of the *Magasin Pittoresque* which had been founded in 1833. It was used by Edmond Morin and his co-workers for weekly periodicals. Daniel Vierge, of Spanish origin, used it for *Le Monde Illustré* with the help of specialists. Finally it was dethroned by photomechanical processes. The Society of Friends of Books, founded in 1896, fostered contemporary illustrated volumes. These included *Paysages Parisiens* and *Paris au Travail* with woodcuts by Lepère, who had turned again to the old technique of carving with the grain (for which he used a penknife), a method he used for *La Bièvre*, *Les Gobelins*, and *Saint-Séverin* (1901) and for Huysmans's *A Rebours* (1902).

Without being backward-looking, engraving was not yet to be involved in the most violent of the æsthetic quarrels of part of the twentieth century. This did not prevent a number of 'advanced' artists from turning to it. The success of photographic reproduction necessarily caused irremediable damage to reproduction engraving. Woodcuts and lithographs on the other hand either kept or soon recovered their devotees. Etchings of the time and their derivatives are unequalled. Their variety, their brilliance, and fecundity in ideas had never been greater. Thanks to the Society of French Painter-Engravers, founded in 1889, to the Independent Painter-Engravers (1923), and to exhibitions of original woodcuts, prints were raised to their highest peak and have stayed there ever since. Illustrated books have met with exceptional favour, despite doubtfully pure motives which between 1920 and 1930 in particular caused a memorable plethora of 'collectors' editions', and at least this has encouraged the use of all processes, black-and-white and colour alike, and has given them incomparable variety.

BOOKBINDING

In Paris the art of bookbinding has been indirectly favoured both by humanism and by the development of book printing, for bookbinding is the indispensable and traditional companion of the book itself. The principal bookbinder's shop in Paris was opened by a bibliophile, one Groslier, Treasurer of France. At first he took up and enriched the oriental style of stamping with a hot iron, chiefly used in Venice from the end of the fifteenth century onwards, then he experimented with bindings having geometrical interlacing, combined with great skill. The most sumptuous of them were made into mosaics by the use of multi-coloured mastic. Irons with fillets, or close parallel lines, were introduced at about the same time to avoid the heaviness of solids, as was the stamping of solid-gold rosettes. Catherine de Médicis and Diana of Poitiers both greatly encouraged the creation of the delicate marvels being produced from, amongst others, the workshops of the titular " Grand Gilder to Henry II ". Bindings made for them brought together panel work, motifs, emblems, scrolls, and ornaments copied from the antique. These were contemporary with, or perhaps slightly preceding, the highly finished work of the Cloverleaf Workshop, run by Thomas Mahieu, the rival of Groslier. He specialized in a decoration based on foliage, deriving from embroidery patterns. Later came the style known as 'fanfare', whose geometrical patterns were filled in with scrolls, little flowers, sprays of leaves, and other foliated forms. In their turn they were followed by patterns relieved by dots, the *semis* or seeding technique practised by Nicolas Eve and his successors.

Bookbinding in Paris had reached such a height of prosperity in the sixteenth century that its success continued during the following centuries. Each succeeding generation continued to produce one or more masters, inheriting family traditions or workshops, whose names are still attached to the styles they created. There was, for example, Le Gascon, who lived in the days of Louis XIII. There are no biographical details of him, and his very existence was at one time in doubt. At least it is now known that he must not be confused with Florimond Badier, who was accepted as a master in 1645. Proceeding from 'fanfare' designs, works of the seventeenth century were stamped with 'pads', a name derived from the coils worn on the head for carrying baskets or other loads. There were many variants of the *tortillon*, or pad, all of them providing great diversity and wealth of pattern. They were in use until well into the second half of the seventeenth century, during which there was a great increase in the bindings wrongly known as " *à la Du Seuil* ". On the flat they are framed by fillets,

*Binding of " The Fables of La Fontaine " with illustrations
from drawings by Oudry, 1755-59.
In the Bibliothèque Nationale.*

with fleurons on the outer angles, and sometimes carry armorial bearings. This severity of decoration was originated by Boyet for the Jansenists. It was replaced in the eighteenth century by 'lace-work', wide borders combining stamping and the use of plaques, of very great delicacy. The first to have this idea is believed to have been Antoine-Michel Padeloup the Younger, who is also credited with having thought up the use of mosaics with a floral decoration. Le Monnier, the Duke of Orleans' bookbinder, used it with the most attractive effect. Others who made good in Paris were Louis Douceur, Du Buisson the Younger, Pierre Anguer-rand, and Pierre Vente. They are, however, less well thought of by today's amateurs than Derome the Younger, descendant of an illustrious family. In the second half of the eighteenth century he produced lace-pattern effects which combined much lightness of touch with a great deal of grace.

Derome looked elsewhere for the simplicity which was a sign of good taste under Louis XVI, and found English models to imitate, with rectangular frames and geometrical motifs, or with Greek key-patterns made with bookbinder's fillet. Derome's son-in-law, Bradel, followed his example in inventing or copying the idea of casing which came into general use in the first half of the nineteenth century.

After the inevitable Egyptomania of the early days of the century and some very heavy bindings at the time of the Restoration, Gothic decoration in the " cathedral manner " became widespread. Eventually this indirectly gave rise to replicas of sixteenth- and seventeenth-century work, and then to a renewal of motifs in the taste of Padeloup under Louis XV.

Towards the end of the century the fashion was for more descriptive bindings in keeping with the words and spirit of the book. After 1900, as might have been expected, it was the turn of floral compositions, from irises to hydrangeas, with the volutes dear to a Guimard. These immediately preceded the linear or geometrical compositions which had their origin in the Decorative Arts Exhibition of 1925, and the symbolism of Pierre Legrain and René Kieffer.

*The Sainte-Chapelle. Detail of a stained-glass window;
the Annunciation and the Visitation.*

THE DECORATIVE ARTS

The decorative arts have always occupied a preponderant place in every style, whether they were being used to enrich the appearance of religious buildings, to underline the pomp and brilliance of religious ceremonies, to complete interiors, to make the background to daily life more attractive, or to beautify everyday objects. Although it is now becoming fashionable to consider them an ' outworn ' notion, it is by them that each art period has been characterized. Doubtless they will continue to perform this function. However, whereas in times past the decorative arts developed from a spontaneous evolution of taste in harmony with the rhythms of man's own cycles of changing thought, technical progress in the second half of the nineteenth century meant that their principal elements no longer evolved naturally but rather were forced into being by the fact of the existence of these techniques. This change of direction was indispensable at a time when the sap of natural growth was running dry. The change was further stimulated by universal exhibitions and the influence they had on art in general. Art Nouveau, the result of much searching and many trials, came into being to illustrate a new conception of artistic creation and its integral assonance. Its intellectuality, cutting across traditional forms, could not be expected to satisfy a very wide public. Nevertheless the formation of a Society of Artist-Decorators, the acceptance of the decorative arts in exhibitions, and the International Exhibition of Decorative Arts (planned for 1916 and postponed until 1925 as a consequence of the First World War) all helped to favour the break with the past, even though there were many doubters. The speed of change has been increasing ever since.

It is very difficult indeed to find the means of presenting the embodiments of the various techniques of past and present.

It was therefore decided to present them in a logical, rational order, that of the date of their beginnings, and their practical use within the framework of the daily life of Paris, spiritual and profane.

The stained-glass window, made for and used in churches, first appeared in France in the tenth

century, though the art could well be older. Suger, abbot and builder of Saint-Denis in the middle of the twelfth century, gave it the place of honour in his new abbey. This is how it came about that stained glass was to be the servant of Gothic architecture, which also derived from Saint-Denis and the influence it radiated. The artists who had worked for Suger travelled far and wide in the royal domain. Chartres was one of their first stages. From the school of Chartres came the master-glaziers who made the windows of Notre-Dame de Paris, begun in 1163. The work was carried on until the end of the century. Ultimately the windows were the victims of the vandalism of the eighteenth century. With the loss of these windows, posterity also lost the only examples which would have allowed the metamorphosis of twelfth-century stained glass into thirteenth-century stained glass to be studied in Paris.

At the beginning of the new era Chartres again became the principal centre for the art of stained glass in the north of France. It was not long before Paris began to supplant it and by the middle of the thirteenth century had recovered its supremacy. In spite of the mutilations and restorations of modern times the Sainte-Chapelle, consecrated in 1248, remains the most complete display of the glass of the period. Most of its glass must have been in position by that date. The progress made in the technique of the oval arch led to a demand for windows of vast proportions. They contain a multitude of small narrative medallions in many different shapes. The iron or lead calms, being no longer needed as a means of support, could now adopt the contours of the medallions and take many different shapes. Borders had a tendency to lose their importance, as compared with those of the twelfth century. The scenes presented were, almost without exception, taken from the Old Testament, episodes in the Life of the Virgin Mary, the lives of the Saints, or the legend of the Holy Cross, or concerned the acquisition of the Relics of the Passion which this church had been built to house. They are soberly and clearly drawn. There is no lack of observation, nor of search for liveliness and natural poses, and bodies are covered with ample, flowing draperies. The key colour is usually blue, with red lozenges punctuated by white at the intersections and filled with yellow lilies or, on occasion, with the arms of Blanche of Castile on a red background. Putting blue and red together, which easily produces a cold tone of purplish-blue, is a characteristic of thirteenth-century production. Although a little confused in detail, the windows of the Sainte-Chapelle give a sparkling polychrome effect and become a translucid mosaic whose brilliance and colour harmony have greatly contributed to its celebrity.

They are only a little earlier than the windows of the Virgin's Chapel in the abbey of Saint-Germain-des-Prés and those of the abbey church itself. Only fragments remain representing *The Annunciation, The Marriage of the Virgin*, Saint Anne, and *Works of Mercy*.

The stained glass of the rose windows of the transepts of Notre-Dame dates from about 1357. Without wishing to traduce the high reputation they enjoy, one should nevertheless remember that the south rose has been remade and contains much modern glass. Only the north rose remains intact, with its incomparable overtones of the gentlest blue. It shows Old Testament characters surrounding the Virgin and Child.

These works, together with those which Abbot Lebeuf and master-glazier Le Vieil were fortunate enough still to be able to see in the eighteenth century but which have now gone, bear witness to the importance of the Paris workshops of the thirteenth century. Their influence was preponderant in the Ile-de-France. It is believed that their work is to be found as far afield as Clermont-Ferrand in Auvergne, for the cathedral windows there were probably the gift of Saint Louis.

During the first half of the fourteenth century, stained-glass technique continued to improve and to change. It was not only churches now but windows of royal and princely dwellings that were adorned with multi-coloured glass. A dry-as-dust list of all the churches and chapels, all the luxurious dwellings, in which stained glass was incorporated would unhappily serve no purpose, for of these fragile and incomparable marvels nothing remains but the memory.

Production from Paris glass-workers remained high at the end of the fourteenth century and in the fifteenth. It began to stand out for its architectural character — a trait which the provincial workshops soon acquired also. Work of this period is rare, because of changes of taste, and the destruction during the Revolution. In his *Art of Painting on Glass* of 1774, Le Vieil called attention to the glasswork of the Collège de Navarre and the church of Saint-Paul, where he points out that amongst the stained glass put up after the liberation of Paris in 1436 there is a presumed portrait of the Maid of Orleans and some pieces which Piganiol de la Force declares to have been composed " by the best glass painters there have ever been ". The rose of the front of the Sainte-Chapelle dates from the reign of Charles VIII and includes ninety apocalyptic subjects. Windows from the second half and the very end of the fifteenth century are still in their places at Saint-Séverin. Some came from the abbey of Saint-Germain-des-Prés and were added to in the nineteenth century by the master-glazier Lafaye. Others on the big scale under canopies show

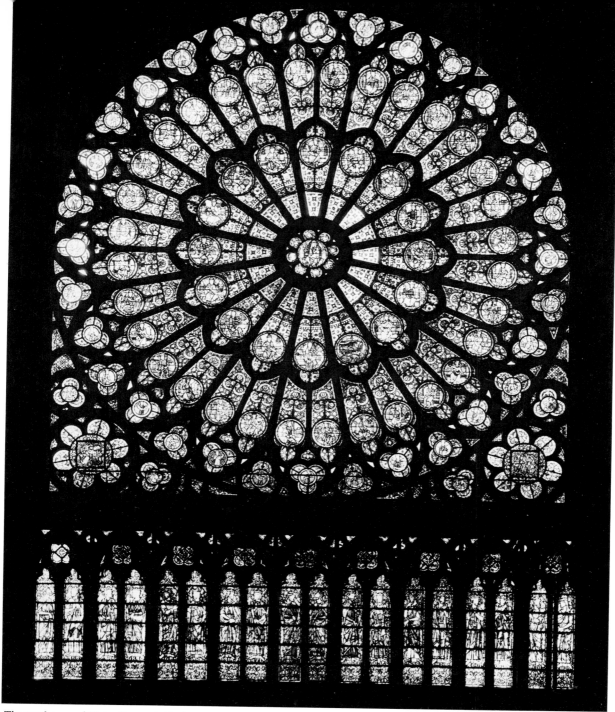

The south rose of Notre-Dame de Paris.

several saints, their donors, and smaller-scale scenes of the New Testament. White tones dominate, and silver-yellow highlights are used generously. Later, in about 1500, a few Renaissance ornaments were introduced into the flamboyant Gothic background of a number of separate sections of stained glass, which have since been united to form a single window in the north transept of Saint-Germain-l'Auxerrois.

In the sixteenth century many production centres came into being in France. Paris could boast of a number of quite famous designers, amongst whom the members of the Pinaigrier family figured. They played their part in the transformation of stained glass, which now became, by the application of enamel to glass, simply a piece of translucid painting. The windows which would have enabled the consequences of this change to be observed and the victory of Italian influences to be noted have disappeared. Most were to be found in their original places, or taken down from elsewhere and put up again at the Abbey of Saint-Victor, the Temple church, the Enfants-Rouges hospital, the ossuary of Saint-Jacques-la-Boucherie, or at Saint-André-

des-Arts. Virtually all that remains from the first half of the sixteenth century is *The Judgment of Solomon* (1531) at Saint-Gervais, sometimes attributed to Jean Cousin and sometimes to Robert Pinaigrier.

A number of different stained-glass windows belong to the immediately subsequent period. They are at Saint-Merri, Saint-Germain-l'Auxerrois, at Saint-Gervais, and — the most important of them — *The Parable of the Guests* at Saint-Etienne-du-Mont, attributed with great probability to Robert Pinaigrier.

There are some well-esteemed pieces to be found in the old ossuaries of this same church, notably the *Mystic Winepress* dating from the reign of

disappeared, they are no more than the reflection of monumental sculpture, or the miniaturization of it. If at that time ivory carvers were lacking in invention, at least their ability was very great. It gave birth to the accomplished work of the thirteenth and fourteenth centuries. It is not possible to determine a specifically Parisian style in the output of this later period, but though there is an absence of manuscript records which would explicitly confirm the existence of a Parisian school, it is significant that Paris is the only French town of that era whose guild statutes mention ivory workers. These were separated into different classes. The most expert took their place amongst " Painters and Carvers of Images " and " Carvers of Images who also carve

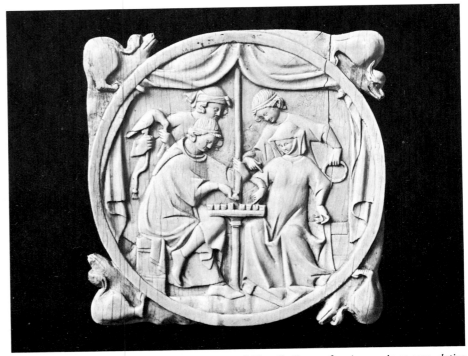

" The Game of Chess ". Cover of an ivory mirror case, dating from the first half of the fourteenth century. In the Louvre Museum.

Louis XIII, which is now known to be the faithful transcription of an engraving by Léonard Gaultier. This alone would serve to show how low the master-glazier's art, which boasted so many masterpieces, had now fallen.

As with stained glass, the carving of ivory began as an essentially religious art. Gothic ivories, as Raymond Kœchlin has pointed out, have not the same importance for the history of art as those of the high Middle Ages. Instead of being the only witnesses of a field of sculptural activity which has

Crucifixes ". Their work was esteemed by foreign princes. The kings of France sent examples of their art by way of gifts to the churches of the kingdom and to their brother sovereigns.

Few ivories of the beginning of the Gothic period exist. Not until the twelfth century does the number become substantial, and is particularly so for the second third of the thirteenth century. In general they represent the Virgin, the Crowning of Jesus, the Deposition from the Cross, and reflect the changes and turns in the evolution of cathedral

The stained-glass windows of the apse of the Sainte-Chapelle.

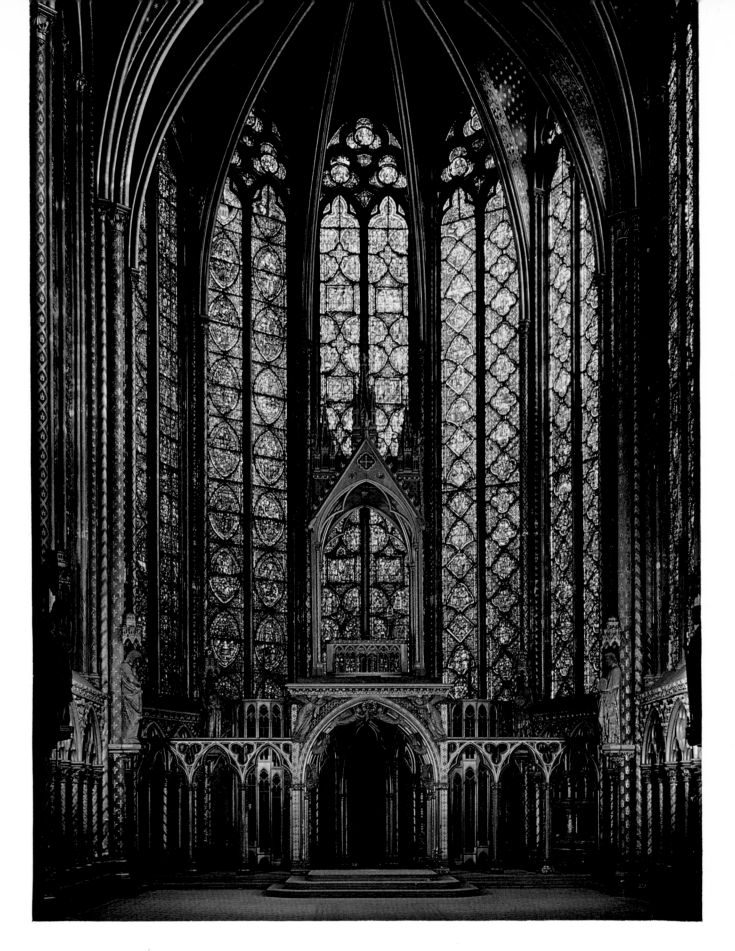

sculpture. The famous sculpture of the choir of Notre-Dame was a source of inspiration for ivory workers, as has already been mentioned in connection with them. Many diptychs, note tablets, and other items illustrating the crucial episodes of the New Testament are to be found in the treasure rooms of most ancient Christian churches, in the great European museums, and in private collections, which makes the recognition and characterization of the various workshops much easier. A more precise observation of nature, and a new realism, brought life to the work of the ivory carvers of the fourteenth century. Carried to excess, sometimes to the point of pomposity, they led to the decadence of the art. This had already come about by the end of the fifteenth century.

Ivory carvers also made objects for non-religious purposes, pieces intended for daily use, such as mirror-box lids, caskets, writing tablets, toilet cases, and combs. These little Paris-made pieces were much sought after by visitors to the city, even though the themes used for illustration were much more limited than in the case of religious work. In style and finish, though, they were not in any way inferior.

Dragons vomiting frogs. Tapestry of the Apocalypse, by Nicolas Bataille, fourteenth century. In the Musée des Tapisseries, Angers.

Though the work of ivory carvers merits attention and a sustained interest, it was not so highly considered as that of the tapestry-makers, with which few of the luxury industries could compare in general appreciation; moreover, there is little that is so much associated with the evolution of customs, or is capable of giving such precise information about the pictorial art, the costume, the furniture, and the public and private life of the Middle Ages. From the very beginning historiated hangings were received with warm favour. First they decorated churches. Soon kings and princes owned many examples and decorated their dwellings with them, both because they kept out the cold and because they admired them. They took them on their travels and hung them on every great occasion, grave or gay.

The term ' high-warp ' is first met with in Paris at the beginning of the fourteenth century, but tapestry-making, whose origins are the subject of much argument, must already have been known there for some time. Soon the high-warp weavers of Paris had become the rivals of those of Arras, where, thanks to the Countess Mahaut d'Artois, prosperous workshops had been set up. King John figured prominently amongst the clients of the Parisian artisans and after him his four sons, each a Mæcenas in his own right. The inventory of Charles V mentions nearly two hundred hangings in 1385. They included designs of trees and flowers, coats of arms, episodes from *chansons de gestes* and tales of chivalry, pastorals, and hunting scenes, as well as contemporary events, such as battles, tournaments, and entertainments.

The infatuation of Charles V for textile art was so powerful that he even agreed to lend a manuscript from his library to his brother, Louis I of Anjou, to enable him to get the weaving started of his " fine carpet " by Nicolas Bataille, the most outstanding of the Parisian tapestry-makers. This " fine carpet " was nothing less than the series of tapestries of the Apocalypse at Angers. This is one of the few contemporary works to have survived into our own times, and possibly the only one. And, of course, Charles V never got his manuscript back!

The cartoons were designed by the Flemish painter known as Hennequin of Bruges, or Jean de Bruges. Thus by inspiration as well as by origin they were related both to the art of the miniaturist and the art of the painter of pictures. At the beginning there were seven groups of pictures, each one opening with a person sitting under a rich architectural canopy and engaged in reading the scriptures. The composition then continued with two friezes placed one above the other, and each containing seven pictures. The background tone was alternately red and blue; around the thirtieth picture the plain colour began to be enriched by the addition of ornaments. Once there had been written words to accompany the pictures. The sky was peopled with angels playing different musical instruments, or else singing, or bearing escutcheons. Below, the ground was covered with flowers, amongst which little animals could be found. The total length of all the episodes of the Apocalypse measured nearly 150 metres (490 feet). After being subjected to infinite vicissitudes which need not be recalled here only sixty-nine scenes and some fragments remain.

Despite being engaged on this laborious task, Nicolas Bataille did not work solely for the Duke of Anjou, or for eminent foreigners such as the Duke of Savoy. The Crown also engaged his looms. For it he designed an apparently remarkable but short-lived *Jousts and Rejoicings at Saint-Denis* in 1383 on the occasion of the admission of the King's brother and their cousin Louis II of Anjou into the Order of Chivalry. Also due to him is the *Tapestry of the Champion Knights*, now in The Cloisters, annex of the Metropolitan Museum of New York.

Bataille died before the year 1400, and for a while after his death his wife managed the workshop. He had had many imitators and some rivals, with, amongst the latter, his own partner Jacques Dourdin, who died in 1407 and was interred in the ossuary of the Innocents. Between 1386 and 1397 he delivered no fewer than seventeen tapestries to Philip the Bold, Duke of Burgundy. But so many precious works were not sufficient for the ostentatious needs of this prince, who seems to have kept another Parisian high-warp weaver permanently in his service, one Pierre Baumetz, or de Baumetz.

The decadence of Parisian weavers in the fifteenth century was very great. Until about 1408 or 1410, Nicolas Bataille's widow did nothing but blue backgrounds strewn with lilies. The tax roll brought out by the English in 1421 mentions only two tapestry-makers left in Paris. They were no more numerous than that during the reign of Charles VI, and there were still only two or three under Charles VII and Louis XI. Chased from the capital by their own poverty and then hesitating to return to it in the absence of a king, tapestry-makers apparently drifted to other centres which had remained prosperous. They took up residence in Touraine near the Court, or went abroad. A papal tapestry-weaving establishment was set up by a Parisian, Renaud de Maincourt, in about 1455. He wove a *Creation of the World*, spoken of with admiration in his own times.

With the turn of the century Parisian tapestry-weavers found renewed activity. Although very few actual specimens are known, the number of historiated hangings mentioned or known to have been contracted for in the sixteenth century was

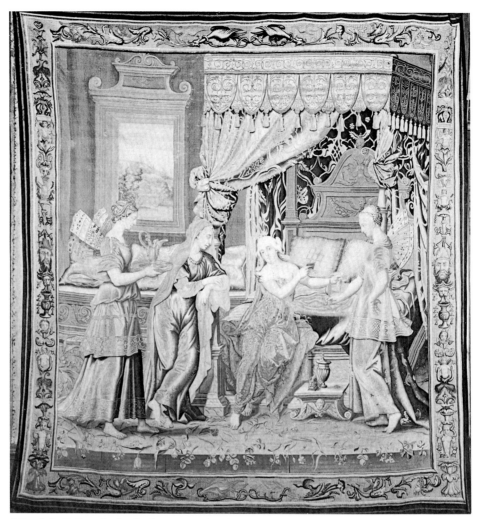

" Psyche's Toilette ", the third tapestry of " The History of Psyche ". Tapestry by F. de la Planche, in the Château de Pau.

considerable, and there was other work available, such as mule trappings and woven armorial bearings. Two pieces in Langres cathedral and one in the Louvre Museum were part of *The Life of Saint Mamas*, from cartoons by Jean Cousin the Elder. It was commissioned from two Parisian high-warp weavers, Pierre Blassey and Jacques Langley, in 1544. Surrounded by wide decorative borders, it confirms the abandonment of medieval forms and the switch to the Italianate, including, according to the rules, antique architecture as a background decoration.

Whilst individual craftsmen continued to work independently, in 1551 Paris was provided with a School of Tapestry at the Hôpital de la Trinité, for the purpose of teaching tapestry techniques to orphans. Under the protection of Henry II this institution took on some importance and its work was not interrupted by the Wars of Religion. It is possible that it was given the Artemisian tapestry

to weave, dedicated to Catherine de Médicis. It was constantly being taken off and put back on to the looms until well into the seventeenth century. In 1584 contracts were signed with Maurice Dubourg, director of the Trinité workshop, for a *Life of Christ*, intended for the church of Saint-Merri. Only two fragments of it are known, and a series of twenty drawings (now in the Cabinet des Estampes) by Larembert.

The main interest of the Trinité workshop is not so much what it achieved as the fact that it introduced the idea of a royal enterprise of this kind which was to dominate tapestry-weaving during the seventeenth and eighteenth centuries.

Sauval the historian has made it known that as soon as Henry IV had won his battle for the throne he expressed the wish to " re-establish in Paris the making of tapestries which had been abandoned during the disorders of the two previous reigns ". This desire coincided with a methodical plan for the

reorganization of commerce and, most particularly, the luxury industries. At that time Flanders was the brilliant centre of the textile industry. So in 1601 the former King of Navarre inveigled a Flemish high-warp weaver into coming to Paris. He was François Verrier or Versier, and one presumes he was accompanied on his move by several of his compatriots. Amongst them one could expect to have found Franz van der Planken of Oudenarde (who became François de la Planche) and his brother-in-law Marc de Comans, of Antwerp. They were formally united by a written agreement, and, by means of a promise to train French apprentices, they obtained in 1607 Letters Patent to open an independent workshop for tapestry-making, and were protected by a number of edicts. They were first established at the Hôtel des Tournelles, but later transferred to the neighbourhood of the old dye works of the Gobelins, mentioned by Rabelais. At the end of their period of privilege the two partners were granted a second one with a duration of eight years. The death of François de la Planche was followed by a split between his heirs and the Comanses. His son, Raphaël de la Planche, moved from the Faubourg Saint-Marcel to the Faubourg Saint-Germain. His looms were active for another thirty years, and his reputation seems to have stood higher than that of any of his rivals. The latter were not the weavers of the Hôpital de la Trinité, who, after being established in the time of Henry II, were still operating up to about 1636, but the men whose looms had been operating under the Grand Gallery of the Louvre since 1608. If not an official one, they had some kind of a semi-official status. They were managed by Girard Laurent and Maurice Dubourg, each being succeeded by sons. The latter had a new neighbour in about 1647, when Mazarin brought Pierre Lefèvre to Paris from Florence. He returned to Italy after three years, but left his son Jean to take up his succession in Paris.

Early tapestries from the Paris looms went on reproducing ancient models more or less brought up to date. Such were *The History of Artemisia* (after Caron and Lerambert), *The Lucas Months*, *The History of Gombault and of Macée* (still in the possession of Harpagon nearly half a century later), *The History of Theagenes and Chariclea*, painted at Fontainebleau by Ambroise Dubois, and *The History of Coriolanus*, by Lerambert. Truly, the early tapestries woven in the Paris workshops offered little that was new. After the death of Lerambert, " painter of the King's tapestries ", Laurent Guyot and Toussaint Dumée were designated by competition success to follow him. They prepared the cartoons illustrating Guarini's *The Faithful Shepherd*. The mediocrity of this school of painting is made sufficiently clear by the fact that Louis XIII commissioned Rubens to paint the models for a *History of Constantine* for the weavers of the Faubourg Saint-Marcel.

The return of Simon Vouet (1627) and his decisive effect upon the evolution of painting had a no less satisfactory influence on the art of tapestry. As his pupil Charles Le Brun did later, Vouet employed a number of clever assistants to complete cartoons from his original designs. Attributed to him are subjects from the Old Testament, of which *Moses saved from the Waters* formed part (now belonging to the Louvre Museum), the tapestry in the Château de Cheverny illustrating *The Labours of Hercules*, and *The History of Rinaldo and Armida*. All these series are remarkable for their composition, for the harmony of colour the wool strands have preserved, and the sumptuously decorative borders. In their turn Philippe de Champaigne and Charles Poerson painted the cartoons for *The History of the Virgin Mary* (1636) in fourteen tableaux, partly woven by Pierre Damour, an independent weaver, for Notre-Dame de Paris (in Strasbourg cathedral since 1739). In collaboration with Eustache Le Sueur and Sébastien Bourdon, Philippe de Champaigne designed the cartoons for a *History of Saint Gervais and Saint Protais* (between 1645 and 1653), a suite presumed to have been carried out on the looms of the Louvre, to which also *The Seven Sacraments* by Poussin, painted in Italy for Cassiano del Pozzo, would presumably have gone had the project not been abandoned.

Soon afterwards the already declining activities of the Paris tapestry-makers were still further slowed down by the troubles of the Fronde. Charles Le Brun took advantage of all that was to be learned from the Paris weavers for a workshop at Maincy, founded in 1658 for Nicolas Fouquet near his château of Vaux. Colbert stepped in after this Superintendent of Finances had been arrested and imprisoned in order to avoid the dispersal of the looms. He ordered them to be taken to a building in Paris he had bought specially for the purpose. To these looms he added those of the Louvre, and those of the last of the Comans family. Profiting by the lessons of the past, the Gobelins factory was ready to spread its wings.

It had been founded in 1662, and was reorganized in 1667 under the title of Crown Furniture Manufactory. It brought the art and the craft of modern French tapestry to so high a pitch of technical and artistic perfection that in several languages *gobelins* is the only word for a tapestry.

In the first period of its existence it was dominated by Charles Le Brun, First Painter to Louis XIV, who turned out to be an exceptional dictator of the decorative arts. Looms for high-warp and low-warp under the management of men like Jans, Le Febvre, de la Croix (all of whom left successors) wove many hangings with wide borders in wool,

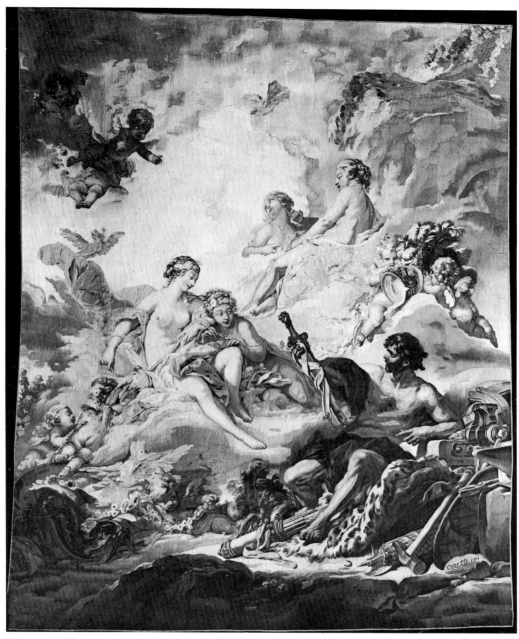

Venus and Vulcan, an eighteenth-century Gobelins tapestry.

silk, and gold, all to his ideas. An entire team of painters produced *The History of Meleager* (begun at Maincy (1661-62), *The Portières of Famous Women* (1660), *Mars, The Triumphal Car, The Elements* (1664), and *The Seasons* (also 1664) before proceeding with a series dedicated to the glory of the Sun King. There were discreet allusions to it in *The History of Alexander* (1668-70) and direct evocations of the wonderful existence of the sovereign in the fourteen episodes of *The History of the King* (1665) and in *Royal Months* or *Royal Houses* (1668) which showed the splendour of his châteaux and the entertainments he gave.

Le Brun had been the protégé of Colbert and suffered from the enmity of Louvois when the former died. Louvois ordered the setting up on the looms of designs, in part inspired by Raphaël and Jules Romains, which had reached Paris via Flanders: *The Rooms of the Vatican* (1682), *The History of Psyche* (1686), *The Arabian Months* (1687), *The Fruits of War* (1688), and *The History of Scipio*; copies from Brussels were added to these, *Maximilian's Hunts* (1687), after Bernard van Orley, and *The Lucas Months* (1688), after Lucas of Leyden. Le Brun died in 1690, and his ex-rival Mignard succeeded him. He completed *The Saint-*

Cloud Gallery from his own paintings. The difficulties of the reign brought about the closure of the Gobelins in 1694, and the tapestry workers were dispersed.

They did not open again until 1699, when the production of religious and mythological subjects was put in hand. These included *Scenes from the Old and New Testaments*, after Jouvenet and Restout (1711), Ovid's *Metamorphoses* (1714), *The Iliad*, after the Coypels (1730), *The Story of Esther*, after de Troy (1737), *History of Mark Antony*, after Natoire (1741), and *The History of Jason* (1743-56). Contemporary events were recalled by *The Turkish Embassy*, after Parrocel (1731-37) and *The Hunts of Louis XV*, after Jean-Baptiste Oudry (1734-45). A repeat of themes already used in a *Tapestry of the Indies*, dating from 1668, was to be found in *The New Indies*, after Desportes (1737). It was a concession to an eighteenth-century taste for the exotic. This inspiration is less clearly to be seen in several portières, such as *The New Diana Portière* (1727) and *The New Portière* (1727) carrying the arms of France, than in the lighter designs with arabesques and ornaments of *The Portières of the Gods* (after 1699) and *A Grotesque View of the Months*, *in Strips*, by Claude Audran III (1709).

However, the principal novelty in the eighteenth century was in the surrounds. Sham pictures stood out from damask backgrounds, and were set about by symbols, trophies, and garlands of flowers. It all began, from 1714 onwards, with *The History of Don Quixote*, by Charles-Antoine Coypel, picked up again in *The Tapestry of Daphnis and Chloë* (*c.* 1715), after the Regent, and *Scenes from the Theatre* (1748-50), again after Charles-Antoine Coypel, and won singular favour with *The Tapestry of the Gods* (1758-63), by Boucher and Maurice Jacques, matched by corresponding furniture upholstery. Again the creator of chubby, pearl-adorned nymphs and plump-cheeked cupids designed more cartoons for *Sunrise* and *Sunset* (1752-57) and three others for *The Lovers of the Gods* (1757), a series subsequently added to by Van Loo, Natoire, Pierre, and Vien. To these can be added *Village Fêtes* (1753), after Jeaurat, and the *Fashions and Customs of the Levant* (1772-76), after Amédée Van Loo.

The all-too-accurate copying of paintings by Van Loo for use in another medium is an example of the success unfortunately obtained by the theories of Jean-Baptiste Oudry (died 1755), who whilst in charge of tapestry-making at Beauvais and the Gobelins insisted upon literal copies of painted originals. Oudry dealt the most dangerous of blows

Staircase of Honour of the Palais-Royal (now the Council of State). Handrail in forged iron, by Corbin.

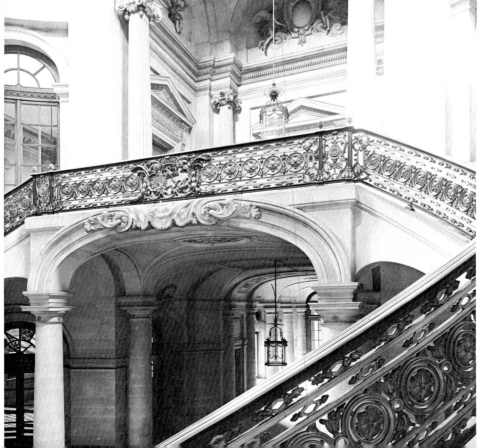

to the essential rules and traditions of tapestry-making by forcing it to imitate the colours and the play of light of painted works. By doing so he put it into direct competition with painting, of which it became no more than a copy carried out in wools and silks. The portraits and genre subjects from Cozette's looms show this all too clearly in the *History of Henry IV* (1783-87), after Vincent, the *Seasons* (1784-87), after Callet, with background and characters aping the antique, and *Tableaux from French History* (1784-87), by Brenet, Durameau, and others.

Under the Empire the Gobelins tried copying paintings intended to glorify the Emperor and his campaigns. More prosaically, they made furniture upholstery for his palaces, for which the Savonnerie wove the carpets. This imitation of painting remained the supreme aim of tapestry-making all through the nineteenth century, in contradiction to its own laws and æsthetics. The multiplying of available colours (a chemical triumph) did no more than send it further along the wrong road. Not until 1937 was there a return to natural colour by which the range was limited to solid tones. The choice of originals belonged to a very different discipline from that of 'official' art which had reigned supreme for a very long period.

As with stained glass, ivory-carving, and tapestry-making, so did wrought ironwork, enamelling, and goldsmith's work have their beginning in the decoration of religious buildings.

No examples still exist which would enable one to localize and study specifically Parisian ironwork. It came within the scope of art in the twelfth century and reached great perfection in the thirteenth. In the latter period one can at least point to the strap hinges of the Saint Anne and Virgin portals of Notre-Dame. These are volutes of leaves and flowers, drop-forged, stamped out, hot welded until they had blossomed into foliated scrolls and bouquets of incomparable delicacy.

Art metal-work also produced many notable objects, of which Etienne Boileau's *Book of Crafts* gives some idea. Craftsmanship remained at a very high level in the fourteenth and fifteenth centuries, gaining much from changes in techniques. A good example is the armature of the well in the one-time residence of the Abbots of Cluny, now the Cluny Museum.

During the seventeenth century and increasingly so in the eighteenth wrought ironwork remained an important decorative feature in Paris. The evolution of architecture and the transformation of techniques — by which welding gave way to embossed and riveted sheet work — greatly helped art metalworkers. It allowed them to carry out work of greater scope, which is as remarkable for its technical perfection as for its elegance and variety of

Forged-iron banisters at the Hôtel de Lagrange, 4-6 Rue de Braque.

adaptation to the different decorative styles in fashion at the time. Unfortunately many of these works, and not the least amongst them, no longer exist. As work dating from the first half of the seventeenth century one can only quote a balcony at the Louvre — and a restored one at that — on the lower floor of the Little Gallery, showing the initials of Louis XIII and Anne of Austria. The choir screens of the Val-de-Grâce chapel by Jean de Mouchy and Sébastien Malthérion (1666) belong to the following period, as do the banisters of the Maison Professe des Jésuites (now the Lycée Charlemagne), and those of some private mansions, like the Hôtel Aubert de Fontenay or Hôtel Salé in the Rue de Thorigny. In place of the relative simplicity of seventeenth-century work, of which the aim was to preserve an architectonic character and a scrupulously observed symmetry in all that was produced, the eighteenth century introduced graceful curves and volutes, foliated scrolls and added ornament in a variety deriving from inexhaustible inventiveness. The fame of Parisian art

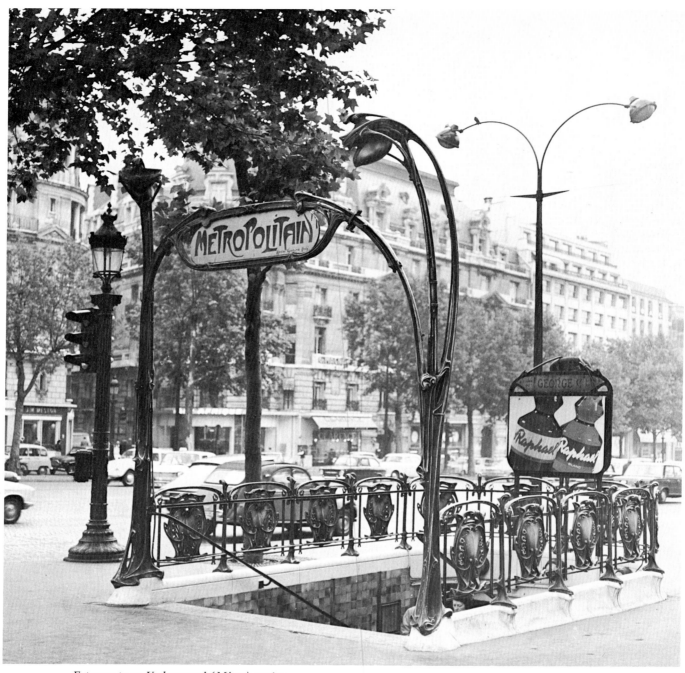

Entrance to an Underground (Métro) station,
by Hector Guimard.

metal-workers spread all over the kingdom, bringing them commissions for churches and hospices in Normandy and Champagne. This did not interfere with their efforts to enrich private houses and churches in Paris itself. The choir screen of Saint-Roch (1760) has gone, but other examples of the professional skill they exercised are still in place elsewhere. They are to be seen in Saint-Gervais (1743), at Saint-Sulpice (wedding sacristy), and in the Hôtel des Monnaies. There are also the banisters of the Palais-Royal (1763) by Jean Corbin and one of the Caffieri, accompanied by gilded bronze

ornaments, as is the communion rail (1767) at Saint-Germain-l'Auxerrois by Pierre Dumiez. This latter one told of the return to the classical style, which in the reign of Louis XVI became even more pronounced. Gabriel designed the rail and the banisters of the Ecole Militaire, with chasing by Claude Fayet (1773), about ten years prior to the monumental, gilded wrought-iron gates with Ionic pilasters and triple openings by Bigeonnet (after Desmaisons the architect) which closed in the Cour de Mai at the Palais de Justice (1783-85).

These large-scale works, always to be appreciated at their own high value, should not be allowed to blind us to the many railings, gates, and banisters which give charm to so many old houses of the end of the seventeenth and of the eighteenth century. The talent of so many unknown art metal-workers made known through them is revealed in all its originality. They also show the skill which the old Parisian artisans possessed in giving a real artistic value to the most ordinary of objects.

After having been in existence for a century without any real sign of brilliance in their use, iron and cast-iron found their place in the Modern style when Guimard used both to decorate the entrances to the new metropolitan railway. They were made into vegetable giants and corollas. For front doors of buildings, for balconies, for lift-gates, and for the banisters of staircases, these materials blossomed into floral motifs, plump stalks, and flaccid arabesques. For house fittings and locksmith's work iron and gilded bronze were used together in the form of chimeric creatures, of strange motifs for lock covers and keys, door-knobs and gongs. Emile Robert and Richard Devallières used iron in accordance with classical methods, but elsewhere other ways were being experimented with. Edgar Brandt improved on hammer work by the use of oxy-acetylene welding. By mechanical means Subes discovered the modern æsthetic ' feel ' of iron. And, curiously enough for such late times, iron was used for the monument to Marshal Leclerc at the Porte d'Orléans.

In the thirteenth and fourteenth centuries gold-smiths' and silversmiths' work gradually ceased to be the almost exclusive monopoly of monastic workshops. Goldsmiths had in fact been working in Paris, on the Grand-Pont, in the middle of the eleventh century. They made themselves into a Guild or Corporation which under Philip Augustus became a religious confraternity. Their statutes were written into Etienne Boileau's *Book of Crafts* in 1268. By favour of Saint Louis they were granted the exclusive privilege of working precious metals in the capital, and retained it until the Revolution. They were, however, subjected to strict super-vision: on several occasions during the fourteenth century their output was brought under regulation. The pieces they supplied to their regular patrons — princes and great lords and wealthy private citizens — were looked upon by their purchasers as reserves to be turned into ready money in times of financial difficulty. During revolutions many pieces were completely destroyed. Between the two, all that we know of them is from descriptions or mentions in the inventories of princely households. Hardly any better preserved has been the work done for various churches, whether it be the reliquary of Sainte Geneviève, chased by Bonnard the gold-

smith in about 1242, or the famous reliquary of Saint Marcel for Notre-Dame, completed about 1262, or the reliquary-bust of Saint Louis supported by four angels in silver-gilt, cast in 1306 by order of Philip the Fair for the Sainte-Chapelle. These items showed the goldsmiths of the time to be inspired by the great monuments of religious architecture, down to the smallest detail.

In the fourteenth century these architectonic considerations more and more frequently gave way to the desire to outrival the carvers of images. The reliquary which Jeanne d'Evreux presented to the abbey of Saint-Denis in 1339 (often said to have originated with a Parisian goldsmith working for the Crown), and now in the Louvre, is nothing

Silver ewer, 1603-4.
In the Musée des Arts Décoratifs, Paris.

else than a figure in the round. The platform supporting it has every appearance of being due to a new technique, originating no doubt from Italy and intended to replace the champlevé enamel work so successful during the previous two centuries, particularly that of Limoges. Here the chased silver plates decorating the base are nielloed with enamel and stand out on a background of blue enamel dotted with little flowers. These, together with a paten of 1333 and a six-sided altar cruet carrying the lily-patterned mark of a Parisian

Silver ewer, 1722. Musée des Arts Décoratifs, Paris.

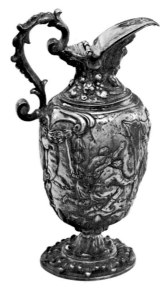

Altar cruet in chased silver from the Colbert family chapel, seventeenth century. In the Treasury of Troyes cathedral.

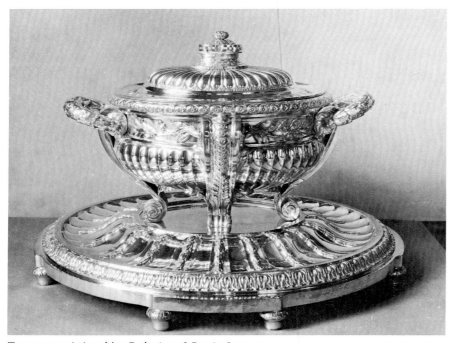

Tureen commissioned by Catherine of Russia from Nicolas Roettiers for Prince Orloff (1770-71). Musée Nissim de Camondo, Paris.

goldsmith (both in the Copenhagen Museum), and with a thick enamelled model for a coin of a period later than 1338-39 and a variation on the technique on a gold cup presented by the Duke of Berry to Charles VI in 1391 (both pieces being in the British Museum), are the oldest surviving examples of French translucent enamel on relief work.

Very little remains of the innumerable pieces of gold and silver work made for Charles V and his brothers, except for a cover for the Gospels (in the Bibliothèque Nationale) presented to the Sainte-Chapelle in 1379, and a sceptre believed to have been made by Hennequin du Vivier, combined valet and goldsmith to the King. This sceptre, which has been greatly restored, came from the Treasure of Saint-Denis and is now in the Louvre Museum.

After the disastrous episodes of the fifteenth century in Paris the return of the sovereign and the

Court in the sixteenth century, together with the luxury with which Francis I and his successors surrounded themselves, naturally gave an immense impetus to the luxury trades. Once more there was work for the goldsmith to do, and he soon became prosperous. Just as in previous periods, the goldsmiths' work was soon melted down when times got a little difficult. Archives have to be consulted, texts and reports (such as the account of the *Entry of Queen Eleanor of Austria*, second wife of Francis I) have to be studied and the pages of Miscellanies (designed and engraved by such men as René Boyvin, Pierre Millan, Jacques Androuet du Cerceau, and Etienne Delaune) turned over, in order to have any idea of what this work was. Outside decoration proper, shape and form of accessories were dominated by the taste for the antique which, in this connection, can be taken to mean for the work of Italian goldsmiths. One of their most famous representatives, the adventurer Benvenuto Cellini, worked for five years at the Hôtel du Petit-Nesle, where he gathered both French and foreign pupils around him. During this period Cellini was mostly engaged on big-scale works of sculpture, and chased only a few pieces of silver. These included some silver vases, a figure of Jupiter, and the famous salt cellar, accompanied by Neptune, and Earth, and attributes, made from a design prepared in Florence. For long it was kept in Austria, but is now in the Louvre Museum. With pieces from the chapel of the Order of the Holy Spirit commissioned by Henry III about 1580 it is amongst the few rare specimens of sixteenth-century goldsmiths' work to have survived. Their artistic value is slight but one should notice a curious censer in the shape of an antique temple.

The art of enamelling is still appreciated, alongside that of the goldsmith, and Limoges is still its centre. Though Léonard Limosin held the office of valet to Henry II and is confirmed by references to him in the Accounts of the King's Buildings to have lived in Paris at one time, it is almost certainly in Limoges and not in Paris that he completed two portable pictures in enamel, after Niccolò dell' Abbate, for the Sainte-Chapelle.

Generally speaking, however, the art of the goldsmith contributed to the widespread fame of

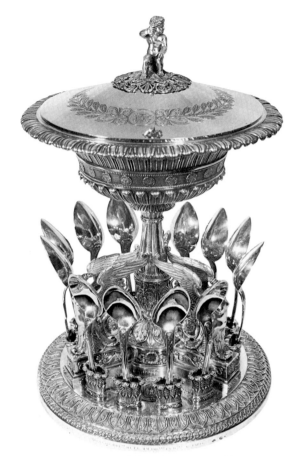

Jam dish with the armorial bearings of Queen Hortense, by Biennais and Lorillon. In the Louvre Museum.

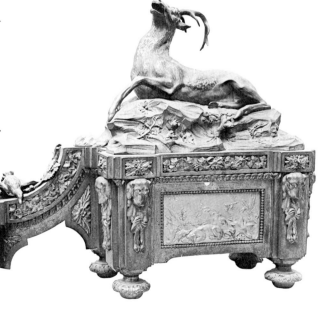

Andiron in gilded bronze, by Gouthière, for the Château de Louveciennes, about 1770. Musée des Arts Décoratifs, Paris.

171

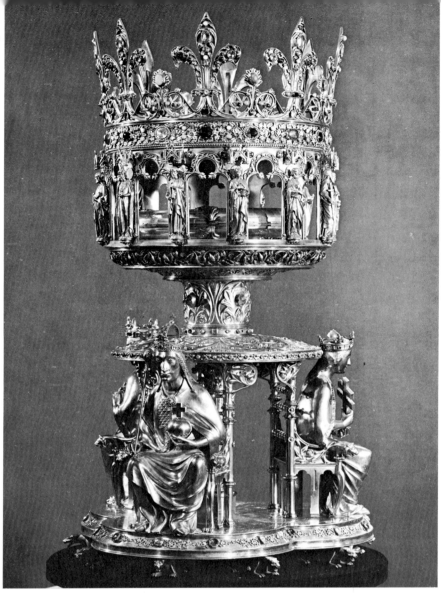

Reliquary for the Crown of Thorns, by Poussielgue-Rusand, 1862. In the Treasury of Notre-Dame de Paris.

A " Sylvia " pendant in gold, with brilliants, rubies, agate, and enamel work, signed Vever, 1900. Musée des Arts Décoratifs, Paris.

Paris as the city of the arts. In the seventeenth century the master goldsmiths of Paris were suppliers to the principal royal Courts of Europe, with the fortunate effect of saving many of their masterpieces from being melted down. In this they were more fortunate than their predecessors, for nothing — or almost nothing — remains of the work commissioned during the first half of the century by Cardinal Richelieu or Mazarin. Utterly destroyed, too, soon after their creation, were the marvellous pieces of furniture in silver designed for Versailles under Louis XIV from the drawings of Charles Le Brun, made at the Gobelins by the de Villiers brothers and Alexis Loir, and under the Louvre Gallery by Claude Ballin, Nicolas de Launay, Thomas Merlin, and Pierre Germain.

Goldsmiths' work in the eighteenth century, like that of the latter part of the seventeenth, was more lay than religious, consisting mainly of objects and utensils for the table — *olla podrida* pots, a recent innovation, soup tureens, terrines for potted meats,

plates, cutlery, chandeliers, statuettes. Excesses of the *rocaille* style, in the manner made popular by the Lyon-born designer-ornamentalist Meissonier, were not always absent from their design. Charles-Nicolas Cochin's campaign for a return to the classic style began significantly by a *Plea to the Goldsmiths, Engravers, and Decorators on Wood* (1754). Thomas Germain, François-Thomas Germain, and Jacques Roettiers did not entirely avoid an undue exuberance, but with them it was lost in the general decorative value of their work and the virtuosity of its execution. Some famous goldsmiths evolved very cautiously and retained greater sobriety. Such was the case of Robert-Joseph Auguste, the leading master of the second half of the eighteenth century, a period in which François Joubert, J. Villetain, and J.-B. Cheret worked and J.-B.-C. Odiot made his beginnings.

Odiot ranks with Auguste and Biennais as the best goldsmith of the Empire. Influenced by Percier and Fontaine, the fashion at this time was for a return to the antique, with a strong tendency towards the architectural. This was in direct contrast to the imitations of sculptures which characterized the Restoration period, with its borrowing of colour schemes and associations with enamel work and with the neo-Renaissance developments of the Romantics, and with the literary preoccupations of Feuchères and Klagmann, devisers of the models from which Froment-Meurice worked. Prior to the search for new themes under the Second Empire, which drew inspiration from the Orient, and to the use of new semi-precious materials, there had been a return to the eighteenth century. Soon, however, all this gave way to a fashion for the floral and the natural. The art of 1900 had but to stylize it to adapt it to the taste of the day.

Goldsmiths' work had an important place in everyday life, which was lived for a long time against a background of excellent examples of the art of wood-carving.

In the seventeenth and eighteenth centuries, after the achievement (*c.* 1556) of Scibec de Carpi with the ceiling of the King's *chambre de parade* (State Room) at the Louvre, and after Pierre Lescot, artistic woodwork took the form of panelling.

Painted with various ornaments, arabesques, grotesque designs, or floral motifs carried into effect by the finest artist-decorators of the period (including Watteau), panels were also carved according to the latest fluctuations of fashion and changes in architectural design.

In general terms, under Louis XIII and Louis XIV they were intended for the mansions of the Marais and the Ile Saint-Louis. Under Louis XV and Louis XVI they were created for the houses of the Place Vendôme, the Faubourg Saint-Germain, and

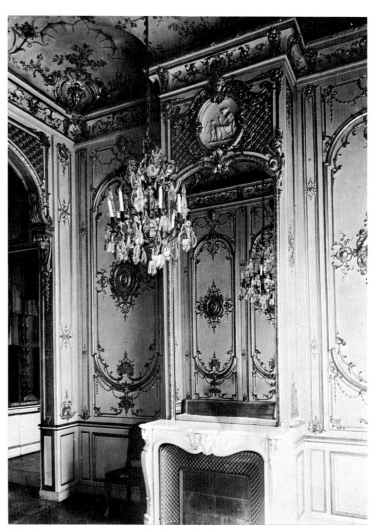

Woodwork in the mansion at 21 Place Vendôme.

Hôtel de Rohan: the Monkey Room.

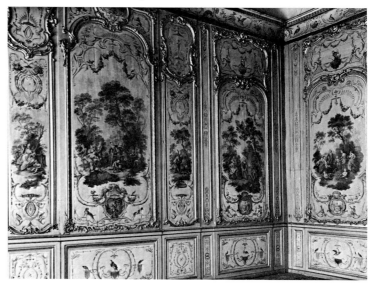

the Faubourg Saint-Honoré. Although many have been mutilated, and others dispersed, the remainder still show the skill of the pupils of Mansart, Robert de Cotte, Boffrand, and Gabriel. With exceptions, these men remain little known. The major exception is Vassé, who was responsible for the woodwork of the gilded gallery at the Hôtel de Toulouse (1714-15), followed by Gilles-Marie Oppenordt, at the Palais-Royal (1719), Pineau, probably employed by Boffrand at the Hôtel de Soubise (*c.* 1752), Jacques Verbeck (*c.* 1715), and Antoine Rousseau at the Ecole Militaire (1775). These anonymous artists expressed, each in his own time but always with unparalleled æsthetic perfection, the aspirations of the moment. They were the interpreters of the

fashions for classicism and of the straight line (which was a little softened during the French Regency period), the jig-saw *rocaille*, the era of rigidity, the return to the antique, and the frail decorations of Pompeian origin.

The art of woodwork also had its place in the enrichment of churches.

The wrecked remains of church furniture still to be seen in Paris reveal the talent of honest artisans. They include doors with heavy leaves dating from the first half of the seventeenth century at Saint-Joseph-des-Carmes, churchwardens' benches at Saint-Germain-l'Auxerrois (1682-84), the choir stalls of Notre-Dame, from designs by Robert de Cotte (beginning of the eighteenth century), and

Small drawing-room, with paintings after Oudry representing the Fables of La Fontaine, from the mansion at 9 Place Vendôme, Paris, and now in the Musée des Arts Décoratifs, Paris.

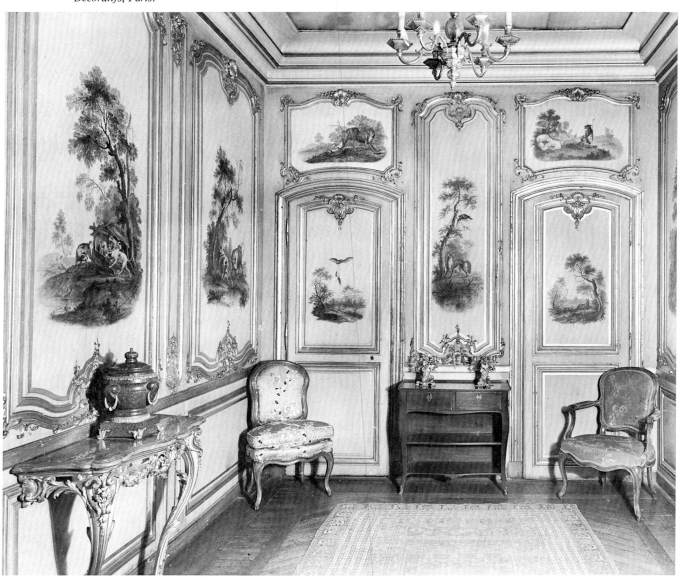

as well the woodwork of the choir, including the stalls and the confessionals.

They were given further opportunities to display their skill and imagination with organ-cases. The principal ones, or at least the most typical, built between the second third of the seventeenth century and the end of the eighteenth, are at Saint-Etienne-du-Mont (1631-33), Saint-Merri (*c.* 1647-66), Saint-Laurent (1682), the Invalides church from plans by Libéral Bruant and Hardouin-Mansart (1673-1703), Notre-Dame (*c.* 1743), Notre-Dame-des-Victoires (1739) Saint-Séverin (1745), Saint-Roch (1751), and Saint-Sulpice (after Chalgrin).

Nowhere, perhaps, is the use of wood more perfectly an art than in furniture, either in individual pieces or in the matching pieces of suites and sets.

A new period in the history of French furniture opened at the close of the sixteenth century, with particular reference to the luxury furniture made in Paris for people of the highest rank. Its use and destination changed. It ceased to some extent to be mobile, and was no longer carried from residence to residence. Instead it was for a time a stable element in the decoration of apartments. In about 1650 the members of the old guild of chest-makers and joiners began quietly to change their title to that of carpenters in oak, and, within a few years, to cabinet-makers. These changes relate to an important evolution, as they underline the preponderant rôle imported hardwoods had come to play, with consequent neglect of home-grown oak and walnut, until then very widely used in France.

For formal furniture, ebony wood was chosen, in particular for the cabinets, pieces looking like chests but supplied with flaps or leaves and carried on some form of support opening up to show drawers, with decorations derived from architecture, carvings and inlays, and other forms of ornamentation. These cabinets were the plaything of Spanish and Flemish and Italian influences exercised by the natives of those countries who had come to Paris to ply their trade.

They were first brought in by Henry IV, who set up a 'nursery' of artisans, some naturalized and some not, who were royally employed and whom he intended should make their contribution to the major and the minor arts in the general resurrection of the arts already mentioned in connection with tapestry. Others had been brought in by Marie de Médicis and by Mazarin. They were soon all in tune with the needs of their patrons. Whilst retaining their native imagination, they played their part in preparing the way for the unfolding of a national art. The great power of assimilation which succeeded in bringing the disparate elements together in harmony and in fusing them into a homogeneous, coherent, and refined whole, accomplished without

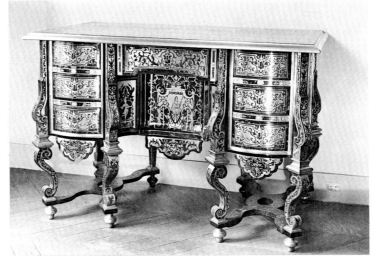

The so-called " Mazarin " desk, with marquetry in copper, tortoiseshell, horn, mother-of-pearl, and ivory, in the style of Bérain. End of seventeenth century. Musée des Arts Décoratifs, Paris.

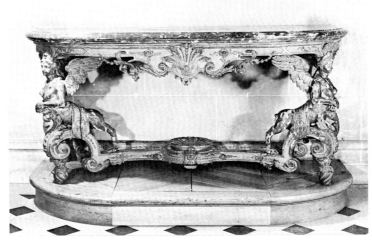

Console in carved and gilded wood and marble, after a design by Le Brun (c. 1680). Musée des Arts Décoratifs, Paris.

Chest of drawers in Brazilian rosewood, bearing the stamp of Jean Gillet who was received as a master cabinet maker in 1737. Musée des Arts Décoratifs, Paris.

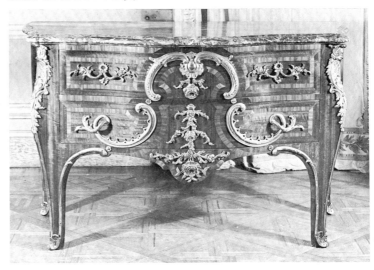

*Console in mahogany of the Louis XVI period,
carrying the mark of J.-H. Riesener who was
admitted as master cabinet maker in 1768.
In the Musée des Arts Décoratifs, Paris.*

restraint or offence, bears the mark of French creative genius. It was also a major miracle, and one which the French furniture industry renewed again and again in the course of the seventeenth and the eighteenth centuries.

Alike in the Great Gallery of the Louvre and at the Gobelins where the Crown Furniture Manufactory opened in 1667 under the direction of Charles Le Brun, First Painter to Louis XIV, men such as the Dutch or Flemish Gole and Oppenordt, the Italian Cucci and Filipo Caffieri, and the French Jean Macé, the Poitou family, and Charles-André Boulle, worked hand in hand with metal founders, stone carvers, and embroiderers on the furnishing of the Château de Versailles and other royal dwellings.

Amongst the members of this brilliant band, the most famous is Charles-André Boulle. If he was not the actual inventor of copper and tortoiseshell marquetry, at least he carried the style to its highest peak, for he lived till 1732, when he was ninety. His wardrobes, his desks, set off by opulent bronzes, can equally be used as examples of the majestic and pompous style of the reign of Louis XIV and of the freer decoration of the beginning of the eighteenth century.

After his death other generations of cabinet makers were already active or ready to go to work.

They were the champions of furniture adapted to the smaller-scale living-rooms of the eighteenth century and to the changed taste of a generation which preferred intimacy and comfort to ostentation and formality. To meet these new requirements, old forms had to be adapted and new pieces of furniture had to be invented, giving rise to the commode (chest of drawers), the secrétaire (writing-desk), and a whole diversity of table shapes. The *bois des Iles*, new woods from the West Indies, were in great demand as being well suited as a base for marquetry.

The fashion in the first half of the eighteenth century was for asymmetric bronze pieces very delicately carved and gilded with *or moulu*, marquetry in the warm purplish tones of Brazilian rosewood, in rosewood, or in mahogany, with multicoloured lacquers from China, genuine or imitated as had been done at the Gobelins at the end of the reign of Louis XIV and by the Martin family under Louis XV.

And there one has, very summarily, indicated the spirit, the raw materials, and the background of the creative work which was presided over by famous masters. These men belonged to the Guild, or occupied privileged positions at the Gobelins, the Louvre, the Arsenal, the Temple enclosure, or the grounds of the Abbey of Saint-Antoine-des-Champs, figurative godmother to the neighbourhood.

Charles Cressent, cabinet maker to the Duke of Orléans and a talented wood-carver as well, marks the transition from the Louis XIV to the Louis XV style. Gaudreau, supplier to the Crown Furniture Manufactory, was his contemporary. After him came the Migeon dynasty, Pierre Bernard, Adrien Delorme, Jacques-Pierre Latz, the once unknown B.V.R.B., now identified as Bernard Van Risen Burgh. They worked when the rocaille craze was at its zenith, and its influence is to be seen in some of their bronzes. The craze was already on the way out for the cabinet makers working between 1750 and 1760, the time when the Frenchified German Jean-François Œben first made his appearance. The cylindrical-lid desk for Louis XV, now in the Louvre Museum, was begun by him but finished by his pupil and successor, the Rhinelander Jean-Henri Riesener.

Riesener shone during the second half of the eighteenth century. It was a period of reaction marked by a return to the straight line and to symmetry, and by the adoption of an ornamental classic-antique stock of ideas. In his early days Riesener produced big pieces with ample, even noble, proportions, but after 1784 he turned to specializing in little pieces, with bronzes of an exquisite delicacy.

These take their place amongst the works of the virtuosos of wood-carving, comparing with the

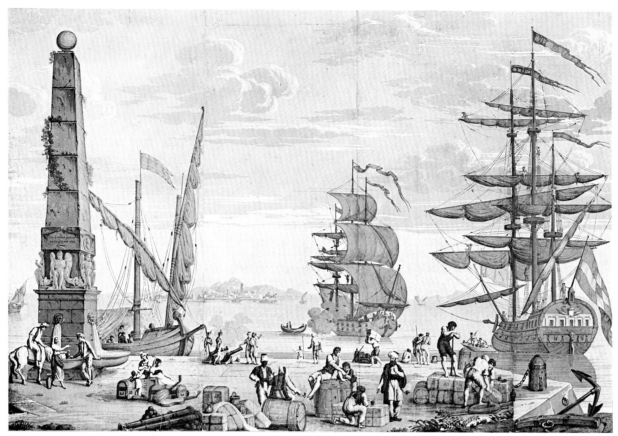

Panoramic painted wallpaper, "View of Italy, or the Bay of Naples". By Dufour and Leroy, about 1823. In the Musée des Arts Décoratifs, Paris.

chairs of Tillard and the Delannois family under Louis XV and the Nadal, the Séné, and the Jacob families under Louis XVI.

The successive phases of the changeover from the style of Louis XV to that of Louis XVI can be traced in the work of Claude-Charles Saunier, P. Garnier, R. Dubois, N. Petit, then Jean-Baptiste Lebas, Van der Cruse (known as Lacroix), Martin Carlin, and Topino, closing with the Germans Weisweiler, Schwerdfegert, Beneman, and Rœntgen. Well before the end of the century the transformation of the Louis XVI style into something beginning to foreshadow the Empire style was already apparent.

Bronzes and carpets took their place amongst the traditional furnishing accessories of the seventeenth and eighteenth centuries.

From the seventeenth century onwards bronze, which until then had been used primarily for casting effigies of the Bourbons or for funerary monuments, was virtually reserved for the making of objects of practical use. In the eighteenth century it served in a wider field, for such things as candelabra, clock-cases, and fireplace ornaments. It was utilized as a mount for precious porcelain and *pot-pourri* jars. Members of the Caffieri and Duplessis dynasties, amongst the most highly appreciated

workers in tooled bronze, were drawn into partnership with cabinet makers during the second half of the seventeenth century.

At the Gobelins Crown Furniture Manufactory, Dominico Cucci was one of the first to enrich ebony cabinets with gilded bronze. The merit of having given bronze a preponderant part in furniture, however, must go to Charles-André Boulle. In the first half of the eighteenth century Charles Cressent followed in his footsteps and ornamented the corners of his desks with graceful feminine busts called *espagnolettes*. Continuing in use to protect the sharp edges of furniture, or to contribute to its usefulness, or simply to decorate it, bronze found an incomparable exponent in the reign of Louis XVI in Gouthière, a gifted metal-worker. He was the inventor of matt gilding, a very able craftsman, and a man who took his inspiration from nature and treated it with minute care. Working as he did in the full period of classical reaction, he borrowed some of his motifs from it. He had some imitators in Feuchères, Forestier, and in particular Thomire, but as he was engrossed in the antique, this last only showed his full capabilities in the days of the Empire.

Carpets, which have just been described as traditional companions of furniture, would appear

177

to have been woven in Paris from the fourteenth century, when they were made from a technique borrowed from the East. For a time this process was set aside or forgotten, until it was honourably revived by Pierre Dupont at the beginning of the seventeenth century. His enterprise, which fell in with the economic plans of Henry IV, brought him the use of accommodation under the Louvre Gallery (1606). A little work by Dupont, *Stromaturgy, or the Manufacture of Turkish Carpets recently established in France*, published in 1632, underlined the variety of his production, some short pile, some long pile in the Turkish fashion, and some shot with gold and silver threads in the Persian manner. For flat Oriental designs Dupont, to his credit, substituted an imitation of relief adapted to contemporary decorative motifs, flowers, masks, and other ornaments. In 1627, in association with one of his apprentices, Simon Lourdet, he installed his workshop in an old soap-making factory *(La Savonnerie)* on the Quai de Chaillot. It was intended that here the art of carpet weaving should be taught to orphans, as had tapestry in earlier days at the Hôpital de la Trinité. The intrigues of Lourdet obliged Dupont to stay on at the Louvre, but their respective looms, at that time being managed by their children, were eventually brought together at Chaillot in 1672, though still operating independently. This continued until 1713, when the

two enterprises were joined together as a single unit.

Dupont, Lourdet, and their successors worked principally on furniture upholstery and carpets. During the seventeenth century the most important works were the carpets for the Apollo Gallery and Grand Gallery of the Louvre (*c.* 1665-85) from models painted by Baudren Yvart and Francart. During the eighteenth century the output from the Savonnerie included carpets, screens, and chair covers for royal dwellings, from designs by Blin de Fontenay, Robert de Cotte, Desportes, Oudry, Gravelot, Chevillon, and Tessier, as well as some portraits. The very high cost of this work made the situation very precarious by the eve of the Revolution, despite reforms suggested by Soufflot. Nevertheless the Savonnerie shone again a little under the Consulate and the Empire with designs by Lagrenée, Percier, Fontaine, Dugourc, and Saint-Ange, before being transferred to the Gobelins in 1826, where it still exists.

Exhibitions of industrial art begun under Napoleon had already speeded up improvement in mechanical processes which it would have been wrong to adapt to past ideas. The improvements also heralded the success of quantity manufacture of furniture in the Faubourg Saint-Antoine, which became the kingdom of Henry II-style dining-room suites, beloved of the nineteenth-century lower

Lady's desk in macassar and ivory, by Ruhlmann, 1933. Musée des Arts Décoratifs, Paris.

Chair in carved pear-wood, by H. Guimard, about 1900. Musée des Arts Décoratifs, Paris.

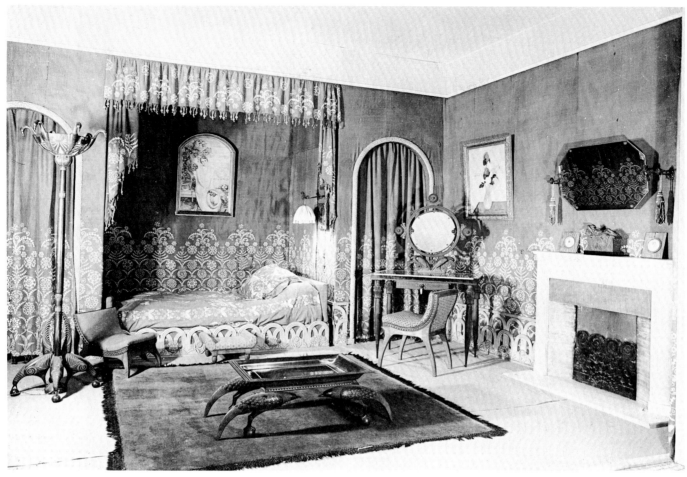

*Reconstruction of Jeanne Lanvin's bedroom by
A. Rateau, about 1920-22, in the Musée des Arts
Décoratifs, Paris.*

middle classes. In the world of tableware there was much the same kind of development, thanks to Christofle's adoption of Ruolz's invention of electro-plating.

Under the First Empire subservience to Græco-Roman antiquity was total. The imitation and adaptation of fashions said to have been familiar to the ancient world, the respect of symmetry, the excessive use of motifs such as bees, sphinxes, Victories, chimeræ, lions, rams, swans, military emblems, and reminders of mythological subjects, fill the designs of a Percier, a Fontaine, and even a Prud'hon. They were also a source of inspiration to cabinet makers. The Jacob family must be considered as being at the head of them, but none the less they included Beneman, Weisweiler, and Séné, survivors of the old régime, and newcomers as well — Arnoult, Bellangé, Molitor, and Biennais, who was established " At the Sign of the Violet Monkey", where he engraved the accessories for the coronation and Napoleon's travelling case, and also worked on inlays and cabinets. The composition of furniture was changing: mahogany reigned supreme, accompanied by gilded bronze, and met no challenge.

The Empire style lived on for a while after the fall of Napoleon, and was succeeded by a Charles X style, characterized by the use of light-coloured woods suitable for inlaying.

Soon, just as had been the case with architecture, a predilection for medieval art fomented by the Romantic movement brought into fashion a Gothic style as steeped in the fanciful as the " Renaissance " style spread by Michel Ménard.

The pastiche flourished over a complete range. Princess Belgiojoso had her Gothic oratory, Baroness Salomon de Rothschild her Gothic-Renaissance gallery, Princess Marie d'Orléans a Renaissance *salon*, Roger de Beauvoir his bedroom in the style of Francis I, and Eugène Sue his Louis XIII entrance hall — in the Louis XIII transition style into the bargain!

As early as the reign of Louis-Philippe the most admired style in furniture was imitation Boulle, followed by imitation Louis XV and imitation Louis XVI. Dark woods began to regain favour, being set off by painted flowers and mother-of-pearl inlays, which increased greatly in favour under the Second Empire. Then the court at the Tuileries

put "neo-rococo" into fashion and, to the great advantage of cabinet maker Grohé, furniture with quilted upholstery. The "Empress" version of the Louis XVI style attempted to recall the great days of the Trianon. Prince Napoleon was quick to counter with his Pompeian villa in the Avenue Montaigne.

And so it continued. Old styles were taken up again without alteration and without anything having been learned from them, and made into heavy-handed combinations, or into pieces of furniture rich beyond the furthest bounds of good taste, finally to appear in a Dufayel furniture-shop version at prices "defying all competition".

The Art Nouveau of the last years of the century set out to correct just such errors. This was not the Art Nouveau of the Nancy school and its pursuit of the out-of-the-ordinary, nor was it the *style nouille*, the "noodle style", but the true Art Nouveau which was to exercise a lasting influence, still felt in our own present times, and which was looking for simple and comfortable shapes to adapt to traditional uses. One might, in fact, prefer to look upon it as a search for the functional before the day of functionalism. This balance, this avoidance of outrageous ornamentation, was encouraged by the founding of a Society of Artist-Decorators in 1910, and was shown by the original work of Maurice Dufrène, Francis Jourdain, and Henri

Clock in soft-paste Vincennes porcelain, mounted in bronze, about 1750-55. Nissim de Camondo Museum, Paris.

Jug with handle, in porcelain, from the Clignancourt Pottery, eighteenth century. In the Musée National de la Céramique, at Sèvres.

180

Sauvage. The display by the Munich artists at the Autumn Salon marked the beginning of a new development in practical furniture, with practical fittings, with veneers, marquetry, and lacquers to ensure there should be no lack of colour. Here again extravagant developments of a style ended by giving it a bad reputation.

After the 1914-18 war, the Decorative Arts Exhibition of 1925 made the reputation of Emile Ruhlmann, the theoretician of the world of luxury furniture. His disciples were Leleu, Domin and Genevrière, Bouchet, Joubert and Mouveau, and Pierre-Paul Montagnac. Louis Sue and André Maré started up the *Compagnie des Arts Français* in order to put their own ideas into practice. At about the same time an individualist, Albert-Armand Rateau, created for Jeanne Lanvin, the great dressmaker, outstandingly original furniture which is now in the Musée des Arts Décoratifs. It made its appearance on the eve of the day when wood was about to give way to the use of modern materials in furniture — steel, aluminium, and light alloys and, eventually, plastics.

The use of the last of these after the 1939-45 war was to cover nearly every object in daily domestic use, making the old ceramics ever more remote and more precious and virtually relegating them to museums and private collections.

Bernard Palissy set up in Paris in 1562, and it would appear to have been there that he brought reptiles, plants, and shells into the field of enamelled ceramics, and they were the distinguishing features of one of the most brilliant periods of his career. These same rustic models served him for the decoration of the grotto put up in the Tuileries Gardens for Catherine de Médicis, of which fragments were unearthed in the nineteenth century.

At the end of the seventeenth and in the eighteenth century many makers of faience set up their furnaces in Paris, but little enough is known of most of them. Claude Révérend obtained a licence from Louis XIV to manufacture Dutch-type earthenware pieces in Paris. His work, or the work of his successors, shows the strong influence of similar work being made in Rouen. It still showed in the chemist's pots made for Chelles abbey at the beginning of the eighteenth century, by Digne, of the Rue de la Roquette. A little later, in the same street, Olivier was making stoves: when it came to items requiring more care he used a Strasbourg décor. During the second half of the eighteenth century the desire to imitate English china set a number of Paris ceramists on the road of emulation. At the Pont-aux-Choux pottery, around 1740-48, production began on agreeable pieces in pipe-clay, a mixture of clay

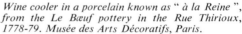

Wine cooler in a porcelain known as " à la Reine ", from the Le Bœuf pottery in the Rue Thirioux, 1778-79. Musée des Arts Décoratifs, Paris.

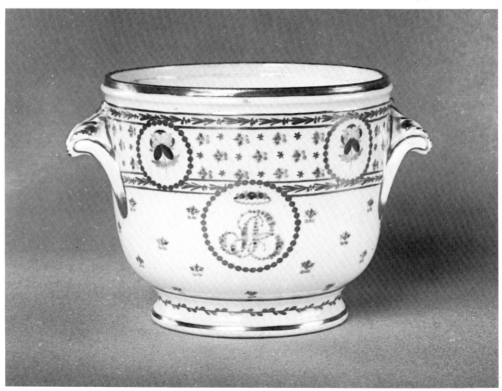

and chalk with a creamy finish. They were in shapes that opened out, copied from goldsmiths' designs. The commercial treaty with England of 1786 favoured the import of English products and thereby did much harm to the Paris potteries producing faience and porcelain and to those of other French ceramics centres, though they carried on during the Empire and the Restoration.

Claude Révérend, according to Letters Patent of 1664, had found the way to " reproduce porcelain as fine as that of the East Indies ". It is not known whether he made practical use of it, but for its first soft-paste pottery Paris had to wait for the first half of the eighteenth century.

The one in the Rue de la Ville-l'Evêque was a branch of the Saint-Cloud manufactory, but at about 1722 became autonomous. A second one, in the Rue de Charonne (about 1734-48), was the place of origin of Mennecy porcelain. The discovery of kaolin, which made hard-paste porcelain possible — the true porcelain — led to several new potteries opening at about 1771 in the Faubourg Saint-Denis, Rue Fontaine-au-Roi, Rue de Bondy (1780), Rue Popincourt (1782), and the Rue Amelot. Placed under the protection of the Princes of the Blood Royal — the Comte d'Artois, the Comte de Provence, the Duc d'Angoulême, and the Duc d'Orléans — as well as of the Queen herself, most of these potteries were authorized by an edict of 1787 to make subjects once reserved for Sèvres. The true *porcelaines à la Reine* were those made by Le Bœuf at his pottery in the Rue Thirioux. His production, like that of his competitors, was an imitation of Sèvres models, patterns with miniatures in medallions, landscapes, and flowers, or else concentrated on cornflowers, the flowers that Marie-Antoinette loved best.

At the beginning of the nineteenth century certain Parisian porcelain makers and decorators, amongst whom were Nash, Dagoty, Honoré, Guerhard, Darte, and Schœlcher, took advantage of the declining privileges of Sèvres to produce porcelain as remarkable for its variety as for the brilliance of its gilding and the perfection of its design. The antithesis of their formalism was to be seen later by the only partly Parisian eccentricities of Jacob Petit which often showed a somewhat dishevelled eclecticism in its exaggerated interpretation of the eighteenth century.

Despite attempts to improve it the general production of porcelain continued with no particular brilliance. In Tours, Avisseau, who set to work on research for a ' secret ' method, and Théodore Deck, who perfected the golden background, linked new methods with past ones. This was true also of Chaplet, at Bourg-la-Reine, who with Dammouse created clad faience. Chaplet opened a pottery in the Rue Blomet, which he sold in 1887 to Dela-

herche. Ceramics came into unexpected favour with the arrival of the Modern style for use in facing the front elevations of blocks of flats or for illustrating historical scenes, as at the Grand Palais. Attention then turned to stoneware, attracted first by Carrie's work (he died in 1894), then to glazed ware by Chaplet, enlivened by polychrome enamels, then to the beflowered stoneware of Hœntschel, and on to the work of Lenoble and Decœur, filled with enthusiasm for stoneware, porcelain, and enamel.

As was the case with stoneware, glass came into fashion again at the 1878 exhibition. Eugène Rousseau invented crackle glass and Henri Gris rediscovered the secret of making glass paste. Gallé's art and his principles belong to the Nancy School, but they co-existed with the work of Decorchement and of Lalique, who founded his glassworks in Paris in 1885 and adapted clear glass to many different uses. Finally, it was through Marinot that the techniques of blown glass were re-created, the first sign of a coming new æsthetic.

Glass flagon, by Marinot.
Musée des Arts Décoratifs, Paris.

Apollo, by Henri Bouchard, on the esplanade of the Palais de Chaillot.

CONTEMPORARY ART

The 1914-18 war brought to an end a coherent development of art, a succession of mainly logical changes, with only occasional dissonance and interference with the even flow of ideas. The 1939-45 war brought to an end the period of research and discovery by trial and error which had begun with the Decorative Arts Exhibition of 1925.

The twentieth century did not really begin for another twenty-five years, or give any foretaste of the year 2000. Not until its second half did technology take over, with industrialization, standardization, rational interpretation of what is indispensable to existence, and the popularizing of synthetic materials adapted to the demands and rhythms of modern life.

The disruption of economies, changes in feelings, and totally new concepts were about to ensure the triumph of systems heretofore unknown. The bases and desiderata of the fine arts have been shaken from top to bottom. By a supreme refinement or through the absence of any true fertility of imagination, the new rules assert themselves by a negation of decorative, or even æsthetic, values in favour of sensations intended to be intellectual and international in character.

These are, in fact, the theories and practices of Gropius, founder of the " Bauhaus ", whose determining influence will be dealt with later, and of Le Corbusier, who even before the 1939-45 war had given new life to the essential bases of the technique and social rôle of architecture.

The establishment of international organizations in Paris led to the erection of buildings of an acute modernity in the most unsuitable neighbourhoods. Their conception came from countries other than France, and they were not compatible with the traditions of the land and its resources. Their compact and joyless masses were added to those of a few public or religious buildings, headquarters of big companies, and to the many blocks of flats — as many as possible, in fact — built to remedy the evils of a colossal housing shortage. Yet these blocks were not of flats to let but for sale in joint ownership, and intended for the more well-to-do

Office block in the Rue Viala by Lopez and Roby for the Caisse d'Allocations Familiales.

classes, or at least for those less destitute than others.

These buildings are subjugated to an architectural language which has now become universal. They nearly all derive from the same basic search for the most economical use of space, through increasing the number of storeys and making them into towers, whilst limiting their shape to the most elementary of volumetric forms eliminating ornament almost entirely, and standardizing the little that remains.

A collection of sugar-lumps (or of dominoes), they stand mainly vertical or mainly horizontal according to the situation of the site, each one related to all the others by the throwing overboard of all natural materials, such as stone and wood, and their replacement by synthetic ones. These include cement, or rather concrete, and pre-stressed concrete in particular because of the daring things which may be done with it, aluminium, steel, and glass. They themselves are now threatened by prefabrication and plastics. The latter are not without polychromatic possibilities, as may be seen on the *Caisse d'Allocations Familiales* by Lopez and Roby (1958) in the Rue Viala, and on some others.

Except for some Civil Service and private buildings, and in the absence of any outstanding new churches other than Sainte-Marie-Médiatrice by Henri Vidal at the Porte du Pré-Saint-Gervais, Sainte-Claire by Le Donné at the Porte de Pantin, and the round church of Notre-Dame-de-la-Salette by Colbroc, it has been left to international organizations to be amongst the first to introduce modern architecture into the Parisian landscape.

The Eiffel Tower, by R. Delaunay. In the Folkwang, Essen.

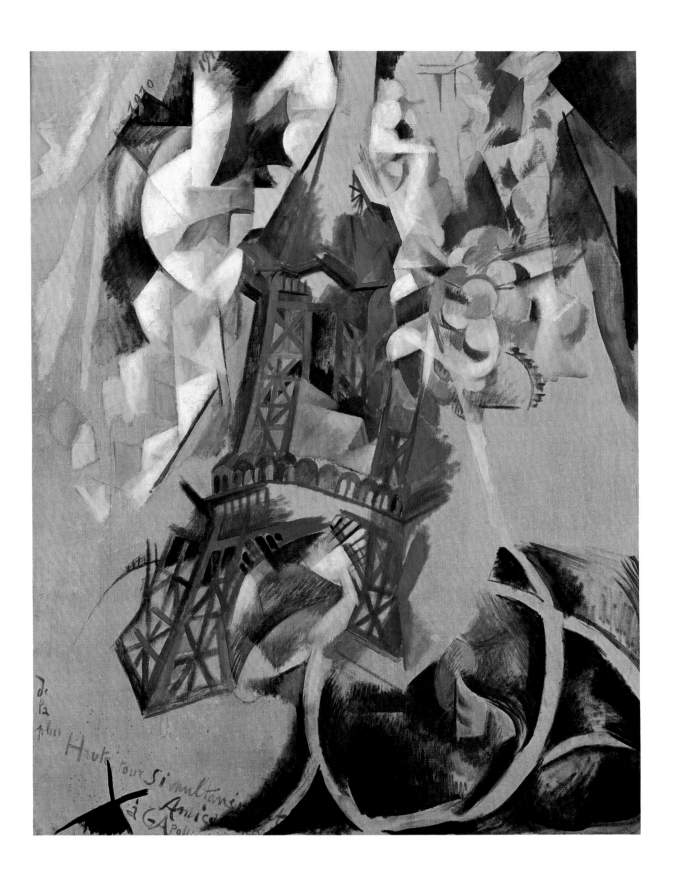

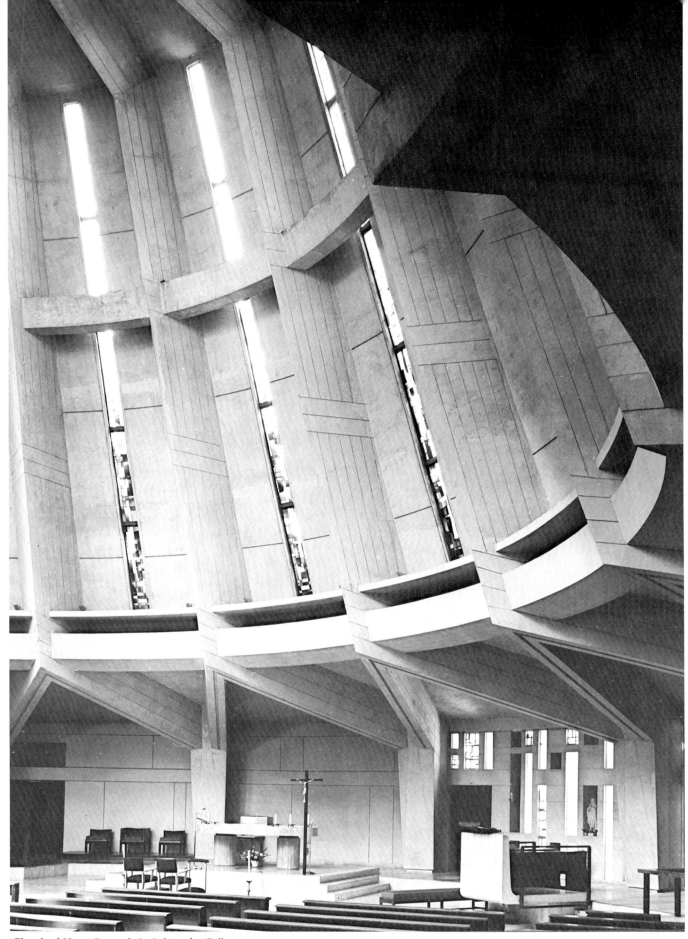

Church of Notre-Dame-de-la-Salette, by Colbroc.

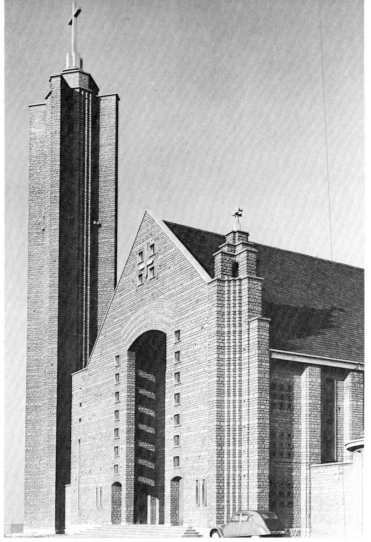

The Church of Sainte-Marie-Médiatrice, by Henri Vidal.

Oddly placed in the Place Fontenoy, behind the Ecole Militaire — that classical, majestic, and graceful masterpiece which Gabriel built at the beginning of the second half of the eighteenth century — stand the Unesco buildings, used by the United Nations Educational, Scientific, and Cultural Organization. It was designed by the Austro-American Breuer, furniture designer to the Bauhaus, the Italian Pier-Luigi Nervi, and the French Bernard Zehrfuss, with the approval of a committee including the Brazilian Lucio Costa, the German-American Walter Gropius, one-time prime mover of the Bauhaus, the French-Swiss Le Corbusier, the Swedish Sven Markelius, and the Italian Ernesto Rogers, in consultation with the Finnish Eero Saarinen, son of Ehel Saarinen, designer of Helsinki Railway Station.

There are three buildings. The highest is of seven storeys and holds the Secretariat. It is Y-shaped, built on piles, and edges the Place Fontenoy. The Great Hall, used for plenary sessions, follows natural forms, and Nervi covered it with an accordion-pleated roof, relieved by the use of copper, and carried out with an exceptional mastery of technique. It occupies all the second building which has its frontage on the Avenue de Suffren. The third building is on the Avenue de Ségur and is four storeys high. The collective eurythmic value of the group of buildings springs from the æsthetic qualities of its different materials.

The principal Unesco building, and the garden.

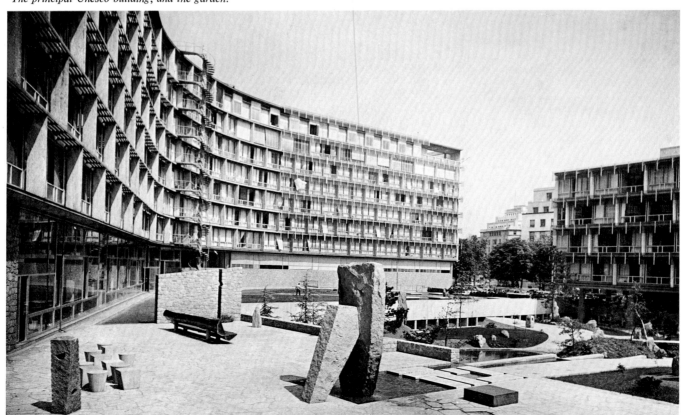

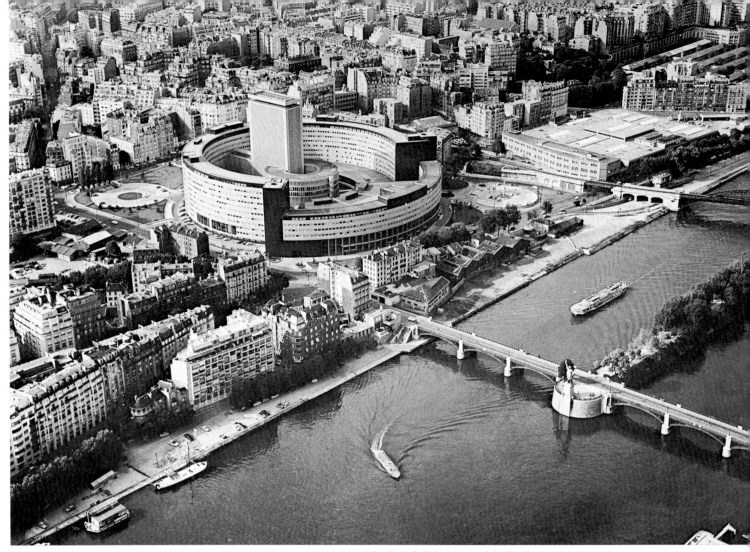

*The French Television and Radio Centre (O.R.T.F.).
Photograph taken before the rebuilding of the Pont de Grenelle
and the completion of the improvements to the Quai de Passy.*

The bareness of the concrete contrasts with the grooved walls of the Great Hall, the piles of the building housing the Secretariat with the Roman travertine, the Breton granite of other parts, and the Norwegian quartz of the paving. Picasso, Joan Miró, Moore, Calder, and Jean Arp were associated with the decorations, both outside and inside, though not in any well-defined way. The buildings were quickly found to be too small, but the French Sites Commission refused to agree to an additional building going up on the gardens. That is why the architect Bernard Zehrfuss was obliged to design an underground building, four storeys deep, round a patio (1963-65).

By way of contrast to the rather aggressive modernism of the Unesco building stands the former building of the North Atlantic Treaty Organisation at the Porte Dauphine. It is in the form of a letter A and Jacques Carlu's design is altogether more traditional. It was built between 1955 and 1959.

Built in a more distant quarter, almost on the outer edge of Paris, and in surroundings less easy to mar than was the case with the Unesco building, is the O.R.T.F. building, the French Television and Radio centre, by Henri Bernard, opened in 1963. There is a crown-shaped building, a vast part-circle ten storeys high, for which aluminium and glass were used, and black ceramic for the purpose of the central courtyard. The tower was intended to be 100 metres (328 feet) high, but was reduced by the Sites Commission to 75 metres (246 feet) to the prejudice of general proportions and the harmony which the balance of contrasting volumes would have brought. Adapted to very special needs, the interiors have had to be very carefully related to these uses. The part played by the major and minor arts was carefully prepared to conform to the architectural design. They include a group by Stahly, mosaics by Singer and Bazaine, an immense red panel with a golden paraph by Georges Mathieu, tapestries by Soulages and Manessier, a hanging by Roger Bezombes in violent colours, and a bas-relief by Georges Leygues with metallic reflections for the rooms designed by the Niermans brothers for public auditions.

At the time of writing (1968) the new Museum of Popular Arts and Traditions has not been entirely

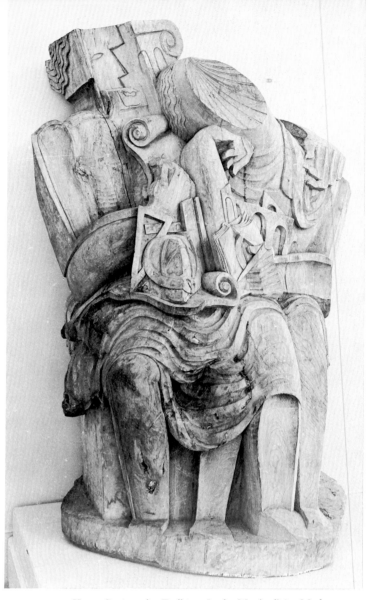

Homo Sapiens, by Zadkine. In the Musée d'Art Moderne.

completed. It was designed by architects Dubuisson and Josserand and is situated on the edge of the Bois de Boulogne, within the Jardin d'Acclimatation (botanic garden). It is in the shape of an upside-down T and thus continues the cycle of the borrowings from the calligraphy of the alphabet. A glazed vertical upper part is completed by a wood-finished horizontal lower part, reserved for exhibition halls. The headquarters of the French Communist Party in the nineteenth *arrondissement* was designed by Oscar Niemeyer, the principal representative in Brazil of modern architecture and one of the creators of Brasilia, yet it is hardly known except that the project was published in the Press.

With the exception of the bas-relief in the Unesco building and of the O.R.T.F. building, sculpture is, generally speaking, absent from the buildings mentioned. Contemporary architects, it would seem, look upon it more as an element foreign to their purpose than as one complementary to their own constructive work.

However, this semi-ostracism has not limited its development nor its bubbling vitality.

In keeping with the examples given to the nineteenth century by the most illustrious of predecessors — Daumier, Degas, Renoir, Gauguin — some of the most noteworthy amongst painters (Modigliani, Picasso, Braque, and Chagall) have put their means of expression at the service of sculpture. In doing so, they have contributed to its renewal and to its expansion.

The cosmopolitan outlook of a school known as the Montparnasse school turned sculpture from its traditions, as it had done with painting. In their place it offered solutions which had never been reached before, though they had been foreshadowed by the suggestion of a hitherto unknown plastic truth in Rodin's exceptional *Balzac* (1898) and by Gauguin's modelling and carving of polychrome wood. They were defined more precisely by the idols and fetishes and masks of Negro art, discovered and exalted by the Fauves and the Cubists. A primitive or barbaric plasticity, a Greek archaism, had begun to be the substitute for the ideal of Greek, Roman, or Gothic statuary. After the experiments by Matisse and by foreigners established in Paris — Modigliani and Gargallo, later to distinguish himself by his figures in beaten metal — the decomposition of form, the simplification of surfaces, the value of voids in suggesting solids, were more fully illustrated by other sculptors, for the most part foreigners. Amongst them were Archipenko, born at Kiev in the Ukraine, who opened a school in Paris and then, in 1920, left for Berlin; Lipchitz, born in Lithuania, who arrived in Paris in 1909 and rallied to Cubism in 1910; Brancusi, born in Rumania, who retained his own strong personality and his independence in expressing "the essence of things". Pevsner was also a stylist and a painter, and with his brother Gabo was author of a *Realist Manifesto*, which was a profession of faith in absolute constructivism and the active void. He returned to Paris in 1923 and took up permanent residence there a year before the arrival of Alberto Giacometti. The latter was born at Stampa in Switzerland, and in his search for appearance and reality started with Cubism and then joined the Surrealists before returning to the human figure.

The examples and the lessons from the works of these different artists and from those of Jean Arp, Strasbourg-born, established in Meudon, innovator of form, passing from Dadaism to Surrealism, and of Henri-Georges Adam, creator of monumental forms in his pursuit of the integration of the arts, and of Zadkine, who stayed close to Cubism — all these preceded the contributions of the new generation who made their names after the 1939-45 war, or else joined in with them.

Two nudes, by Pascin. Musée d'Art Moderne, Paris.

The new generation had little use for doctrinaire principles, but remained dominated by a latent feeling of suffering which found an outlet in an expressionism in which lingered memories of Surrealism with its resurgence of the subconscious and the unconscious.

Germaine Richier thought up fantastic figures belonging to a non-human world, insects, a monstrous spider, only survivor from a possible atomic cataclysm. She has used lead and iron wire and metal embedded in glass. César, a sculptor in iron like Gonzalès or Gargallo, set out with his intuition for guide to try out quite incredible experiments. If he feels they meet his purpose, he brings together off-the-scrap-heap motor body parts and oddments of scrap iron. Jacobsen, born in Copenhagen, has been in Paris since 1949 and Robert Muller, born in Zurich, since 1950. They are both artisans working in iron. They put into practical form the theories and visions they have been elaborating. The same is true of Nicolas Schöffer, born in Hungary, and

Stahly, born in Constance, and Dubuffet, originator of art in the raw, using slag, tow, and sponges, and of Tinguely and his efforts to convey movement.

Despite this general diversity, this endlessly renewed variety of form and balance and rhythm, an æsthetically outdated project has won the competition for the design of a monument to Marshal Leclerc at the Porte d'Orléans. The winners are Messrs Subes and Martin. Between over-magnified champagne glasses of the tall, thin kind known as *flûtes* in France, in stainless steel, linked by a transverse bar, and each topped by a Cross of Lorraine, the second part of the project is to stand, an upright statue in gilded bronze, with arms straight down beside its body.

After sculpture, where stands painting? Excluding once again Unesco and the O.R.T.F. building, it has not been enriched recently by any vast canvases. The only big works to mention are the ceiling of the Opéra auditorium by Chagall, and one by André Masson for the Odéon theatre. The

The Cage, by Raoul Dufy.

The Pont Saint-Michel, by Marquet.
Musée des Beaux-Arts, Grenoble.

former has undeniable merit but is hardly any nearer integration than were Braque's earlier paintings for the State Room at the Louvre in a setting more or less of the Second Empire.

None of this affects the fact that painting is torn by violent cross-currents similar to those which separate sculptors. Like them, painters are divided between the figurative and the abstract, finding their means of expression only in combinations of colour and form.

Alongside true amateurs, true connoisseurs of painting who seek æsthetic satisfaction first of all, there is an increasing number of buyers who have only commercial considerations in view and are ridden by their desire to make a good investment. The latter are the ones who have encouraged the growth in the number of art galleries since 1950. To satisfy the demand some of these, opened by part-time salesmen, have tried to launch a painter as if he were a breakfast food or a beauty cream, calling in the help of advertising in the shape of articles in specialized magazines and holding ' open days ' with free buffets offering rich food — solid and liquid. The choice of a ' colt ' of their own was made all the easier by the great influx of painters of all origins and nationalities returning to Paris after the 1939-45 war, not so much in the hope of learning anything as of acquiring the prestige of being an artist who works in Paris. This new Paris school, whilst including some who have proved their worth, has also stimulated those with all the unpredictable manners and the audacity of the uncultivated, the people with set minds and the opportunists whose ingeniosity and naïveté are only equalled by their extravagance.

Between 1940 and 1958 when many of the last representatives of the older generation had gone — Vuillard in 1940, Bonnard in 1947, Dufy in 1953, Matisse and Derain in 1954, Léger in 1955, Rouault in 1958 — there remained only Braque, Picasso, and Delaunay of those who had so strongly marked and developed the principal aspects of and variations on Cubism.

In spite of the German occupation, an exhibition of young painters in the French tradition was held in the month of May 1941. Lapicque was represented as one whose own creative work had turned others in the same direction as himself. Of these Bazaine, Estève, Gischia, Manessier, and Pignon, each of whose work was impregnated with his own personnality, showed the same predominating tendency to operate in the borderland where the figurative and the abstract overlap. The autumn Salon of 1944 confirmed and focused on this tendency.

If the movement still spoke with the accents of the various tendencies current since the end of the nineteenth century, the moment was close at hand when some artists would be demanding total liberty,

Still Life with Candlestick, by F. Léger.
In the Musée Municipal d'Art Moderne, Paris.

to be shown by the elimination of the object. This was implicitly to return to a theory formulated in 1911 by the Russian Kandinsky, in his book *Über das Geistige in der Kunst* (The Spiritual in Art). It was then, in general, a theory of abstract art, which its principal initiator would have preferred to call " concrete art ". It preaches the destruction of the naturalist world of form in order to put a mental world in its place. A form which has become real is then used as the precise term in a plastic language. Paris was not ignorant of plastic art; Picabia had introduced it in 1908-9 with his watercolour *Caoutchouc*. It was, however, in Soviet Russia in about 1920, then in Germany and the Netherlands, that it made its most faithful adepts.

Born in Moscow, Kandinsky had taken part in the first Expressionist movement in Munich. He gave life to the Blaue Reiter (1911) circle, returned to Russia in 1914, and became Professor at the Academy of Fine Arts in Moscow and President of the Academy of Art and Science. He returned to Germany and taught at the Bauhaus in Weimar. He took refuge in Neuilly-sur-Seine in 1933, and there he composed the greater part of his abstract work. He died in 1944. His work, together with that of the Dutchman Mondrian, who also painted in Paris, was soon seen to be one of the fundamental bases of the Abstract. It soon divided into two streams, the one following Kandinsky with the Expressionists and the Lyricists, and the other Mondrian with the Classicists and the Rationalists. These two currents of thought brought other differences into

View of Paris, by Picasso. In a private collection.

the open, some of which separated and some of which united those who were engulfed in a sudden exuberance of new ideas. They ranged from a primary obscurity of thought to an intellectualism which linked up with the Ugolin della Gherardesca myth. New ideas pullulated, intermingled, crossed with each other — lyric abstraction, calligraphy, micro-realism, taoism, the informal, daubing with colour in repudiation of smooth painting techniques, the use of the most unusual materials, of which tar and sawdust were the nearest to being ordinary, and the addition of assorted detritus.

In about 1958-59 the figurative which had been attracting Nicolas de Staël came back with some vigour. Following on Pop Art, a return to the human figure is inevitable. It may be considered as an entity or as a spiritual presence. It could be thought of as the invention of today, or tomorrow, or the day after. Certainly it will lead to the birth or the rebirth of essential works of art which will be recognized by the eyes of posterity as characteristic of the second half of the twentieth century. Dependent upon how successfully the Beaux-Arts can catch and hold the attention of posterity, these will be held to be the masterpieces of that period of French art — or, to be more precise, of art in France at that period.

In the same way as painting, engraving could not withstand the temptation of abstract international-ism. This, however, did not prevent Lucien Coutaud from prolonging, or bringing to life again, a sur-realism somewhat tainted with eroticism, nor did it prevent the growth of a certain amount of resistance to it. In spite of fairly wide concessions to it, this resistance is to be observed in the works of a few members of the *Jeune Gravure*, an association of young engravers founded by Pierre Guastalla, and of the *Société des Peintres-Graveurs* (Society of Painter-Engravers). Amongst the works which helped to revivify engraving are those of both paint-ers and sculptors, Picasso, Henri-Georges Adam, and Zadkine being amongst the most effective. Nevertheless, apart from this exceptional activity, danger might well have been discernible had it not been for the importance accorded to content and to engraving in relief. Wood and the engraver's needle, part of the fundamental and essential techniques, were set aside, and etching and lithography fa-

voured. Abandoning the contrasts of black and white which suggest colour, there has been an onrush of colour, often strident, with the intention of making the engraving the rival of the painted picture, for which it cannot truly be substituted.

On their side, furniture and applied arts were subjected to radical changes and total rethinking of structure, of the same order as the changes in architecture, sculpture, painting, and engraving.

In about 1920 a Dutch group, *De Stijl*, decided to detach itself from materialism and the fetters of the past with the intention of helping human evolution to move towards spirituality. It preached the need for a complete breach with tradition, and a search for abstract forms, in order to arrive at the desired result. Its action was the determining factor for the future of another group, a German one this time, the Bauhaus group.

Formed by the union of the School of Decorative Arts with the Weimar Academy, it was organized by Walter Gropius, son of a family of architects and an architect himself, and a man anxious to bring art and technique together. The adepts of the Bauhaus set out to create the architectonic framework necessary for an industrial civilization, and the accessories and usual objects pertaining to it. Amongst its members was Breuer, who distinguished himself around 1925 by using curved steel tubing as the frames for tables, chairs, and stools. It is worth remembering that as early as 1903 Théodore Lambert had exhibited metallic furniture at the Salon des Artistes Français. Breuer also thought up the use of bent and moulded plywood and of aluminium framework for furniture.

A quarter of a century later Bauhaus theories and novelties for furniture had been adopted and vulgarized in many countries. This had been speeded by changes in architectural practice and problems, and the lack of space in shrunken flats for which matched unit furniture and furniture sunk into the walls was equally desirable.

Whilst many kinds of furniture previously in use, chests of drawers, sideboards, wardrobes, and tallboys, were being banished from rooms, chairs and other forms of seating, in fact everything that derived from them, were being designed as functions of the human body and the object of intense research.

Modern furniture looks to the products of industry even more than to moulded wood or the varieties of wood in light tones, for the new symmetrical, plain, and comfortable furniture either imported from Scandinavia or imitated from Scandinavian originals. Steel, aluminium, moulded polyester, and fibreglass (which made its appearance in the United States during the 1939-45 war) are clad in real or imitation leather, cloth, and plastic materials.

These items of furniture do not reflect Parisian taste, or even French taste. They arise from an irresistible international movement which industry exploits. In form and appearance this furniture oscillates between the lessons of the Bauhaus and the recollections of Le Corbusier, assisted by

Chaise longue, by Le Corbusier. Independent stand in ovoid tubing, lacquered black. Main structure in chrome-plated steel tubing. Cover in pony skin.

Jeanneret and Charlotte Perland, and his creation of adjustable metallic chairs. These, however, were the object of academic research, never intended for immediate manufacture. They were exhibited in 1928-29 between Cubism and Synthesis. On them the last word has not yet been said. Inflatable rubber, transparent furniture in perspex, and furniture in vinyl will not be long in opening up new vistas of furniture of kinds as yet unknown, and means of rest never yet contemplated.

Whilst these novelties are multiplying and dry-as-dust copies of older styles are still being made, members of the upper middle classes in particular are turning away from the present and taking refuge in the adaptation of a past forgotten or disdained. This attitude goes hand in hand with the search for old and often purely utilitarian objects — old coffee-mills, old irons, or red copper sweet moulds (considered rarities), ugly curios resurrected from the back premises of shops, from lumber-rooms, attics, and cupboards. Stimulated by clever antique dealers and specialized magazines, new infatuations and caprices of fashion follow each other with ever-increasing frequency. They create a momentary taste for (often supposedly) English mahogany, gold- and silversmiths' ware from the other side of the Channel, Staffordshire china, more or less Spanish pieces of the high period, pieces in the Louis XIII style, of the Belle Epoque, or the end of the Louis XVI style, with side-glances at the styles of the United States — rigid Northern Colonial or richer Southern Colonial. These incongruous changes and the search for still further change are in themselves a sign of the times. Art in Paris still consists of a tightly linked past and present. It may no longer entirely possess the supremacy which it held for part of the twentieth century, but it does still possess undeniable prestige. It may be presumed that this will continue as long at least as the values which make our present civilization are retained.

Drawing by Kandinsky.

The Louvre and the Carrousel Gardens.
In the foreground, a statue by Maillol.

PARIS BUILDINGS AND MONUMENTS

Antiquities

The Luxor obelisk, about 1560 B.C., erected in the Place de la Concorde, 1836. The Arènes de Lutèce (Gallo-Roman arena), 2nd half of 2nd c. or 3rd c., Rue de Navarre, V. The Palais des Thermes, wrongly so-called, alongside the Cluny Museum, Place Paul-Painlevé, V. Gallo-Roman ruins of a building probably used by the Guild of Seine Boatmen (with baths).

ARCHITECTURE

CIVIL

Administrative, Judicial, and Institutional Buildings

18th c. Hôtel des Monnaies, by Antoine (1771-75); 11 Quai de Conti, VI. — **19th c.** Paris Octroi, by Lusson (1821-26), transformed by Gau into a Lutheran church (1842-43); 16 Rue Chauchat, IX. Bourse du Travail, by Bouvard (c. 1893); 3 Rue du Château d'Eau, X. — **20th c.** Cour des Comptes, by Guadet and Moyaux (1911); 13 Rue Cambon, I. Institut Médico-légal, by Tournaire (1913); Quai de la Rapée, XII. Caisse des Dépôts et Consignations, by L. Fauré-Dujarric (c. 1936); at the Porte Molitor, XVI. Caisse Centrale d'Allocations Familiales, by Lopez and Roby (1954-59); 10 Rue Viala, XV. O.R.T.F. House, by H. Bernard, the brothers Niermans, J. Lhuillier, G. Sibelle (Architects), N. Couturie (Engineer-in-Chief) (1958-60); Quai J. F. Kennedy, XVI.

Banks

Hôtel de la Vrillière, by F. Mansart (1635-49), later Hôtel de Toulouse and, since 1811, Banque de France. Underground hall, by Defrasse (1937); 39 Rue Croix-des-Petits-Champs, I. — **19th c.** Comptoir National d'Escompte, by Corroyer (1878-82); 14 Rue Bergère, IX. Crédit Lyonnais, by Bouwens van der Boyen; 19 Boulevard des Italiens, II. Banque de l'Union Parisienne, by A. Sauffray (1880), enlarged 1921; corner Rue Chauchat and Boulevard Haussmann, IX. — **20th c.** Crédit National Hôtelier, by A. and G. Perret (1926); 3 Rue de la Ville-l'Evêque, VIII. Société Marseillaise de Crédit, by A. and G. Perret (1926); 4 Rue Aubert, IX. Crédit du Nord, by Imandt (c. 1928); 59 Boulevard Haussmann, VIII. Banque Dupont, by J. Marrast (pre-1930), 26 Avenue du Président-Roosevelt, VIII. Banque Nationale pour le Commerce et l'Industrie, transformed by Marrast and Letrosne (c. 1931). 16 Boulevard des Italiens, IX. National City Bank of New York, by Arfordson (c. 1932); Avenue des Champs-Elysées, VIII.

Columns

15th c. Colonne de l'Hôtel de Soissons; Rue de Viarmes, I. — **19th c.** Colonne Vendôme, by Denon, from designs by Gondouin and Lepère, in the Place Vendôme, I. Colonne de Juillet, by Alavoine and Duc (1831-40);

Binet (c. 1900-10), Boulevard Haussmann, IX. La Samaritaine, by Frantz-Jourdain and Sauvage (1927); 67-81 Rue de Rivoli, I. Nouveaux Magasins du Bon Marché, by L. Boileau and Eiffel, VII. Galeries Lafayette, the new façade (c. 1926); Boulevard Haussmann, IX.

V. Laloux (1931-33); 2 Avenue Gabriel, VIII.
Private Houses for nearly all the Embassies.

Educational Establishments

Former Collège de Bayeux, founded in 1308; Rue de la Harpe, pulled down in 1859; former Collège de Champagne, later Collège de Navarre, founded in the 14th c., (Ecole Polytechnique); 5 Rue Descartes, V. — **16th c.** Tower named after Calvin, Rue Vallette, V. — **17th c.** Collège des Quatre-Nations, by Le Vau, Lambert, and d'Orbay, 23-25 Quai de Conti, VI. Observatory, by Claude Perrault (1667), enlarged; Observatoire, XIV. Amphitheatre of Saint-Cosme, by Joubert (1691-94); Ecole de l'Ecole-de-Médecine, VI. — **18th c.** Former Anatomy amphitheatre, by... Association des Etudiants; 13 Rue de la Bûcherie, V. Ecole Militaire, by J.-A. Gabriel ... Faculté de Médecine, begun by Gondoin (1769-86), enlarged and completed in the ... cine, VI. Faculté de Droit, by Soufflot (1770-83), enlarged in 1830 and 1908; ... Ecole Nationale des Beaux-Arts, by Debret (1820-32) and Duban (1839) and ... Collège de France, foundation stone laid by Louis XIII (1610), by Chalgrin ... buildings and amphitheatre by A. and J. Guilbert (1938); Place Marcellin-... Laisné (1876-85); 4 Avenue de l'Observatoire, VI. Cercle de la Librairie, by ... Boulevard Saint-Germain, VI. La Sorbonne, rebuilt by Nénot (1885-1900); 47 Rue

des Ecoles, v. Institut National Agronomique, by Hardy (1888-90); 16 Rue Claude-Bernard, v. Ecole Supérieure du Commerce, by J. Bernard and E. Robert (1898), 79 Avenue de la République, xi. Ecole Coloniale, by Yvon (1896); 2 Avenue de l'Observatoire, ii. **20th c.** Académie de Médecine, by Rochat (1902); 16 Rue Bonaparte, vi. Hôtel de la Ligue de l'Enseignement, by Blondel (1909); 3 Rue Réaumur, ii. Institut Océanographique, by Nénot (1910); 195 Rue Saint-Jacques, v. Institut de Paléontologie Humaine, by Pontremoli (1911-14), opened 1920; 1 Rue René-Panhard, xiii. Ecole Nationale des Arts et Métiers, by Roussi (1912); 151 Boulevard de l'Hôpital xiii. Cité Universitaire (1923-39), various buildings, particularly the Japanese pavilion by P. Sardou, and the Swiss Institute by Le Corbusier; xiv. Institut d'Art et d'Archéologie, by P. Bigot (*c.* 1924-31); 3 Rue Michelet, vi. Institut d'Optique, by G. Hennequin father and son (pre-1927); 3 Boulevard Pasteur, xv. Institut de Biologie Physico-Chimique, by G. Debré (*c.* 1931); 1 Rue Pierre-Curie, v. Ecole de Puériculture de la Faculté de Médecine de Paris (Fondation Franco-Américaine), by Duval and Gonse, Dresse and Oudin (*c.* 1933); 26 Rue Brune, xiv. Ecole Normale Supérieure, new building by A. and J. Guilbert (1934); 45 Rue d'Ulm, v. Ecole Municipale de Physique et Chimie, by Heuber and Lefol (*c.* 1934); 10 Rue Vauquelin, v. Ecole Spéciale des Travaux Publics du Bâtiment et de l'Industrie, by J.-B. Mathieu and J. Chollet (*c.* 1935); 57 Boulevard Saint-Germain, v. Maison Internationale de la Cité Universitaire, by Larson and Beckmann (1936); 21 Boulevard Jourdan, xiv. Ecole Hôtelière de Paris, by R. Gravereaux (1938); 20 Rue Guyot, xvii. Faculté de Médecine, by Madeline and Walter (1937-53); Rue des Saints-Pères, vi. Faculté de Droit et des Sciences Economiques, by Le Maresquier, Le Normand, and Carpentier (1963); 92 Rue d'Assas, vi.

Fountains

16th c. Fontaine des Innocents, by P. Lescot and J. Goujon (1550); corner Rue Saint-Denis and Rue au Fer, additions by Pajou and Houdon (1788), moved and altered by Davioud (1850), now in the Square des Innocents, i, with 3 bas-reliefs in the Louvre. — **17th c.** Fontaine de Médicis, attributed to S. de Brosse (1624-30), completed in 1852 by the Fontaine de Léda; Rue du Regard, Jardin du Luxembourg, vi. Fontaine de l'Echaudé (1671); corner Rue de Poitou and Rue Vieille-du-Temple, iii. Fontaine de Joyeuse (1687); 41 Rue de Turenne, iii. Fontaine Boucherat (1698); corner Rue de Turenne and Rue Charlot, iii. — **18th c.** Fontaine des Haudriettes (*c.* 1705), Naiad by Mignot (*c.* 1705); 53 Rue des Archives, iii. Fontaine du Vert-Bois (1633), rebuilt 1712; corner of Rue du Vert-Bois and Rue Saint-Martin, iii. Fontaine Childebert (1716); formerly on corner Rue Childebert and Rue des Ciseaux, now Square Monge, v, and Musée Carnavalet. Fontaine Maubuée (pre-1320), remade 1833; 122 Rue Saint-Martin, iv. Fontaine de la Rue de Grenelle-Saint-Germain, by Bouchardon (1739-46); 57-59 Rue de Grenelle, vii. Fontaine de l'Arbre-Sec (1529); formerly Place de la Croix du Trahoir, moved in 1636 and rebuilt to a design by Soufflot, 1775; now on the corner of the Rue Saint-Honoré and the Rue de l'Arbre-Sec, i. Fontaine de la Poissonnerie, or de Jarente (about 1700), remade by Caron (1783); Impasse de la Poissonnerie, iv. — **19th c.** Fontaine de Charonne, formerly Trogneux (1710), rebuilt 1806-10; corner of Faubourg-Saint-Antoine and Rue de Charonne, xi. Fontaine de l'Egyptienne (1806); facing no. 97 Rue de Sèvres, vii. Fontaine de Mars, by Beauvarlet; 129 Rue Saint-Dominique, vii. Fontaine du Palmier, or de la Victoire, by Bosio (1808); removed 1855-56 to the Place du Châtelet, i. Fontaine du Marché Saint-Germain, by Destournelles (1813); formerly in the Place Saint-Sulpice, vi. Fontaine du Château-d'Eau (1815); in the Cattle Market of La Villette, xix, formerly in the Place du Château-d'Eau, later Place de la République. Fontaine Gaillon, remade by Visconti and Jacques (1823); Rue Saint-Augustin, between Rue du Port-Mahon and Rue de la Michodière, ii. Fontaine des Carmes (about 1830); Marché des Carmes, v. Fontaine de Cuvier, by Vigoureux and Feuchères (1840); Rue Cuvier, v. Fontaine Louvois; by Visconti and Klagman (1844), Square Louvois; ii. Fontaine Molière, by Visconti, Seurre, and Pradier (1844); corner Rue de Richelieu and Rue Molière, i. Fontaine de la Place Saint-Sulpice, by Feuchères, Hanno, Feuquier, and Desprez, design by Visconti; Place Saint-Sulpice, vi. Fontaine de Notre-Dame, by Vigoureux and Merheux (1845); in the Square de l'Archevêché, iv. Fontaine de Saint-Michel, by Davioud (1860); in the Place Saint-Michel, v-vi. Fontaine de la Trinité, by Lequesne, after Duret (1864); Square de la Trinité, ix. Fontaine de l'Observatoire, by Davioud, Carpeaux, and Frémiet; Avenue de l'Observatoire, vi. — **20th c.** Fontaine lumineuse de la Porte de Saint-Cloud, by Pommier, Billard, and P. Landowski (1936); Porte de Saint-Cloud, xvi.

Hospitals

17th c. Saint-Louis, by Claude Villefaux from plans by Claude Chastillon (1607-12); 71 Place du Docteur-Fournier, x. La Salpêtrière, by Le Vau, Duval, and Le Muet (*c.* 1660); 47 Boulevard de l'Hôpital, xiii. — **18th c.** Maison Royale de Santé des Frères de la Charité, for indigent clergy and soldiers, by Vial de Saint-Maur (1781-83), enlarged by Antoine (1802), known as the Hospice de la Rochefoucauld since 1822; 15 Avenue d'Orléans, xiv. Hôpital Beaujon, by Girardin (1784), from 1946 a Police Higher Training Institution; 208 Faubourg-Saint-Honoré, viii. — **19th c.** Institution des Jeunes Aveugles, by Philippon (1843); 56 Boulevard des Invalides, vii. Lariboisière, by Rohault de Fleury (1846-53); 2 Rue Ambroise-Paré, x. Maison de Santé Municipale (Maison Dubois), by H. Labrouste (1856-58); 200 Faubourg-Saint-Denis, x. Hôtel-Dieu, rebuilt by Gilbert (1858-60); 1 Place du Parvis-Notre-Dame, iv. Asile Sainte-Anne, by Questel (1861-76); 1 Rue Cabanis, xiii. — **20th c.** Saint-Antoine (former abbey of Saint-Antoine-des-Champs), rebuilt by Renaud (*c.* 1905); 184 Faubourg-Saint-Antoine, xii. Nouvel Hôpital de la Pitié, by Justin (1911); 83 Boulevard de l'Hôpital, xiii. Maison Chirurgicale et Laboratoire du Bâtiment et des Travaux Publics, by Patouillard-Demoriane (*c.* 1935); Place d'Alleray, xv.

International Organizations

Ex-NATO Building by J. Carlu (1955-59); Porte Dauphine, xvi. UNESCO Palace, by Breuer, Nervi, and Zehrfuss (1958); 9 Place de Fontenoy, vii.

Libraries

Bibliothèque Nationale, former Palais Mazarin, 17th-c. building by J. Thiriot (1635-42), galleries by F. Mansart (1645); 8 Rue des Petits-Champs, ii. 18th-c. building by R. de Cotte; 19th-c. building by H. Labrouste (1854-90);

and Cabinet des Estampes (Print Room) by M. Roux-Spitz (1937-46);
'Arsenal, building partly of the 17th c., altered several times, particularly
: de Sully, IV. Bibliothèque Sainte-Geneviève, by H. Labrouste (1843-50);

uildings for Letting

.Rue Volta, III. — **14th c.** House known as Maison de la Hanse, later
.e, v. Remains of the so-called Hôtel d'Hercule (c. 1355, rebuilt 1470);
l de Clisson (1375), turreted entrance, now part of the Hôtel de Rohan-
es Archives, III.

, built by Nicolas Flamel (1407); Rue de Montmorency, III. Hôtel de Sens
de Cluny (1485-98), now Musée de Cluny; Place Paul-Painlevé, v. Gabled
.de, v. Hôtel de la Vieuville, with 17th and 18th-c. additions; 4 Rue Saint-
16th c.), demolished 1841, fragments extant in courtyard Ecole Nationale
. Bourdonnais, I. House, end 15th, beginning 16th c.; 5 Place de l'Ecole, I.
ôtel de la Reine Blanche (remains; replaced an older house); 17 Rue des
. Rue Charles-V, 18 Rue du Figuier, and 6 Rue Saint-Paul, IV. Turret on
d house, with carvings; 30 Rue François-Miron (2nd courtyard), IV. Arc
iambre des Comptes and its Archives to the Palais de Justice, flying over
in the Musée Carnavalet, III. Hôtel Torpanne (traces); Rue des Bernardins,
tyard); VI. Hôtel des Abbés de Fécamp (with 16th-c. turret); 5 Rue Haute-
feuille, VI. House; 10 Rue de Charenton, XII. Maison du " Censier " des
son des Carneaulx (1518); 28 Rue de la Parcheminerie, v. Hôtel Carnavalet,
by J. Goujon (post-1546); altered by Mansart (1600); (Carnavalet Museum
ue de Sévigné, III. Petit-Luxembourg (pre-1546), altered by Lemaire (post-
.s Presidency of the Senate until 1940; 17 Rue de Vaugirard, VI. Remains
uilt post-1715; 17-19 Rue Demours, XVII. Hôtel d'Albret (1550), rearranged
eois, IV. Remains of the Hôtel Scipion Sardini (1565), now Central Bakery
de Lamoignon (1580); 24 Rue des Francs-Bourgeois, IV. Arsenal, rebuilt
any times, in particular by Boffrand in 1718, now the Arsenal Library;

ault; 20 Rue Jean-Jacques Rousseau, I. Hôtel de Ferrare, later Hôtel de
I. Hôtel Jabach (middle of the century), traces; 110 Rue Saint-Martin, IV.
); 79 Rue du Temple, III. Hôtel, of reign of Louis XIII; 12 Rue des Lions, IV.
éthune, IV. Hôtel de Sandreville; 26 Rue des Francs-Bourgeois, III. Hôtel
: Saint-Augustin, II, rebuilt in the Carnavalet Museum, III. Hôtel de Rohan-
' Victor Hugo; 6 Place des Vosges, III. Hôtels in the Place des Vosges
uerite (remains presumed to be of), by Autissier (c. 1606); 6 Rue de Seine,
onwards); 14 and 26 Place Dauphine, I. Hôtel de Châlons-Luxembourg;
Mayenne, or d'Ormesson, by J. Androuet du Cerceau (c. 1613), rebuilt by
IV. Hôtel de la Brinvilliers (c. 1620); 12 Rue Charles-V, IV. Hôtel de Canil-
tel de Hillerin (c. 1622-28); 9 Quai Malaquais, VI. Hôtel de Fourcy (1623),
de Jouy, IV. Hôtel de Sully, rebuilt 1624-30 by J. Androuet du Cerceau;
(1626); 133 Rue Saint-Antoine, IV. Hôtel de Vigny (1628); 10 Rue du Parc-
the Galeries des Proues remain; enlarged in the 18th c. by Contant d'Ivry
; I. Hôtel de Garsanlan (c. 1630); 5 Quai Malaquais, VI. Hôtel d'Almeras
I. Hôtel de Chevry, later Hôtel du Président Tubeuf, wrongly attributed to
was part of the Palais Mazarin to which F. Mansart contributed the upper
oles (since destroyed). Now part of the Bibliothèque Nationale, completed
9th c. by Visconti and H. Labrouste; 8 Rue des Petits-Champs and 60 Rue
,35-38), by F. Mansart, later Hôtel de Toulouse, rearranged by R. de Cotte
19th c., now part of the Banque de France; 3 Rue de la Vrillière and Rue
l, rebuilt about 1936; 55-57 Quai de la Tournelle, v. Hôtel Amelot de Chail-
); 78 Rue des Archives, III. Hôtel d'Avaux, also known as Hôtel de Saint-
ue du Temple, III. Hôtel de Cavoye (c. 1640), altered during second half of
ts-Pères, VII. Hôtel Hesselin, by Le Vau (c. 1640); 24 Quai de Béthune, IV.
Quai d'Anjou, IV. Hôtel de la Bazinière, by F. Mansart (c. 1640), now an
Quai Malaquais, VI. Hôtel de Claude Le Rageois de Bretonvilliers (1640), by
t for the arcade; 3, 5, and 7 Rue Saint-Louis-en-l'Ile, IV. Hôtel de Rieux,
Garancière, VI. Hôtel d'Astry (1643, 1661); 16 and 18 Quai de Béthune, IV.
Rue Vivienne, II. Hôtel d'Aumont, rebuilt by Le Vau and Villedo, façade
Pharmacy for Hospitals (c. 1648); 17 Rue de Jouy, IV. Hôtel Colbert de Villa-
Hôtel de Fresnes (c. 1650); 34 Rue de Turenne, IV. Hôtel de Lauzun, later
u; 17 Quai d'Anjou, IV. Hôtel de Mortagne (c. 1650), by Delisle-Mansart;
(c. 1652); 13-15 Quai de Bourbon, IV. Hôtel du Sieur Pidoux (1652); 1 Rue
or Hôtel des Ambassadeurs de Hollande (1655), by P. Cottard; 47 Rue
iis (1655), by Antoine Le Pautre; 68 Rue François-Miron, IV. Hôtel de
y (1656), known as Hôtel Salé; 5 Rue de Thorigny, III. Hôtel by Le Vau,
Guénégaud (a small mansion) (1659); 13 Quai de Conti, VI. Hôtel de Maxi-
iple, IV. Hôtel de Vendôme (c. 1670); old entrance 132 Rue de Vaugirard,

now 25 Boulevard de Montparnasse, vi. Hôtel de Lulli (1671-87), by Gittard; 45 Rue des Petits-Champs, i. Hôtel de la Grange, or Hôtel de Braque (1673); 4 and 6 Rue de Braque, iii. Hôtel de Charmy (c. 1676); 22 Rue Beautreillis, iv. Hôtel Fieubet, or Hôtel de Lavalette, rebuilt to plans by J. Hardouin-Mansart (1676-81), façade remade in the 19th c., now Ecole Massillon; 2 Quai des Célestins, iv. Hôtel by Libéral Bruant (1685); 1 Rue de la Perle, iii. Hôtels in the Place des Victoires (1685), by J. Hardouin-Mansart; i. Hôtel Le Peletier de Souzy, later Hôtel de Saint-Fargeau, rebuilt by P. Bullet (1686), now Bibliothèque de la Ville de Paris; 29 Rue de Sévigné, iii. Hôtel d'Ecquevilly, or Hôtel du Grand-Veneur (c. 1686), altered later; 66 Rue de Turenne, iii. Hôtels in the Place Vendôme, by J. Hardouin-Mansart (1686); i. Hôtel Amelot de Gournay, by Boffrand (c. 1695); 1 Rue Saint-Dominique, vii. Hôtel Hardouin-Mansart, or Hôtel de Sagonne, by J. Hardouin-Mansart (1699); 28 Rue des Tournelles, iv.

18th c. Hôtel d'Ollonne (now Caisse d'Epargne et de Prévoyance de Paris); 9 Rue du Coq-Héron, i. Hôtel d'Estrées; 8 Rue Barbette, iii. Hôtel Mégret de Sérilly (early 18th c.); 106 Rue Vieille-du-Temple, iii. Hôtel de Blouin (Gentleman of the Bedchamber to Louis XIV), by Gabriel (early 18th c.), now Hôtel Pillet-Will; 31 Faubourg Saint-Honoré, viii. Hôtel de Beauvau (second half of 18th c.), by Le Camus de Mézières, now the Ministère de l'Intérieur; 96 Faubourg Saint-Honoré, viii. Favart's Country House (second half of 18th c.), now occupied by the Sisters of Saint-Vincent-de-Paul; 119 Rue de Ménilmontant, xi. " Petite Maison " du Duc d'Orléans (Duke of Orleans's Love Nest); 24 Rue Cadet, façade on 19 Rue Saulnier, ix. Hôtel de Charolais (about 1700-4), by Lassurance, now Ministère du Commerce; 101 Rue de Grenelle, vii. Hôtel du Président F. Duret, later Hôtel du Président de Longueil, Marquis de Maisons (1700-7), by Lassurance, decorated by Leroux; 51 Rue de Villersexel, vii. Hôtel de la Chancellerie de France (c. 1700), now Ministère de la Justice; 11-13 Place Vendôme, i. Hôtel de la Monnoye, later Hôtel de la Ferté-Senneterre, by Servandoni; 24 Rue de l'Université (in the courtyard), vii. Hôtel wrongly called de Lebrun (c. 1700), by Boffrand, now Office Public d'Habitations à Bon Marché; 47 Rue du Cardinal-Lemoine, v. Hôtel d'Antoine Crozat (1702) by P. Bullet; 17 Place Vendôme, i. Hôtel de Furstemberg (c. 1703), by Delisle-Mansart; 75 Rue de Grenelle, vii. Hôtel de Revel, later Hôtel de Broglie (1704), enlarged by Boffrand (1711); 35 Rue Saint-Dominique, vii. Hôtel de Soubise, rebuilt by Delamair (1705-9), now part of the Archives Nationales; 60 Rue des Francs-Bourgeois, iii. Hôtel du Président Duret (1706), by Predot; 57 Rue de Lille, vii. Hôtel de Vendôme (1707), by Courtonne and Le Blond, now the Ecole des Mines; 60 bis Boulevard Saint-Michel, vi. Hôtel de Rohan-Strasbourg (1708), by Delamair, now the Minutier Central; 87 Rue Vieille-du-Temple, iii. Hôtel de Seissac, or Hôtel de Boucher d'Orsay (1708), by Le Blond; 69 Rue de Varenne, vii. Hôtel de Villars, altered by Boffrand (1709) and by Leroux (1713), now the Mairie of the 7th arrondissement; 116 Rue de Grenelle, vii. Hôtel d'Auvergne (1710), by Cailleteau, usually known as Lassurance, added to by C. Lefranc and E. Brayer (c. 1934), now the Maison de la Chimie; 28 Rue Saint-Dominique, vii. Hôtel de Tingry-Mortemart (1710-13), by Boffrand; 1 Rue Saint-Dominique, vii. Hôtel de la Duchesse d'Estrées (1713), by R. de Cotte, now the Embassy of the U.S.S.R.; 79 Rue de Grenelle, vii. Hôtel de Mortemart (about 1713), by J. Marot; 14 Rue Saint-Guillaume, vii. Hôtel de Rannes (1713); 21 Rue Visconti, vi. Hôtel de Seignelay (1713), by Boffrand; 80 Rue de Lille, vii. Hôtel de Boffrand (1714), by himself, later Hôtel de Beauharnais, rebuilt in 1803, formerly the German Embassy; 78 Rue de Lille, vii. Hôtel Duret, then the Petit Hôtel de Brienne (1714), by Aubry; 16 Rue Saint-Dominique, vii. Hôtel Antier (the actress), later Hôtel des Demoiselles de Verrières (1752); 43-47 Rue d'Auteuil, xvi. Doorway of the Bureau des Lingères (1746); Square des Innocents, i, taken from no. 6 Rue Courtalon, i. Hôtel d'Avaray (1718), by Aubert or Leroux (Netherlands Legation); 85 Rue de Grenelle, vii. Hôtel d'Evreux (1718), by Molet, altered (pre-1764) by Lassurance, again by Percier and Fontaine, and by Lacroix (1854-55), now Palais de l'Elysée; 51 Faubourg Saint-Honoré, viii. Hôtel de Villars (1718), small mansion by Boffrand; 118 Rue de Grenelle, vii. Hôtel de Rohan-Montbazon (1719), by Lassurance; 27 Faubourg Saint-Honoré, viii. Pavillon de l'Hermitage (later than 1719), remains of the outbuildings of the Château de Bagnolet, now part of the Hôpital Debrousse; 148 Rue de Bagnolet, xx. Palais-Bourbon (1722-28), begun by Giardini, continued by Lassurance, and completed by Aubert and Gabriel, now the Chamber of Deputies; vii. Hôtel de Lassay, later the Petit-Bourbon (1722), by Aubert, now the Presidency of the Chamber; 35 Quai d'Orsay, vii. Hôtel de Noirmoutiers (1722), by J. Courtonne, later Hôtel de Sens (1735), decorated by Lassurance (now General Headquarters of the Army); 138-140 Rue de Grenelle, vii. Hôtel de Roquelaure (1722), begun by Lassurance, completed (1733) by Leroux, now Ministère des Travaux Publics; 246 Boulevard Saint-Germain, vii. Hôtel de Charost (1723), later Hôtel Borghèse, by Mazin, now the British Embassy; 39 Faubourg Saint-Honoré, viii. Hôtel de Salm-Dyck (c. 1723); 97 Rue du Bac, vii. Hôtel de Mademoiselle Demares, or Hôtel de Villeroy by Aubry (1724), decorated by Leroux, now Ministère de l'Agriculture; 78 Rue de Varenne, vii. Hôtel de Maillebois (about 1724), by Delisle-Mansart, later (1787) altered by Antoine; 102 Rue de Grenelle, vi. Hôtel Gouffier, later Hôtel de la Galaisière (1727); 56 Rue de Varenne, vii. Hôtel Peyrenc de Moras (1728-1731), later Hôtel de Biron, by Aubert and Gabriel, now the Musée Rodin; 77 Rue de Varenne, vii. Hôtel Chenizot (1730); 51 Rue Saint-Louis-en-l'Ile; iv. Grand Hôtel de Mailly (Loménie de Brienne) (1730), by Aubry, now Ministère de la Guerre; 14 Rue Saint-Dominique, vii. Houses by Gabriel for the Saint-Gervais manufactory (1735); 14 Rue François-Miron and 17 Rue des Barres, iv. Hunting Lodge for Monsieur de Julienne (1735); 7 Ruelle des Gobelins, xiii. Hôtel de Madame Juillet (1735), by Boffrand; 73 Rue de Varenne, vii. Hôtel de Montmorency-Bours (1743), by J. Caillon; 85 Rue du Cherche-Midi, xv. Hôtel Augeard (1750); 11 Boulevard Poissonnière, ii. Hôtel d'Augny (1750), rebuilt in the 19th c. by Aguado, now Mairie of the 9th arrondissement; 6 Rue Drouot, ix. Petit Hôtel de Chenac (1750), by Delamair, now the Swiss Legation; 142 Rue de Grenelle, vii. Hôtel Cœur du Dragon, re-arranged by Cartault in 1750 (only the doorway remains); 50 Rue de Rennes, vi. Hôtel de Brienne, joined in 1760 to the Hôtel du Président Duret (1714) and the Hôtel de la Duchesse de Mazarin (1730); the combined buildings now form part of the Ministère de la Guerre; 14-16 Rue Saint-Dominique, vii. Pavillon de Hanovre (1760), by Chevolet; corner of Boulevard des Italiens and Rue Louis-le-Grand, ii, transferred (1931-34) to the Parc de Sceaux. Hôtels of the Place de la Concorde (c. 1763-72), by J.-A. Gabriel: to the right, now the Ministère de la Marine; to the left, now the Cercle de la Rue Royale, Automobile Club de France, and the Crillon hotel; i and viii. Hôtel de Bérulle (1766), by Brongniart; 15 Rue de Grenelle, vii. Hôtel Phelippeaux de la Vrillère (1767), by Chalgrin, later Hôtel Talleyrand; 2 Rue Saint Florentin, i. Hôtel de Fleury (1768), by Antoine, enlarged in the 19th c., now the Ecole des Ponts et Chaussées; 28 Rue des Saints-Pères, vii.

Hôtel du Châtelet (1770), by Cherpitel, now the Ministère du Travail; 127 Rue de Grenelle, VII. Hôtel d'Aligre (1772); 54 Rue de Bondy, with Pavilion at no. 56, X. Hôtel de Galiffet (about 1775), rebuilt by Legrand, now the Italian Embassy; 73 Rue de Grenelle, VI. Hôtel Montholon (1775), by Soufflot le Romain; 25 Boulevard Poissonnière, IX. Petit Hôtel de Nivernais (1775), by Peyre; Rue Palatine, VI. Hôtel de l'Architecte Rousseau (about 1776); 66 Rue de la Rochefoucauld, IX. Hôtel Titon (about 1776); 58 Rue du Faubourg-Poissonnière, X. Hôtel de Rochechouart (1778), by Cherpitel, now the Ministère de l'Education Nationale; 11 Rue de Grenelle, VII. Hôtel du Fermier Deshayes (1779), by Aubert; 1 Rue Caumartin, IX. Hôtel de Bony (about 1780), by Ledoux; 32 Rue de Trévise, IX. Maison de Gouthière (the engraver), (1780); 6 Rue Pierre-Bullet, X. Hôtel de La Corée (1780), by Pérard de Montreuil; 44 Rue des Petites-Ecuries (in the courtyard), X. Hôtel d'Hallewyl, rebuilt by Ledoux (about 1787); 28 Rue Michel-le-Comte, III. Hôtel de Salm-Kyrburg (1782), by Rousseau, burned down 1871, rebuilt 1878, now the Palais de la Légion d'Honneur; 64 Rue de Lille, VII. Houses for letting, built for the Strict Bernardines *(Feuillants)*; 229-235 Rue Saint-Honoré, I. Hôtel des Ambassadeurs Extraordinaires, altered by Peyre (1783); 10 Rue de Tournon, VI. Hôtel de Jarnac (1783), by Legrand; 8 Rue Monsieur, VII. Hôtel Massa (1784), by Le Boursier; 56-80 Avenue des Champs-Elysées, transferred in 1928 to the Rue du Faubourg Saint-Jacques for the Société des Gens de Lettres. XIV. Hôtel de Monaco (1784), by Brongniart; 57 Rue Saint-Dominique, VII. Maisons de l'Architecte Belanger (c. 1785), by himself; 20 and 22 Rue Joubert, IX. Hôtel de Cossé-Brissac (c. 1785), by Antoine; 45 Rue de Varenne, VII. Hôtel de Jaucourt (c. 1785), by Antoine; 45 Rue de Varenne, VII. Hôtel de Mademoiselle de Bourbon-Condé (1786), by Brongniart; 12 Rue Monsieur, VII. Hôtel de Masserano (1787-88), by Brongniart; 11 Rue Masseran, VII. Hôtel Bourrienne (1787); 58 Rue d'Hauteville, X. Hôtel de Mademoiselle Dervieux (1788), by Belanger; 15 bis Rue Saint-Georges, IX. Hôtel de Crussol (1788), by Aubert; 138 Rue Amelot, XI. Hôtel de Clermont-Tonnerre (1789); 118 Rue du Bac, VII. Building for letting (c. 1792); 2 Rue de la Chaussée-d'Antin, IX. Hôtel Cheret (1795); 30 Rue du Faubourg-Poissonnière, X.

19th c. Maison Egyptienne (c. 1800); Place du Caire, II. Houses (c. 1800), in the Rue des Colonnes, II. Hôtel Empire; 50 Rue Saint-Sébastien, XI. Hôtel de Beauharnais (1803); see above Hôtel de Boffrand (1714), VII. Hôtel de Talma (c. 1808); 9 Rue de la Tour-des-Dames, IX. Hôtel Raoul (c. 1810); 6 Rue Beautreillis, IV. Hôtel de Mademoiselle Duchesnois (c. 1820); 3 Rue de la Tour-des-Dames, IX. Hôtel de Mademoiselle de Mars, altered c. 1820; 1 Rue de la Tour-des-Dames, IX. Hôtel Bony, later Hôtel Uribarren (post-1826); 32 Rue de Trévise, IX. Hôtel " à l'Italienne " (about 1827); 67 Rue Raynouard, XVI. Maison " des Goths "; 116 Rue Saint-Martin, IV. Romantic building; 34 Rue Henri-Monnier, IX. Building for letting (c. 1832), by Lemaistre, formerly the Maison Dorée; Boulevard des Italiens and 1 Rue Laffitte, IX. Hôtel de Pourtalès (1836), by Duban; 7 Rue Tronchet, IX. House (1840); 45 Rue de la Victoire, IX. Pavilion (1840); 6 bis Passage Violet, IX. Building for letting (1841), by Renaud; 28 Place Saint-Georges, IX. Façades " à l'Italienne " (mid-19th c.), attributed to Leclerc; Place Lafayette, X. Hôtel du Duc de Morny (c. 1850); 15 Avenue des Champs-Elysées, VIII. Hôtel Païva (1856-66), by P. Maugain; 25 Avenue des Champs-Elysées, VIII. Palais Pompéien of the Prince Napoleon (remains), at the Hôtel de Sully; 62 Rue Saint-Antoine, IV. Hôtel Thiers, by Aldrophe (rebuilt post-1871); 27 Place Saint-Georges, IX. Hôtel Edmond de Rothschild (1878), by F. Langlais (street façade by Visconti); 14 Faubourg Saint-Honoré, VIII. Mansion and building for letting (1888), by P. Sédille; 11 and 13 Rue Vernet, VIII. Hôtel (about 1888), by P. Monnier; 8 Rue Chardin, XVI. Hôtel and building for letting (about 1893), by Magnan; 54 Rue de Varenne, VII. Building for letting, by Dainville; 34 and 34 bis Avenue Foch, XVI. Hôtel (1894), by L.-C. Boileau the Younger; 11 Rue Hamelin, XVI.

20th c. Building for letting (1900) by Besse; 14 Rue d'Abbeville, X. Building for letting (c. 1902; first use of reinforced concrete), by A. and G. Perret; 25 bis Rue Franklin, XVI. Hôtel (1904), by L. Sorel; 65 Rue des Belles-Feuilles, XVI. Hôtel de Peintres et d'Artistes (c. 1906), by Huillard and Sue; 3 and 5 Rue Cassini, XIV. Building for letting (1913), by Charles Plumet; 50 Avenue Victor-Hugo, XVI. Group of buildings for letting (pre-1914), by Huillard; 126 Boulevard du Montparnasse, XIV. Building for letting (c. 1924), by A. Bocage; 8 Rue du Renard, III. Cité Mallet-Stevens (c. 1925); Rue Raffet, XVI. Terraced houses (1926), by H. Sauvage; Rue Vavin VI. Building for letting (about 1926), by H. Sauvage; 137 Boulevard Raspail, VI. Building for letting; 14 Boulevard Raspail, VII. Hôtels (c. 1926), by A. Lurçat; Cité Seurat, XIV. Building for letting (about 1927), by Patouillard-Demoriane and Pellechet; 14 and 16 Boulevard Poissonnière and 2, 4, and 6 Rue Rougemont, IX. Commercial Hotel (about 1927), by Pasquier and Jacquard; 5 Rue Montalembert, VII. Building (1928), by M. Roux-Spitz; 14 Rue Guynemer, VI. House for the Students at the Ecole Centrale des Arts et Manufactures (c. 1928), by Leprince-Ringuet; 4 Rue de Citeaux, XII. Building for letting, with underground street (about 1931), by Plousey and Cassan; 168-172 Faubourg Saint-Honoré, Rue Paul-Cézanne, 25-29 Rue de Courcelles, VIII. Ford Building (c. 1931), by M. Roux-Spitz; corner Boulevard des Italiens et Rue du Helder, IX. Maison de France (c. 1932), by Boileau; Avenue des Champs-Elysées, VIII. Block of apartments at low rents (c. 1932), by Pontremoli, de Rutte, Bassompierre, and Sirven; 36 Rue Antoine-Chantin, XIV. Immeuble du Vert-Galant (1932), by H. Sauvage; Quai des Orfèvres, I. Building for letting (1932) by J. Marrast; 3 Quai de Conti, XI. Buildings (c. 1932) by Roux-Spitz; corner of Avenue Henri-Martin and Rue de Franqueville, XVI. Buildings for letting (c. 1934), by Le Corbusier and Jeanneret; at the Parc-au-Prince, XVI. Building (c. 1934) by J. Ginsbert and F. Hepp; 42 Avenue de Versailles, XVI. Block of buildings (c. 1936) by R. and H. Bodecher; 33 Avenue Montaigne and 2-4, Rue Clément-Marot, VIII. Building (c. 1938), by Tilder; 1 Avenue Paul-Doumer, XVI. Building (c. 1938) by M. Gras and X. Rendu; 131 and 133 Avenue Malakoff, XVI. Offices of the Fédération Nationale du Bâtiment (1950), by R. Gravereau, with Lopez and Prouvé; Rue Lapérouse, XVI. Immeuble Lorraine-Escaut (1956), by J. Demaret, R. Busse, and J. Zimmermann; Rond-point Bugeaud, XVI. Office block (1957-58), by J. Balladur and Lebeigle; corner of Rue Saint-Georges and Rue de la Victoire, IX. Electricité de France building (1961-62), by R. Coulon and A. Roux (architects), and L. K. Wilenko (engineer); 2 Rue Louis-Murat, VIII.

Mills

18th c. (?) Le Radet, in wood, probably from the Butte Saint-Roch, and the But-à-fin, or Blutefin, in wood from Montrouge, are part of the Moulin de la Galette; 1 Rue des Deux-Frères, XVIII. — **18th c.** Moulin des Frères de Saint-Jean-de-Dieu, called the Moulin de la Charité, in stone; in the Cimetière Montparnasse, XIV.

Ministries

Affaires Etrangères (Foreign Affairs), by Bonnard and Lacornée (1844-46); 78 Rue de Grenelle, VII. Guerre (War), (1867-77); 37 Quai d'Orsay, VII. Agriculture; enlarged by Brune (1886); 231 Boulevard Saint-Germain, VII. Marine Marchande (Merchant Navy), by A. Ventre (1932); 3 Place de Fontenoy, VII. Services Techniques des Constructions Navales (1932), by A. and G. Perret; Boulevard Victor, XV.

Monuments and Unspecified Buildings

15th c. Inspection structure known as La Lanterne, for the Belleville aqueduct (pre-1457); 213 Rue de Belleville, XIX, in a cul-de-sac to the right. — **16th c.** Naumachia of the Parc Monceau; columns from the abbey of Saint-Denis, VIII. — **17th c.** Façade of the Office of the Merchant Drapers (Bureau des Marchands Drapiers) (c. 1650), refashioned by Boffrand; formerly in the Rue des Déchargeurs, I, now in the Musée Carnavalet, III. Manufacture des Gobelins, building in the courtyard of 142 Avenue des Gobelins, XIV. — **18th c.** Mire du Nord (1736), north sighting mark by Cassini; in the garden of the Moulin de la Galette, XVIII. Mire de l'Observatoire or Mire du Midi, south sighting mark; in the Parc Montsouris, XIV. Monument to Chancellor d'Aguesseau (1753), Place d'Auteuil, XVI. Temple of the King's Preserve, or of Love's Preserve; southern tip of the island of Neuilly bridge (formerly in the Parc Monceau). — **20th c.** Grand Palais (1897-1900), by Deglane, Louvet, and Thomas; Avenue Alexandre-III, VIII. Garde-meuble National (State Furniture Repository), by A. Perret (about 1936); 1 Rue Berbier-du-Mets, XIII. Aquarium of the Trocadéro, by R. Lardat (1937); XVI.

Museums (as Buildings)

19th c. Galliéra, by Ginain (1878-88), 10 Avenue Pierre-1er-de-Serbie, XVI. — **20th c.** Petit Palais, or Palais des Beaux-Arts de la Ville de Paris, by Charles Girault (1900); Avenue Alexandre-III, VIII. Gobelins, by Formigé (1914); 42 Avenue des Gobelins, XIII. France d'Outre-Mer, by Laprade and Jaussely (1931); 293 Avenue Daumesnil, XII. Art Moderne, by Dondel, Aubert, Viard, and Dastugue (1937); Quai de New-York, XVI. Palais de Chaillot, by Carlu, L.-H. Boileau, and Azéma (1937); Place du Trocadéro, XVI. Travaux Publics, by A. Perret (c. 1937-38); Place d'Iéna, XVI.

Palaces

14th c. Royal Palace of the Capetians, whose remains in the Conciergerie are known as the Guard Room, the Saint-Louis Room, and the Saint-Louis Kitchens, begun by Jean de Cérens, Nicolas des Chaumes, and Jean de Saint-Germer. The Palais de Justice, built on the site of the old royal palace, was rebuilt (after the 1776 conflagration) by Antoine Desmaisons, Moreau, and Couture. The Place Dauphine façade was by Duc and Dommey (between 1857 and 1866). — **14th c. to 19th c.** The Louvre. — **16th c. to 19th c.** Tuileries Palace, by Philibert Delorme from 1567, and by Jean Bulland from 1570; altered in the 17th c. by Le Vau, from 1664, and later by Dorbay. The Pavillon de Flore remains; it was rebuilt by Lefuel (1863-68); the Pavillon de Marsan, rebuilt in 1874, also remains. Substantial remains of the original were transported to the Château de la Punta, near Ajaccio (Corsica) in 1886-94. Some of its columns are to be found in the Tuileries gardens, the Palais de Chaillot, Ecole Nationale des Beaux-Arts, and the Ecole Spéciale d'Architecture, 254 Boulevard de Raspail, XIV. — **17th c. to 19th c.** Luxembourg Palace, by Salomon de Brosse (1615-27), altered by Chalgrin (1804), enlarged by H. de Gisors (1835-41). Palais-Royal: of the buildings by Lemercier (1624-28), only the Galerie des Proues remains. The palace was partly rebuilt by J. Hardouin-Mansart (c. 1692), by the Regent, and, following the fire of 1763, by P. Moreau and Contant d'Ivry, and restored by Chabrol (1872-76). Galleries by Louis (1780-84); Orléans Gallery altered by A. Ventre (1935).

Railway Stations

Gare d'Orléans, or Gare d'Austerlitz, by Callet father and son (1835), rebuilt and enlarged by Renaud (1865-69); 55 Quai d'Austerlitz, XIII. Gare Saint-Lazare, by Armand (1841-42), rebuilt by Lisch (1880-89); Rue Saint-Lazare, VIII. Gare de l'Est, by Du Quesney (1847-52), completely changed between 1895 and 1899, and again, by Bernaut, between 1928 and 1931; Rue and Place de Strasbourg, X. Gare de Lyon-Méditerranée, by Cendrier (1847-52), rebuilt in 1899; 20 Boulevard Diderot, XII. Gare du Nord, by Hittorf (1861-65), replacing a station by Raynaud (1847); 18 Rue de Dunkerque, X. — **20th c.** Gare du Quai d'Orsay, by Laloux (1900); 5 Quai d'Orsay, VII.

Schools (Lycées and Collèges)

19th c. Lycée Chaptal, by Train (1867); 45 Boulevard des Batignolles, XVII. Lycée Rollin, by Roger (1868-77); 12 Avenue Trudaine, IX. Lycée Condorcet (former convent building of the Capuchins of the Rue Saint-Honoré), by Brongniart (1781), façade by Duc (1864-65); 8 Rue du Havre, IX. Lycée Louis-le-Grand, former Collège de Clermont, rebuilt (c. 1865) by Bonnet, then (c. 1885-92) by Le Cœur; 123 Rue Saint-Jacques, V. Lycée Molière, by Vaudremer (c. 1885); 71 Rue de Ranelagh, XVI. Lycée Buffon, by Vaudremer (c. 1890); 16 Boulevard Pasteur, XV. — **20th c.** Lycée Saint-Louis, monumental entrance by Bailly (c. 1916); 44 Boulevard Saint-Michel, VI. Lycée Camille-Sée, by F. Le Cœur, (c. 1933); 11 Rue Léon-Lhermitte, XV. Lycée Jean de la Fontaine, by G. Héraud (c. 1937); Place de la Porte-Molitor, XVI.

School Complexes; Schools other than Lycées

20th c. Boys' School, by A. Berry (c. 1934); Rue Saint-Martin, X. School complex, by R. Expert (c. 1934); Rue Kuss, XIII. Bessières school complex, by Molinié and Nicod (c. 1935); Boulevard Bessières, XVII. School complex by P. Sardou (c. 1936); Rue des Morillons, XV.

Theatres, Circuses, Cinemas, Concert Halls, Music Halls

17th c. Remains of the old Comédie-Française, installed in 1668 by F. d'Orbay in an indoor tennis court; 14 Rue de l'Ancienne-Comédie, VI. — **18th c.** Théâtre National de l'Odéon, by Wailly and Peyre (1779-82), rebuilt by Chalgrin (1807) and modified in the 20th c.; Place de l'Odéon, VI. Théâtre Français, by V. Louis (1786-90), façades

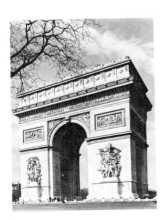

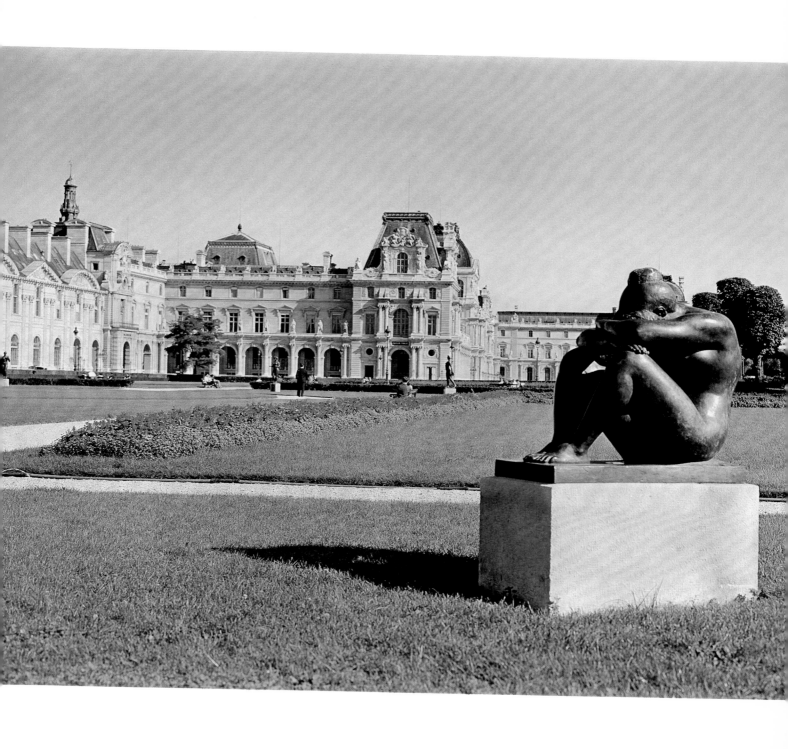

remade by Chabrol (1860-64), rebuilt by Guadet (post-1900), modified in the 20th c.; Place du Théâtre-Français, ɪ. Théâtre du Marais (1791-1807), now baths; 11 Rue de Sévigné, ɪv. — **19th c.** Théâtre des Variétés, by Cellerier (1807); 7 Boulevard Montmartre, ɪx. Hall of the former Conservatoire de Musique, by Delannoy (1811); 2 *bis* Rue du Conservatoire, ɪx. Théâtre Ventadour (the Italian Theatre), by Huvé and de Guerchy (1827-31), now a branch of the Banque de France; 2 Rue Ventadour, ɪɪ. Cirque d'Hiver, by Hittorf (*c.* 1852); 110 Rue Amelot, xɪ. Académie Nationale de Musique (Opéra), by Charles Garnier (1861-75); Place de l'Opéra, ɪx. Théâtre du Châtelet and Théâtre Sarah-Bernhardt, by Davioud (1862); Place du Châtelet, ɪ. Théâtre de la Gaîté-Lyrique (formerly Théâtre du Prince-Impérial) by Cursin (1862); Square des Arts-et-Métiers, ɪɪɪ. Opéra-Comique, by L. Bernier (1899);Place Boïeldieu, ɪɪ. — **20th c.** Théâtre des Champs-Elysées, by R. Bouvard, with A. and G. Perret (1911-13); 13-15 Avenue Montaigne, vɪɪɪ. Cinéma Marivaux (*c.* 1920); 15 Boulevard des Italiens, ɪɪ. Théâtre de la Michodière, by Bluysen and Bally (*c.* 1927); 4 Rue de la Michodière, ɪɪ. Salle Pleyel, by Aubertin, Granet, and Mathon (1927); 252 Faubourg Saint-Honoré, vɪɪɪ. Théâtre Saint-Georges, by Charles Siclis (*c.* 1928); 51 Rue Saint-Georges, ɪx. Cinéma Gaumont-Palace, modified by H. Belloc (*c.* 1932); Boulevard de Clichy, xvɪɪɪ. Cinéma Marbeuf, by Taverney (*c.* 1934); 34 Rue Marbeuf, vɪɪɪ. Théâtre du Palais de Chaillot, by Carlu, L.-H. Boileau, and Azéma (*c.* 1937); Place du Trocadéro, vɪ.

Towers
12th c. rebuilt **15th c.** Tower described as the Clovis Tower, in fact once part of the Sainte-Geneviève abbey; Rue Clovis, v. — **14th c.** Tour de Jean sans Peur, remains of the Hôtel de Bourgogne (*c.* 1375); 20 Rue Etienne-Marcel, ɪɪ. **15th c.** Tour Saint-Jacques, all that remains of the church of Saint-Jacques-la-Boucherie; Square Saint-Jacques, ɪv. Tower rebuilt in the 15th c., known as the Tour Calvin, remains of the Collège de Fortet; 2 Rue Valette, v. — **19th c.** Eiffel Tower (1887-89); Parc du Champ-de-Mars, vɪɪ.

Town Gates and Triumphal Arches
17th c. Porte Saint-Denis, by F. Blondel (1675); Boulevard Saint-Denis, x. Porte Saint-Martin, by P. Bullet (1674); Boulevard Saint-Martin; x. — **19th c.** Arc de Triomphe du Carrousel, by Percier and Fontaine (1806); Place du Carrousel, ɪ. Arc de Triomphe de l'Etoile, by Percier (1806), continued by Hugon and Blouet, work interrupted in 1814 and completed under Louis-Philippe; Place de l'Etoile, vɪɪɪ.

Town Walls and Barriers
Enceinte de Philippe-Auguste, remains of the end of the 12th and beginning of the 13th c.: 20 Rue Etienne-Marcel, ɪ; 15 Rue Charlemagne, ɪv; 31, 33, and 37 Rue des Francs-Bourgeois, ɪv; 17, 19, and 21 Rue des Jardins-Saint-Paul, ɪv; 8, 10, and 14 Rue des Rosiers, ɪv; 9, 11, 23, 25, and 27 Rue d'Arras, v; 49 and 50 Rue du Cardinal-Lemoine, v; 5 and 7 Rue Clovis, v; 45 and 47 Rue Descartes, v; Cour du Commerce Saint-André, vɪ; Passage Dauphine, 34 Rue Dauphine, vɪ; 27 and 29 Rue Guénégaud, vɪ; 35 Rue Mazarine, vɪ; and 7 Cour de Rohan, vɪ. Enceinte des Fermiers-Généraux (wall of the Farmers General of Taxes), by Ledoux (1781-90): Barrière d'Enfer (1784), Place Denfert-Rochereau, xɪv; pavilions (1787) and columns of the Barrière du Trône, Place de la Nation, xɪ; La Villette rotunda, Boulevard de la Villette, xɪx; and Observation Post at the North Gate of the Parc Monceau, Boulevard de Courcelles, vɪɪɪ.

Various Public Buildings
Palais de Justice, 13th-20th c.; Boulevard du Palais, ɪ. Chambre des Députés, façade by Poyer (1804-7), also known as the Palais Bourbon; Quai d'Orsay, vɪɪ. Bourse (Stock Exchange), by Brongniart and Labarre (1808-27), with two additional wings by F. Cavel (1903); Place de la Bourse, ɪɪ. Tribunal de Commerce, by Bailly (1860-63); Quai aux Fleurs, ɪv. Hôtel-de-Ville, by Bally and Deperthes (1874-82); Place de l'Hôtel-de-Ville, ɪv. Arcade from the old Hôtel de Ville, burnt down in 1871; in the Parc Monceau, vɪɪɪ.

MILITARY
13th c. Traces of the defensive wall of the priory of Saint-Martin-des-Champs: south-west corner tower and stair well; 7 Rue Bailly, ɪɪɪ; north-west tower on the corner of the Rue du Vert-Bois and turret in the Rue du Vert-Bois, ɪɪɪ. — **14th c.** Royal palace of the Capetians (Conciergerie), Towers (Argent, César, and Bonbec); Quai de l'Horloge, ɪ. Bastille (built 1369-82, demolished 1789): perimeter shown on the Place de la Bastille, xɪɪ, by stone insets; traces of the counterscarp are to be seen in one of the Métro stations and the remains of the Liberty Tower have been arranged in the Square Henri-Galli, Quai des Célestins, ɪv. Stones from the Bastille were used to build the house of Citoyen Pallard, 37 Rue des Imbergères, at Sceaux.

RELIGIOUS BUILDINGS

Chapels and Churches

Gallo-Roman Period
Saint-Germain-des-Prés (11th c. and 1163); Place Saint-Germain-des-Prés, vɪ. Saint-Martin-des-Champs (*c.* 1125-1250), now Musée des Arts et Métiers; 292 Rue Saint-Martin, ɪɪɪ. Saint-Pierre de Montmartre (1134-15th c.); 2 Rue du Mont-Cenis, xvɪɪɪ. Romanesque crypt of the old church of Notre-Dame-des-Champs, rebuilt in 1895 (formerly belonging to the Carmelite Order); 25 Rue Denfert-Rochereau, xɪv.

Gothic Period
Remains of the chapel of Saint-Aignan (about 1115-18); 19 Rue des Ursins, ɪv, and 26 Rue Chanoinesse, ɪv. Notre-Dame (1163-1350); on the Ile de la Cité. Saint-Julien-le-Pauvre (*c.* 1170-17th c.), Square René-Viviani, v· Saint-Denis de la Chapelle (early 13th c.-18th c.); 96 Rue de la Chapelle, xvɪɪɪ. Traces of the Virgin's chapel within the walls of the abbey of Saint-Germain-des-Prés (*c.* 1212-25); Place de Saint-Germain-des-Prés and Square du Musée de Cluny, vɪ and v. Sainte-Chapelle (1245-48); Boulevard du Palais, ɪ. Saint-Séverin (mid-13th-15th c.), includes portal from Saint-Pierre-aux-Bœufs in the Cité (mid-13th c.); 1 Rue des Prêtres-Saint-Séverin, v. Saint-

Germain-de-Charonne (late 13th-15th c.); 4 Place Saint-Blaise, xx. Saint-Germain-l'Auxerrois, (late 13th-15th c.); Place du Louvre, ı. Saint-Leu-Saint-Gilles (1319-1611); 92 Rue Saint-Denis, ı. Chapel of the Collège de Beauvais (1375-80); 9 *bis* Rue Jean-de-Beauvais, v. Saint-Laurent (pre-1429-17th, and 19th c.); 68 *bis* Boulevard de Strasbourg, x. Saint-Médard (pre-1450-1586); 141 Rue Mouffetard, v. Saint-Nicolas-des-Champs (1420-1580); 254 Rue Saint-Martin, ııı. Les Billettes (church) (1450-1580), now a Lutheran church; 24 Rue des Archives, xıv. Saint-Gervais-Saint-Protais (1494-1621); 2 Rue François-Miron, ıv. Saint-Merri (1515-1612); 78 Rue Saint-Martin, ıv. Western portal of Saint-Benoît (*c.* 1600-25, destroyed when the Rue des Ecoles was made in 1854); Square du Musée de Cluny, v.

Renaissance Period

Saint-Etienne-du-Mont (1492-1626); Place Sainte-Geneviève, v. Saint-Eustache (1532-1637), Rue du Jour, ı.

Neo-Classical Period

Chapel of the Hôpital Saint-Louis (1607-10); 40 Rue Bichat, x. Chapel of the Petits-Augustins (1608-10); now Ecole Nationale des Beaux-Arts, 14 Rue Bonaparte, vı. Saint-Joseph-des-Carmes (1613-20); 74 Rue de Vaugirard, vı. Temple de l'Oratoire (former chapel of the Oratorian Fathers), (1621-30); 147 Rue Saint-Honoré, ı. Sainte-Marguerite (1625-1764); 36 Rue Saint-Bernard, xı. Saint-Paul-Saint-Louis (1627-41); 99 Rue Saint-Antoine, ıv. Sainte-Elisabeth (1628-30), former chapel of the nuns of the Third Order of Saint Francis; 195 Rue du Temple, ııı. Sainte-Chapelle du Calvaire (1629-31); 70 Rue de Vaugirard, vı. Notre-Dame-des-Victoires (1629-1740); Place des Petits-Pères, ıı. Saint-Jacques-du-Haut-Pas (1630-84); 252 Rue Saint-Jacques, v. Temple Sainte-Marie (1632-34), former chapel of the Daughters of the Visitation of Sainte-Marie; 17 Rue Saint-Antoine, ıv. Chapel of the Hôpital Laënnec (1634), former Hospice des Incurables; 42 Rue de Sèvres, vıı. Church of the Sorbonne (1635-53); Place de la Sorbonne, v. Church of the Val-de-Grâce (1645-70); 277 Rue Saint-Jacques, v. Chapel of La Maternité, formerly the Port-Royal chapel (1646-48); 123 Boulevard du Port-Royal, xıv. Saint-Roch (1653-1736); 296 Rue Saint-Honoré, ı. Chapel of the Hospice des Enfants Assistés, former chapel of the Oratorian Fathers (1655-57); 72-74 Rue Denfert-Rochereau, xıv. Saint-Sulpice (1655-1777); Place Saint-Sulpice, vı. Saint-Nicolas-du-Chardonnet (1656-63; façade 1934); 30 Rue Saint-Victor, v. Chapel of the Collège des Quatre-Nations, now the Hall of Public Sessions of the Institute (1660-68); Quai de Conti, vı. Saint-Louis-en-l'Ile (1664-1726); 19 *bis* Rue Saint-Louis-en-l'Ile, ıv. Chapel of L'Assomption (1670-76); 263 *bis* Rue Saint-Honoré, ı. Chapel of La Salpêtrière (1670-77); 47 Boulevard de l'Hôpital, xııı. Saint-Louis-des-Invalides (Church of the Soldiers) (1671-1706); Church of the Dome (1679 - *c.* 1726); Esplanade des Invalides, vıı. Saint-Thomas-d'Aquin, former chapel of the Dominican Novitiates (1682-83), with portal of 1770; Place Saint-Thomas d'Aquin, vıı. Chapelle des Missions Etrangères (1683-90); 128 Rue du Bac, vıı Notre-Dame-des-Blancs-Manteaux (1685-90 and 1883), with portal from the Church of the Barnabites in the Cité (*c.* 1703); 12 Rue des Blancs-Manteaux, ıv. Saint-Jean-Saint-François, former chapel of the Capuchins of the Marais (1715); 6 Rue Charlot, ııı. Chapelle des Irlandais (*c.* 1740); 14 Rue des Carmes, v. Temple de Pentemont, former chapel of the Pentemont Nuns (1747-56); 106 Rue de Grenelle, vıı. Sainte-Geneviève, now the Panthéon (1757-end of 18th c.); Place du Panthéon, v. Chapelle du Séminaire du Saint-Esprit (1768-70); 30 Rue Lhomond, v. Chapel of the Ecole Militaire (1769-72); 43 Avenue de la Motte-Picquet, vıı. Saint-Philippe-du-Roule (1774-84); 153 Faubourg-Saint-Honoré, vııı. Church of the Madeleine (1774-1842); Place de la Madeleine, vııı. Saint-Louis-d'Antin, former chapel of the Capuchins of the Rue Saint-Honoré (1781-82); 63 Rue Caumartin, ıx. Chapel of the Hôpital de la Charité (1613-20, altered in 1798); 49 Rue des Saints-Pères, vı.

Modern Period

Chapel of the Hospice de la Rochefoucauld (1802); 15 Avenue d'Orléans, xıv. Chapelle Expiatoire (1816-26); 73 *bis* Boulevard Haussmann, vııı. Saint-Pierre du Gros-Caillou (1822-35, 1910-13); 92 Rue Saint-Dominique, vıı. Notre-Dame-de-Lorette (1823-26); 18 Rue de Châteaudun, ıx. Saint-Vincent-de-Paul (1824-44); Place Lafayette, x. Notre-Dame-de-Bonne-Nouvelle (1825-30); 25 *bis* Rue de la Lune, ıı. Saint-Denis-du-Saint-Sacrement (1826-35); 68 Rue de Turenne, ııı. Saint-Jean-Baptiste de Grenelle (1827-28, 1924-26); Place Félix-Faure, xv. Lazarist Chapel (1827-30); 95 Rue de Sèvres, vı. Sainte-Marie des Batignolles (1828-29, 1834-35); 69 Rue des Batignolles, xvıı. Saint-Jacques-Saint-Christophe de la Villette (1841-44, 1930); 158 *bis* Rue de Crimée, xı. Saint-Ferdinand des Ternes (1844-47, 1935-39); 27 Rue d'Armaillé, vıı. Sainte-Clotilde (1846-56); Square Sainte-Clotilde, vıı. Notre-Dame-de-Grâce de Passy (rebuilt 1846-49); 19 Rue de l'Annonciation, xvı. Saint-Lambert de Vaugirard (1848-56); Rue Gerbert, xv. Saint-Eugène (1854-55); 6 Rue Sainte-Cécile, ıx. Saint-Martin des Marais (1854-56); 36 Rue des Marais, x. Saint-Jean-Baptiste de Belleville (1854-59); 139 Rue de Belleville, xıx. Saint-Honoré d'Eylau (1855, 1886, 1898-99); Place Victor-Hugo, xvı. Notre-Dame de la Gare (1855-64); Place Jeanne-d'Arc, xııı. Saint-Marcel (1856); 82 Boulevard de l'Hôpital, xııı. Saint-Bernard de la Chapelle (1858-61); 1 Rue Affre, xvııı. Notre-Dame-de-Clignancourt (1859-63); 2 Place Jules-Joffrin, xvııı. Saint-Augustin (1860-71); Place Saint-Augustin, vııı. Saint-François-Xavier (1861-74); 39 Boulevard des Invalides, vıı. La Trinité (1863-67); Square de la Trinité, ıx. Saint-Pierre du Petit-Montrouge (1863-72); 88 Avenue d'Orléans, xıv. Notre-Dame-de-la-Croix de Ménilmontant (1863-74, completed 1880); Place de Ménilmontant, xx. Saint-Ambroise (1865-69); 71 *bis* Boulevard Voltaire, xı. Saint-Joseph (1867-74); 161-163 Rue Saint-Maur, xı. Notre-Dame-des-Champs (1867-76); 91 Boulevard du Montparnasse, vı. Saint-François-de-Sales (1873, 1910-13); 6 Rue Brémontier, xvıı. Sacré-Cœur (1876-1919); Rue du Chevalier-de-la-Barre, xvııı. Notre-Dame-d'Auteuil (1877-88); Place d'Auteuil, xvı. Chapelle du Martyre (1884-87); 13 Rue Antoinette, xvııı. Sainte-Geneviève des Grandes-Carrières (1891-1911); 174 Rue Championnet, xvııı. Notre-Dame-de-Perpétuel-Secours (1892-96); 55 Boulevard de Ménilmontant, xı. Sainte-Anne de la Maison-Blanche (1894-98); 186 Rue de Tolbiac, xııı. Saint-Charles de Monceau (1896-1910); 29 *bis* Rue Legendre, xvıı.

Contemporary Period

Saint-Jean de Montmartre (1894-1904), by A. de Baudot; 19 Rue des Abbesses, xvııı. Notre-Dame-du-Travail (1899-1901), by Astruc; 59 Rue Vercingétorix, xıv. Chapelle Notre-Dame-de-la-Consolation (1900-1), by Guilbert; 23 Rue Jean-Goujon, vııı. Saint-Antoine des Quinze-Vingts, by Vaudremer; 66 Avenue Ledru-Rollin, xıı. Saint-

Jean-Baptiste-de-la-Salle (1903-10), by A. Jacquemin; 9 Rue Dutot, xv. Saint-Hippolyte (1909-22), by Astruc; 27 Avenue de Choisy, xiii. Notre-Dame-du-Rosaire-de-Plaisance (1909-10), by P. Sardou; 194 Rue de Vanves, xiv. Notre-Dame-de-Lourdes (1909-10); 128 Rue Pelleport, xx. Saint-Joseph des Epinettes (1909-10), by Thomas; 40 Rue Pouchet, xvii. Saint-Dominique (1913-21), by Gaudibert; 20 Rue de la Tombe-Issoire, xiv. Saint-Michel des Batignolles (1913-31), by B. Humbold; 12 Rue Saint-Jean, xvii. Chapelle Saint-Charles de la Croix-Saint-Simon (1914-21), by Nicod and Lambert; Rue de la Croix-Saint-Simon, xx. Saint-François-d'Assise (1914-22), by P. and A. Courcoux; 7 Rue de Mouzaïa, xiv. Saint-Christophe de Javel, plans by C.-H. Besnard (1921-22, built 1926-34); 22 Rue de la Convention, xv. Saint-Léon (1925-31), by E. Brunet; Place du Cardinal-Amette, xv. Saint-Esprit (1928-33), by Tournon; 186 Avenue Daumesnil, xii. Saint-Pierre-de-Chaillot (1933-38) by E. Bois; Avenue Marceau, xvi. Saint-Jean-Bosco (1933-38), by Rotter; Rue Alexandre-Dumas, xx. Saint-Antoine-de-Padoue (1934-36), by Azéma; Boulevard Lefebvre, xv. Sainte-Odile (c. 1935-37), by J. Barge; Avenue Stéphane-Mallarmé, xvii. Cœur-Eucharistique de Jésus (c. 1938), by Charles Venner; Rue du Lieutenant-Chauré, xx. Saint-Gabriel (c. 1933), by Murcier; Rue de la Plaine (Cours de Vincennes), xx. Sainte-Bernadette d'Auteuil (1938), by P. Hulot; 4 Rue d'Auteuil, xvi. Chapelle des Otages (1938), by Barbier; Rue Haxo, xix. Saint-Cyrille-et-Saint-Méthode (c. 1939), by Laffillée; Rue de Bagnolet, xx. Sainte-Marie-Médiatrice (1950-54), by Henri Vidal; Porte du Pré-Saint-Gervais, xix. Sainte-Claire (1959), by Le Donné; Porte de Pantin, xix. Notre-Dame-de-la-Salette (1963), by Colbroc; 27 Rue de Dantzig, xv. Saint-Eloi (c. 1967), by Marc Leboucher; Rue de Reuilly, xii.

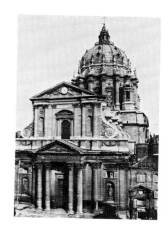

Churches and Chapels other than Roman Catholic

Temple de Grenelle, Protestant (1865), by Godebœuf. Temple d'Auteuil, Protestant (c. 1932), by Wulffleff and Verrey; 53 Rue Erlanger, xvi. *(For other Protestant churches, see above: Temple-Sainte-Marie, Oratoire, Les Billettes, and Pentemont.)* American Church (1927-31), by Carroll Greenough, and Cram; Quai d'Orsay, xv. Anglican Church (1833), Rue d'Aguessau, viii (British Embassy Church). Swedish Lutheran Church (1913), by Falk; 9 Rue Guyot, xvii. Armenian Church (1903-5), by A. Guilbert; Rue Jean-Goujon, viii. Russian Orthodox Church (1859-61), by Strohm, from plans by Kouzmine; Rue Daru, viii. Synagogue (1865-76), by Aldrophe; Rue de la Victoire, ix. Synagogue (c. 1920), by Beckmann; Rue Chasseloup-Laubat, xv. Mosque (1922-26), by Heubès, Fournez, and Mantout; Place du Puits-de-l'Ermite, v.

Convents, Monasteries, and Hospices

Remains of the Cordelières convent founded between 1270 and 1284, now the Hôpital Broca; 111 Rue Léon-Maurice Nordmann, xiii. Traces of the convent of Les Filles de Sainte-Avoye (1283-1792), Rue Geoffroy-Langevin; 61 Rue du Temple, iii. — **13th c.** Buildings of the Abbey of Sainte-Geneviève, now the Lycée Henri IV, with 13th-c. cellars, 15th-c. cloister, 18th-c. library, staircase and Royal Hall, and the so-called Clovis Tower built for the 12th-c. church and rebuilt in the 15th c.; Rue Clovis. Refectory and Sacristy of the Bernardine College, now a Fire Station; 24 Rue de Poissy, v. Priory of Saint-Martin-des-Champs, church and refectory by P. de Montereau, and some 18th-c. buildings, now part of the Conservatoire des Arts et Métiers; 292 Rue Saint-Martin, iii. — **14th c.** Remains of the refectory of the Great Austins convent of the beginning of the century; 6 Rue du Pont-de-Lodi, vi. — **15th c.** Refectory and dormitory of the Franciscan convent (end of century), now the Musée Dupuytren; 15 Rue de l'Ecole-de-Médecine, vi. Cloisters of Les Billettes convent; 24 Rue des Archives, iv. — **16th c.** Abbatial Palace of Saint-Germain-des-Prés (1586, altered 1599); 3 Rue de l'Abbaye, vi. — **17th c.** Building once part of the Couvent des Blancs-Manteaux, in part occupied by the Crédit Municipal; 14-16 Rue des Blancs-Manteaux, iv. Remains of the Couvent des Récollettes; 85 Rue du Bac, vii. Remains of the Couvent des Théatins: chapel entrance, 26 Rue de Lille, vii; buildings, 13 Quai Voltaire, vii. Entrance to the former Carmel, founded in 1603; 284 Rue Saint-Jacques, v. Convent of the Franciscans or Recollects (about 1603-14), now the Villemin Military Hospital; 8 Rue des Récollets, x. Traces of the Minims Convent; 12 Rue de Béarn, iii. Noviciate of the Capuchins of the Rue Saint-Honoré, founded 1613; once the Hôpital Ricord, and now annex of the Hôpital Cochin; 111 Boulevard de Port-Royal, xiv. Dependencies of the Carmel of the Rue Chapon (1619-1790); 45-47 Rue Chapon, corner of Rue Beaubourg, iii. Chapel and Cloister of the Filles-du-Calvaire (c. 1622), rebuilt and assimilated into the Petit-Luxembourg buildings; 19 Rue de Vaugirard, vi. Abbey of Port-Royal (1626-48), now La Maternité hospital; chapel by A. Lepautre; 119 Boulevard de Port-Royal, xiv. Remains of the abbey of Saint-Antoine-des-Champs, founded 1190-98, restored in 1643 and again 1767-70, now the Hôpital Saint-Antoine; 184 Rue du Faubourg-Saint-Antoine, xii. Former Benedictine convent of Notre-Dame-de-Liesse, installed in 1645 in an earlier building which became a hospice in 1778, and then the Hôpital Necker in 1802; 151 Rue de Sèvres, xv. Institution of the Oratory, or Noviciate of the Oratorian Fathers (post-1650), now Hospice des Enfants-Assistés; 72-74 Rue Denfert-Rochereau, xiv. Traces of the priory of the Sisters of La Madeleine de Trainel, installed in 1654; 100 Rue de Charonne, xii. Val-de-Grâce monastery (1653-65), now the Val-de-Grâce Military Hospital; 277-279 Rue Saint-Jacques, v. Seminary of the Foreign Missions (1663); 22 Rue de Babylone and Rue du Bac, vii. Convent of the English Benedictines (1674), now the Schola Cantorum; 269 and 269 *bis* Rue Saint-Jacques, v. Convent of the Filles de Sainte-Geneviève, or Miramiones, (c. 1691), now Musée de l'Assistance Publique; 47 Quai de la Tournelle, v. — **18th c.** Former Community of Sainte-Anne; façade in the courtyard of 27 Rue Lhomond, v. Seminary called after the Saint-Esprit, installed in 1731, chapel by Chalgrin; 30 Rue Lhomond, v. Pentemont building, rebuilt about 1750, now Ministère de la Guerre; 37-39 Rue Bellechasse, vii. Convent of the Filles de Saint-Joseph or Filles de la Providence, rebuilt about 1770, now part of the Ministère de la Guerre; 8-12 Rue Saint-Dominique, vii. Noviciate of the Convent of the Capuchins of the Rue Saint-Honoré, by Brongniart (1780-82), now the Lycée Condorcet; 65 Rue Caumartin, ix.

Ossuaries

14th or **15th c.** Traces of arcades and vaults of the Charnier des Innocents; 7-11 Rue des Innocents, i. — End **15th c.** Charniers de Saint-Séverin, restored 1923-28, dependency of the church of Saint-Séverin; v.

PARIS MUSEUMS

National

The Louvre; Thermes and Cluny, medieval and Renaissance, applied arts, 1 Place Paul-Painlevé, v; Art Moderne, Avenue du Président-Wilson, xvi; Jeu-de-Paume, French Impressionist school, north terrace of the Tuileries gardens, i; Orangerie des Tuileries, Claude Monet's water lilies, and temporary exhibitions; Monuments Français and Musée de la Fresque, mouldings, reproductions of Romanesque paintings, Palais de Chaillot, Place du Trocadéro, xvi; Arts et Traditions Populaires, and Musée de l'Homme, Palais de Chaillot, Place du Trocadéro, xvi, soon to be transferred to the edge of the Jardin d'Acclimatation; Guimet, Far East, 6 Place d'Iéna, xvi; Ennery, Far East, etc., 59 Avenue Foch, xvi; J.-J. Henner, 43 Avenue de Villiers, xvii (exhibits the works of this Alsatian painter); Gustave-Moreau (permanent exhibition of his paintings in the house in which he used to live), 14 Avenue La Rochefoucauld, ix; Rodin (finished sculptures and the sculptor's own collections left to the State), Hôtel Biron, 77 Rue de Varenne, vii.

Museums of the City of Paris

Carnavalet (history of Paris), 23 Rue de Sévigné, iii; Orangerie de l'Hôtel Le Peletier de Saint-Fargeau (lapidary), Rue Payenne, iii; Palais des Beaux-Arts de la Ville de Paris, formerly Petit-Palais (ancient art, including Dutuit and Tuck collections); Art Moderne, Avenue Alexandre-III, viii; Palais des Arts Modernes de la Ville de Paris (Salons and other temporary exhibitions), Quai de New-York, xvi; Cernuschi (Chinese art), 7 Avenue Velasquez, viii; Cognacq-Jay (paintings, sculptures, furniture, and items for 18th-c. display cabinets), 25 Boulevard des Capucines, ii; Galliéra (decorative arts, temporary exhibitions), Avenue Pierre-1er-de-Serbie, xvi; Maison de Victor Hugo, 6 Place des Vosges, iv. Hôtel de Lauzun, or Hôtel de Pimodan (remarkable interior decorations; the house is put at the disposal of distinguished guests, who have included Queen Elizabeth and the Duke of Edinburgh), 17 Quai d'Anjou, iv.

Specialized Museums

Army, Hôtel des Invalides, vii; Decorative Arts from the Middle Ages to the present day, 107 Rue de Rivoli, i; Public Assistance, 47 Quai de la Tournelle, v; Balzac's House, 47 Rue Raynouard, xvi; Bibliothèque Nationale, medals, antiques, gems, jewellery, etc.; Galerie Mansart, temporary exhibitions of engravings; Bourdelle (sculpture), 16 Rue Antoine-Bourdelle, xv; Musée de Caen, works by Prix de Rome graduates, Palais de l'Institut, vi; Conservatoire National des Arts et Métiers (Arts and Crafts), 292 Rue Saint-Martin, iv; Musée du Conservatoire National de Musique, 14 Rue de Madrid, viii; Eugène Delacroix, 6 Rue de Furstenberg, vi; Musée de l'Ecole Nationale des Beaux-Arts, sculptures from the Musée des Monuments Français and works from the Académie Royale de Peinture et de Sculpture, Rue Bonaparte, vi; Musée de la France d'Outre-Mer (France Overseas), 293 Avenue Daumesnil, xii; Musée des Gobelins, 42 Avenue des Gobelins, xiii; Jacquemart-André (from the Italian Renaissance to French 18th c.), 158 Boulevard Haussmann, viii; Musée de la Légion d'Honneur, 2 Rue de Bellechasse, vii; Musée de la Marine (French Navy), Palais de Chaillot, Place du Trocadéro, xvi; Hôtel des Monnaies (Mint), 11 Quai de Conti, vi; Nissim de Camondo (18th-c. French decorative arts), 63 Rue de Monceau, viii; Musée de l'Opéra, at l'Opéra, Place Charles-Garnier, ix. Musée Paléographique et Sigillographique de l'Histoire de France, decorations by Boffrand, 18th-c. paintings; Archives Nationales (documents), 60 Rue des Francs-Bourgeois, iii; Paul-Marmottan (Middle Ages, First Empire), 2 Rue Louis-Boilly, xvi; Musée du Protestantisme Français, 54 Rue des Saints-Pères, vi; Musée des Travaux Publics (Public Works), Place d'Iéna, xvi; Musée du Vieux-Montmartre, 22 Rue Tourlaque, xviii; Musée de la Chasse (hunting and shooting), Hôtel Guénégaud, 60 Rue des Archives, iii.

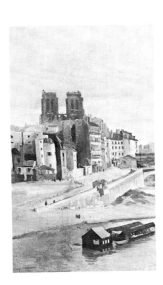

PHOTOGRAPHS

Alinari-Giraudon: 114 (below). Archives Photographiques: 8 (middle), 12 (below), 24, 37 (above), 41, 60, 105 (above), 117 (below), 127, 128, 131, 132, 133, 134, 135, 136, 140 (below), 160, 163, 165, 166, 167, 170 (above right), 171 (above), 173, 188. Bertrand: 52. Bibliothèque Nationale: 8 (above), 13, 18, 35, 39, 44 (above), 45 (above), 47 (above), 48, 50, 120/121, 121, 122, 144, 147, 148, 149, 150, 151, 152, 154. Bulloz: 8 (below), 9 (below), 16/17, 20 (above), 21, 27, 28, 32 (above), 36 (above), 37 (below), 45 (below), 49, 136/137, 139, 190 (above). Michel Chapuis: 56/57. Editions Diderot: 156. Editions Hermann: 9 (above). Jean Feuillie: 34/35, 59, 61, 63, 64, 64/65, 65, 66, 67, 69, 70, 71, 72, 73, 74, 76, 77 (above right), 78, 80, 81, 82, 83, 84, 85, 86, 88 (below), 89, 91, 93, 95, 96, 97, 98, 99, 100, 103 (above), 107, 110, 111, 115, 116, 119 (below), 157, 159, 160/161, 161, 172 (above), 183, 184, 185, 186 (above). Giraudon: 8/9, 12 (above right), 14 (below), 16 (below), 17, 23, 25, 31, 32 (below), 36 (below), 40 (above), 40/41, 101, 103 (below), 104 (above), 105 (below), 106, 108, 109, 112, 112/113, 114 (above), 118, 119 (above), 120, 123, 124, 125, 126, 130, 137, 138, 140 (above), 141, 142, 142/143, 153, 180 (below), 184/185, 189, 190 (below), 191, 192. Patrick Guilbert - Horizons de France: 29 (below), 34, 38, 42, 44, 145, 146. Harlingue - Viollet: 43. Horizons de France: 10, 12 (above left), 14 (above), 15, 16 (above), 19, 20 (below), 29 (above), 30, 33, 40 (below), 143. Barbara Jackson: 26. Loïc-Jahan: 79. L.A.P.I.: 51. Musée des Arts Décoratifs: 169, 170 (above left and below), 171 (below), 172 (below), 174, 175, 176, 177, 178, 179, 180 (above), 181, 182, 193. N.-D. - Giraudon: 36 (below). Aerial view Alain Perceval: 6, 53, 187. Roger Perrin: 54 (below), 55, 56, 56/57, 58, 68, 87, 92, 94, 168, 186 (below). Phédon Salou: 48/49, 80/81, 88/89, 194/195. Collection Viollet: 47 (below). Roger Viollet: 46, 75, 77 (below left), 88 (above), 102, 104 (below), 113, 117 (above).

The jacket photograph is by Phédon Salou. The endpapers reproduce an engraving of the seventeenth century: " Louis XIII and Anne of Austria on the heights of Belleville " (photo Bulloz).

Works of Bourdelle, R. Delaunay, Kandinsky, A. Marquet, and Zadkine: Rights reserved A.D.A.G.P., Paris. Works of Bernard, H. Bouchard, R. Dufy, F. Léger, A. Maillol, Pascin, A. Perret, P. Picasso, A. Rodin, and Zehrfuss: © by S.P.A.D.E.M., Paris, 1971.

INDEX

(Figures in *italics* refer to illustrations)

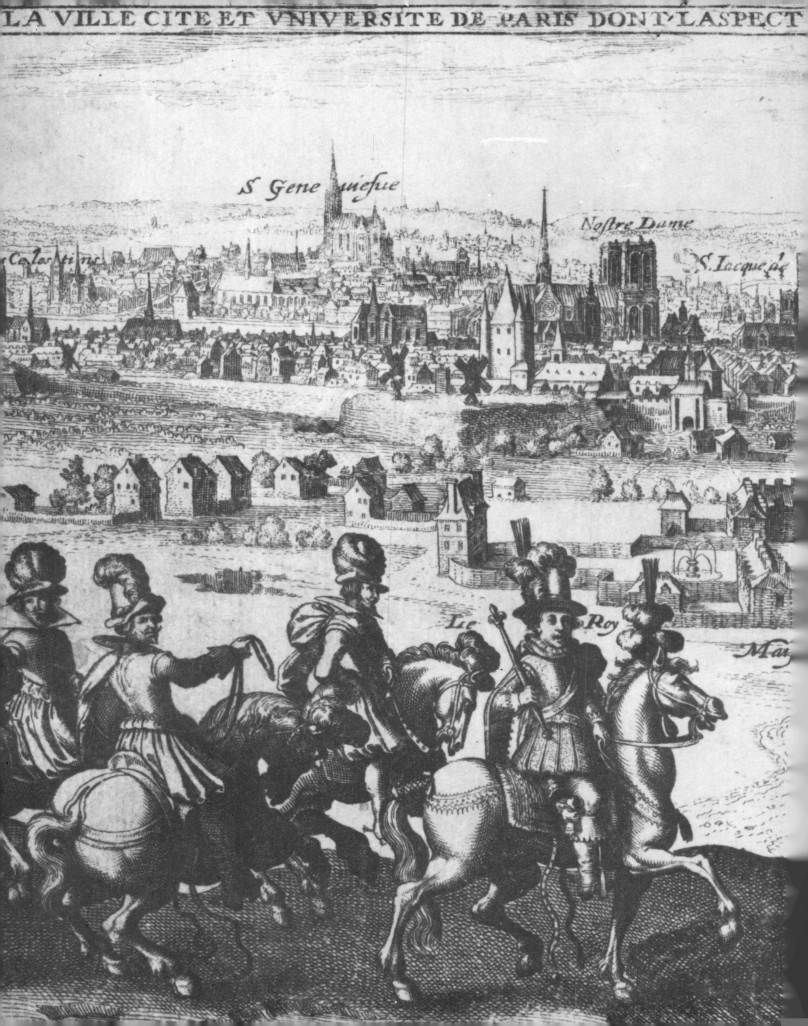